THE IMAGE OF CHR

SUPPORTED BY THE JERUSALEM TRUST
AND THE PILGRIM TRUST

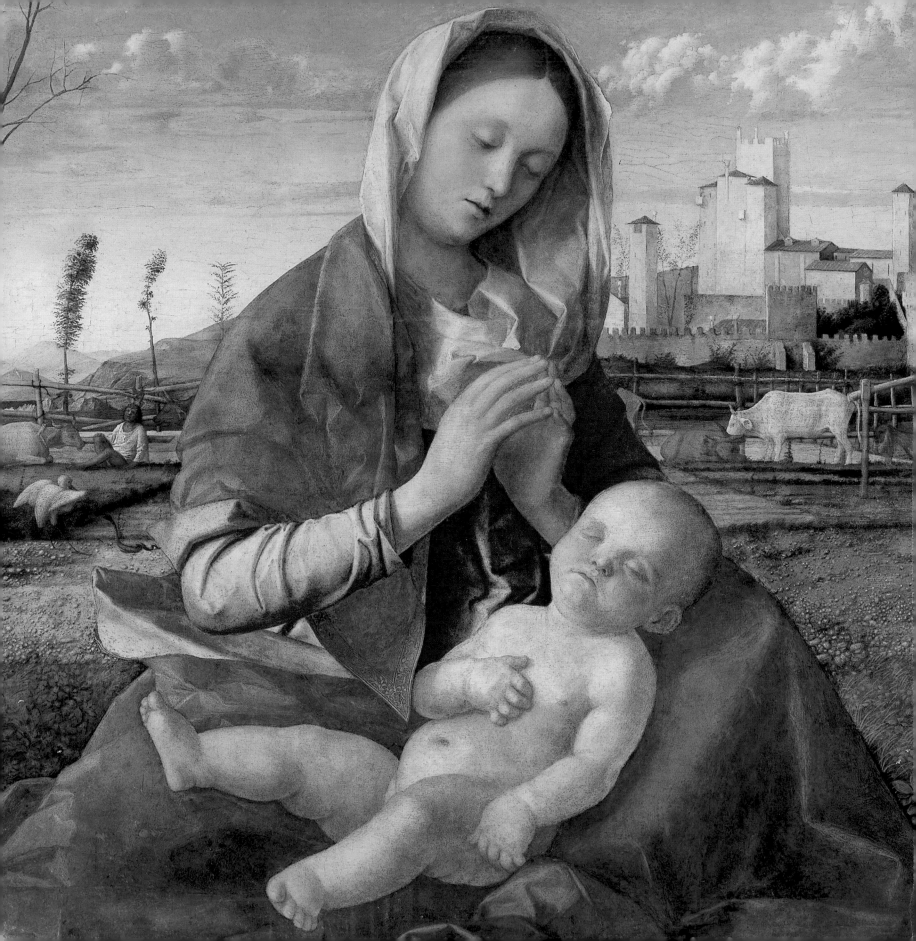

THE IMAGE OF CHRIST

Gabriele Finaldi

with an Introduction by

Neil MacGregor

and contributions by

Susanna Avery-Quash

Xavier Bray

Erika Langmuir

Neil MacGregor

Alexander Sturgis

NATIONAL GALLERY COMPANY LIMITED, LONDON

DISTRIBUTED BY YALE UNIVERSITY PRESS

Supported by The Jerusalem Trust and The Pilgrim Trust

This book was published to accompany an exhibition at
The National Gallery, London
26 February – 7 May 2000

First published in Great Britain in 2000 by
National Gallery Company Limited
St Vincent House, 30 Orange Street, London WC2H 7HH

ISBN 1 85709 292 9
525459

British Library Cataloguing-in-Publication Data
A catalogue record is available from the British Library
Library of Congress Catalog Card Number 99-076293

MANAGING EDITOR Caroline Bugler
DESIGNER Sarah Davies
ASSISTANT EDITORS Mandi Gomez and Tom Windross
PICTURE RESEARCHER Xenia Geroulanos
INDEXER Anne Coles

Printed and bound in Great Britain by Butler and Tanner, Frome and London

All biblical quotations are taken from the Authorized Version (King James) Bible unless otherwise stated
Provenance and Bibliography for individual entries is given on pages 208–212

Authors' abbreviations:
Susanna Avery-Quash *SA-Q*
Xavier Bray *XB*
Gabriele Finaldi *GF*
Erika Langmuir *EL*
Neil MacGregor *NM*
Alexander Sturgis *AS*

CONTENTS PAGE Christ carrying the cross as a
Model for Painters. *Engraving by Theodore Galle*
from Johann David's Veredicus Christianus *(The*
True Christian), Amsterdam, 1603.

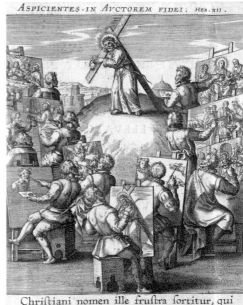

ASPICIENTES·IN·AVCTOREM FIDEI. HEB.XII.

Chriſtiani nomen ille fruſtra ſortitur, qui
Chriſtum minime imitatur. D.Auguſt.de ver.Chriſt.

Introduction

ALL GREAT COLLECTIONS OF European painting are inevitably also great collections of Christian art. In the National Gallery, London, roughly one third of the pictures – and many of the finest – are of Christian subjects. This is hardly surprising, for after classical antiquity, Christianity has been the predominant force shaping European culture. It is central to the story of European painting, preoccupying artists from Duccio to Dalí, inspiring some of the supreme masterpieces of all time.

Yet if a third of our pictures are Christian, many of our visitors now are not. And it is clear that for most this is a difficult inheritance. In part this is because the pictures, made to inspire and strengthen faith through public and private devotion, have been removed from the churches or domestic settings for which they were intended and hang now in the chronological sequences of the Gallery, not to the glory of God, but as part of a narrative of human artistic achievement.

Worse, addressing questions of slender concern to those of other – or no – beliefs, they seem to many irrecoverably remote, now best approached in purely formal terms. But this is surely to risk losing the heart of the matter: Piero della Francesca's *Baptism* (fig. 1) is of course a marvel of harmony and balance, an epitome of compositional values, but it was conceived as an exploration of the central mystery of the Christian faith – the total fusion of the human and the divine. It is also a theological triumph.

The aim of this exhibition and book is to focus attention on the purpose for which the works of art were made, and to explore what they might have meant to their original viewers. We have put some of the Gallery's religious pictures in a new context, not – as in other exhibitions – beside works by the same artist or from the same period, but in the company of other works of art which have explored the same kinds of questions across the centuries. A new neighbour for a painting allows us to have a different dialogue with it, and that usually leads to the discovery of a picture even richer and more complex than the one we thought we already knew.

Our focus is the Collection in Trafalgar Square, which ranges from 1200 to 1900, but we have borrowed over a much wider time range – from the early Christians to Graham Sutherland. Foreign lenders have been outstandingly generous, but we have tried to borrow mostly from the public collections of the United Kingdom. That we are able to put the exhibition on at all – and free of charge – is thanks to the generous support of The Jerusalem Trust and The Pilgrim Trust.

Rather than presenting Christ's life in art, the exhibition and book look at the difficulties Christian artists have had to confront when representing Jesus – God who became a man. They look not at the theological intricacies of the Incarnation, but at the pictorial problems it led to: deciding what Jesus looked like (for we have no records), how his suffering could be shown as not just personal but cosmic, how his human and divine nature could both be made clear at the same time. Biblical texts, commentators and mystics often solve this kind of problem by indicating the ungraspable nature of God through contradiction: he is both the Prince of Peace and the Suffering Servant,

FIG 1 *Piero della Francesca,* The Baptism of Christ, *1450s. Egg on poplar, 167 x 116 cm. London, National Gallery,* NG 665.

Saviour and Sacrifice, the sheep and the shepherd, the stumbling block and the corner-stone – paradoxes resonant and powerful in language, but almost impossible to paint. The word has universal authority, acknowledged and asserted from the beginning. The image is always individual and specific, forced to opt for one aspect only out of the many that we know exist. Two illustrations show the extremes of the problem and the extreme solutions advanced by different Christian traditions. In the seventeenth-century English Protestant church of St Martin Ludgate in the City, a Baroque Italianate altar houses not an image, but the Word of God – the Ten Commandments and the Lord's Prayer (fig 2). This is in every sense the authorised version of the faith of the Old and New Testaments, and a monument to that enduring anti-pictorial tendency which runs from the earliest Church to the Byzantine iconoclasts and the Protestant reformers: only the Word. The little print by Theodore Galle (contents page) puts the traditional Roman Catholic case in defence of representation. It pleads not just for the image, but for lots of images: artists try to paint Christ, just as Christians must try to imitate him, but every artist inevitably shows a different vision. Images are inadequate, but the answer is not to ban them but to multiply to infinity the opportunities for contemplation that they afford.

It is, in fact, the very difficulties Christian artists have had to resolve that makes it possible for these images to speak now to those who do not hold Christian beliefs. Christian artists confronted one great problem. They had to make clear that when repre-senting an historical event – the life and death of Jesus – they were not just offering a record of the past but a continuing truth; we the spectators have to become eye-witnesses to an event that matters to us now. Theological concepts must be given human dimen-sions and if only words can tackle the abstract mysteries, paintings are uniquely able to address the universal questions through the intelligence of the heart.

In the hands of the great artists, the different moments and aspects of Christ's life become archetypes of all human experience. The Virgin nursing her son conveys the feelings every mother has for her child: they are love. Christ mocked is innocence and goodness beset by violence. In the suffering Christ, we encounter the pain of the world, and Christ risen and appearing to Mary Magdalene is a universal reaffirmation that love cannot be destroyed by death. These are pictures that explore truths not just for Christians, but for everybody.

Neil MacGregor
Director of the National Gallery

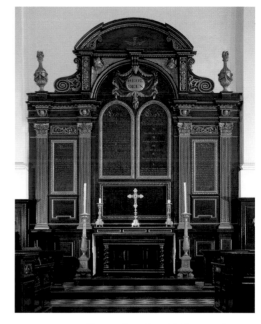

FIG 2 *Altar and reredos with Commandment Panels, 1680s. St Martin Ludgate, City of London. The church was designed by Sir Christopher Wren.*

1 SIGN AND SYMBOL

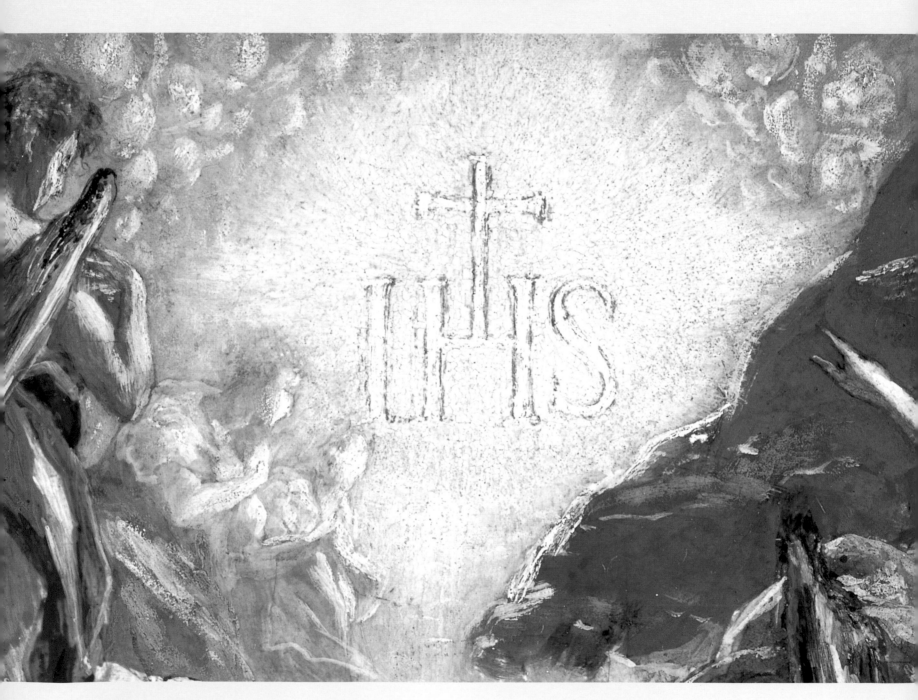

EARLY CHRISTIANS DID NOT represent the person of Jesus, so much as the belief that he was the Messiah, the Anointed One – 'Christ' in Greek – the Saviour. As this belief was founded above all on Scripture, the written Word of God, the earliest images of Christ were also created out of written letter- and word-signs, or were visual translations of the verbal imagery of the Bible.

In the ancient world, such signs and symbols inspired awe. The name of God in the Hebrew Bible is so sacred it cannot be pronounced; its letters, YHWH, have a title of their own, the tetragrammaton, the Greek word for 'four letters'. Metaphors are used throughout both the Hebrew Bible and the Gospels to suggest that Godhead is so far beyond human understanding it can be apprehended only by analogy.

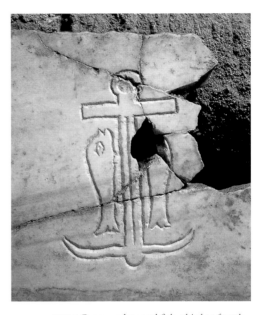

FIG 3 Cross-anchor and fish, *third or fourth century* AD. *Inscribed on a funerary slab in the catacomb of Priscilla, Rome.*

But if Christ's holy otherness could most forcefully be represented through signs and symbols, there was another compelling reason why early Christians did not attempt to portray Jesus's appearance. God's Second Commandment given to Moses on Mount Sinai forbids the making and worship of idolatrous images (fig 2). Since Jesus and his first followers were Jews, members of a culture hostile to images, no contemporary portraits of him were made. And the Gospels, written in the first century after his death, give no description of what he may have looked like.

Some hundred years later, Christianity had attracted many non-Jewish converts. Yet although the prohibition against images was relaxed, fear of idolatry remained. The early Church had no cult images of Christ – nor did Christians have churches, as we understand them, in which to place such images. They assembled in each other's houses to break bread together in memory of the Lord's Supper, celebrating their fellowship with Christ in expectation of his imminent return.

It was in designated burial places outside the city walls of Rome that the first Christian images were made around AD 200. As pressure of numbers grew, these areas were extended underground, producing many-storeyed catacombs – long corridors, lined with wall tombs stacked like bunk-beds, here and there widening into small rooms containing the graves of a single family or group. Pagans called them necropolises, cities of the dead, but to Christians they were cemeteries, dormitories where the faithful slept awaiting resurrection, when they would wake to join Christ in Paradise.

The marble slabs that sealed the tombs were inscribed with the names of the dead, proclamations of faith, and Christian emblems (cat. nos. 2–4); the vaults of the burial chambers were painted. This funerary decoration has nothing funereal about it, no indication of mourning, not even of fear of judgment – only affirmations of belief in Christ's victory over death. Beginning in the fourth century, when Christianity became the Roman state religion, the catacombs gradually fell into disuse, except as places of pilgrimage to the tombs of martyrs. Christians began to bury the dead inside purpose-built churches, in stone sarcophagi carved with similar images of trust and triumph.

The instrument of Christ's victory, the cross, was seldom represented; early Christians were reluctant to depict the gallows on which common criminals were executed. In the catacombs, they showed the cross covertly, for example in the crosspiece of a ship's anchor, emblem of hope (fig 3). Accompanying the anchor, or as a sign within an inscription, we find the oldest symbol for Christ: the fish (cat. no. 4).

This is a visual pun based on an acrostic. The initial letters of the Greek phrase, Jesus/ Christ/ Son of God/ the Saviour, formed the Greek word for fish, *ichthys*. But there are many additional reasons why the fish became an enduring symbol of Christ. Its native element, water, recalls the waters of Baptism necessary for salvation. Edible fish occur in Gospel accounts read as allegories of the Eucharist: the multiplication of the loaves and fishes (MARK 6: 34–44), and the appearance of the resurrected Christ on the shore of the Sea of Tiberias (JOHN 21). By following Christ, the disciples became fishers of men (MARK 1: 17; LUKE 5: 10). In the fish, the initials of a declaration of faith became a word, the word a sign, the sign an image that recalls entire texts, giving rise to a host of allegorical interpretations.

But there is another, more abstract early Christian letter-sign: the monogram formed from the first two letters of his Greek title, *Khristos*, XP, transliterated as chi rho in the Roman alphabet. This monogram already existed among the pagans as an abbreviation of the Greek word *khrestos*, meaning 'auspicious'. It may have been for this reason, and not as a Christian emblem, that the Emperor Constantine first adopted it on the Roman imperial standard. But if the x of the monogram is turned sideways, it forms a cross; the reference is even more pointed when the chi rho is wreathed in a victor's laurel crown. Set between the letters Alpha and Omega, the first and last letters of the Greek alphabet, the monogram unambiguously represents Christ himself: 'I am Alpha and Omega, the beginning and the ending' (REVELATION 1: 8). Both the fish and the chi rho readily migrated from sepulchres to objects in daily use: lamps (cat. no. 12), tableware, amulets, brooches and rings (cat. nos. 9 and 10), even the coins of Christian emperors (cat. nos. 6 – 8).

From about the sixth century, the Greek chi rho monogram, or monogram of Christ, was displaced – though never replaced – by the Latin trigram, IHS, an abbreviation of the Greek *Ihsous* (Jesus), later interpreted as an acrostic of *Iesus Hominum Salvator* (Jesus Saviour of Mankind). Its veneration was popularised by the fifteenth-century Italian preacher, Saint Bernardino of Siena, and it was later adopted as the device of the Society of Jesus founded by Saint Ignatius Loyola in 1534. The Jesuits (for whom it also signifies *Iesum Habemus Socium*, 'we have Jesus for our companion'), still promote its use in the devotional practice of the Adoration of the Name of Jesus (cat. no. 14).

Early Christian artists drew on secular tradition not only for emblems such as the fish and the chi rho, but also when translating into visual form the verbal imagery of the Bible, notably the metaphors of Christ as the vine (JOHN 15: 1, cat. no. 20) and Christ the Good Shepherd (JOHN 10: 14–15; 27–28).

Vines, grapes and wine-making – symbolic of Christ's sacrifice and of the Eucharist (fig 4) – had long been associated with the Graeco-Roman god of wine, Dionysos or Bacchus, who had died, been buried, and rose again. As an emblem of the afterlife, they were already a staple of funerary decoration; Christian tombs can normally be distinguished from pagan ones by the chi rho monogram appearing among the scrolling vines.

The early Christian Good Shepherd, who lays down his life for his sheep, is indistinguishable, except by context, from shepherds in the idyllic pictures of country life painted in Roman villas. He is young and beardless, dressed in the short tunic of a farm-labourer. He usually carries a sheep across his shoulders, while other sheep stand trustingly by his side (cat. nos. 1–3).

But if Christ speaks of himself as the Good Shepherd, he is also the Lamb – the sacrificial animal of the Hebrew Bible, the 'Lamb of God which taketh away the sin of the world' in the Gospel of Saint John (JOHN 1: 29, 36). The image of the Lamb has a chequered history. Perhaps to avoid confusion with the Good Shepherd, the artists of the catacombs never represent it. In the triumphant fifth-century Church, it appears as the victorious Lamb of the Book of Revelation (REVELATION 17: 14). A Greek Church council in 692 forbade the depiction of Christ in animal form; but the practice continued in the West. Influenced by the new theology popularised in the 1200s by Saint Francis of Assisi, the sacrificial Lamb became the prime symbolic representation of the suffering Saviour (cat. no. 17).

There is one biblical metaphor which largely eluded early Christian artists: Christ as the Light of the World (LUKE 2: 32; JOHN 1: 5; 3: 19; 8: 12; 12: 35). They hinted at it (cat. no. 12); they identified Christ with pagan sun gods; they pictured him with a golden halo, or clothed in the radiance and glitter of gold mosaic. But not until the fifteenth century did artists have the technical means – oil paint – of making the dark visible. And you can't picture light until you can show it dispelling darkness (cat. no. 15).

Artists continued to represent Jesus Christ through signs and symbols, even after an agreed likeness was established and it became permissible to portray him (cat. no. 16). Likeness brings us face to face with the man Jesus, enabling us to feel with him and for him. Words, letter-signs and metaphors do something else, for there has always been something uncanny and awesome about them: 'In the beginning was the Word'.

It is by combining the likeness of Jesus Christ with words, signs and symbols that art succeeds in depicting his dual nature: fully human and fully divine. *EL*

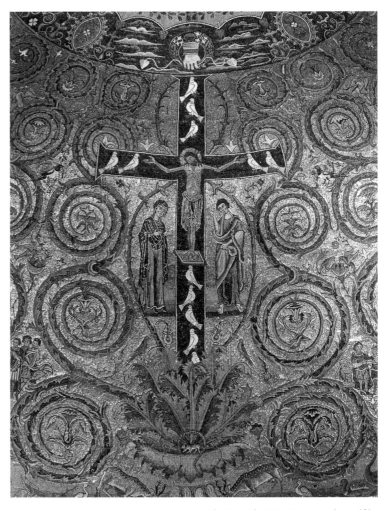

FIG 4 Christ on the Vine Cross, *early twelfth century. Apse Mosaic, Rome, S. Clemente.*

1 The Good Shepherd, Roman, fourth century AD

Marble, height: 43 cm., including base

Rome, Museo Nazionale di Roma, INV. 67618

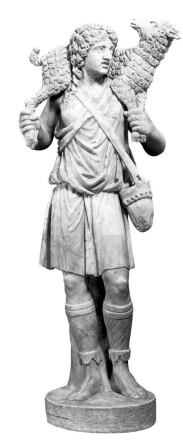

FIG 5 The Good Shepherd, *late third or early fourth century. Marble, height: 100 cm. Vatican City, Vatican City Museums.*

1 On Good Shepherd imagery, see Didron 1851: I, pp. 337–41; Hertling/Kirschbaum 1960, pp. 223–24; Himmelmann 1980.

2 *Vatican Collections*, cat. no. 134.

THE IMAGE OF CHRIST as the Good Shepherd is based on the metaphor that Christ uses of himself in the Gospel of Saint John: 'I am the good shepherd: the good shepherd giveth his life for the sheep' (JOHN 10: 11, 14–15). Christ's assertion was a claim to messiahship, since according to a prophecy of Ezekiel, dating from the sixth century BC, and well known to Jesus's contemporaries, God would raise a new and virtuous king-shepherd who, like King David, would lead his people and bring them to rich pastures (EZEKIEL 34). Depictions of the Good Shepherd became common from the third century AD, especially in the Roman catacombs, the ancient Christian cemeteries outside the city of Rome, where they appear in wall paintings and on sarcophagi and funerary slabs. The Good Shepherd images should not be understood as representations of the person of Christ but as visual renditions of the metaphor employed by him to cast light on his nature and mission.[1]

The imagery of this sculpture is based on the parable of the Lost Sheep (LUKE 15: 4–5), which stresses Christ's special concern for sinners and for the marginalised, and highlights his saving activity:

> What man of you, having an hundred sheep, if he lose one of them, doth not leave the ninety and nine in the wilderness, and go after that which is lost, until he find it? And when he hath found it, he layeth it on his shoulders rejoicing.

The sculpture shows a youthful and beardless figure wearing the short belted tunic typically worn by shepherds in the imagery of the classical world, and carrying a ram on his shoulders. The image of the Good Shepherd harks back to ancient Greek votive figures – known as *Kriophoroi* – of pagan worshippers bearing animals for sacrifice, and to representations of the shepherds in the pastoral themes of antiquity. Images of shepherds were employed in pagan funerary monuments to symbolise the peace of the afterlife, and these proved very amenable for use in a Christian funerary context (cat. nos. 2 and 3). The Roman sculptural workshops that produced sarcophagi and sepulchral carvings found it easy to adapt their patterns to the demands of a Christian clientele. Good-Shepherd imagery remained current until the sixth century, and its gradual disappearance after that may be due in part to the abandonment of the catacombs as places of Christian burial and the emergence of other types of image which focused more on the person of Christ.

The figure and pose of this sculpture are very similar to the celebrated free-standing *Good Shepherd* in the Vatican Museums (fig. 5).[2] It is not clear whether that sculpture and the one shown here were conceived from the start to be free-standing or whether they were cut away from sarcophagus reliefs in later times and adapted into independent carvings. The narrow depth and frontal presentation of this work would suggest that it was the latter. *GF*

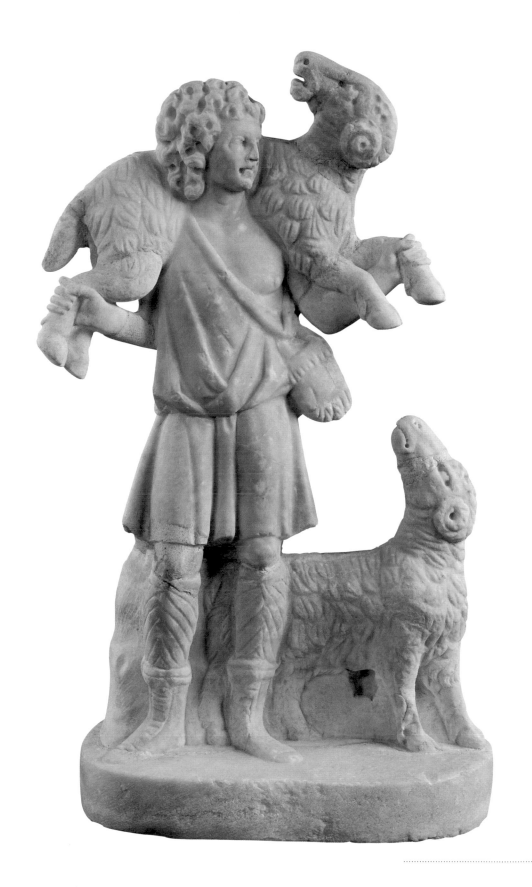

2 Funerary slab of Aurelius Castus with the Good Shepherd, Roman, third or fourth century AD

Marble, 34 x 83 x 2 cm.

Inscribed AVRELIVS CASTVS/ M VIII FECIT FILIO/ SVO ANTONIA/ SPERANTIA *(Aurelius Castus, 8 months old. Antonia Sperantia made [this tomb] for her son)*

Vatican City, Vatican Museums, INV. 32457

3 Funerary slab of Florentius with the Good Shepherd, Roman, fourth century AD

Marble, 22.5 x 77 x 2 cm.

Inscribed FLORENTIVS/ IN PAÇAE *(Florentius [rests] in peace)*

Vatican City, Vatican Museums, INV. 32456

1 For further discussion see Hertling/Kirschbaum 1960.
2 Quoted in Marucchi 1910, p. 57.

THESE TWO FUNERARY SLABS, together with that inscribed with a fish (cat. no. 4), come from the catacombs of Rome. Between the second and early fifth centuries, the Roman Christians established vast underground burial sites in the soft tufa stone, made up of networks of passages, often on several levels, with thousands of tomb cavities on either side. The catacombs took the name of the wealthy benefactors in whose land they were established, for example the Catacomb of Domitilla, a member of the Emperor Flavian's family, or of the saints who were buried in them, like the Catacomb of Saint Callixtus, Pope from 217 to 222. The funerary slab of Aurelius Castus (cat. no. 2) comes from the latter. From early times the catacombs were venerated as holy sites because they housed the tombs of the martyrs; they appear not to have been used, as has sometimes been said, for the clandestine meetings of persecuted Christians.[1]

Most of the funerary slabs that were once used to close up the tomb cavities in the catacombs are unmarked but many bear the names of the deceased, often together with a pictogram or emblem relating to their faith or trade. A large group of these slabs was assembled in the nineteenth century for the Vatican Museums with the specific purpose of illustrating the practices, rites, imagery and beliefs of the early Christians. Many of them bear the image of the Good Shepherd, or the fish, and many more the monogram of Christ, often combined with the Greek letters Alpha and Omega, symbolising the eternal nature of Christ, as the beginning and the end. The inscriptions and images on the slabs are carved rather crudely and would have been filled with coloured wax or paint to make them more visible. Some of these fillings were renewed when the slabs entered the Vatican Museums.

The Good Shepherd appears frequently in catacomb murals and on sarcophagi and grave slabs because it was an image intimately bound up with the belief in an afterlife spent in the presence of Christ himself. The words of Psalm 23 (verses 1, 2, 4, 6) speak of God as a shepherd and were understood in the early Church to allude to the eternal life promised by Christ:

> The Lord *is* my shepherd: therefore can I lack nothing. He shall feed me in a green pasture: and lead me forth beside the waters of comfort […] Yea, though I walk through the valley of the shadow of death, I will fear no evil: for thou art with me […] thy loving-kindness and mercy shall follow me all the days of my life: and I will dwell in the house of the Lord for ever.

A common prayer in the early Church was the one made for the deceased, that they should be led to heaven 'borne on the shoulders of the Good Shepherd' (*boni pastoris humeris reportatum*).[2]

In looking at the funerary slabs of these early Christians, the infant Aurelius Castus (cat. no. 2) and Florentius (cat. no. 3), individuals about whom we know nothing, we are struck by the simplicity and power with which they proclaim their faith. *GF*

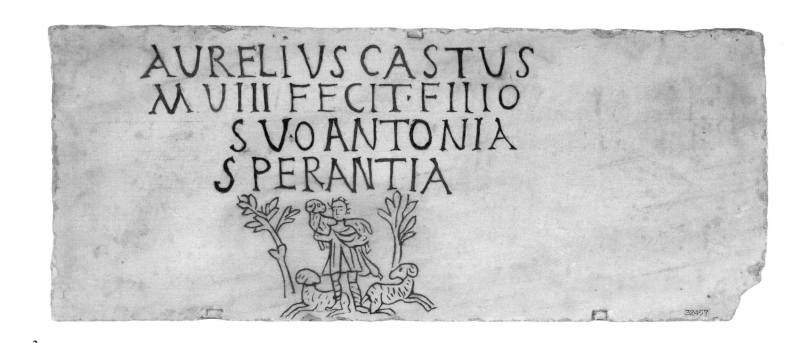

AURELIVS CASTVS
M VIIII FECIT·FILIO
SVO ANTONIA
SPERANTIA

2

FLORENTIVS
INPACAE

3

4 Funerary Slab with a Fish, Roman, fourth or fifth century AD

Marble, 28.5 x 62 x 2 cm.

Vatican City, Vatican Museums, INV. 32511

THE IMAGE OF THE FISH was adopted at an early date as a Christian symbol. The fish was understood specifically as a sign for Christ as opposed to a representation of him, or the visualisation of a metaphor, like the Good Shepherd (cat. nos. 1–3). Its origin lies in a play with words, rather than in New Testament imagery.[1] In Africa, the fourth century Bishop of Milesia, Optatus, explains that the letters which form the Greek word for fish, ΙΧΘΥΣ (*Icthys*), are an acrostic of the phrase, which he renders in Latin, '*Jesus Christus Dei Filius, Salvator*' (Jesus Christ, Son of God, the Saviour). On some early Christian funerary slabs the inscriptions identifying the deceased are preceded by the word ΙΧΘΥΣ, but depictions of the fish in a Christian context appear as early as the second century.

The fish was interpreted in an allegorical key by the Church Fathers (the bishops, writers and theologians of the first centuries). Several of them draw parallels between Christ's offering of himself, and the fish which gives itself to be eaten. Saint Augustine (AD 354–430) in his *City of God* gives an ingenious interpretation, which, incidentally, demonstrates the process whereby the acrostic becomes an image and the image, in its turn, becomes an allegory: 'ΙΧΘΥΣ is the mystical name of Christ because he descended alive into the depths of this mortal life, as into the abyss of waters'. The associations of the fish with water (Baptism), with food (the loaves and fishes of the Gospels, often interpreted as figures of the Eucharist), and with fishermen (Christ's announcement to the Apostles that they would become 'Fishers of men', MARK 1: 17 and LUKE 5: 10), gave the image of the fish a wide symbolic resonance and it has consequently been much used in a Christian context.

The precise provenance of this funerary slab is uncertain but it came from a tomb in the Roman catacombs. In its original and complete state it may have had a name on it to identify the deceased. *GF*

1 See Didron 1851: I, pp. 344–67.

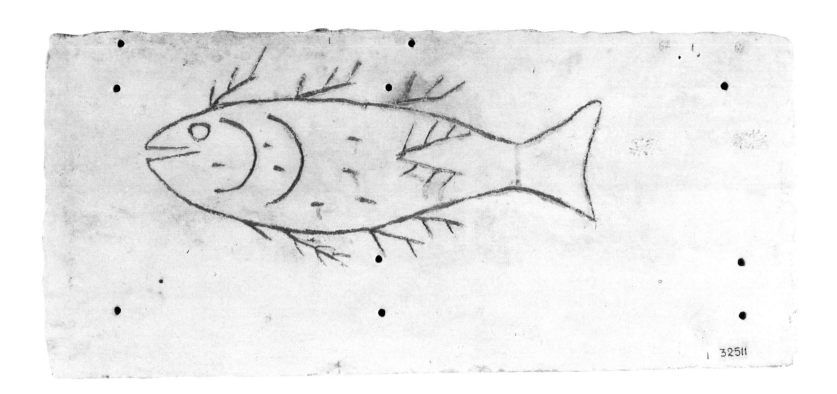

5 Coin of the Emperor Constantine looking Heavenwards, Roman, AD 327

Obverse of a gold two-solidus piece of Constantine, mint of Nicomedia (modern Izmit in Turkey), diameter: 22 mm.

London, British Museum, 1844–10–15–309

6 Coin of the Emperor Constantine with the monogram of Christ crowning the Labarum, Roman, AD 327

Reverse of a bronze billon centenionalis of Constantine, mint of Constantinople, bronze, diameter: 12 mm.

Inscribed SPES PUBLICA *(Hope of the State)*

London, British Museum, 1890–8–4–11

THE UBIQUITOUS SIGN of Christ in the late antique world, which is still current today, is the monogram made up of the Greek letters XP, chi and rho. These are the first two letters of the name of Christ in Greek, ΧΡΙΣΤΟΣ (*Khristos*), which means 'anointed' and is the equivalent of the Hebrew 'Messiah'. The monogram is not, of course, a representation of Christ, but a sign or mark which stands for him. In the early Church it signified the user or wearer's alignment with Christ. The simplicity of the design made it especially popular, and even after the adoption of the cross as the prime Christian symbol in the fifth century, it continued to be widely used. The monogram is known by various names: the Christogram, the Sacred monogram, or the Constantinian monogram, and the last of these alludes to its origin under the Roman Emperor Constantine the Great who ruled from 307 to 337.

Constantine was declared Emperor on the death of his father, Constantius I, in 306. In 312 he was at war with Maxentius who had seized imperial power, and on 27 October their respective armies were ranged against each other near the Milvian Bridge in Rome. The Church historian Eusebius (*c*.260–*c*.341) recounts in his *Life of Constantine* that on the eve of battle, Constantine prayed for help and saw in a vision above the setting sun a fiery cross and the inscription '*Hoc signo victor eris*' (By this sign you will conquer). Christ appeared to him in his sleep that night and commanded him to make a likeness of the cross and use it as a safeguard against his enemies. A complementary version of the story is given in the biography of Constantine written by Lactantius, who was tutor to one of the emperor's sons: Constantine was directed in a dream to put the sign of Christ, that is the chi rho monogram, on his soldiers' shields. This he did and the following day won a resounding victory against Maxentius which he attributed to Christ's intervention.

In 313 he issued, together with Licinius, the ruler of the eastern part of the empire, the

5

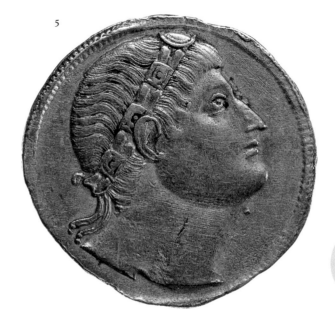

Actual size

Edict of Milan, which granted toleration to Christians, and thereafter he actively encouraged the growth of the Church. Although Constantine himself was only baptised on his deathbed in 337, his conversion marks a turning point in European history, since it is in large measure due to him that Christianity became the dominant religion in the Western world.

The gold two-solidus piece of Constantine (cat. no. 5) is mentioned by Eusebius, who says that the Emperor 'directed his likeness to be stamped on a gold coin with his eyes uplifted in the posture of a prayer to God'.[1] Although this type of image is ultimately derived from the coins of Alexander the Great of some six centuries earlier, the story of Constantine looking up at the vision of the flaming cross, suggests that a Christian interpretation of this coin is appropriate.

Constantine gave the monogram of Christ official status by employing it on his coinage.[2] A silver coin struck in the mint of Ticinum (modern Pavia) in about AD 315 and a bronze coin struck at the mint of Siscia (modern Sisak in Croatia) show the head of Constantine with the chi rho marked on his helmet. The bronze coin shown here (cat. no. 6), dating from the year 327, has on the obverse the Labarum, or imperial standard, marked with three balls which stand for Constantine himself and his two sons Constantine II and Constantius II. The standard is plunged into a writhing snake and surmounting it is the monogram of Christ. The imagery signifies that the Roman armies under imperial leadership and the patronage of Christ will overcome evil opponents. The legend SPES PVBLICA (Hope of the State) reinforces the message. This coin was struck in the newly founded Constantinople, where the Emperor established the capital of the eastern empire following his defeat of Licinius in 324. The snake is often interpreted as a thinly veiled reference to his vanquished rival. *GF*

6

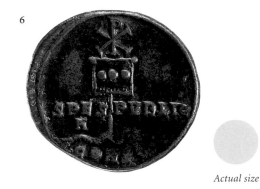

Actual size

1 Quoted in Alexander 1997, p. 56.
2 For further discussion see Bruun 1962 and Bruun 1997.

7 Coin of Decentius with the monogram of Christ and the Alpha and Omega, Roman, AD 351

Bronze nummus, mint of Trier (Germany), diameter: 27 mm. Obverse shows profile of Decentius (351-53), inscribed D N DECENTIVS FORT CAES (Our Lord Decentius, Strong Caesar); reverse shows the monogram of Christ with the Greek letters Alpha and Omega, inscribed SALVS DD NN AVG ET CAES (Salvation of Our Lords Augustus and Caesar)

London, British Museum, obverse B0932, reverse B0933

8 Coin of the Emperor Jovian holding the Labarum with the monogram of Christ, Roman, AD 363-4

Gold solidus, mint of Sirmium (modern Sremska Mitrovica in Serbia), diameter: 15 mm. Obverse shows profile of Jovian (363-4) inscribed D N IOVIANVS PF AVG (Our Lord Jovian, the Good, the Blessed, Augustus); reverse shows the emperor holding a globe and the Labarum bearing the monogram of Christ, at his feet a bound captive, inscribed SECVRITAS REPVBLICE (Security of the State)

London, British Museum, obverse 1860-3-29-93, reverse R0202

FROM ABOUT 320 the monogram of Christ was quickly diffused throughout the Roman Empire; it came to be perhaps the most common sign on Christian tomb slabs (cat. no. 13), and became an important part of Roman state imagery. Catalogue number 7 is a coin struck in 351 by Decentius, who together with his brother Magnentius, sought to usurp the throne of Constantius II the son of Constantine the Great. The coin shows the monogram combined with the Greek letters Alpha and Omega, the first and last letters of the alphabet, and their use is in accordance with Christ's description of himself in the Book of Revelation as 'I am Alpha and the Omega, the Beginning and the End, the first and the Last' (REVELATION 22: 13), signifying his eternal nature.

7 OBVERSE

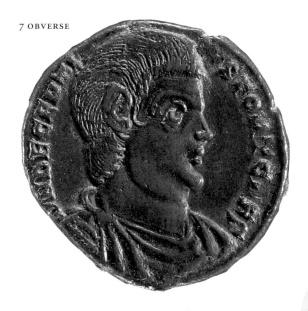

7 REVERSE

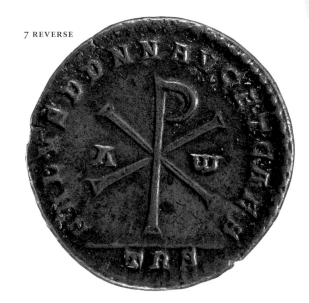

Actual size

In the gold coin of the Emperor Jovian (cat. no. 8), the chi rho appears on the Emperor's standard, as a military emblem. He wears armour and stands in triumph over a cringing enemy, holding an orb in his left hand. The monogram of Christ had first been employed as a military badge by Constantine at the Battle of the Milvian Bridge in 312 (cat. nos. 5 and 6). Later on the Mandylion of Christ, the miraculous image imprinted on a cloth, would serve as a military banner (cat. no. 41 and fig. 28), and the likeness on the Turin Shroud as one of the emblems associated with the House of Savoy (cat. no. 42). *GF*

8 OBVERSE

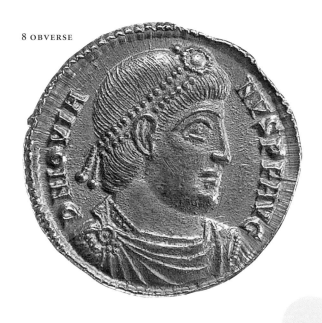

8 REVERSE

Actual size

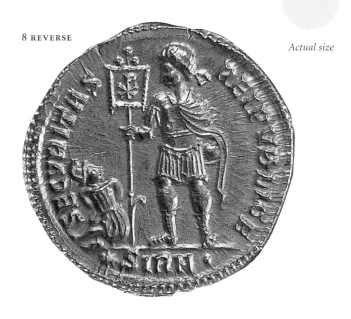

9 Ring with the monogram of Christ, Roman, fourth or fifth century AD

Plain hoop and circular open-work bezel containing the monogram of Christ. Gold, diameter at widest point: 19.5 mm.

London, British Museum, M & LA AF 217

10 Ring with the monogram of Christ, Roman, fourth or fifth century AD

Octagonal faceted hoop; the bezel is an applied setting in the form of the monogram of Christ, originally containing stones, now lost. Gold, diameter at widest point: 20 mm.

London, British Museum, M & LA 1872.64.315

THESE TWO RINGS DATE FROM the fourth or fifth centuries, although their exact place of origin is not certain. Following the Christianisation of the Roman Empire, the monogram of Christ found its way on to every kind of object, from grave slabs (cat. no. 13) and votive plaques (fig. 6), which had a ritual function, to jewellery and household goods, which did not. It expressed the religious affiliation of the user or wearer, but it also served as a protective charm. The closeness of the holy name of Christ to the wearers of these rings would have been thought to make them especially effective.

It had long been a practice among Christians to engrave signet rings with religious emblems. In his *Pedagogus Christianus* (Christian Teacher) written in the early third century, the theologian Saint Clement of Alexandria suggested certain images as particularly suitable. Among them are the fish, and a man fishing, both of which stand for Christ (cat. no. 4), or the ship's anchor, which symbolises the cross. He also recommends emblems suggestive of heaven and the church, like the lyre and a ship running before the wind.[1] The monogram of Christ had not yet been devised in Saint Clement of Alexandria's time, but it was to become especially popular on rings. In fact, it is found more frequently than any other symbol on early Christian rings. *GF*

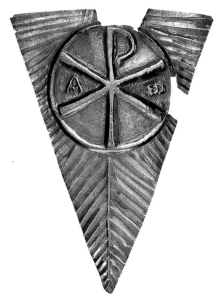

FIG 6 Silver and gilt plaque with the monogram of Christ and the Alpha and Omega, *fourth century AD, Roman; height: 15.7 cm. London, British Museum, M & LA P.1975, 10–2, 18. This plaque, found in Water Newton, Cambridgeshire, is part of the earliest known British hoard of Christian plate.*

1 See Fortnum 1871, pp. 266–67.

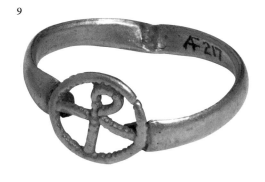

9

10

THE MONOGRAM OF CHRIST appears at the centre of this representation of a Roman family of father, mother and daughter. Their names are given in the inscription and it has been thought that the use of the name 'Lea' may indicate that the family was of Jewish origin.[1] The monogram confirms that they are a Christian family and their dress is indicative of relatively high social status. The woman wears a tunic and *palla* (an overgarment, often held together by a brooch) folded at the front, and she is richly adorned with jewellery. The man also wears a tunic and overgarment folded at the front. The object above the monogram is probably a stylized wreath with decorative ribbons. Similar objects appear on the bases of other gold-glass vessels of this period.

The disc comes from the base of a glass vessel, probably a bowl. The gold leaf was attached to a piece of glass and the design made by scratching away the gold. A second layer of glass was applied and the design was thus sealed inside. Numerous bases of this kind have been found in the Roman catacombs, embedded in the mortar used to seal up the tombs, and presumably sometimes served to identify the deceased. They are thought to come from glass vessels which were made as wedding or family gifts.[2] *GF*

11 Family Group with the monogram of Christ, Roman, fourth or fifth century (?)

Base of a gold-glass vessel, diameter: 84 mm. (3 mm. thick).

Inscribed SEBERE COSMAS LEA ZESES *(Drink O Severus, Cosmas and Lea)*

London, British Museum, M & LA 63, 7–27, 5

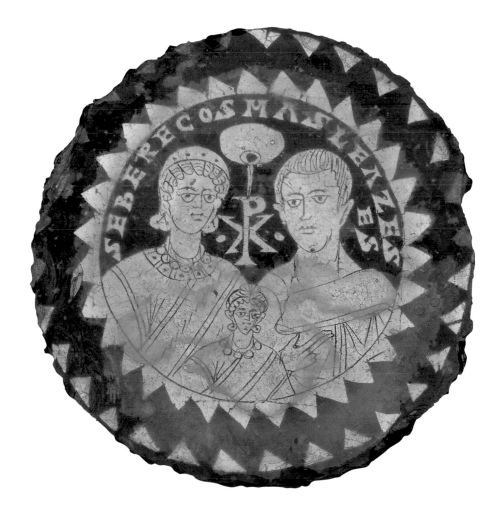

1 See Dalton 1901, no. 610, p. 120.
2 See *Glass of the Caesars*, pp. 262–68.

12 Lamp with the monogram of Christ, Roman, fifth or sixth century AD

Bronze, length: 11.7 cm; width: 5.4 cm.

London, British Museum, M & LA 1929.7–13.2

THIS OIL LAMP BEARS THE monogram of Christ in a ring. The intention may have been that when the wick was alight a large shadow of the chi rho symbol would be cast on a nearby wall or surface. The lamp suggests a double allusion to Christ: on the one hand, it bears the sacred name, and on the other the symbolism of the light itself recalls Christ's claim in the Gospel of Saint John (JOHN 8: 12) that he is the light of the world. The metaphor of light occurs frequently throughout the Gospels, to describe both Christ and the events of his life. In the episode of the Transfiguration, Christ's face shone 'as the sun, and his raiment was white as the light' (MATTHEW 17: 2). By contrast, during his Crucifixion 'there was darkness over all the earth' (LUKE 23: 44).

One of the oldest liturgies of the church, the *Lucernarium*, which has survived to the present day in the Easter Vigil, the nocturnal liturgy held from Holy Saturday evening to Easter Sunday morning, makes use of the light of a candle to announce that the light of Christ's Resurrection breaks through the darkness of evil and sin. A passage of the *Exultet*, the ancient Easter hymn which is sung during the Vigil in the presence of the Easter candle, runs as follows:

> Accept heavenly Father, this Easter candle,
> a flame divided but undimmed,
> a pillar of fire that glows to the honour of God.

> Let it mingle with the lights of heaven
> and continue bravely burning
> to dispel the darkness of this night!

> May the morning Star which never sets find this flame still burning:
> Christ, that Morning Star, who came back from the dead,
> and shed his peaceful light on all mankind.

This lamp was intended to be hung by a chain on a stand, as it has a lug at the front end and a hole in the centre of the chi rho emblem. It may have been made for domestic use or have been placed near a tomb, as its supposed provenance from the catacombs of Rome might imply. It is known that oil lamps were burned in the catacombs before the tombs of the martyrs in their honour. The symbolism of this lamp would have had a special relevance in a funerary context as the early Christians were said to fall asleep in Christ, awaiting resurrection in his name. *GF*

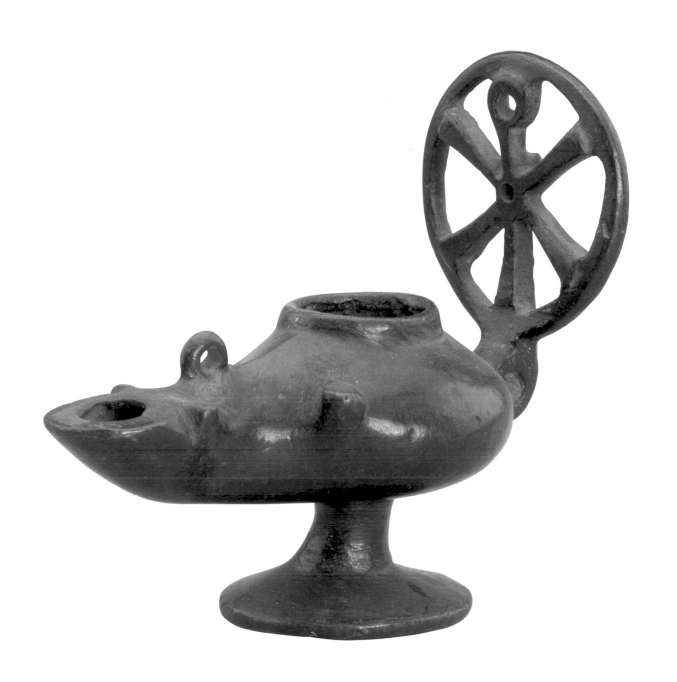

13 Grave Slab with the monogram of Christ and the Alpha and Omega, Merovingian, fifth–sixth century AD

Terracotta tile, height: 25.4 cm.

Inscribed VRSICINVS IACET CVM PACE

(Ursicinus rests in peace)

London, British Museum: M & LA 89, 9-25, 1

THIS GRAVE SLAB BEARS THE monogram of Christ, flanked by the Alpha and Omega. These symbols of Christ are joined by figurative elements and an inscription, which alludes to Christ's ability to intervene powerfully on behalf of his followers. There is a wreath encircling the monogram and Greek letters, which is reminiscent of a victor's crown of laurels, and signifies Christ's victory over death. The life after death which Christians hope for as a result of Christ's own Resurrection is indicated by the bird which flies to the left of the wreath. It is probably intended to be a dove, since according to the popular legend of the martyrdom of Saint Polycarp, Bishop of Smyrna (who died in around AD 155), his soul was released from his body in the form of a dove. The idea that the afterlife in Christ would be peaceful is brought out in the Latin inscription, which reads: 'Ursicinus rests in peace'. The word 'peace' occurs often on early Christian burial monuments, recalling passages from the Office of the Dead (the set prayers and readings for those who have died), whereas it never occurs on pagan tombs. The grave slab as a whole may be interpreted as a vision of a human soul enjoying, in safety and peace, the garland of victory over death which Christ has won.

The kind of symbolic language which is employed here was exported from Christian Rome and spread throughout Europe including the Merovingian Kingdom.[1] Merovingian sarcophagi are usually decorated only with the Roman cross (a traditional cross) or Greek cross (one with arms of equal length), with much geometric foliage patterning, whereas Merovingian grave slabs combine inscriptions with a variety of Christian symbols, most commonly the monogram of Christ or the cross in one form or another. These motifs are sometimes surrounded by a wreath and are usually flanked on either side by the Alpha or Omega symbols, or a pair of doves or peacocks. Indeed, it is possible that a second dove was originally incised on the grave slab shown here; there are some slight marks to the right of the wreath which are difficult to make out as the surface has become so worn.

Similar motifs to the ones on this grave slab, which was found close to St Acheul, near Amiens, were employed on that of the Merovingian Bishop Boethius of Carpentras, in the Church of Notre-Dame de Vic at Venasque: the cross, rosette patterns, and the Alpha and Omega appear there, too. Interestingly, on the Bishop's slab the Greek letters are shown reversed, possibly to indicate that in Christ, death is not the end but rather the beginning of a new heavenly after-life. In contrast to Bishop Boethius's slab which was made specifically for his tomb, the slab shown here is unusual in that it is a recycled architectural fragment adapted for use as a grave stone. *SA-Q*

1 The Frankish kingdom of north-west Europe during the fifth to eighth centuries AD, named after Merovech, the founder of the dynasty.

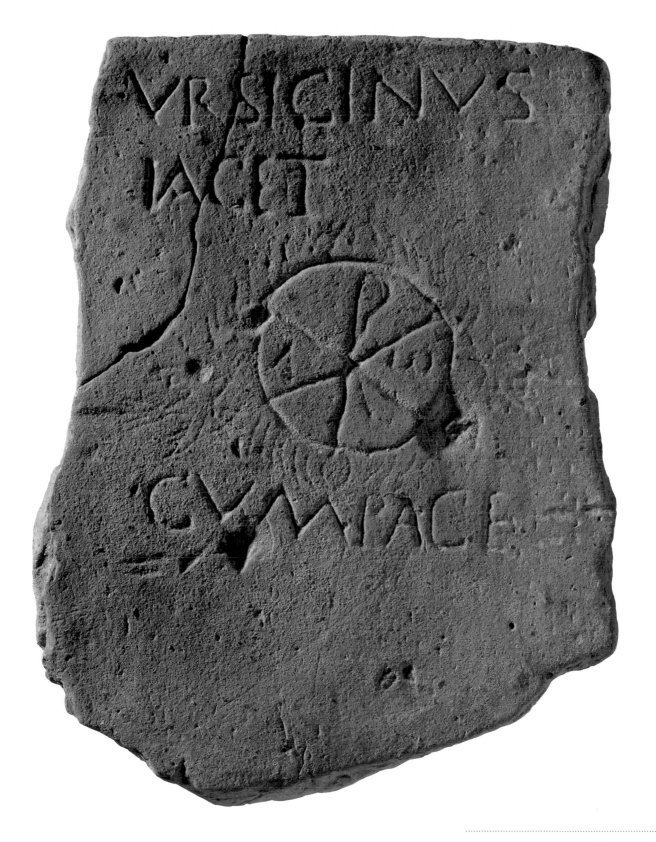

14 The Adoration of the Name of Jesus, about 1578

El Greco (1541–1614)

Oil on pine, 57.8 x 34.2 cm. Signed in Greek capitals on a rock in the left foreground: DOMENIKOS THEOTOKOPOULOS CRETAN MADE IT

London, National Gallery, NG 6260

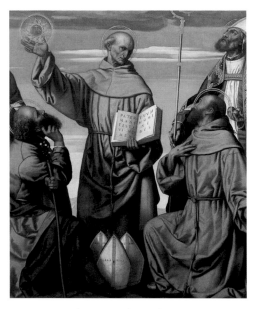

FIG 7 *Moretto da Brescia,* The Madonna and Child with Saint Bernardino and other Saints, *c.1540–54 (detail). London, National Gallery, NG 625.*

THE NAME OF JESUS, referred to in the title of this painting is represented by the three letters IHS which appear in the glory at the top of the composition. This trigram is an abbreviation in Latin letters of the Greek word for Jesus (ΙΗΣΟΥΣ), which itself comes from the Hebrew *Jehoshua*, meaning 'Yahweh [God] saves'. It became a common way of signifying Christ and played a similar role to the chi rho, or monogram of Christ, as a Christian emblem.

The text on which this painting is based is from the Letter to the Philippians (2: 9–11):

Wherefore God also hath highly exalted him, and given him a name which is above every name: That at the name of Jesus every knee should bow, of things in heaven, and things in earth and things under the earth; And that every tongue should confess that Jesus Christ is Lord, to the Glory of God the Father.

The trigram was given particular prominence in the fifteenth century by the Franciscan preacher Saint Bernardino of Siena (1380–1444), who persuaded the inhabitants of various Italian towns to take down the arms of their warring factions from churches and palaces and replace them with the trigram. In 1424, while preaching at Volterra, he made a plaque on which he inscribed the letters IHS surrounded by rays of light, presenting this to his audience at the end of his sermon for their veneration (fig. 7).

The Adoration of the Name of Jesus, painted shortly after El Greco's arrival in Spain in 1577, shows the angels, earthly authorities and the inhabitants of the Underworld all submitting to the sacred trigram. It commemorates the victory of the combined forces of the Holy League, made up of Spain, Venice and the Papacy, over the Turks in the naval battle of Lepanto in 1571. Philip II, King of Spain, kneels in the foreground dressed in black, with the Doge of Venice to the left and the Pope between them. The Name of Jesus was employed as an emblem in the struggle against the infidel from the time of the first crusades, but in combining the themes of the military alliance with the adoration of the trigram, El Greco no doubt wanted to allude to Constantine's vision at the Milvian Bridge (cat. nos. 5 and 6). On that occasion he saw a flaming cross with an inscription which is sometimes given as '*In Hoc Signo*' (By this sign [you will conquer]), the initials of which form IHS. The ligature or line that sometimes appears above the trigram (to indicate that it is an abbreviation) could be readily transformed into a cross, as in El Greco's painting.

This combination emphasised the sacrificial and redemptive connotations of the Holy Name of Jesus. A print by the seventeenth-century printmaker, Hieronymus Wierix, of the trigram adored by angels is captioned with a quotation from the Acts of the Apostles: 'There is none other name under heaven given among men, whereby we must be saved' (ACTS 4: 12). The trigram was also understood as an abbreviation of '*Iesus Hominum Salvator*' (Jesus the Saviour of Mankind), in accordance with the biblical principle that the name encapsulates the nature of the person who bears it. *XB*

15 The Nativity at Night, late fifteenth century

Geertgen tot Sint Jans (about 1455/65; died about 1485/95)

Oil on oak panel, 34 x 25.3 cm. (cut on all four sides).

London, National Gallery, NG 4081

FIG 8 *Paris Bordone*, Christ as the Light of the World, *between 1540 and 1560. Oil on canvas, 90.8 x 73 cm. London, National Gallery, NG 1845. The painting is inscribed* EGO SUM LUX MUNDI, *'I am the Light of the World'.*

1 Quoted in Snyder 1960, p. 123.

IN THIS PAINTING OF the Nativity, the Netherlandish artist, Geertgen, draws on the imagery of Christ as light or *the* Light. Saint John says of Christ that he is 'the true Light, which lighteth every man' (JOHN 1: 9) and the artist has centred the composition on the tiny figure of the Christ child from whom radiance emanates. The light dispels the immediate darkness to illuminate the sides of the stony crib, the hands and faces of the awestruck angels, and the sweet-sad, wondering countenance of his mother. Christ's divine light outshines all other sources of illumination in the picture, even the glowing angel in the background announcing the Saviour's birth to some shepherds. The angel, in turn, has made the light of the campfire seem insignificant. To distinguish the light which Christ emits from all the other sources, Geertgen makes the rays beaming from Christ more emphatic and, although they are now somewhat faded, they would once have been much more visible.

The notion of the Christ Child emanating divine illumination was well established in Geertgen's time and is clearly articulated in the *Revelations* of the fourteenth-century mystic, Saint Bridget of Sweden (1303–73), who had a vision of the baby radiating, 'such an ineffable light and splendour that the sun was not comparable with it, nor did the candle that Saint Joseph held there shine any light at all, the Divine light totally annihilating the natural light of the candle.'[1] Many artists were inspired to paint the Nativity in accordance with Saint Bridget's vision and the increasing competence of painters in rendering light effects in oil meant that the metaphor of Christ as light could be treated very powerfully, as in this painting. By comparison the use of an inscription is visually much less effective (fig. 8).

Geertgen's picture is one of several versions of a similar scene, based on a lost original by the Netherlandish painter Hugo van der Goes (active 1467; died 1482). Geertgen's version differs from its model both in some details (for instance, Joseph is shown here placing his hand over his heart and not shielding a candle), as well as in its emphasis: the darkness is more profound, the child smaller and more fragile, and the animals larger. These elements allow Geertgen to suggest the deep mystery of the Incarnation, while his inclusion of stems of corn from a sheaf, barely visible in the darkness, in front of the crib are surely an allusion to the Eucharist, reminding the spectator that the Christ Child has been sent into the world not only to be *the* light but also to become the 'bread of life'.

The small size of the painting would have made it appropriate for use in private devotion and the open space in the foreground seems to invite the viewer to participate in the crib-side meditation. This advocacy of private devotion could reflect the interest of artists like Hugo van der Goes and Geertgen's in the '*Devotio Moderna*', a movement founded in the late fourteenth century by Geert Groote in the northern Netherlands and popularised throughout Europe by such texts as Thomas à Kempis's *Imitation of Christ*, which encouraged private prayer and meditation on the life of Christ as ways of approaching ever more closely to God. *SA-Q*

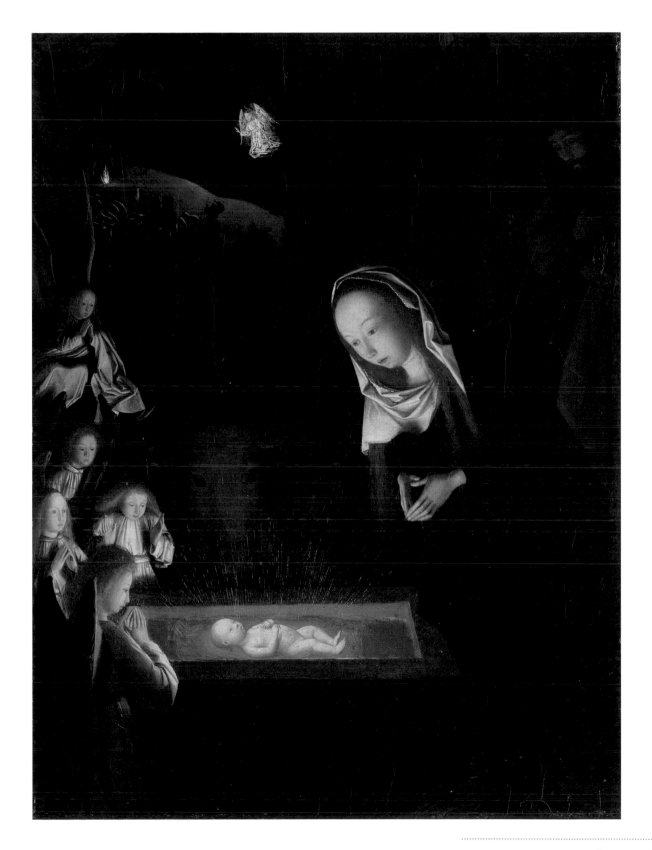

16 The Light of the World, about 1900–1904

William Holman Hunt (1827–1910)

Oil on canvas, 233 x 128 cm.

London, The Dean and Chapter of Saint Paul's Cathedral

THE TITLE OF THE PAINTING, Hunt's third version of the subject, is based on Christ's description of himself and his mission: 'I am the light of the world: he that followeth me shall not walk in darkness, but shall have the light of life' (JOHN 8:12). The starkly symbolic nature of the representation stands in contrast to the artist's narrative paintings of episodes from Christ's life, such as the *Finding of the Saviour in the Temple* (Birmingham Museums and Art Gallery), and also to images like Geertgen's *Nativity at Night* (cat. no. 15), where the symbolic element of light is integrated into the narrative.

Hunt explores the idea of Christ coming into the world as light through a variety of symbols. The lantern which he holds is meant to stand for Christ as the source of illumination. This analogy is rooted in biblical metaphor: 'Thy word is a lamp unto my feet, and a light unto my path' (PSALM 119: 105). The lantern became an increasingly important part of the composition for Hunt: whereas in his early sketches it is not very prominent, he later had an elaborate model manufactured so he could paint from it. Also, its patterning became more complex, so that the simple perforations of the lamp seen in the first two versions of the painting (Keble College, Oxford, and Manchester City Art Galleries, of 1851–3 and 1851–6, respectively), here clearly include stars and crescents as a reference to the relevance of Christ's message to the whole world, including the Islamic east.[1] Hunt deliberately set the scene at night, explaining in a letter to the painter John Everett Millais that he wanted to 'accentuate the point of its meaning by making it the time of darkness, and that brings us to the need of this lantern in Christ's hand, He being the Bearer of the light to the sinner within, if he will awaken.'[2]

Apart from using the obvious symbols of light, Hunt overlaid many of the objects in the picture with symbolic meaning to demonstrate the world's inability to recognise Christ. He explained that, 'The closed door was the obstinately shut mind; the weeds the cumber of daily neglect, the accumulated hindrance of sloth; … the bat flitting about only in darkness was a natural symbol of ignorance.'[3] And when asked why the door had no outside handle, he replied: 'It is the door of the human heart, and that can only be opened from the inside.'[4]

Although Hunt used symbols to 'elucidate, not to mystify, truth',[5] their success was obviously dependent on whether the public was able to read them in the way that Hunt intended. Certainly, the meaning of his pictures was not always apparent. His painting of the *Scapegoat* (Lady Lever Art Gallery, Port Sunlight), an image of the goat sent by the Jewish priests into the wilderness symbolically laden with the sins of the people, failed to inspire Hunt's public because they were unable to make the connection between a moribund goat and the persecuted Saviour.

In this image, however, where Christ is shown in human form, Hunt believed he had succeeded because 'any occult meaning in the details of my design was not based upon ecclesiastical or archaic symbolism, but derived from obvious reflectiveness. My types were of natural figures such as language had originally employed to express transcendental ideas.'[6] All three versions of the picture seem to have conveyed their message and

1 Maas 1984, p. 111.
2 Ibid., p. 24.
3 Hunt 1905, p. 350.
4 Maas 1984, pp. 40–1.
5 Hunt 1905, p. 351.
6 Ibid., p. 350.

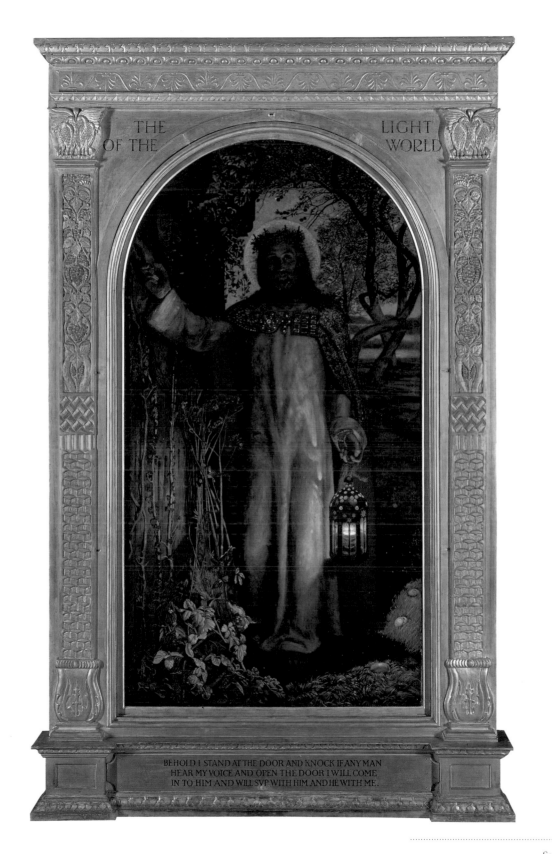

THE LIGHT OF THE WORLD

BEHOLD I STAND AT THE DOOR AND KNOCK IF ANY MAN
HEAR MY VOICE AND OPEN THE DOOR I WILL COME
IN TO HIM AND WILL SVP WITH HIM AND HE WITH ME.

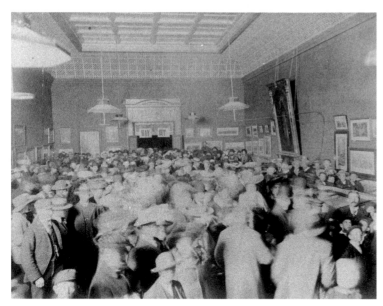

FIG 9 The Light of the World *on view in the National Gallery of Victoria, Melbourne, Australia, February–March 1906. Booth Collection, University of London Library, Senate House.*

achieved much more besides; many people were deeply impressed by what they saw, including the writer and critic, John Ruskin, who on 5 May 1854 wrote to *The Times* of the first version (Keble College) that it was 'one of the very noblest works of sacred art ever produced in this or any other age'.[7] One notable exception was the Scottish historian and philosopher, Thomas Carlyle. He was aggrieved that Hunt had painted Christ in a symbolic way, 'bedizened in priestly robes and a crown ... with ... jewels on his breast, and a gilt aureole round His head',[8] rather than in a more realistic way, as the man who is recorded in the Gospel as 'toiling along in the host sun ... tired, hungry often and footsore ... His rough and patched clothes bedraggled and covered with dust, imparting blessings.'[9]

The *Light of the World* became the most popular representation of Christ in the English-speaking world and the St Paul's version was sent by its agnostic owner, Charles Booth, on a tour of Canada, Australia, New Zealand, and South Africa between early 1905 and late 1907 (fig. 9). Along the way countless people saw it, many of them queuing for several hours and saying that they were deeply moved by it. A certain J. H. Roy from Dunedin in New Zealand, an employee of the Government Insurance Department, wrote after seeing the picture that, 'the vast crowd stood gazing in silent wonderment, and many in adoration, as though held by some irresistible magnet. I was, on viewing the wondrous face, impelled to uncover my head in reverence thereto.'[10] The painting was reproduced and pirated in a variety of forms and the image was widely disseminated throughout the British Empire, acquiring the status of a Protestant icon. Hunt himself was keenly aware of its spiritual power and told his friend, William Bell Scott, that it was while painting the first version of the picture that he was converted to Christianity.[11] It is perhaps appropriate, therefore, that Booth's painting should have come to rest in St Paul's Cathedral in London, rather than in the Tate Gallery, where Hunt had originally hoped it would go as an example of high art. Hunt was buried in St Paul's Cathedral in 1910.

Ironically, the St Paul's version of the *Light of the World* which is the best known of the three, was only partly executed by Hunt. He embarked on this life-size version thinking that his original picture was deliberately being kept from public view by the dons at Keble College, Oxford, into whose hands it had passed. In order to paint it he made use of the second, smaller, painting (now in the Manchester City Art Galleries) as a guide which, as it turns out, was almost entirely the work of another artist, Frederick G. Stephens. When painting the St Paul's picture, Hunt had to rely, due to his failing eyesight, on help from the painter Edward R. Hughes, a fact that he was careful conceal to for a number of years. *SA-Q*

7 Ibid., p. 417.
8 Ibid., p. 355.
9 Ibid., p. 358.
10 Maas 1984, p. 178.
11 Scott 1892: II, p. 312.

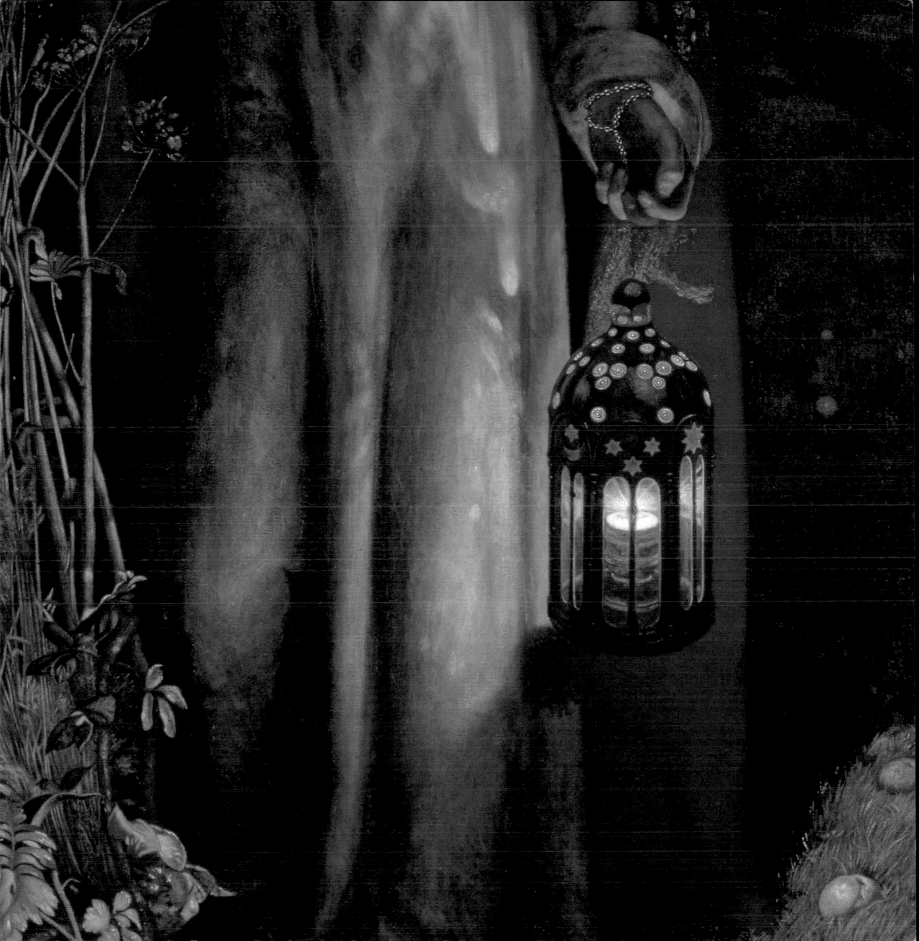

17 The Bound Lamb ('Agnus Dei'), about 1635–1640

Francisco de Zurbarán (1598–1664)

Oil on canvas, 38 x 62 cm.

Madrid, Museo Nacional del Prado, INV. 7293

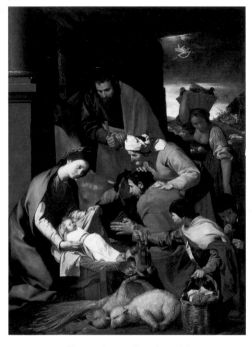

FIG 10 *Neapolitan painter*, Adoration of the Shepherds, *1620s. London, National Gallery,* NG 232.

1 San Diego Museum and the version sold at
 Sotheby's, New York, on 28 May 1999, lot 67, and
 now in the Museo de la Academia de San
 Fernando, Madrid (INV. 1417).
2 Quoted in Didron 1851: I, p. 332.
3 Quoted in Paris 1988, p. 295.
4 Palomino (1724) 1986, p. 198.

AS WELL AS BEING THE Good Shepherd (cat. nos. 1–3), Christ is also the Lamb. John the Baptist, when he first saw Jesus approaching him at the River Jordan, cried out, 'Behold, the Lamb of God [*Agnus Dei*] which taketh away the sin of the world' (JOHN 1: 29). Zurbarán's highly naturalistic painting shows a young lamb with horns, lying on a stone slab, its feet bound with rope. By setting the brilliant white lamb against the dark, austere background, the artist has intensified the sense of the animal's physical presence. Although it could be considered a still life in its own right, this painting is intended to be interpreted symbolically, as an image of the sacrifice of Christ.

The Old Testament offerings of an unblemished lamb came to be seen as a foreshadowing of the death of Christ, a sacrificial substitute for sinful mankind. Saint Peter, for example, makes the comparison explicit: 'ye were not redeemed with corruptible things … but with the precious blood of Christ, as of a lamb without blemish and without spot' (PETER 1: 18–19). Such comparisons were influenced by the prophecies of Isaiah – often quoted in the Gospels and in the Acts of the Apostles – which speak of a suffering Messiah characterised as a sacrificial lamb: 'He was oppressed, and he was afflicted, yet he opened not his mouth: he is brought as a lamb to the slaughter, and as a sheep before her shearers is dumb, so he openeth not his mouth' (ISAIAH 53: 7–8). In his conversation with the Ethiopian eunuch, Saint Philip says explicitly that this passage refers to Christ (ACTS 8: 32), and Zurbarán too, in two of the six known versions of his *Bound Lamb*, makes the imagery explicit by including a halo on the lamb's head and the inscription '*Tanquam agnus*' (like a lamb), a paraphrase of Isaiah's words.[1]

In early Christian sculpture and mosaics, Christ was frequently represented as a lamb. In later times there was a reaction against this kind of symbolic animal imagery and a Church Council held under Justinian II in Constantinople in AD 692 decreed that in future Christ should be represented only in human form, since 'the painter must, as it were, lead us by the hand to the remembrance of Jesus, living in the flesh, suffering and dying for our salvation and thus obtaining the redemption of the world'.[2] However, the wealth of imagery associated with the lamb, for example in the Book of Revelation (REVELATION 4–7) meant that it remained a popular visual image. A lamb bound as an offering often appears in paintings of the Adoration of the Shepherds, a direct allusion to Christ's forthcoming sacrifice (fig. 10). Zurbarán's removal of the bound lamb from such scenes and its stark presentation on an altar slab yields a particularly impressive image. He and his patrons were probably familiar with the writings of the sixteenth-century Spanish mystic, Fray Luis de León, who explained in his *De los nombres de Cristo* (Of the Names of Christ) that when he was called 'Cordero', or Lamb, this signified his 'meekness of character, innocence and purity of life, and his fulfilment of sacrifice'.[3]

Zurbarán's paintings of lambs were widely admired. The eighteenth-century biographer of Spanish artists, Antonio Palomino, referred to a painting by him of a little lamb in a Sevillian collection whose owner was said 'to value it more than a hundred living lambs'.[4] *XB*

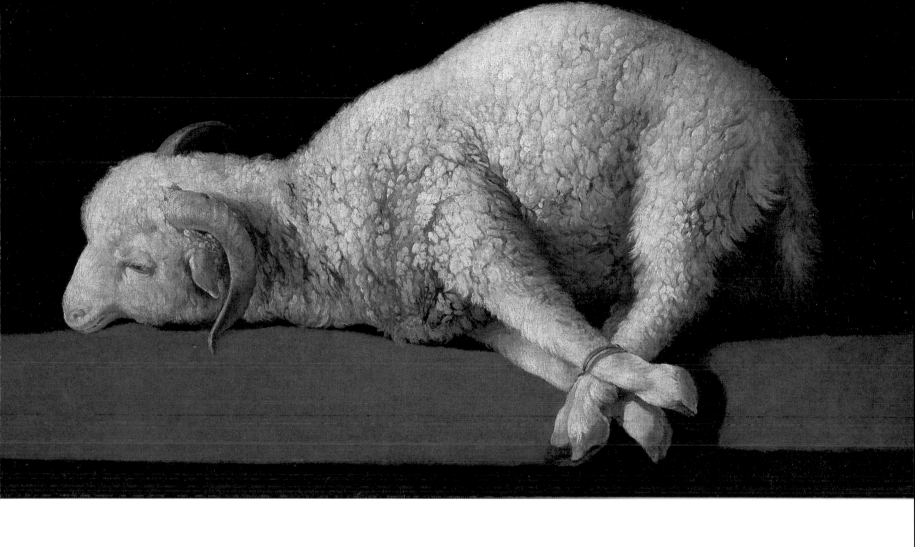

18 Coin of the Emperor Valens holding the Labarum inscribed with a Cross, Roman, AD 364–7

Gold solidus of Valens, mint of Antioch (in modern Turkey), diameter: 16 mm.
Reverse inscribed RESTITVTOR REIPUBLICAE *(Restorer of the State)*

London, British Museum, 1866-7-21-15

THE CROSS IS THE MOST FAMILIAR and universal of Christian symbols. It stands for Christ himself but also for his sacrifice and more generally for the Christian religion.[1] It is the emblem of atonement and the symbol of salvation and redemption through the Christian faith. Many Christians 'cross' themselves, making the sign of the cross on their forehead and chest invoking the Trinity. Although the imagery of the cross is much employed in the New Testament, especially by Saint Paul, it appears relatively infrequently in early Christian monuments, becoming more common in the fourth and fifth centuries. It has been suggested that this delay in its widespread adoption is the result of the early Church's struggle to come to terms with a shamed and tortured God, but this is hardly justified by the written sources. The Christian apologist, Saint Justin the Martyr, addressing a pagan interlocutor in about AD 135, stated that the cross was the principal symbol of the power of Christ:

> Think for a moment how universal the sign of the cross is, how closely it is connected with every aspect of life. Take the mast of a ship, for example – the cross formed by the yardarm is like a symbol of victory as it drives ahead through the stormy seas. Ploughs and spades have this cross shape.[2]

The bishop-theologian, Saint Clement of Alexandria, could speak early in the third century of the cross as 'the symbol of the Lord', and shortly afterwards Saint Hippolytus composed his hymn to the 'Glorious Cross' employing a rich and sensual vocabulary to express the splendour of the sign: 'Tree of salvation, ... bed of love where the Lord married us, skeleton of the earth, pillar of the universe'. The earliest evidence for the use of the cross to symbolise Christ (but not the crucifix, which appears later) dates

1 Didron 1851: I, pp. 367–417; Sulzberger 1925.
2 Quoted from Winter 1977, Day 88.
3 Ibid.

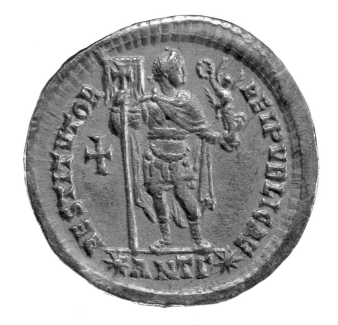

Actual size

from before the end of the first century AD. An intriguing case is the celebrated Latin palindrome or magic square which is known to have been in use before AD 79 (fig. 11).

Although the principal Christian symbol in the coinage of the Roman emperors who succeeded Constantine was the monogram of Christ (cat. nos. 6–8), the cross, too, makes a sporadic appearance, this coin of the Emperor Valens being an early example. After the brief interlude of the Emperor Julian the Apostate (AD 361–63), when paganism was resumed and the Church persecuted, Christianity continued to develop under the patronage of Jovian (see cat. no. 8) and then Valens, who ruled the empire in the east from 364 to 378, together with his brother Valentinian, who governed the west. On the coin, Valens appears as a triumphant general, draped and cuirassed, with a diadem on his head. He carries in his left hand a winged figure of victory with palm and laurel wreath, a traditional Graeco-Roman emblem, and in his right hand the Labarum, or standard, marked with the cross. The cross which appears to the left of the figure of Valens is a mark associated with the mint of Antioch where this coin was struck. The more widespread use of the cross from the fourth century onwards was due largely to Constantine's adoption of it following his vision at the Milvian Bridge (cat. nos. 5 and 6) and also to the story about Constantine's mother, Saint Helena, who discovered the True Cross in Jerusalem.

In the light of the imagery on this coin, the words of Saint Justin the Martyr more than a century earlier, in completely different historical circumstances, seem almost prophetic: '… when the Roman legions march behind their ensigns they are in fact marching under the cross, and when victory poles are carried, the victory they remind us of is the victory of the cross'.[3] *GF*

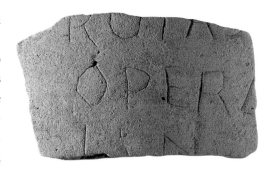

FIG 11 Fragment of an amphora inscribed with the 'Christian' palindrome, *about AD 185. Manchester Museum. The amphora was probably from Spain. The words which form the palindrome in its complete state can be read up and down, backwards and forwards:*

R O T A S
O P E R A
T E N E T
A R E P O
S A T O R

The phrase they make has been interpreted as follows: 'The Sower (sator, i.e. Christ who sows the seed), at the plough (arepo, on the cross), holds (tenet), with his sacrifice (opera), the wheels (rotas, of destiny or history)' (for more on this topic, see Hommel 1952). Although the Christian origins of the palindrome are disputed, it is significant that the letters can be rearranged around the central letter N, the only letter which does not appear more than once, to form the shape of the cross made up of the words 'Pater Noster' (Our Father), together with the letters A and O (twice) of Alpha and Omega:

```
              P
              A
   A          T          O
              E
              R
   P A T E R N O S T E R
              O
              S
   O          T          A
              E
              R
```

19 Cross, 1897

Designed by Philip Webb (1831–1915) and executed by Robert Catterson-Smith
Wood covered with silver plate, height: 115 cm.
London, Victoria and Albert Museum, INV. M34–1970

THE DECORATION OF Philip Webb's late nineteenth-century silver cross, with its rich subsidiary symbolism, brings out many resonances of the Christian cross. At the centre is the sacred trigram IHS (cat. no. 16) which gives the cross a triumphal character, emphasised by the crown at its top. At the base is a roundel which contains an image of the Lamb of God (cat. no. 17). The presence of the sacrificial lamb reinforces the association of the cross with Christ's sacrifice, but here again the emphasis appears to be on Christ's victory over death: the lamb carries the standard of Resurrection, is surrounded by twelve stars, and surmounts two roundels containing emblems of the sun and moon. Christ's continuing sacrifice and its re-enactment in the Eucharistic sacrament is also alluded to symbolically by the vine (cat. no. 20) that winds through the entire cross.

The symbolic intricacy of Webb's cross reflects the abiding influence of medieval art on his work. Primarily an architect, Webb was a lifelong friend and collaborator of William Morris (1834–1896), and designed both his home, the Red House (1860), and his tomb (1896). As well as buildings, he designed furniture, fabrics, fittings and stained glass for Morris's firm, Morris, Marshall, Faulkner and Co., of which he was a founder member. Made the year after Morris's death, the cross is strongly marked by his friend's influence. Its decoration of vines and grapes, in particular, recalls Morris's borders for the ambitious *Works of Geoffrey Chaucer* published by the Kelmscott Press in 1896, on which Robert Catterson-Smith, who made the cross, collaborated. The cross was made for Morris's younger sister, Isabella Gilmore, Deaconess of the Rochester Diocesan Deaconess's Institute. It was designed to hang on the east wall of the chapel Webb built in 1896–7 for the Institute. One of Webb's last buildings, the simple chapel still stands behind 113 North Side, Clapham Common, now called Gilmore House.

The cross was unfinished when the chapel was opened and the draft of a letter from Webb to Isabella Gilmore dated 6 April 1897 talks of her hiring an altar cross for two or three months. Placing a cross on or near the altar is common practice in the Church of England but not a requirement. It takes the place of the crucifix – an image of the Crucified Christ – which is almost universally present on Catholic altars. The absence of the figure of Christ ultimately reflects Protestant suspicion of images of Christ and the use of the cross has a long history among the enemies of figurative imagery. During the eighth-century iconoclast controversy, which ranged the supporters of religious imagery against those who sought to ban it, the cross was one of the few symbolic images permitted by the iconoclasts who consistently replaced the images they destroyed with them. *AS*

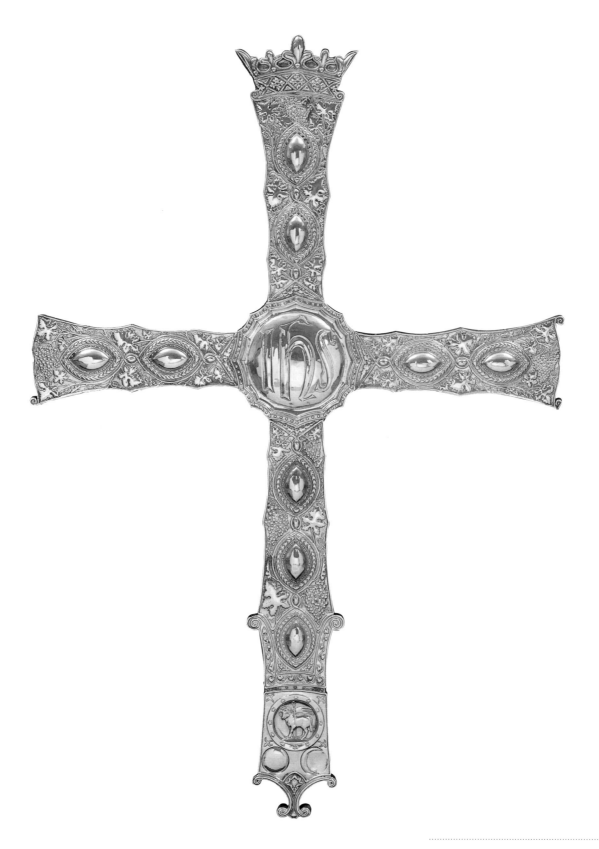

20 Christ Crucified on the Vine, about 1435

German, Middle Rhineland
Plaster, painted, diameter: 21.6 cm.
London, Victoria and Albert Museum, London,
INV. 2569–1856

THE IMAGERY OF THIS CURIOUS plaster roundel derives from the text written on the scroll at its top: EGO SUM VITIS VOS PALMITES (I am the vine, ye are the branches, JOHN 15:5). Like so many others, the symbol of the vine derives from one of Christ's own metaphors, in this instance the famous passage in which he describes himself as 'the true vine' and his disciples the branches that 'bear much fruit' (JOHN 15: 1–8). The symbolism of the vine, however, does not depend on this passage alone. In the Old Testament the vine sometimes symbolises the blessings of the promised Messianic age,[1] and it was used in the early Church to stand for eternal life. Grapes were also a common symbol of the Eucharistic wine and hence of the blood of Christ.

Early images of Christ crucified on the vine, such as the famous early twelfth-century apse mosaics of San Clemente in Rome (fig. 4), derive from the association of the cross with the 'Tree of Life' described in the Book of Revelation (REVELATION 22: 2). The vine was just one of a number of different trees that Christ was shown nailed to, although its association with the Eucharist provided an added impetus to its use.[2] Some late medieval German sculptures of the crucifix, such as those at Doberan (Mecklenburg, Northern Germany) of about 1360, and at Saint Lorenz in Nuremberg (about 1450), show Christ's cross sprouting grapes in clear reference to the sacrament.

The Victoria and Albert Museum's roundel combines the established imagery of Christ crucified on the vine with the innovatory addition of the twelve bust length figures of the apostles in its branches. The apostles turn the image into a more direct illustration of the metaphor of the True Vine and make explicit the vine's symbolism as both Christ himself and the Christian Church. This seems to be the earliest known example in which the vine, cross and apostles are combined in this way. In a further imaginative development the artist of the roundel, again taking his lead from the words of the Gospel ('I am the true vine and my Father is the husbandman', JOHN 15: 1), has added the figures of God the Father and the Virgin tending the roots of the tree. On the left, God the Father – his halo inscribed with a cross – breaks the sods of earth with his hoe accompanied by the inscription PATER UMIFICAT (the father makes moist). The Virgin is on the right and waters the vine next to the words MARIA FECUNDAT (Mary makes fruitful). Above the figure of Christ hovers the dove of the Holy Spirit.

The roundel is one of a small group of similar objects with identical imagery. A second version – but without the frame – was recorded at Mainz, before it was destroyed in the Second World War. Another, also without a frame and unpainted, survives in Berlin and in 1986 the fragment of a fourth roundel was discovered in the monastery of Marienwohlde near Lauenburg (Elbe). A further version of the same scene survives cast on a bell of the church of Saint Rupert at Außerteichen (Carinthia, Austria). All these examples were probably cast from a metal mould but variations in size make it clear they were not all made from the same one.

With the exception of the bell, the original functions of these objects remains uncertain. The fact that the Victoria and Albert Museum's example has an integral frame –

1 For example, PSALM 80: 8ff.
2 On the Tree-Cross, see Schiller 1972: II, pp. 135ff.

decorated with a vine – suggests it may have been an independent devotional image. That the fragment from Marienwohlde was discovered during the excavations of a Brigittine convent is surely of some significance, given how important the imagery of the vine was to that order. In one of the visions of Saint Bridget of Sweden (1303–73), Christ spoke to her of founding a new order in terms of planting a new vineyard. The vision is recounted in the prologue of the order's rule:

> I will plant a new vineyard for myself, where vine branches will be brought to take root … From this vineyard, many other vineyards will be renewed, which have been arid for long and they will bear fruit after the day of their renewal.[3]

The imagery of the roundel relates perfectly to this passage, but it is impossible to say whether all the surviving examples of the design were produced within a Brigittine context. *AS*

3 'Regula Salvatoris', quoted in Morris 1999, p. 161.

2 THE DUAL NATURE

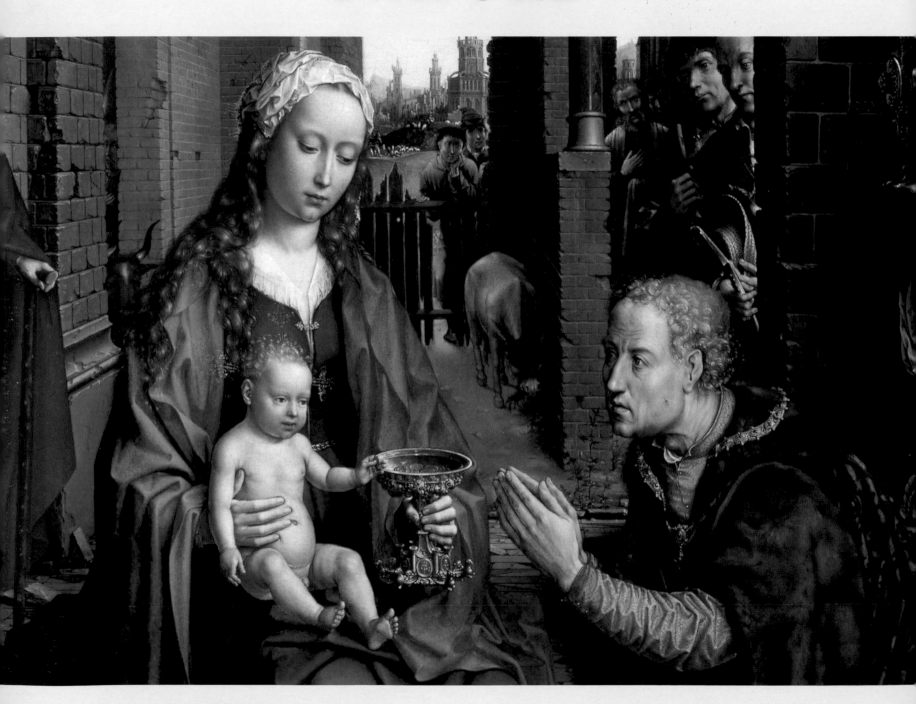

T HE MOST DIFFICULT TASK for for the artist seeking to represent Christ is how to depict his dual nature: fully human and fully divine. The Book of Revelation tells us he is also Alpha and Omega, the beginning and the end. But as Christianity evolved from a minority religion to a State religion, and as both the powerful and the oppressed rallied under his banner, Christ came to embody further dualities: Victor and Victim; Saviour and Sacrifice; King of kings and 'despised and rejected of men' (ISAIAH 53: 3). Christmas is celebrated with joy, yet the Christ Child was born to suffer and die. The shepherds adored a Christ for the poor (fig. 12), and the Three Kings, a Christ for the rich. In order to engage fully with images of Christ, we need to understand which aspect they depict.

Duality is most readily represented in images of Christ's infancy, above all perhaps by the *Adoration of the Magi*, a favourite subject of early Christian funerary art (fig. 13) In the catacombs of Rome, Old and New Testament scenes record the past only to forecast the future: as Daniel was saved from the lions, the three Jewish boys rescued from the burning fiery furnace, the paralytic healed, and Lazarus resurrected, so would the dead buried here be raised again. In this setting, the Adoration of the Magi – the Epiphany, when the child's divinity is recognised by the peoples of the world – also points forward to future salvation. The Magi greet Christ at his first coming, as all believers will greet Christ in Glory at his Second Coming.

While the early Church stressed Christ's divinity, later theology – under the influence of a cloistered mystic, Saint Bernard of Clairvaux (1090–1153), and the popular preacher Saint Francis of Assisi (1182–1226) – focused on his Incarnation. The humanity of Christ is most apparent in the first and last moments of his earthly life, his early childhood and the events leading up to the Crucifixion: God choosing to be born, to suffer and die as a human being, in order to redeem our sins and purchase our salvation with his own body and blood. Since Christian art is above all theology in visual form, artists found different ways of depicting these two key themes of the Incarnation within a single image. The fifteenth-century panel attributed to Bonfigli rather naively juxtaposes the Adoration of the newborn Child with the Crucifixion (cat. no. 30). By the time this was painted, the Magi, the wise men from the East from the Gospel of Saint Matthew had been raised to royal status. In paying tribute to him, they show the Christ Child to be a greater

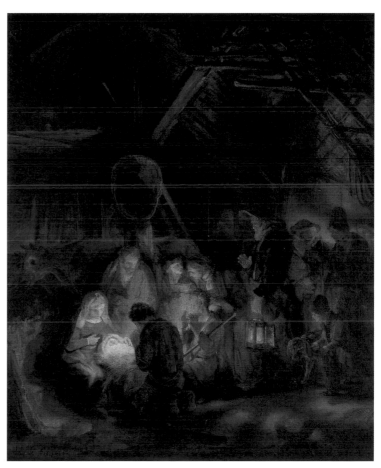

FIG 12 *Rembrandt*, Adoration of the Shepherds, *signed and dated 1646. London, National Gallery*, NG 47

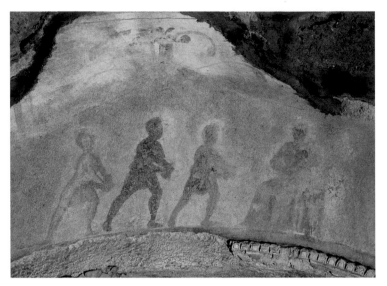

monarch: the King of kings. As the bright transparency of his tunic on this cold January night recalls the shining marble nudity of ancient statues of the pagan gods, the image also incorporates the notion of the Child's divinity. The Saviour on the cross is but another aspect of the sovereign God.

Gossaert's majestic altarpiece of the *Adoration of the Kings* demonstrates the Christ Child's divinity with greater theological precision (cat. no. 31). There is no crucifix – though there would have been one on the altar in front of the painting. The notion of Christ's sacrifice is integrated within the scene of the Adoration through the Eucharistic imagery of the gold offering, its vessel, and the Child's gesture as he proffers one of the coins to the kneeling king. As befits an image designed to focus all eyes on the central mystery of Christian worship, the painting depicts Christ as at once God, High Priest and Sacrifice.

A more idiosyncratic *Adoration of the Kings* was painted in 1564 by Bruegel (cat. no. 32). Here the cruelly caricatured kings seem to represent fallen humanity, and the Child shrinks from an offering of myrrh – the precious spice used for preparing bodies for burial. This is more pointedly an image of the Child condemned to die by human wickedness.

The shepherds, wise men or kings adoring the Christ Child stand for all believers – but they also stand, as it were, in our way. Mantegna's view of the *Holy Family with Saint John* (cat. no. 22) admits us directly into the Child's presence, where he commands our unmediated adoration. This unusual image may be read as a learned representation of the two triumphal aspects of Epiphany celebrated on 6 January: the Adoration of the Magi and the Baptism (see also cat. no. 31). The infant John the Baptist with his scroll, once inscribed with the words 'Behold the Lamb of God', (JOHN 1: 29), brings to mind the Baptism, when the Holy Spirit descended on Jesus, and Saint John recognised in him the long-awaited Messiah. The Christ Child's olive branch – emblem of peace – recalls the Christmas promise of the Gospel of Saint Luke: 'on earth peace, good will toward men' (LUKE 2: 14).

Mantegna's picture was designed to evoke awe within a small compass. His Christ Child appears as God, Emperor, Judge, the Prince of Peace – and this is also the subtext of most of the images of the Adoration of the Magi or the Three Kings, even those which make plain that this Child was born to die.

But after the focus of devotion shifted from Christ the victorious God, to Christ the suffering man, most other images of his infancy sought to elicit a quite different range of emotions. We find artists emphasising the Christ Child's helplessness and vulnerability; he suffers pain when his blood is first shed (cat. no. 26). He is as graceful and playful as any baby; this is a Child whom we must care for and love. The Queen of Heaven herself

tends to his bodily needs, suckles him, bathes him and changes his nappies (cat. no. 25). He may be divine and royal, but like any baby, he needs a cradle (cat. no. 24). Yet his mother knows what every viewer knows: the fate that will befall him. We may not now respond as the artist would have wished to the sight of a chubby Child asleep on the cross (cat. no. 29), but there are still few images more affecting than those of the Virgin grieving over the sleeping infant as she will grieve over the dead body of the man (cat. nos. 27 and 28). The tenderheartedness of our response must be tempered by guilt and resolution, for this pain and this grief are our fault. Christ's sufferings are commensurate with our sins, and our love for this child, our pity for him and for his mother, must lead to our sinning no more. These images are meant to change our lives.

There is one painting here which may – through its psychological acuity and its command of pictorial means – encompass most things understood as Christ's dual nature, and evoke the most complex and deepest response. It is not, at first sight, in tune with modern sensibilities, although the artist's contemporaries and many later viewers – Catholics and Protestants, believers and unbelievers, connoisseurs and first-time gallery visitors – found it very moving. It is one of Murillo's last and greatest works, the *Heavenly and Earthly Trinities* (cat. no. 21). The image is both direct and subtle, and much less sentimental than it looks. The Holy Family of Jesus, Mary and Joseph form the terrestrial trinity, which intersects in the person of Jesus with the Celestial Trinity of God the Father, God the Son and God the Holy Spirit. The Christ Child stands on a cornerstone, a recurrent biblical metaphor. It allows Murillo to raise him above his earthly parents so that they may kneel to him. But this stone is also unmistakably an altar, the billowing clouds are clouds of incense, and the Child's upward glance is one of submission. Yet he is both submissive and commanding; yearning and regretful; standing still and moving onward. The hand gestures linking these parents and this child are equally ambiguous and eloquent: of love, trust, entreaty, of holding on and letting go. And what of Mary's and Joseph's gazes – whom do they address, and what do they express? Is the picture as a whole joyous or melancholy?

This is an image of Christ, but like all great Christian art, it also reveals much about ourselves. In representing Christ's dual nature, Murillo also expresses human ambivalences. *EL*

21 The Heavenly and Earthly Trinities, 1681–82

Bartolomé Esteban Murillo (1617–1682)
Oil on canvas, 293 x 207 cm.
London, National Gallery, NG 13

Iefus Matris deliciæ, Iefus Patris folatium.
Hieronymus Wierx fecit et excud. Cum Gratia et Priuilegio. Bufchere.

FIG 14 *Hieronymus Wierix*, The Return from the Temple (The Heavenly and Earthly Trinities), about *1600. Engraving, 97 x 66 mm.* London, British Museum.

1 Mâle 1932, pp. 312–13.

IN THIS WORK, almost certainly an altarpiece, Murillo has given visual form to the belief that Christ is both human and divine, earthly and heavenly. The Christ Child is placed in the centre of the composition, emphasising his role as the fulcrum of the 'Two Trinities'. Together with the hovering dove of the Holy Spirit and the figure of God the Father above, he is part of the Holy or Heavenly Trinity. In the lower half of the picture, together with his human parents, Mary and Joseph, he forms a part of the Holy Family sometimes thought of, especially in Counter-Reformation Catholicism, as the 'Earthly Trinity', the terrestrial counterpart of the Holy Trinity.[1] The painting demonstrates very effectively how the rhetoric of image-making can make a complex and profound theological notion accessible, persuasive and attractive.

Although this is not a narrative painting, Murillo's treatment of the *Heavenly and Earthly Trinities* is linked both compositionally and thematically to representations of the Return from the Temple recounted in the Gospel of Saint Luke (fig 14). When Christ was twelve years old Mary and Joseph took him to the Temple in Jerusalem for the Feast of Passover (LUKE 2: 41–50). As they returned home they realised that Jesus was not with them. They found him three days later in the Temple talking with the Doctors and astounding them with the intelligence of his replies. Mary said to him, 'Son, why hast thou thus dealt with us? Behold, thy father and I have sought thee sorrowing'; to which Jesus replied, 'Wist ye not that I must be about my Father's business.' With these words, Jesus declared his divine paternity, manifesting for the first time his awareness that he was the Son of God. Murillo's painting does not actually represent this Gospel subject (his Christ Child is anyway too young), but it draws out from the episode the essential theological point that Christ's nature was both human and divine and that he was entrusted with a divine mission.

The Gospel states that Mary and Joseph did not understand what Jesus meant by his reply to them, but Murillo shows them in attitudes of adoration, recognising his divinity. Joseph kneels and looks directly at the viewer, inviting us too to adore Jesus. The rod he holds in his left hand relates to a story recounted by Saint Jerome (*c.* 341–420). He wrote that all Mary's suitors brought a rod to the high priest at the temple, but Joseph's was the only one that blossomed. This was a sign from heaven that he was chosen to be her husband. In Murillo's painting Christ stands on a piece of stone, perhaps symbolic of an altar, but maybe also intended as a reference to the difficulties of belief raised by the paradox of the dual nature of Christ. In the Gospel of Saint Matthew, Christ speaks of himself using a metaphor from the Psalms (118: 22–23), as the rejected cornerstone: 'Jesus saith unto them, "Did ye never read in the Scriptures, The stone which the builders rejected, the same is become the head of the corner: this is the Lord's doing, and it is marvellous in our eyes?"' (MATTHEW 21: 42). Saint Paul in the Letter to the Romans contrasts the Gentiles' welcoming of Christ with the people of Israel's rejection of him, describing him as 'a stumblingstone, and rock of offence: and whoever believeth on him shall not be ashamed.' (ROMANS 9: 33 and 1 PETER 2: 4–8). *XB*

22 The Holy Family with Saint John, about 1500

Andrea Mantegna (1430/31–1506)
Glue on canvas, 71.1 x 50.8 cm.
London, National Gallery, NG 5641

FIG 15 *Margarito of Arezzo,* The Virgin and Child Enthroned, with Scenes of the Nativity and the Lives of the Saints, *(detail) 1260s. Tempera on wood, total size 92.7 x 182.9 cm. London, National Gallery, NG564.*

The Christ Child sits, as though enthroned, on the Virgin's lap, and wears a classical tunic and cloak suggestive of an antique ruler. He blesses with his right hand while in his left hand he holds a scroll, signalling his role as teacher.

AS IN MURILLO'S *The Heavenly and Earthly Trinities* (cat. no. 21), the infant Christ is shown here with his earthly family, although the emphasis is on his status as divine ruler. So emphatic is the impression of the Christ Child's majesty that the painting was formerly known simply as the '*Imperator Mundi*', or 'Ruler of the World'.[1] The classical resonances of the Latin title are wholly appropriate since Mantegna, an artist genuinely obsessed with the world of antiquity, has conceived a Christ who is both Roman emperor and infant Hercules. The Child adopts the elegant pose of the statues of Augustus, and his chemise, which resembles a classical garment, is thrown over the shoulder like a Roman *pallium* or cloak. In his left hand he carries an orb, the sign of earthly dominion (see cat. no. 8) and in his right hand, in place of a sceptre or commander's baton, he bears an olive branch, recalling Christ's messianic title of 'Prince of Peace' (ISAIAH 9: 5). The vocabulary of the classical-ruler portrait is here deployed to emphasise the Child's divinity. Christ's gaze does not meet the viewer's, instead he looks beyond what is immediately before him, as though mysteriously conscious of his destiny. Mantegna almost certainly made this work for the private devotion of a north Italian family.

In representing Christ in the early centuries of Christianity, artists drew heavily on Roman imperial imagery. Christ was both divine king and judge, he was priest and law-giver, and the imagery of the emperors in coins, sculptures, mosaics and paintings offered visual prototypes for all these roles. Christ was therefore shown enthroned and sitting in judgement, bearing the staff of authority, his head adorned with the nimbus of divine power. The symbiosis between the imagery of Christ and emperor was most apparent, however, in the art of Byzantium, the Christian Roman empire in the east. An interesting medieval Italian example in the National Gallery of the Christ-ruler image, based on a Byzantine type, is to be found in Margarito of Arezzo's altar panel (fig. 15).

There is nothing very childlike about Mantegna's Christ, or Margarito's for that matter, with the exception of his size relative to neighbouring figures. Christ is mature beyond his years; the attributes of the adult and eternal Christ have been foisted on his infant self. This representational tradition is very much older than the tradition which we witness, for example, in the painting of the *Virgin and Child in an Interior* from the workshop of Robert Campin (cat. no. 25), where the human and vulnerable condition of the infant, the more genuinely 'incarnational' qualities, are emphasised. That said, Mantegna's painting does convey something of the central paradox of Christ's dual nature: he is shown, after all, with his earthly family, the Virgin Mary apparently engaged in domestic needlework behind the curved, well-like, parapet. On the left of the composition Christ's cousin, John the Baptist, points him out to the viewer and his winding scroll bears the words *Ecce Agnus Dei* (only *Dei*, the last word, survives), 'Behold, the Lamb of God [which taketh away the sin of the world]' (JOHN 1: 29). Christ is presented to the viewer both as victor and victim, divine ruler and earthly infant. *GF*

1 Richter 1910, I, p. 255.

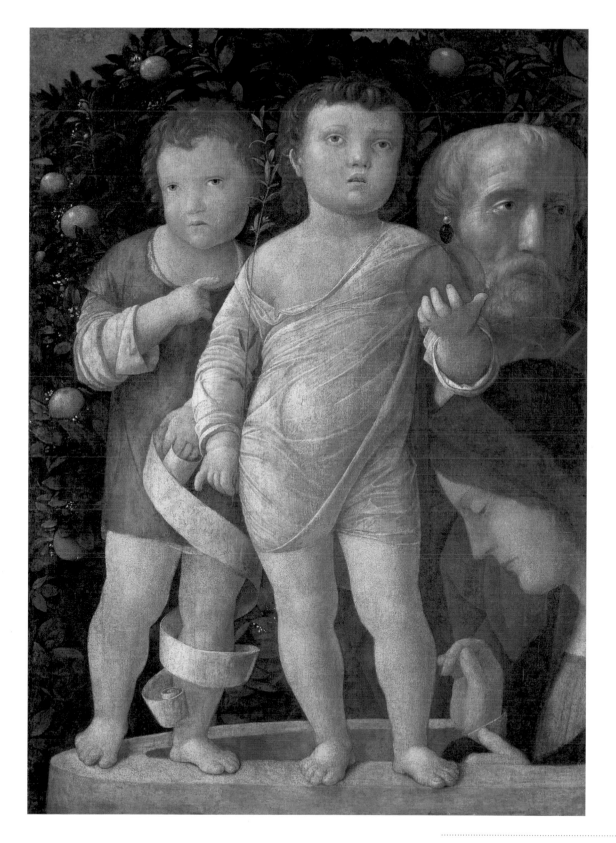

23 Saint Francis receiving the Christ Child from the Virgin, about 1583–85

Ludovico Carracci (1555–1619)

Oil on canvas, 103 x 102 cm.

Amsterdam, Rijksmuseum, INV. SK A3992

SAINT FRANCIS LOOKS lovingly at the infant Christ and embraces him tenderly, having received him from the arms of the Virgin Mary. The episode on which Ludovico Carracci based this picture is recounted in the *Annales Minorum*, the medieval compendium of stories of Saint Francis and the first Franciscans.[1] A young friar who nurtured doubts about Saint Francis's holiness, on finding his hut empty one night, sought him out in the nearby woods. There he witnessed the Virgin appearing to Saint Francis and presenting her child to him. The friar fell to the ground in terror and was woken from his faint some time later by Saint Francis himself. In the painting, the doubting friar appears in the background, his hands joined in prayerful devotion. The episode recalls the better-known story of the origin of the traditional Christmas crib, when on Christmas Eve in 1223 in Greccio Saint Francis re-enacted the Nativity in a cave, with a crib and an ox and ass. His biographer Tommaso da Celano records that as he prayed he took up the infant Christ, who seemed to come alive in his arms.[2] For Saint Francis, Christ was the 'peaceful, tender and loving brother', and he was especially drawn to the Nativity because it demonstrated unequivocally the humility of Christ's Incarnation, in that he, the King of the Universe, should take flesh in such abject circumstances.

It would be hard to overestimate the role of Francis of Assisi (1182–1226), and of the religious order he founded, in developing a spirituality which promoted a sympathetic and emotional bond with the Saviour and especially with the Christ Child. Representations of episodes from the life of the Saint, like the one shown here, indicate that the relationship between God and man was being thought of in a new way and Christ himself was being perceived in a different light. No longer was he principally the infant ruler or the child judge (cat. no. 22 and fig. 15); instead, he is the vulnerable baby who requires the affection, care and protection of human beings. The flood of religious literature and art which issued from the Franciscan renewal in the thirteenth and fourteenth centuries placed great emphasis on the human nature of Christ, his consciousness, his feelings and the physical pain he endured during the Passion. While retaining fully his divinity, the Christ of the Franciscans was more approachable, more sympathetic and easier to identify with.

Ludovico Carracci made the painting in his native Bologna, a city which was in the vanguard of Catholic Church reform following the Council of Trent in the mid-sixteenth century. The period saw a great revival of the imagery of Saint Francis and, especially, of his mystical experiences. The artist has subtly blended the natural and the supernatural in this work, playing up the contrast between the real and the visionary in the contrast of dark and light. The figure of the Saint emerges gradually from the shadows on the left side to be intensely illuminated on the right by the radiance of the Child and of the Virgin. She stands on a cloud, a figure of exquisite poise and elegance, partly sharing the real space inhabited by Saint Francis and partly outside it. As the earthly meets the divine there is an atmosphere of solemn, silent contemplation. *GF*

1 The *Annales Minorum* were edited and published in 1625 by Lucas Wadding.

2 The episode is recounted in the *Vita Prima*.

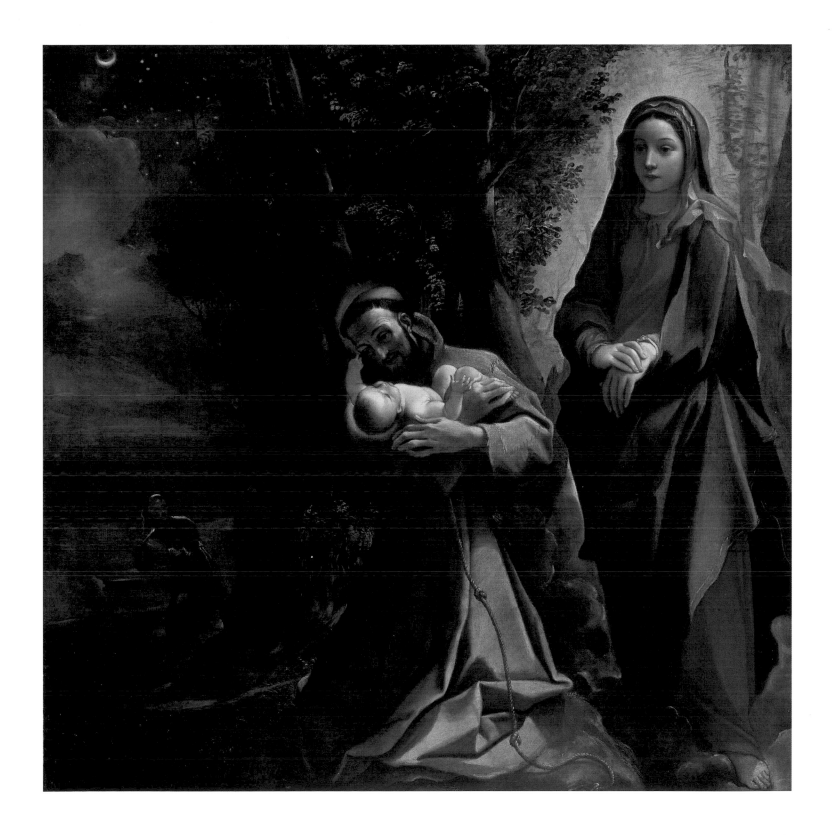

24 Cradle, about 1480–1500

Southern Netherlandish

Painted and gilded oak, height: 25.4 cm.,
length: 19 cm., width: 11 cm.

Glasgow, Burrell Collection, INV. 50/239

FIG 16 *Anonymous (Liège),* Crib with Christ
Child, *early fifteenth century. Silver gilt, 12.6*
x 12 x 8 cm. Namur, Musée des Arts Anciens.

1 Quoted in Wentzel 1960, p. 276.
2 On Christ cradles and dolls see: Niffle Anciaux
 1889; Niffle Anciaux 1911; Wentzel 1960; Klapisch-
 Zuber 1985; *Art of Devotion*, p. 102; Keller 1998.
3 *Meditations*, p. 38.
4 Quoted in *Art of Devotion*, p. 102.

IN 1344 MARGARETHA EBNER, a Dominican nun at the convent of Maria-Medingen near Nuremberg, received a small model of a cradle containing a figure of the Christ Child. The gift made a huge impression on her and by her own account it inspired a number of mystical dreams. On one occasion, woken by the Christ Child playing in his cradle, she picked him up to kiss and cuddle him, on another she suckled him at her breast.[1]

This small wooden cradle was made about 150 years after Margaretha wrote about hers, but it too would once have contained a doll-like figure of the Christ Child (fig. 16). Its purpose would also have been the same, providing a focus for a particular kind of devotion, in which the owner – very possibly also a nun – imagined herself caring for the infant Christ. Like most surviving cradles of this type, this example probably comes from the southern Netherlands. We know that they were often given by wealthy families as gifts to women entering a convent and the evidence of inventories suggests that such objects were also common in grand homes. The bases of these cradles – missing in this example – often held relics.[2]

The popularity of such cradles derives ultimately from Saint Francis's devotion to the Christ Child (cat. no. 23) reflected, for example, in the anonymous thirteenth-century Franciscan author's *Meditations on the Life of Christ*:

> Kiss the beautiful little feet of the infant Jesus who lies in the manger and beg His mother to offer to let you hold Him a while. Pick Him up and hold Him in your arms. Gaze on His face with devotion and reverently kiss Him and delight in Him.[3]

Although this particular form of cradle was a Netherlandish phenomenon, the use of child dolls as an aid to devotion was common throughout Europe. Preaching in Florence in the late fifteenth century, the Dominican Savonarola accused nuns of treating their infant dolls like idols.

The purpose of such devotional aids was, of course, to provide a path to spiritual communion with Christ. A devotional handbook published in Antwerp in 1488 (and so from the same area and period as this cradle) aimed to instruct the reader in preparing for the birth of Christ in one's soul. One illustration (fig. 17) shows the personifications of Meditation (*Meditatio*) and Prayer (*Oratio*) apparently tucking the Christ Child into bed and plumping his pillow, accompanied by the text:

> One now gathers up the sweet little Child Jesus and lifts Him from His crib. As He Himself said, one must lift up the Son of Man so that all those who believe in Him do not perish, but may have eternal life.[4]

While the cradle helped to focus attention on the humanity of the Christ Child, its form emphasises his divinity. This is no ordinary bed. Reminiscent of ecclesiastical architecture, it is gilded and richly decorated with a wealth of subsidiary imagery which only partly survives. At one end is a carving of Saint Martin dividing his cloak for the beggar,

an exemplar of charity. At the other end the Virgin Mary is shown grieving over the dead Christ, a stark reminder of Christ's future suffering and death. The relief makes explicit the link between the care for the human Christ Child and the recognition that in becoming flesh, Christ was bound to die. *AS*

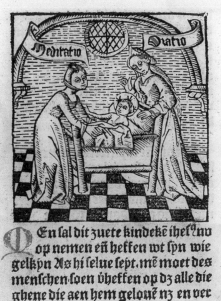

FIG 17 Meditation and Prayer putting the Christ Child to Bed. *Woodcut illustration from G. Leen*, Van die gheestelijker kintheyt Iesu, *(On the Spiritual Infancy of Jesus), Antwerp, 1488, fol. 20v.*

25 The Virgin and Child in an Interior, about 1430

Workshop of Robert Campin, late 1370s–1444 (Jacques Daret?)

Oil on oak panel, 22.5 x 15.4 cm., including integral frame

London, National Gallery, NG 6514

TO MODERN EYES THIS SMALL fifteenth-century Netherlandish panel shows a scene of unaffected domesticity, simply, if meticulously, recorded. In an apparently time-less display of maternal intimacy a mother hugs and kisses her child either just before or after his bath. A bowl of water is warming by the fire and in the foreground sits a basket of nappies. The emphasis on the homely setting and the bond between the mother and her naked and vulnerable child are intended to help the viewer focus on Christ's human-ity, but a fifteenth-century viewer would have been able to see much more than this.

Mary's sanctity and Christ's divinity are clearly indicated by their haloes. Both figures are too large – Alice-in-Wonderland like – for the room they occupy. The room itself has a grand fireplace and half-panelled wall, similar to those one sees in depictions of Burgundian palaces. The bench before which the Virgin sits is covered with an expensive cloth of gold, as is the partially visible cushion on which she rests. It has even been sug-gested that the floor is paved with semi-precious stones. Mary's loose, uncovered hair would have been understood as a sign of virginity to a contemporary audience, although queens of the period also wore their hair this way on formal occasions. That such a woman in such a setting should be bathing her own baby would have been seen as a flagrant breach of the conventions of the real world, in which aristocratic mothers sent their babies off to nurse immediately after birth. What to our eyes appears a natural scene in simple surroundings would at the time have been seen as neither natural nor simple, its very incongruities identifying the figures as Mary, the mother of God, and Christ her son. Christ's divinity is also perhaps alluded to by the detail of the candle above the fireplace, lit in broad daylight. Burning candles were associated with prayer and were often placed before religious images.

The child's pose is extraordinary: he arches his neck to kiss his mother on the lips while cupping her chin with his left hand, a gesture associated with adult lovers. It prob-ably alludes to the identification of the Virgin and Child with the bride and bridegroom in the biblical Song of Songs. Commentators saw in the embrace of the poetic lovers, a metaphor for the mystical union between Christ and the Virgin – a symbol of the Church. At the same time the Christ Child's right hand is twisted round to both take hold of and display his genitals. The gesture is equally contrived and it is perhaps here that we find the artist alluding most deliberately to Christ's humanity. Leo Steinberg, in his exhaustive study on the subject, has not only demonstrated the popularity of the motif of the Christ Child displaying his genitals but has also explained its theological justification which centres on the notion of Christ's dual nature. His genitals make ex-plicit his descent into manhood, but his ability to display them without shame mark him as divine – a mirror image of fallen Adam whose first act after eating the forbidden fruit was to cover his nakedness in shame.[1] Christ's gesture may also refer to his circumcision which, as the first shedding of his blood, was seen as prefiguring his sacrifice (cat. no. 26) and his future suffering may also be alluded to by the cross – formed by the window's bars – directly above his head. *AS*

1 Steinberg 1996.

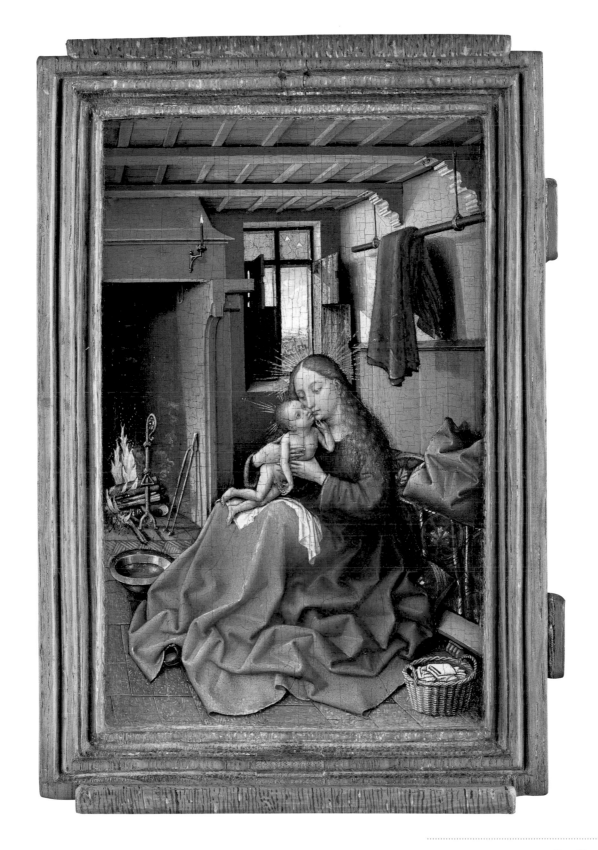

26 The Circumcision, about 1500

Workshop of Giovanni Bellini (active from around 1459, died 1516)

Oil on wood, 74.9 x 102.2 cm. Signed on a cartellino: IOANNES/ BELLINVS.

London, National Gallery, NG 1455

CHRIST'S CIRCUMCISION EIGHT DAYS after his birth is an event commemorated in the Christian calendar on the first day in January. The Gospel of Saint Luke recounts that, 'when eight days were accomplished for the circumcising of the child, his name was called Jesus' (LUKE 2: 21). Circumcision, or the ritual removal of a male infant's foreskin, was the sign of the covenant between God and Abraham (GENESIS 17: 11–12) and was part of the religious laws given by Moses (LEVITICUS 12: 3). It remains an important part of Jewish religious practice. Like Baptism in the Christian Church, circumcision has traditionally served as a rite of purification, marking the moment of a male child's formal naming.

Bellini has conformed to the traditional representation of the subject showing the High Priest performing the act while Mary holds the Infant Jesus and Joseph and two other figures look on.[1] Christ clenches his fists, bravely bearing the pain. In undergoing the ritual as the law required, he demonstrated his readiness to submit to the law and to share in the human condition. Christ's circumcision was subjected over time to a variety of interpretations on the part of theologians who extended its significance and drew parallels with other episodes of his life. For medieval Christians, the event was significant as the first occasion on which the Redeemer's blood was shed, in a direct allusion to his coming Passion. Later, the Jesuits (who take their name from Jesus) laid special emphasis on the Feast of the Circumcision because of its association with the act of his naming.[2] Through the association between the naming of Jesus and the first shedding of his blood, the circumcision came to symbolise the moment in which God's plan of salvation for humanity, through Christ's sacrifice on the cross, began to be made manifest.

Paintings like this may have been commissioned by the members of lay associations, or brotherhoods, who perhaps had a special devotion to the name of Christ or to the relics of his blood, or even his foreskin. In the absence of any physical vestiges of the mature Christ's bodily presence on earth following his Ascension into heaven, relics purporting to be his foreskin were much prized in medieval times. Alarmingly, as many as fifteen such items are known at one time or another to have been the object of veneration in different parts of Europe. *XB*

1 On the iconography of the circumcision, see Réau 1957, II, pp. 256–61; Voragine 1993, I, pp. 71–78.
2 Even before the Jesuits, the Name of Jesus had been revered by figures such as Saint Bernard who claimed the name to be like 'honey in the mouth, music in the ear, and a cry of joy in the heart', Voragine 1993, I, p. 72; see also cat. no. 14 in this catalogue.

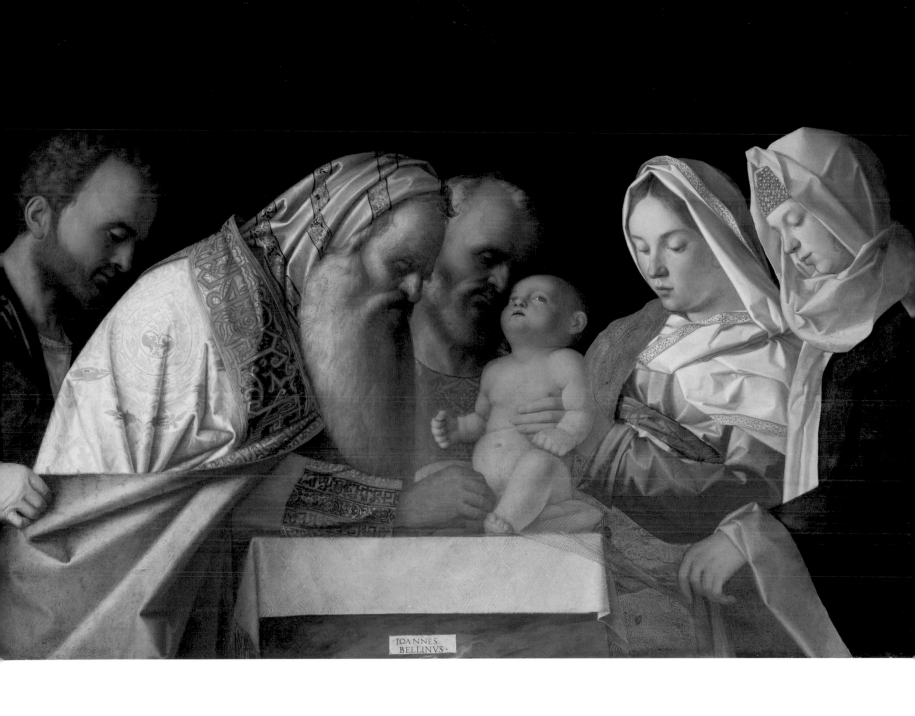

27 The Virgin with the Dead Christ (The *Pietà*), about 1430

'The Rimini Master' (Southern Netherlandish)
Alabaster (with traces of polychromy), height: 38.4 cm., width (of base): 31 cm.
London, Victoria and Albert Museum, INV. A28–1960

THE REPRESENTATION OF the sorrowing Virgin alone with the body of Christ lying across her knees is known as the *Pietà* (the Italian for pity or mercy). It does not correspond with a scene recounted in the Gospels, but is a later invention, dating from the twelfth century, which bridges the gap between Christ's Deposition from the Cross (cat. no. 51) and his Entombment (cat. no. 53). In devotional terms the scene provided the faithful with a peaceful moment, devoid of narrative, on which to focus their prayer and contemplation. It also gave a special prominence to the Virgin Mary in the context of the Passion and therefore in the central drama of Redemption.

This fifteenth-century alabaster sculpture by the so-called Rimini Master, a southern Netherlandish artist whose work was exported to north-eastern and central Italy, shows the Virgin leaning over the dead Christ with a sorrowful expression. She holds his outstretched arm with one hand, while with the other she supports his head as it falls back. His head, tilted towards us, reveals the expression of death, his mouth half open and his eyes closed. The wound in Christ's side, administered to his lifeless body on the cross, is clearly visible. Tiny traces of gesso and discoloured paint found on the drapery, hair and beard of Christ indicate that the alabaster was originally at least partly coloured. In its current state, the veins of the alabaster stone have the effect of intensifying the realistic depiction of Christ's naked body. The deeply carved folds of the Virgin's cloak, falling heavily downward, emphasise the general mood of pathos.

In contemplating the *Pietà*, the faithful were expected to not only associate themselves with the Virgin's personal suffering, but also to feel gratitude that she was ready to give up her son for the salvation of mankind. The Virgin's sentiments are articulated by the thirteenth-century Franciscan writer of the *Meditations on the Life of Christ*:

> She wept uncontrollable tears; she looked at the wounds in His hands and side, now one, now the other; she gazed at His face and head and saw the marks of the thorns, the tearing of His beard, His face filthy with spit and blood, His shorn head; and she could not cease from weeping and looking at Him … 'My Son, I hold you in my lap dead … You abandoned yourself for love of mankind, whom you wished to redeem. Hard and exceedingly painful is this redemption, in which I rejoice for the sake of the salvation of man.[1]

The German Carthusian mystic, Heinrich Suso (*c*.1295–1366), sought complete self-identification with the Virgin, asking that she place her son's body 'on the lap of my soul so that, according to my ability, I may be vouchsafed in a spiritual manner and in meditation that which befell you in a physical manner'.[2] He also engages his readers with the Virgin's first-person account of her feelings: 'I took my tender Child on my lap and looked at Him again and again, there was neither awareness nor voice'.[3] These words not only illuminate the sentiment of this sculpture but apply equally well to Giovanni Bellini's *Madonna of the Meadow* (cat. no. 28). *XB*

1 *Meditations*, pp. 342, 344.
2 Quoted in *Art of Devotion*, p. 104.
3 Ibid.

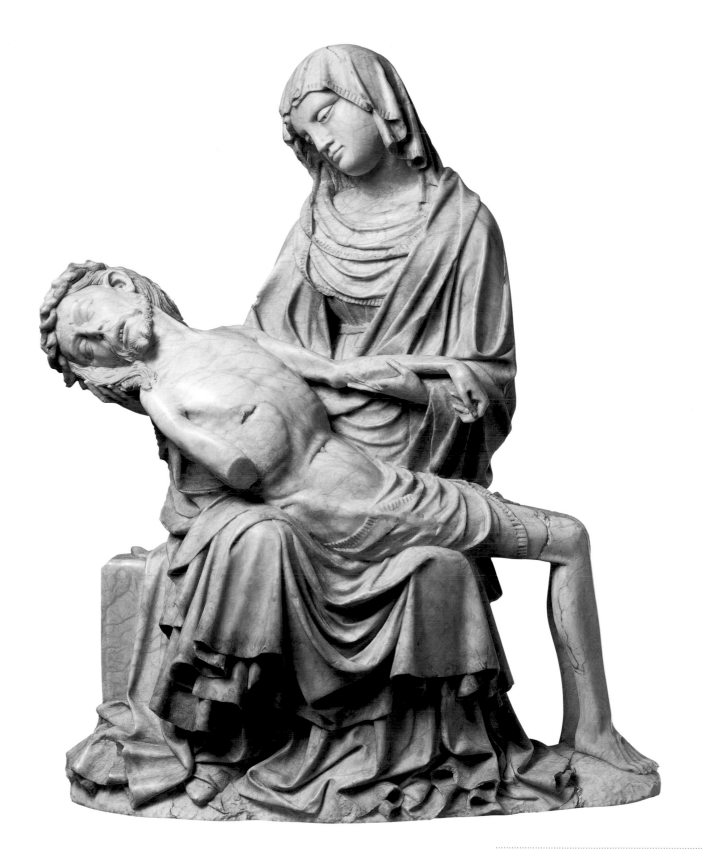

28 The Madonna of the Meadow, about 1500

Giovanni Bellini (active from around 1459, died 1516)

Oil and egg on synthetic panel transferred from wood, 67.3 x 86.4 cm.

London, National Gallery, NG 599

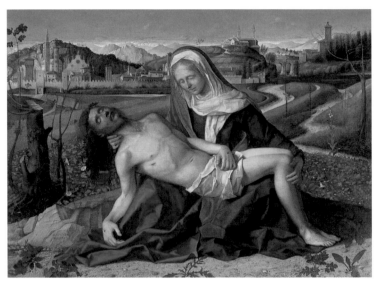

FIG 18 *Giovanni Bellini,* Pietà, *c.1500. Oil on panel, 65 x 87 cm. Venice, Galleria dell'Accademia.*

BELLINI PRODUCED SEVERAL devotional paintings like this one for domestic use, showing the Virgin and Child set in a landscape. In this work, however, rather than depicting the infant Jesus awake in the Virgin's arms, Bellini shows him lying fast asleep on his mother's lap. He appears to be slumbering comfortably, but there are darker undertones in the painting.

In both the biblical tradition and in Classical antiquity, sleep was considered a natural metaphor for death: 'Consider and hear me, O Lord my God: lighten my eyes, lest I sleep the sleep of death.' (PSALM 13: 3). Bellini's sleeping Child inevitably resonates in the devout viewers' mind with echoes of the *Pietà* (cat. no. 27) where, similarly, the dead Christ lies across the Virgin's lap, and the Virgin, as though mysteriously aware of his fate, looks at him in adoration and joins her hands in prayer. Christ's hand, placed across his chest, recalls the pose traditionally adopted for burial, while the rigidity of his right leg evokes the stiffness of death. The medieval mystic, Saint Bridget of Sweden (1303–73), whose *Revelations* were widely known in Europe, reflected on the painful prescience of the Virgin: 'Wherefore even as she was of all mothers the most blessed when she beheld the Son of God born of her … so was she also of all mothers the most afflicted by reason of her fore-knowledge of His most bitter Passion.'[1] Bellini's lyrical *Pietà* in the Accademia in Venice (fig. 18), which shows the fully-grown Christ lying dead across the aged Virgin's lap in a similar landscape, is the ideal companion piece and the poetic sequel to the *Madonna of the Meadow*.

The beautiful landscape in this work, reminiscent of the flat alluvial mainland provinces of Venice, beyond which rise the foothills of a mountain range, lightens the pathos of the painting. The budding leaves on the trees evoke spring and rebirth. In the background a crane fights with a snake, a motif perhaps derived from the Roman poet Virgil's *Georgics*, where events appropriate to spring are described: 'The best planting season for vines is when in blushing spring the white bird, the foe of long snakes, is come.'[2] The crane was regarded as a harbinger of spring and hence of new life, and it is possible that Bellini intended an allusion both to Christ's Resurrection and to his victorious battle with the devil, symbolised by the snake. *XB*

1 Quoted in Cast 1969, p. 248.
2 Book II, 319–20.

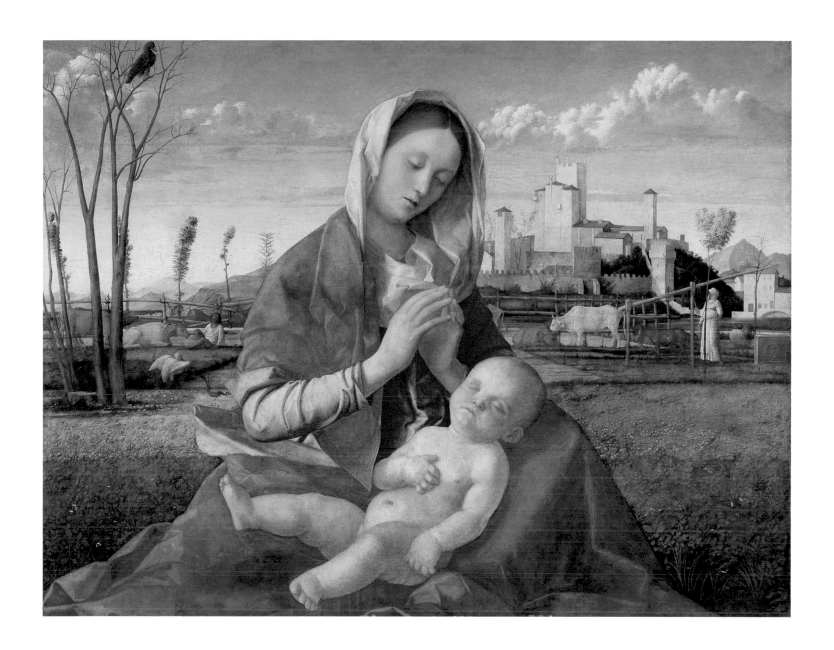

29 The Christ Child Resting on the Cross, 1670s

Bartolomé Esteban Murillo (1617–1682)

Oil on canvas, 141 x 108 cm.

Sheffield Galleries and Museums Trust, Graves Art Gallery, INV. 73

FIG 19 *Giacomo Francia,* The Christ Child asleep on the Cross, *c.1530–50. Engraving, 13.5 x 19.6 cm. London, British Museum.*

FIG 20 *Murillo,* The Infant Saint John the Baptist, *1670s. Oil on canvas, 142 x 107 cm. Duke of Buccleuch and Queensberry, Boughton House, Kettering.*

1 See Cast 1969, p. 228.

IN WHAT TO MODERN EYES may seem an unusual juxtaposition, Murillo shows the innocently sleeping Christ Child resting on a cross of size and proportions appropriate to his small stature; beside him is a skull. Both these objects allude directly to Christ's coming sacrifice, emphasising in the clearest possible way the notion that his fate was to be born into the world in order to die for the world. Paintings of this subject were very popular in Spain in the second half of the seventeenth century, and they were probably produced for private devotion. In this work the two angels hovering above the Christ Child invite the viewer to contemplate Christ's Passion.

The sleeping Cupid was a favourite motif of Classical art, and its resonances of love and death could be readily adapted to extend the range of meanings in representations of the Christ Child. An important early example is a print by the Bolognese engraver, Giacomo Francia (*c.*1486–1557), which shows the sleeping Child with a cross and other emblems alluding to his future sacrifice (fig. 19). Among the texts in the engraving is the quotation from the biblical Song of Songs: 'I sleep, but my heart waketh' (SONG OF SOLOMON 5: 2), which was interpreted in medieval times as signifying withdrawal from the world in order to contemplate God. Applied to Christ, it referred allegorically to his temporary sleep of death in the tomb, and by analogy to his role as the shepherd of souls, who even in sleep was attentive to the needs of mankind.[1] Below, on a scroll bearing the crown of thorns, is a verse from the Book of Job (JOB 3: 13): 'For now should I have lain still and been quiet, I should have slept: then had I been at rest', suggesting that had Jesus not awoken he might not have had to face his Passion.

Murillo's painting was probably influenced by the treatments of this subject by Bolognese artists like Guido Reni and Francesco Albani, disseminated in the form of prints. The seventeenth century saw the elaboration of a fascinating iconography of the Christ Child in which he is shown living out aspects of his Passion. The most inventive images are those produced by the Flemish Wierix family of engravers, who supplied vast numbers of devotional prints of Christ and the Virgin, the saints and biblical narratives, to the whole of the Catholic world, including the Americas and the Philippines. One of these shows the Infant Christ carrying his cross and holding a basket filled with the instruments of the Passion.

This picture was originally conceived as a companion piece to another of near-identical dimensions showing the Infant Saint John the Baptist sitting on a rock in a similar landscape (fig. 20). The connection between the two pictures emerged during the course of research for this exhibition; they were listed as companions as early as 1757. When put side by side their allegorical significance becomes clear. Saint John the Baptist, seated beside a lamb, holds a cross from which hangs a banner with the inscription *Ecce Agnus Dei* (Behold the Lamb of God). With his right hand on the lamb's back, he points across, out of the composition, towards the pendant picture, which shows Christ asleep on the cross. The Infant Precursor identifies the future Saviour. The drama of salvation is played out by mere children. *XB*

30 The Adoration of the Kings and Christ on the Cross, about 1465–75

Attributed to Benedetto Bonfigli (active 1445; died 1496)

Tempera on wood, painted surface 37.5 x 49.5 cm.

London, National Gallery, NG 1843

A RTISTS EMPLOYED A VARIETY of means to express the idea that Christ was born in order to die for humanity. Some adopted a subtle and poetic approach, as did Bellini in the *Madonna of the Meadow* (cat. no. 28), while others were more direct. In this picture, thought to be by the fifteenth-century Perugian painter Benedetto Bonfigli, the Adoration of the Kings has been dramatically juxtaposed with the Crucifixion to emphasise clearly how from the very beginning of his life Christ was destined to die. Together, the two episodes mark the beginning and the end of the earthly life of Christ.

The story of the Adoration of the Magi (from *magus*, magician) is recounted only in the Gospel of Saint Matthew (MATTHEW 2: 1–12). They are described as 'wise men from the east' who were seeking the King of the Jews guided by a star. Few clues are given regarding their origin or identity, or even their precise number. In early representations, two, three and four Magi are shown in scenes of the Adoration (fig. 13). Their number was set at three by the theologian Origen (AD 185–254) on account of Saint Matthew's text mentioning three gifts: 'they presented unto him gifts; gold, and frankincense, and myrrh' (MATTHEW 2: 11). In time, theologians came to interpret the three Magi as representative of the three ages of man, or the three continents of the ancient world – Asia, Europe and Africa – recognising Christ as King. Their gifts were also interpreted symbolically, as an allusion to Christ's dual nature, both mortal and divine: gold, as a homage to Christ's kingship; frankincense, as a homage to his divinity; and myrrh, which was used for embalming, as a sign of his sacrificial death. The twelfth-century monk and theologian Saint Bernard of Clairvaux, however, offered a more practical interpretation, suggesting that the gold was to assist the Holy Family with their trip to Egypt; the frankincense, to sweeten the air in the stable; and the myrrh, to get rid of worms from Christ's intestines![1]

In Bonfigli's composition the Infant Christ is shown seated on a cushion on the Virgin's lap and assumes a position of authority as he accepts the gifts and the homage of the Magi, who are shown as kings. The eldest of the three has laid his crown before him and kneels in submission while holding Christ's feet in his right hand, perhaps intending to kiss them 'with reverence and devotion', as the anonymous Franciscan author of the *Meditations on the Life of Christ* puts it.[2] Acceptance of the Magi's homage was later understood as Christ's prophetic acknowledgment of his destiny to die on the cross. Bonfigli shows the crucified Christ in the middle distance among the hills, his head bowed down and blood trickling from his wounds. The ox and ass in the stable, often shown in Nativity and Adoration scenes, are derived from an Apocryphal Gospel dating from the sixth century AD and written by an author known as the Pseudo-Matthew. Their presence in Bethlehem is based on a quotation from Isaiah: 'The ox knoweth his owner, and the ass his master's crib' (ISAIAH 1: 3).

The painting was probably made as part of a predella, the lower section of an altarpiece. It is noteworthy that the kings wear contemporary Renaissance dress, although they do not appear to be portraits. *XB*

1 Réau 1957, II, p. 242.
2 *Meditations*, p. 51.

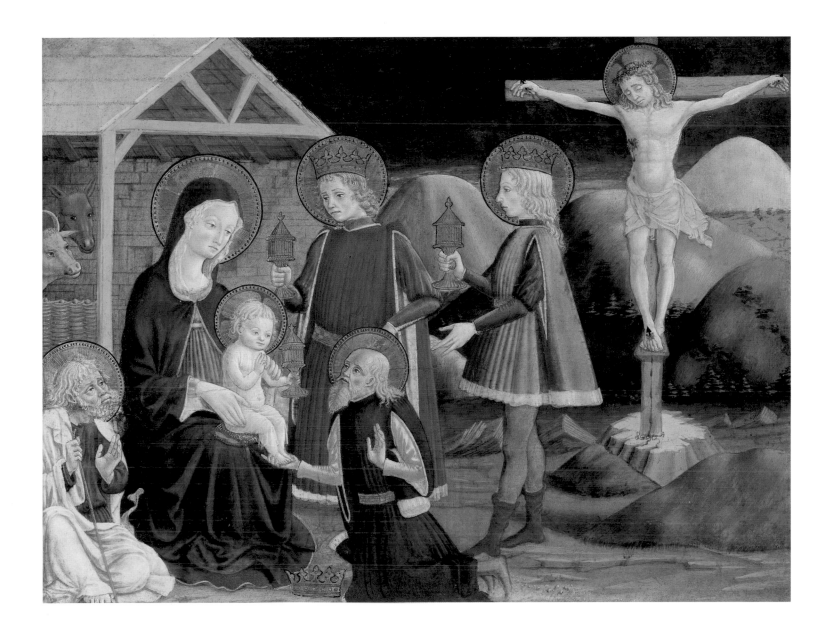

31 The Adoration of the Kings, 1500–15

Jan Gossaert (active 1502; died 1532)

Oil on oak panel, 179.8 x 163.2 cm. Signed IENNIN GOSS… *on the collar of the black king's attendant, and* IENNI/ GOSSART: DEMABV… *on the black king's hat. Inscribed on the black king's hat:* BALTAZAR; *near the hem of the cloth held by Balthasar:* SALV[E]/ REGINA/ MIS [ERICORDIAE]/ V:IT [A DULCEDO ET SPES NOSTRA] (Hail Queen, [Mother] of Mercy, [Hail] our life, our sweetness and our hope); on the scroll held by the second angel from the left:* GLORIA: IN: EXCELCIS: DEO: (Glory to God in the highest); on the lid of the chalice presented by the eldest king:* [L]E ROII IASPAR (the king Caspar).*

London, National Gallery, NG 2790

1 Lorne Campbell kindly allowed me to see a draft of his entry on this picture for his forthcoming National Gallery publication: *Sixteenth-century Netherlandish Painting*.

THIS PAINTING IS ELOQUENT on the regal and divine nature of the Christ Child: heaven and earth are united in an act of homage to the King of kings.[1] His earthly sway is seen to extend over both Jews and Gentiles, represented by the shepherds and kings respectively (LUKE 2: 8–20, and MATTHEW 2: 1–12). Two shepherds peer out from behind a wall opposite Joseph waiting to worship the Christ Child, while others stand behind, some receiving the angel's tidings. But the painting focuses on the kings and their retinue who have sought out the 'King of the Jews'. Various different names were assigned to them, although the Western church settled on Caspar, Melchior and Balthasar. Here Caspar's name is inscribed on the chalice he presents to Christ, while Balthasar's is shown on his hat. Each king was associated with a different country of origin. Saint Augustine (AD 354–430) suggested that they came from the north and south as well as the east, and the medieval writer known as pseudo-Bede explained further that the Magi signified the known continents of the world (Asia, Africa, and Europe), which explains why in paintings one of them, in this case Balthasar, is usually black.

The prominent gifts of the Magi allude to the true nature of the recipient. Saint Irenaeus, at the end of the fourth century, and later Saint Augustine, specified that gold was for tribute, frankincense for sacrifice and myrrh for burial, and consequently that the gifts alluded to Christ's kingship, divinity and humanity. In 1603 the Governors of the Spanish Netherlands, Albert and Isabella, who owned this painting, had a frame made for it with a Latin inscription which drew attention to this symbolism: 'They bring as gifts to the king and the man and the God, gold, frankincense and myrrh'. Gossaert emphasises Christ's kingly nature by showing him accepting the gift of gold from an earthly king who kneels in adoration to him. Christ's kingship over the heavens is alluded to by means of his golden halo; by the nine angels in heaven, most of whom look towards him with hands folded in prayer; and by the golden light and the dove which hover above him, representative of God the Father and God the Holy Spirit, respectively. The scene prefigures the Baptism of Christ, when:

> the heavens were opened unto him, and he saw the Spirit of God descending like a dove, and lighting upon him: And lo a voice from heaven, saying, This is my beloved Son, in whom I am well pleased. (MATTHEW 3: 16–17).

The Baptism, like the Epiphany (when the Three Kings recognised Christ at Bethlehem), was an event in which the divine nature of Christ was manifested; for this reason both were celebrated by the Church on the same day (6 January).

In the present painting Christ takes one of the coins from the cup offered to him by Caspar, a gesture which inevitably brings to mind the action of a priest taking a communion wafer from the ciborium (the vessel for reserving the consecrated bread), thus conferring on it a priestly and Eucharistic significance. The intimations of death and burial evoked by the gift of myrrh resonate in other details in the picture, developing the theological idea that Christ is as much human victim as heavenly priest. The

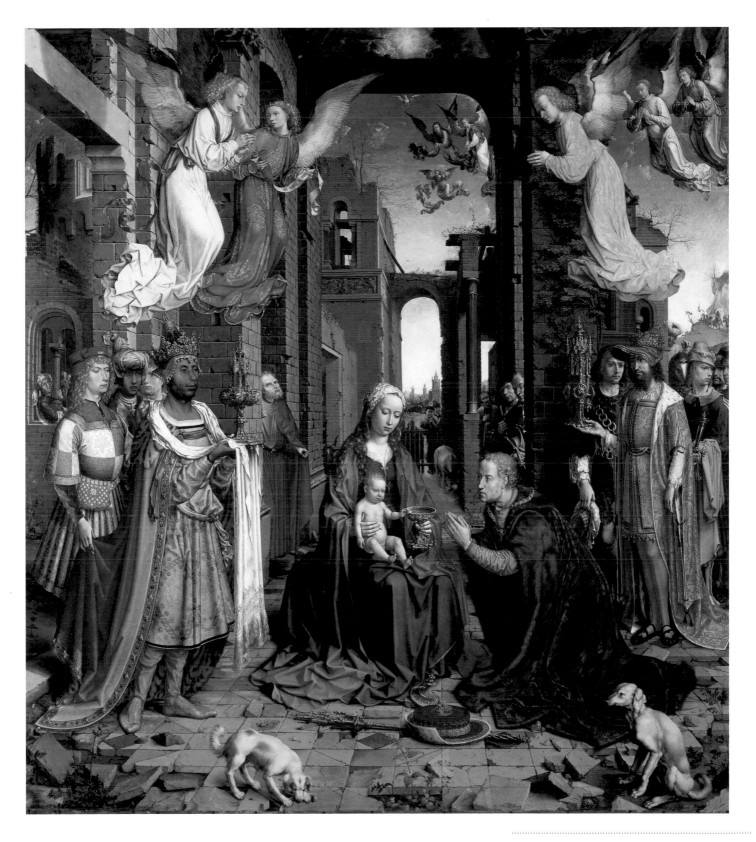

decoration of a capital above the eldest king shows the sacrifice of Isaac (GENESIS 22: 9–13), which was traditionally interpreted as a prefiguration of Christ's own sacrifice, while prominent in the background architecture is a column reminiscent of the one to which Christ would be bound and flagellated during the Passion. Gossaert elaborates a dense texture of symbolic allusion in this work to expound and explore the deep mystery of the person of Christ.

In their sumptuous costumes, the kings maintain a courtly and imperious dignity which may well have made the picture especially appealing to the succession of rulers or people of high rank who owned it. Albert and Isabella acquired it from the Benedictine Abbey of Geraardsbergen, east Flanders, and placed it in the chapel of their palace in Brussels (where there was a relic, a fragment of clothing of one of the Three Kings). It was later owned by Charles of Lorraine, the Governor of the Austrian Netherlands, and then by the Earls of Carlisle. Certainly the Epiphany was an event with which rulers in the past liked to associate themselves. Several chose to have themselves painted as one of the Magi. Various members of the Florentine Medici family appear in Botticelli's *Adoration of the Kings* (Florence, Uffizi), and 6 January was often chosen for kingly ceremonies. In early 1378, for example, Charles v of France met Charles iv, the Holy Roman Emperor and the latter's son Wenceslas, King of the Romans. *S-AQ*

32 The Adoration of the Kings, 1564

Pieter Bruegel the Elder (active 1550/1; died 1569)

Oil on oak panel, 112.1 x 83.9 cm. Signed and dated: BRVEGEL M. D. LXIII. *(1564)*

London, National Gallery, NG 1564

IN CONTRAST TO GOSSAERT's *Adoration of the Kings* (cat. no. 31), Pieter Bruegel the Elder's painting of the subject draws attention to the humanity and vulnerability of the Christ Child. He looks very small and evidently naked in comparison to the crowd of richly dressed or heavily armed men which presses in on all sides; his body seems weighed down rather than protected by the heavy blanket, and he shrinks back for protection into his mother's lap. Nor is there anything very obviously divine about the Holy Family: Mary's veil is slipping over one eye, and what might at first glance be mistaken for her halo turns out to be nothing more than a straw hat. Joseph, meanwhile, inclines his ear to the whisperings of his neighbour. Even the kings present a rather motley crew, with their straggling haircuts and hunched postures.

The particular gift that the Child is being offered emphasises his humanity; it is a vessel of golden-red grains of myrrh, which alludes to his future death and burial. The Child recoils from the gift, a gesture which the artist may have intended to foreshadow Christ's moment of anguish before the Passion when he pleaded in the Garden of Gethsemane that his father should 'take away this cup [of suffering]' (MARK 14: 36). Other artists made use of the same gesture for the same end, including Michelangelo in the *Taddei Tondo* where Christ recoils from a goldfinch, symbolic of his Passion. Further elements in Bruegel's painting may also refer to the Passion: the soldiers prefigure those who tormented and nailed him to the cross; at least two of the pikes are cross-shaped; and the blanket surrounding Christ looks somewhat like a shroud. It becomes clear, then, that Christ is being shown not as the Godly infant, but as a vulnerable human being who experiences as much anxiety, fear and pain as the rest of humanity. This representation of the Saviour encourages the viewer to meditate on the humility of the Incarnation.

Bruegel may be using this picture to explore not only the theme of Christ's humanity, but also the world's inhumanity. He does this by making ambiguous the reactions of the bystanders to the presence of God in their midst. Admittedly some of them stand with their eyes boggling and mouths hanging open, but it would be perhaps over-generous to ascribe this amazement to a true recognition of the Incarnation. Indeed, few eyes look at the Christ Child, whereas many focus on the rich gifts. One of the crowd wears spectacles and this detail, together with the other pairs of roving eyes which refuse to settle on the infant, suggests that the painting may be read as a comment on humanity's inability to recognise what is really important, even when it is right under its nose. This message would fit in well with much of Bruegel's oeuvre, especially his secular works, and it also reveals his debt to Hieronymus Bosch. Bruegel's presentation of this scene is both complex and ambiguous, but it is certainly not anti-religious. Almost nothing is known about Bruegel's life and beliefs. It has never been proven whether he was a Catholic, Calvinist, or free-thinker; indeed, he may well have been most sympathetic to those who, like Erasmus of Rotterdam (*c.*1466–1536), advocated tolerance and freedom of belief in an age of religious fanaticism. What seems clear is that his religious pictures were painted for connoisseurs rather than churches. *S-AQ*

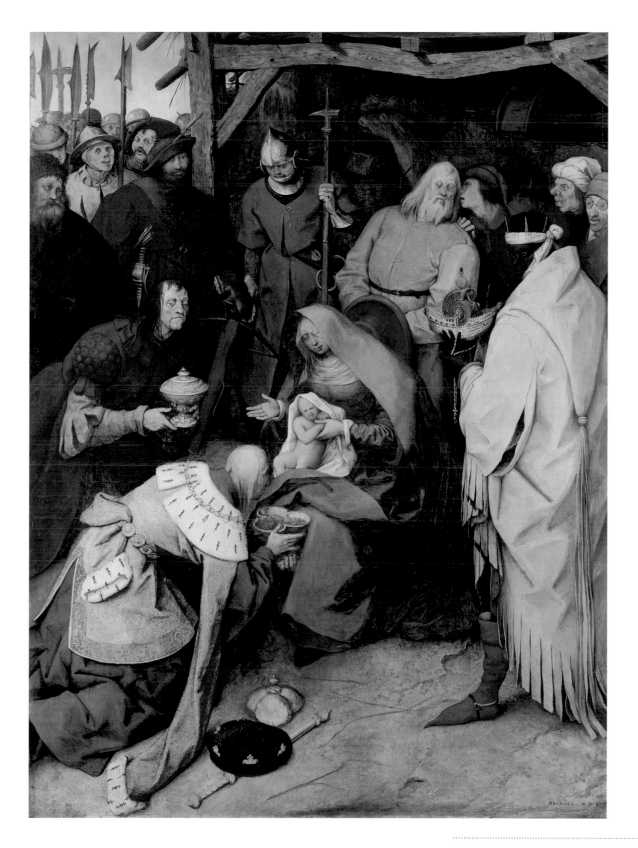

3 THE TRUE LIKENESS

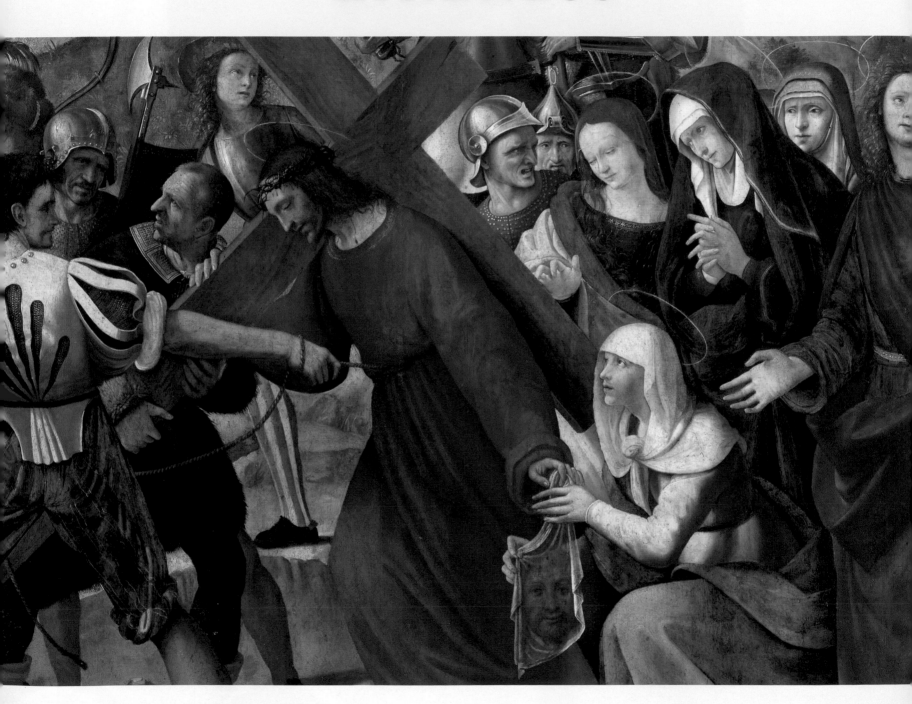

EVERYONE IN MEDIEVAL Europe would have been confident that they knew what Christ looked like. Images of his face were everywhere, many of them claiming to be copies or versions of a miraculous 'true likeness' of Christ housed in St Peter's in Rome. This was the 'Veronica', also known as the *vernicle* or the *sudarium* (meaning a cloth for wiping sweat). According to the most familiar version of the story, this was a cloth offered to Christ by Saint Veronica on the road to Calvary so that he could wipe his face. On receiving it back she discovered Christ's features miraculously imprinted upon it. A play on the word Veronica, which can be read as *vera icon* (meaning 'true image'), meant that the saint's name was also used to describe her cloth.

The Veronica became the most reproduced image in Christendom and perhaps the most famous relic in Rome. The Italian poet Dante (1265–1321), writing after the Holy Year of Jubilee in 1300 when pilgrims had flocked to Rome to see the Veronica (fig. 21), tells:

> … Of one
> Who haply from Croatia wends to see
> Our Veronica, and while 'tis shown,
> Hangs over it with sated gaze
> And all that he has heard revolving, saith
> Unto himself in thought: "And did'st thou look
> E'en thus, O Jesus, my true Lord and God
> And was this semblance Thine?"[1]

Nearly 300 years later Michel de Montaigne (1533–1592), the French man of letters, could claim that, 'No other relic has such veneration paid to it. The people throw themselves down before it upon their faces, most of them with tears in their eyes and with lamentations and tears of compassion'.[2] This despite the fact that the relic being venerated was probably not the original: the Veronica had apparently been lost during the Sack of Rome by German Lutheran soldiers in 1527, when, according to one contemporary, it 'was passed from hand to hand in all the taverns of Rome'.

Considering the masses of pilgrims who came to see the image and the innumerable copies of it, it is perhaps surprising that we do not know what the Veronica actually looked like. Its original crystal frame preserved in the Vatican gives its measurements as 40 x 37 centimetres, but we can be certain of little else (fig. 22). The earliest accounts of the relic in the eleventh century do not mention an image at all and the 'copies' that proliferated from the thirteenth century differ considerably from each other even if they share a family resemblance. They show a long-haired, bearded man whom we still easily recognise as Jesus. But this version of Christ's face was well established before the

FIG 21 The Veronica displayed to pilgrims in Rome. *Woodcut illustration from the* Mirabilia Urbis Romae *(The Wonders of the City of Rome), c.1475. Munich, Bayerische Staatsbibliothek.*

1 *Paradiso*, canto XXXI, lines 103–108, trans. Cary.
2 Quoted in Thurston 1900, p. 273.

3 Quoted in Belting 1994, p. 543; see also Lewis 1986, pp. 126 ff. and plates 4–5.
4 Quoted in Hamburger 1998, p. 323.

Veronica came to be reproduced. In the same way it was the Veronica image that at least partly inspired the 'eye-witness' account of the appearance of Christ given in the 'Letter of Publius Lentulus', the Roman Governor of Judea, an influential literary forgery dating from the thirteenth or fourteenth century (cat. no. 40).

The compelling nature of the Veronica did not rest solely on its claim to be a true likeness of Christ, however. Dante's Croatian and Montaigne's pilgrims would have been especially anxious to see the Veronica because it brought with it a particular benefit in the shape of a Papal Indulgence: a guaranteed reduction in the time spent in Purgatory, the place or state in which the soul was purified after death so that it could enter Heaven. The Indulgence was not originally associated with the Veronica image itself but with prayers in its honour. In 1216, Pope Innocent III had written an office (a collection of hymns, texts and prayers) dedicated to the Veronica and established an Indulgence of forty days (or according to one source, ten days) for those who recited it. The Veronica was not the only Indulgenced relic in Rome, but crucially the Indulgence also attached itself to copies of the original, a fact that helps to explain the Veronica's wide dissemination. In 1245 the English chronicler Matthew Paris wrote that, 'Many have commended the prayer [to the Veronica] and everything connected to it to the memory and, to arouse more devotion in themselves, have illustrated it as follows', adding on the page a miniature of the face of Christ.[3] Other hymns to the Veronica followed (see cat. no. 37) and these too carried Indulgences whose value grew exponentially from Innocent's forty days to 10,000 days, to 10,000 years, and beyond. Those unable to go to Rome (and this included members of monastic communities who were discouraged from pilgrimage) were instead urged in the words of a German fifteenth-century Carthusian prayer book, to 'Go to Rome in spirit, [where] the face of Christ is shown as he wiped and pressed it against Veronica's cloth and large Indulgences and grace are dispensed'.[4] For these spiritual pilgrims, confined to their cloisters, copies of the Veronica brought with them benefits as great as the original.

The importance and popularity of the Veronica is easily described, but the history of the relic and the development of the legend are exceptionally difficult to reconstruct. The most familiar version of the Veronica story – in which she receives Christ's likeness on the road to Calvary – was not established until about 1300, when it was first written down in a French devotional text known as the Bible of Roger of Argenteuil. Earlier versions of the story identify Veronica with the woman who was cured of a haemorrhage by Christ (MATTHEW 9: 20–22), describing her receiving the image of Christ's face before his Passion and later using it to cure the Emperor Tiberius of a serious illness. According to an early Greek tradition the woman cured of a haemorrhage was called Berenike and it is from here that Veronica derives her name – the play on the words *vera icon* apparently no more (or less) than a happy accident.

The Veronica was the most famous 'True Image' of Christ known in medieval Europe, but it was not the only one. Three images, housed from the thirteenth and fourteenth

centuries in Paris, Genoa and Rome, each claimed to be the object known as the *Mandylion of Edessa* (cat. no. 41), which for centuries held a position in the Eastern Church similar to that which the Veronica came to have in the West. The legend of the Mandylion – the word means cloth – is considerably more ancient than that of the Veronica and the latter certainly borrowed elements from it.

The Mandylion was one of a number of miraculous images of Christ known as *acheiropoieton* – a Greek word meaning 'not made by human hand' – that appeared in sixth-century Byzantium. Their name makes clear that these images were deliberately distinguished from the human artefacts that were worshipped as idols by pagan cults. Their existence also came to be used by theologians to defend the use of religious imagery against the iconoclasts, those who wanted to do away with such images. If these images were divinely made, it was argued, then the making of representations of Christ was approved by God. Parallels were also drawn between the manner of their creation and Christ's mysterious conception in the womb of Mary.[5]

A number of images 'not made by human hand' claimed heavenly or angelic origins, but both the Mandylion and the Veronica had a more special status, for they claimed to have been created by physical contact with Christ himself. This made them both images and relics – tangible proof of Christ's historical existence as well as signs of his continuing presence in the world.

This supposed origin in direct contact with the body of Christ is of course shared by the miraculous image that has now eclipsed both the Mandylion and Veronica to become probably the most famous relic in Christendom, the Turin Shroud (figs. 23 and 30). This fourteen-foot length of cloth which is believed by many to be the Shroud in which Christ's dead body was wrapped and on which his image was mysteriously imprinted, has apparently been shown by Carbon-14 dating to have originated between 1260 and 1390. It was first recorded at the end of the fourteenth century when Pierre d'Arcis, Bishop of Troyes, wrote in fury to the Pope describing a cloth 'cunningly painted' which some clergy in his diocese were pretending was the true Shroud of Christ, 'not from any motive of devotion but only of gain'. From these unpromising beginnings the Shroud's reputation has steadily grown, receiving its biggest boost in 1898 when it was photographed. This revealed that it is as a 'negative' that the image on the Shroud appears most clearly – and it is indeed as a negative image that the Shroud is now most familiar. It is also the devotion afforded the Shroud today – both as a relic touched by Christ and as a 'true likeness' – that gives us the clearest glimpse of how the Veronica and Mandylion were once viewed and venerated. *AS*

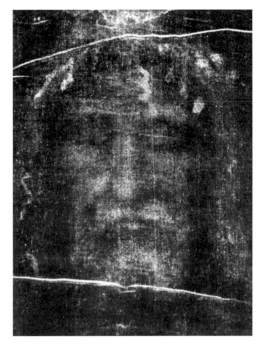

FIG 23 The Turin Shroud. *Detail of the face from a photographic negative made by Giuseppe Enrie in 1931.*

5 A poem by the seventh-century Byzantine, George the Pisidian, states:

> The *Logos* [Word], which forms and creates all, appears in the image as a form, without having been painted. He once took form without seed, and now without being painted, so that by both these forms of the *Logos* the faith in the Incarnation might be confirmed and the error of dreamers might be confounded.

From the poem, *The Persian Campaign* (AD 622), quoted in Belting 1994, p. 497. The image celebrated by George the Pisidian was not the Mandylion itself but another sixth-century image believed to have descended direct from Heaven, before being discovered in a well in the Capadoccian town of Kamuliana.

33 The Procession to Calvary, probably about 1505

Ridolfo Ghirlandaio (1483–1561)

Oil on canvas, transferred from wood, 166.4 x 161.3 cm.

London, National Gallery, NG 1143

THIS ALTARPIECE SHOWS the most familiar version of the Veronica story which, despite its subsequent popularity, only became established early in the fourteenth century. Veronica, a pagan woman, described as a virgin, witnessed Christ carrying the cross on the road to Calvary. Taking pity on him she wiped his face with a cloth. As a reward for her compassion Christ's features were miraculously transferred onto the cloth.

The subject of Christ carrying the cross was unusual as the principal scene of an altarpiece in Italy (although not in northern Europe) and this, together with the prominence given to Veronica and her veil, suggests that the painting may have been intended for a chapel dedicated to the Saint. She kneels in the foreground and receives the cloth from Christ's outstretched hand. Ghirlandaio has arranged the gestures in such a way that the miraculous image, while playing its role within the narrative, is also presented frontally; a picture within a picture. The cloth has been painted to appear gauze-like and translucent, an effect that has survived the evident wear of this painting. Also just visible are traces of blood trickling down Christ's forehead. The open eyes and full face on the cloth are in marked contrast to the lowered lids and perfect profile of the figure of Christ carrying the cross. It is surely deliberate that it is the miraculous image that engages most directly with the spectator, allowing for its contemplation divorced from its narrative surroundings. The profile view of the figure of Christ is unusual but might reflect a dependence on another 'True Likeness', the so-called Emerald Vernicle (see cat. no. 40).

There is one other figure looking out of the painting; the man with close-cropped hair on the left who, in a startling anachronism, has a gun slung over his shoulder. His face has the characteristics of a portrait – one of many in the painting if we are to believe the Renaissance biographer, Giorgio Vasari, who described this picture at some length in the 1550 edition of his *Lives of the Artists*. Vasari claimed that Ghirlandaio included a number of 'very beautiful heads taken from life and executed with lovingness', including portraits of Ridolfo's father – the leading fifteenth-century artist Domenico Ghirlandaio – and a number of friends and studio assistants. Distinguishing portrait heads in narrative paintings is always a tricky business but others that suggest the requisite degree of particularity are the figure in the black hat on the extreme right and the figure of the man taking hold of the cross, presumably intended to be Simon of Cyrene who helped Christ with his burden. In contrast the face of the grimacing helmeted soldier to the right of Christ appears to derive not from life but from a drawing by Leonardo da Vinci. Vasari tells us that the altarpiece was painted for the church of San Gallo in Florence, which was destroyed in 1529, and implies that it was one of Ridolfo's earliest important commissions. *AS*

34 Saint Veronica with the Sudarium about 1420

Master of Saint Veronica (active early fifteenth century)

Oil on Walnut, 44.2 x 33.7 cm.

Saint Veronica's halo is inscribed sancta veronica; *Christ's halo is inscribed* ihs. Xps. ihs. x. *(a repeated abbreviation for Jesus Christ).*

London, National Gallery, NG 687

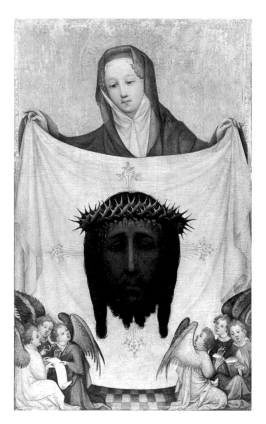

FIG 24 *Master of Saint Veronica,* Saint Veronica with the Sudarium, *c.1415. Tempera with traces of oil and resin on panel, 78.1 x 48.2 cm. Munich, Bayerische Staatsgemaldesammlungen, Alte Pinakothek.*

IN THIS SMALL PANEL by an anonymous Cologne artist of the early fifteenth century, Veronica is shown holding the *sudarium* in front of her. She is on a different scale to the miraculous image she presents for veneration and is clearly subsidiary. She appears not in any narrative context but almost as a mark of authenticity. By her presence she both identifies the image and, as the relic's first owner, provides visual 'proof' of its age and origin. She inclines her head and lowers her eyes directing attention towards the disembodied face of Christ. The way she holds up the cloth recalls how the *sudarium* would have been displayed to pilgrims in Rome (fig. 21), reminding those in front of the painting of the reality of the relic and the veneration due to it. Reinforcing the theme of veneration, two angels were punched into the gold background on either side of Veronica, but they are now barely visible.

Once removed from its narrative context the Veronica had several different meanings. It came to stand for Christ's continuing presence – suggested by the physical reality of the relic itself – and, by extension, the continuing presence in the world of Christ's body in the Eucharist. In a fifteenth-century German prayer book a miniature of the Veronica holding the *sudarium* exactly as in this painting accompanies prayers to be said at the elevation of the Host – the moment in the Mass when the consecrated Host is shown to the congregation.[1]

The painter of this panel is known as the Master of Saint Veronica but is named not after this painting, but after another one of the same subject now in Munich (fig. 24). The similarities between the two in arrangement and style are clear and extend to the similarly punched borders in the gold background. It is the differences between the images that are most intriguing: in the National Gallery painting the frame cuts the figure of Saint Veronica off just below the knee, making her physically more substantial and bringing her closer to the picture plane than in the Munich version. The conceit of the cloth being thrust out of the painting towards us is enhanced by Veronica's fingers, which project over the edge of the gilded and punched border. What is more, Christ's face with its gilded halo (absent in the Munich version) appears to float free of the cloth. In the Munich painting Christ is dark-faced and wears the crown of thorns, in contrast to his 'perfect' and untroubled features in the National Gallery picture. It is tempting to see this as reflecting the contrast between the two most popular Indulgenced prayers associated with the Veronica: on the one hand, the early fourteenth-century *Salve sancta facies* (Hail, holy face) which speaks of the 'vision of divine splendour which was imprinted on the white cloth' (cat. no. 37), and on the other, the thirteenth-century *Ave facies praeclara* (Hail, splendid face) which dwells on a countenance 'darkened by fear and stained with holy blood', which it calls the 'standard of compassion'. *AS*

1 Hamburger 1998, fig. 7.19, p. 335.

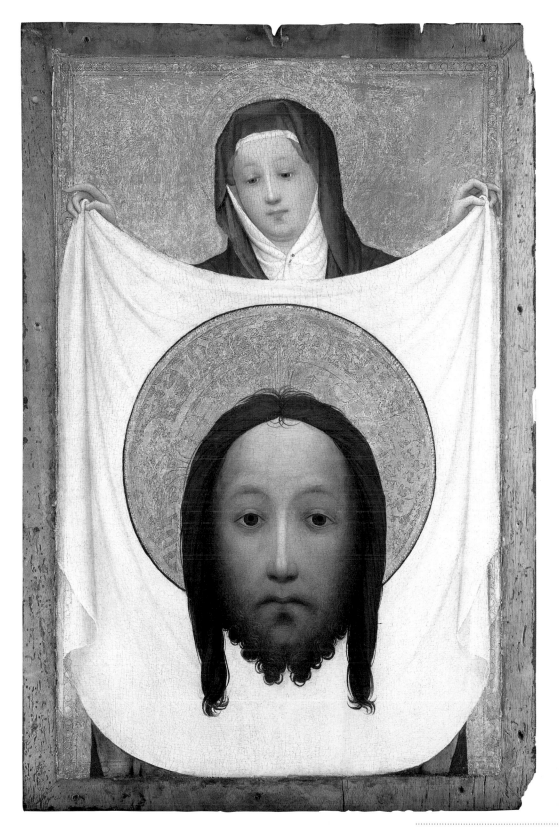

35 Two Angels Holding the Veronica, 1513

Albrecht Dürer (1471–1528)

Engraving, 102 x 140 mm.

Signed with monogram and dated 1513

London, British Museum, E.4–98

FIG 25 Two Angels holding the Veronica and the Arms of Pope Sixtus IV, *Woodcut illustration from the* Mirabilia Urbis Romae, c.1475. *Munich, Bayerische Staatsbibliothek.*

Ⓘ N THIS ELABORATE ENGRAVING the German Renaissance master, Albrecht Dürer has removed Veronica's veil both from its narrative context and from Veronica herself. He shows it instead displayed by two angels, in a manner similar to its heraldic presentation in an illustration from a fifteenth-century guidebook to the marvels of Rome (fig. 25). Although the Veronica is presented 'out of time', the print clearly encourages an emotional and empathetic response and is intended to act as an aid to the contemplation of Christ's suffering and sacrifice. Christ stares out from under the crown of thorns with a pained expression, as blood trickles down his forehead. More significantly the angels do not merely present the image but respond to it with faces and gestures of extreme grief, directing the viewer's devotional response.

Dürer had already included an image of the Veronica in his 'Small Passion' (cat. no. 56), where it is also divorced from any narrative context and is held between Saints Peter and Paul, the two Saints of Rome where the relic itself was kept. The print shown here was produced the year after Dürer's so-called 'Engraved Passion' of ten scenes, with which it shares its dark background. Although clearly independent of that Passion series, and different in size and format, thematically this print has been seen as its concluding and crowning illustration.

The Veronica image seems to have had a particular significance for Dürer and he made a number of versions of the subject. A drawing by him in green ink of 1515 is in the *Prayer Book of the Emperor Maximilian,* and an engraving of the Veronica held by an angel dates from the following year. In his diary of 1520, recording his travels in the Netherlands, he mentions a number of images of 'Veronica's face' he distributed as gifts, including two impressions of the present engraving and four, presumably small, paintings. There may also have been a more elaborate painting of about 1500 known from a description and drawing dating from some hundred years later. [1]

Dürer's most startling response to the Veronica was, however, his own self-portrait of 1500, now in Munich, in which he presented himself full-face with Christ-like beard and hair, in apparent emulation of the Veronica. The implications of this have been the subject of considerable discussion. [2] Among other things, Dürer may have intended to suggest that like the miraculous Veronica image of Christ, his self-portrait was a true likeness, an entirely faithful record. It has often been noted that even in this engraving of 1513, Christ's features, which stand out from the cloth and the page almost like relief sculpture, bear a resemblance to Dürer's own. *AS*

1 Koerner 1993, p.92.

2 See especially Koerner 1993.

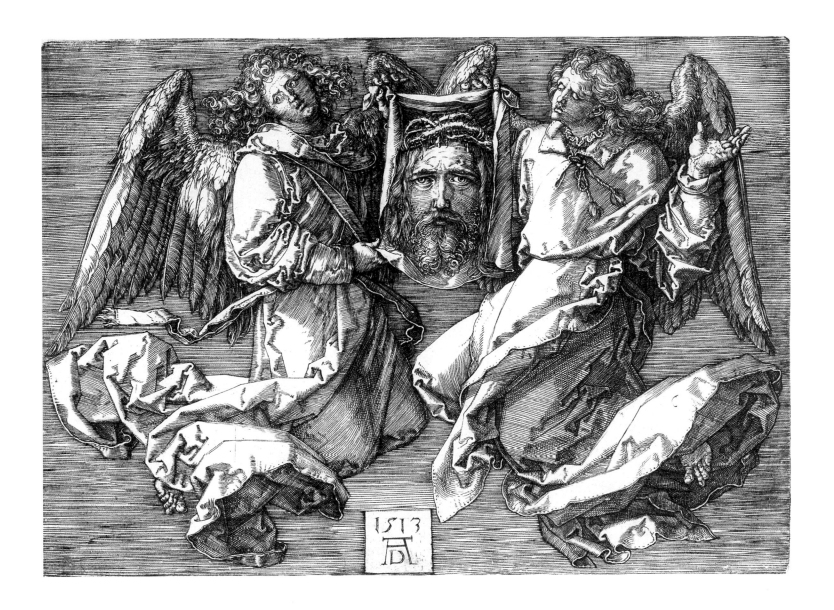

36 The Veil of Saint Veronica, about 1635

Francisco de Zurbarán (1598–1664)

Oil on canvas, 70 x 51 cm.

Stockholm, Nationalmuseum, NM5382

THE SPANISH PAINTER Zurbarán's imaginative recasting of the image of the Veronica survives in a number of versions, some of which are the work of his assistants and collaborators.[1] This painting from Stockholm is perhaps the finest of the surviving examples, but they all share its essential features. It is a masterpiece of illusionistic painting, a *trompe l'oeil* in which the cloth appears to hang, pinned to the surface on which it is actually painted. The cloth is tied at its top corners to hang from two pieces of string, while two pins on its central axis raise its bottom edge and form a gable over Christ's face. Although the degree of Zurbarán's illusionism was new, he was not the first artist to attempt to paint the Veronica image in this way: El Greco set a notable precedent. Indeed the very nature of the *sudarium* as both object (a piece of cloth) and image (the face of Christ) encouraged this kind of depiction.

Zurbarán's originality lies in the way in which he has shown the face on the cloth. He has abandoned the traditional appearance of the Veronica image – full face and colourful and often seeming to hover in front of the cloth itself. Instead, in a remarkable piece of imaginative reconstruction, he has attempted to show what the legend describes – a cloth on which the features of the suffering Christ have been miraculously imprinted. This is no small development, for the familiar Veronica images claimed to be a record of Christ's true likeness as preserved on the *sudarium* in Rome. In abandoning the iconic version of the image, Zurbarán chose to ignore the significance of the *sudarium* as a true likeness and instead to treat it as a physical relic of Christ's Passion and an aid to empathetic meditation. Zurbarán's depiction of Christ's face indeed derives less from earlier images of the Veronica than images of Christ on the road to Calvary – a fact confirmed by the curious three-quarter view which makes no logical sense as the impression that would be left by pressing a cloth to a face. Christ's mouth is open, recalling the moment when he turned to the grieving women on the road to Calvary to say 'Daughters of Jerusalem, weep not for me' (LUKE 23: 28), a scene which is often illustrated.

The intense emotional involvement elicited and encouraged by images such as Zurbarán's in seventeenth-century Spain is suggested by the account of Juan Acuña de Adarve describing a nun's experience in front of a Veronica: 'One day, during Holy Week, having flagellated with iron chains as was her custom, and having prostrated herself before the Veronica, she said: "Oh! Gentle Jesus, I beg you Lord, in the name of your Holy Passion, allow me through the taking of my vows to be your bride, so that once liberated from the things of this world I may devote myself more entirely to You, Saviour of my soul". Having uttered these words, the Veronica was transformed, becoming the beautiful face of Our Lord Jesus Christ, as lifelike as sinful mortal flesh and bones. And such were her words at the sight of our Saviour, such her tears, her lamentations and torment born of so much love, that the Lord himself comforted her, promising to take her as his bride … Having spoken thus, the Veronica returned to its former shape'.[2] *AS*

1 Gállego/Gudiol 1976, nos. 554–563; Stoichita 1991.
2 Quoted in Stoichita 1995, pp. 63ff.

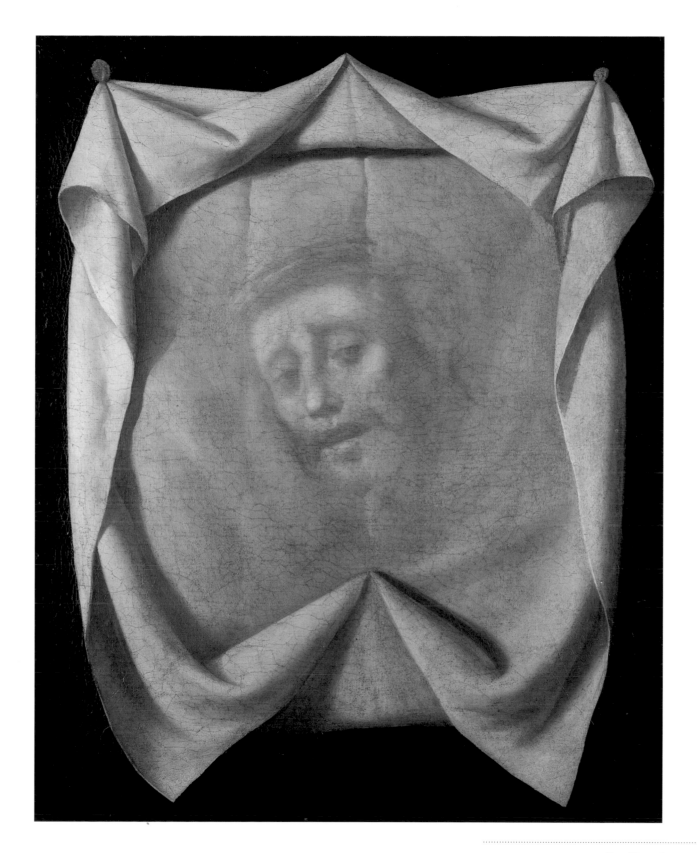

37 Portrait of a Young Man, 1450–60

Petrus Christus (active 1444; died 1475/6)

Oil on oak, 35.5 x 26.3 cm.

London, National Gallery, NG 2593

THIS PORTRAIT BY THE fifteenth-century Netherlandish painter Petrus Christus shows how the image of the Veronica entered people's homes and how it might have been displayed and used by the devout. On the wall behind this unidentified young man is a sheet of parchment tacked onto a wooden board and framed with a strip of red tape. The tape has broken at the bottom right hand corner where the parchment is shown curling away from the board. At the top of the sheet is an illumination of the face of Christ with the Greek letters Alpha and Omega above it. Below, in two columns are the legible, if worn, words of the prayer 'To the holy Veronica' known as the *Salve sancta facies* or 'Hail, holy face'.

Incipit or[ati]o ad s[an]c[t]am V[ero]nica[m.]

Salue sa[n]cta facies
Nostri rede[m]ptoris
in q[ua] nitet (spec?)ies
Di[vi]ni splendoris
Imp[re]ssa paniculo
Niuei coloris
Data q[ue] Veronice
Signu[m] ob amoris(.)
Salue n[ost]ra gloria
In hac vita dura
Labili q[ue] fragili
Cito transitura
Nos p[er]duc ad p[at]riam
Ofelikx figura
Ad videndu[m] faciem
Que est xpi pura(.)

Salue o sudariu[m]
Nobile iocale
Es n[ost]r[u]m solaciu[m]
Et memoriale
Non depicta ma[n]ibus
Scolpta vel polita
Hoc scit su[mmus] Artifex
Qui te fecit ita(.)
Esto nobis q[uae]sim[us]
Tutu[m] adiuuame[n]
Dulce refrigeriu[m]
Atq[ue] [c]o[n]solamen
Vt nobis no[n] noceat
Hostile grauamen
Se[d] fruamur requie
Dicam[us] o[m]nes Ame[n].

Explicit

Beginning of the Prayer to the Holy Veronica. Hail, Holy Face of our Redeemer, in which shines the vision of divine splendour that was imprinted on the white cloth given to Veronica as a token of love. Hail, our glory in this hard life – fraught, fragile and soon to be over – lead us, wonderful image, to our true homeland, that we may see the face of Christ himself. Hail, Sudarium, excellent jewel, be our solace and reminder. No human hand depicted, carved or polished you, as the heavenly Artist knows who made you as you are. Be to us, we beg, a trusty help, a sweet comfort and consolation, that the enemy's aggression may do us no harm but we may enjoy rest. Let us say together Amen. End.

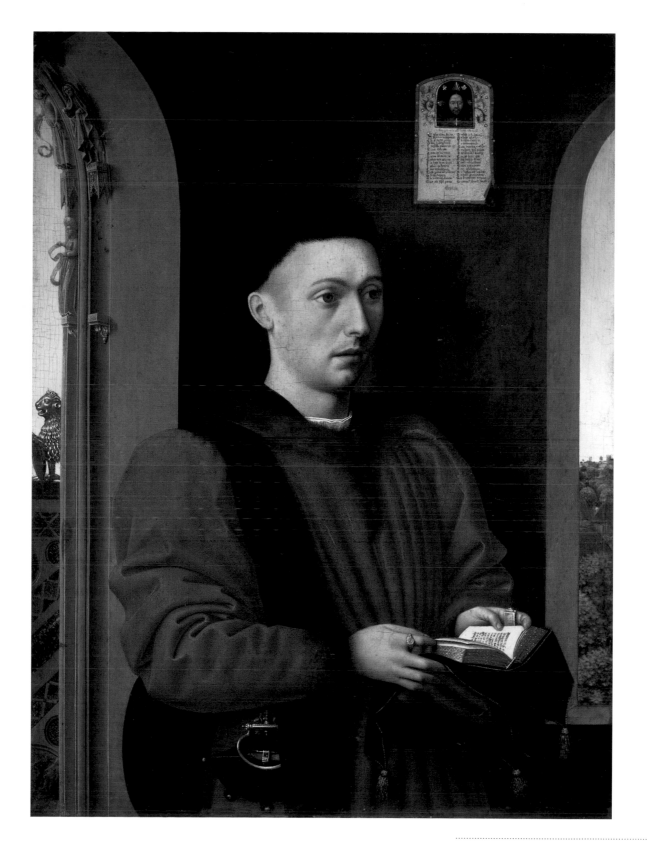

The prayer, which is given in abbreviated form, is the most famous of those associated with the Veronica image. It is usually attributed to an anonymous author writing during the papacy of John XXII (1316–1334), but sometimes to the Pope himself. The prayer was of particular importance as one of those that carried with it an Indulgence – a remission from time spent in Purgatory – for those who recited it in front a depiction of the Veronica. The emphasis of the prayer is reflected in the type of 'holy face' shown in Christus's painting. Christ is depicted without the crown of thorns and, although the prayer was written after the establishment of the Veronica story within the Passion narrative, it concentrates on the 'divine splendour' of the 'wonderful image', rather than its role as a reminder of Christ's suffering. In Christus's painting the Greek letters Alpha and Omega – the beginning and the end – above the face emphasise Christ's abiding presence just as the prayer anticipates the moment at the Last Judgement when the elect may see 'the face of Christ himself', recalling the famous words of Saint Paul to the Corinthians: 'For now we see through a glass darkly but then face to face' (1 CORINTHIANS 13: 12). *AS*

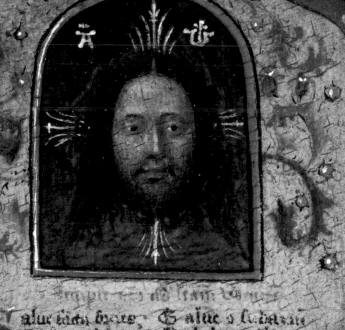

38 The Face of Christ, late fifteenth century

German/Netherlandish

Papier-mâché, painted, 19 x 15 x 5.5 cm.

Utrecht, Museum Catharijneconvent, INV. ABM
V 279

THIS PAPIER-MÂCHÉ FACE of Christ is not strictly a Veronica, although it clearly derives from Veronica images. It may originally have been shown in front of a cloth, but the only indications as to its original display are a number of small holes on the reverse at the top suggesting it was hung from a thread, as it still is today. The image focuses on Christ's suffering: blood is painted dripping down the brow from the prominent thorns of his crown. It differs from most representations of the Veronica image in showing Christ with closed eyes.

Fragile and damaged, this is a rare survivor among similar Veronica-related objects which were produced cheaply and were widely available in fifteenth-century Europe. Such objects illustrate the extent to which the devotion to the 'Holy Face' permeated all levels of society. Another comparable papier-mâché head is recorded in a private collection in Wiesbaden, Germany.

Encouraged by the Devotions and Indulgences attached to the image, the Veronica was copied, imitated and adapted in a variety of different ways in the fifteenth century. These included prints and pilgrim badges and led to the establishment of specialised groups of artists and merchants – the *pictores Veronicarum* (Veronica painters) and the *mercanti di Verniculi* (Vernicle vendors) – dedicated exclusively to the production and sale of Veronica-related images. *AS*

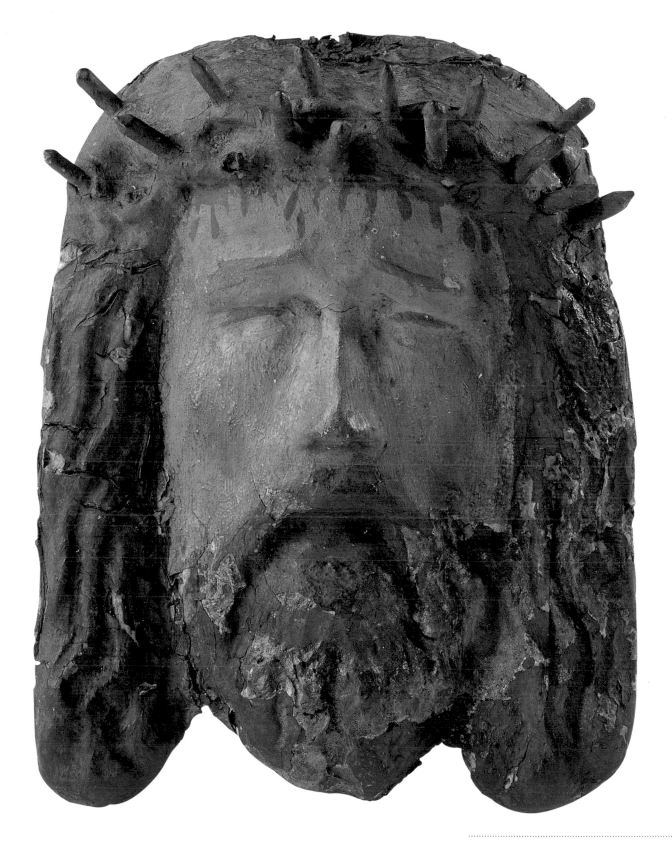

39 The Veil of Saint Veronica, 1649

Claude Mellan (1598–1688)
Engraving, 430 x 306 mm.
Signed: MELLAN G. P. ET F. IN ÆDIBUS
REG. / 1649 *(Mellan, engraved, designed*
and made it in the royal palace. 1649)
On the hem of the veil: Formatur Unicus
Una / Non Alter

London, The Strang Print Room, University
College, INV. 1557

THE FACT THAT THE Veronica was a miraculous image, an exact replica of Christ's face not made by any artist's hand, made it an object of particular interest for artists themselves. It is this aspect of the Veronica that must have suggested it as the subject for this near miraculous print. Astonishingly, the image is conjured from one single line which starts at the tip of Christ's nose and then, varying in thickness, spirals outward to the edge of the page. How the French painter and engraver, Claude Mellan, made the print was described by his earliest biographer, Claude Augustin Mariette: having first placed the point of his burin (the engraver's cutting tool) at the centre of the copper plate he engraved a single slightly undulating spiralling line – although because the plate is rectangular rather than circular, the line is in fact broken at the corners. He then drew the design onto the plate itself and, using this as his guide, strengthened and widened the line as necessary to produce the finished image, including the inscriptions at the bottom.

Shown as if written on the hem of the veil itself are the words '*Formatur Unicus Una*' (the unique one made by one), and below them, and the veil, the further inscription '*Non Alter*' (no other). Both short epigraphs were devised by Michel de Marolles, Abbé de Villeloin (1600–1681), a voracious collector of prints, who, in 1667, sold his collection of 123,000 works to King Louis XIV for over 50,000 *livres*. Marolles had his portrait made by Mellan a year earlier in 1648 and later in his memoirs he laboured the point that his inscriptions were intended to refer as much to Mellan's artistry as to the print's subject: '*Formaturque* [*sic*] *unicus una* alludes to the beauty of the only son of the Eternal Father, born of a Virgin, and to the single spiralling line … *Non alter*, because there is no one else who looks like [Christ] and because the engraver of this image had produced such a masterpiece, that anyone else would have great difficulty equalling his achievement'.[1] The challenge implied by the words *Non alter* were possibly the spur for at least five copies from the seventeenth and eighteenth centuries, which all omit this phrase. The original copper-plate for Mellan's print survives in the Brussels Royal Collection.

Mellan's print unequivocally demonstrates his printmaking skills but it also testifies, like Zurbarán's painting (cat. no. 36), to the continued popularity of the Veronica image in the seventeenth century. It is interesting that he made the print the year before the Holy Year, or Jubilee, of 1650 in whose celebrations in Rome the display of the *sudarium* had always played a central role. In a number of the medals cast by Innocent X in 1649 to celebrate the impending Holy Year, the *sudarium* is shown hanging in the Holy Door of St Peter's basilica, which was ceremonially opened at the beginning of a Holy Year. *AS*

1 Quoted in Paris 1988, p. 121.

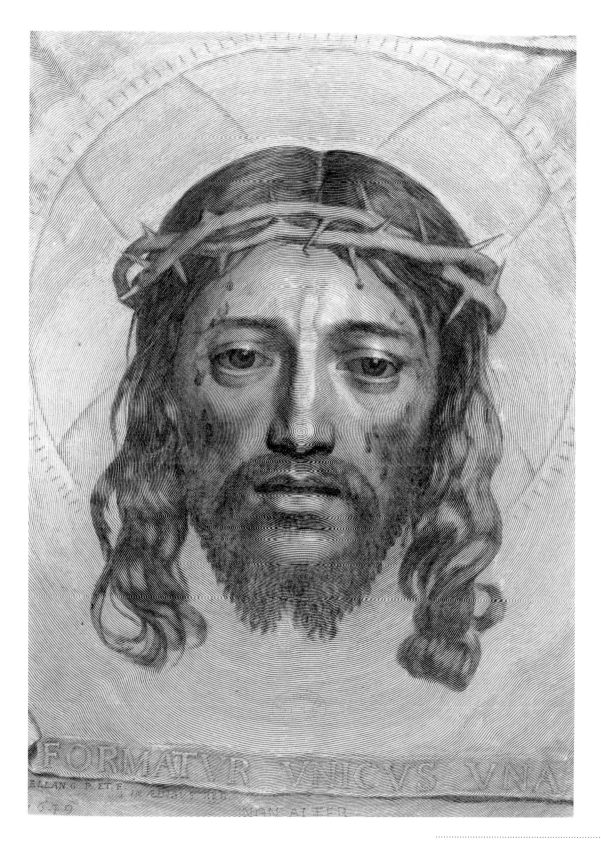

FORMATVR VNICVS VNA

ELLAN ... P. ET F. ... IN ÆDIB. ...

NON ALTER

40 Diptych with the Head of Christ and the Lentulus Letter, late fifteenth- or early sixteenth-century

Southern Netherlandish

Oil on wood, 38.5 x 27.3 cm.

Utrecht, Museum Catharijneconvent, INV. BMR S 2

1 Temporibus octauiani Cesaris cum ex uniuersis mundi partibus. hii qui pro senatu populoq(ue) romano preerant proui(n)ciis, scriberent senatoribus qui rome erant. novitates que occurrebant per mu(n)di climata. publius lentulus in Iudea preses senatui populoq(ue) romano. Ep(isto)lam hanc misit cuius (?) verba hec sunt videlicet Apparuit temporibus n(ost)ris et ad huc est homo magne virtutis. Cui nomen est Cristus Jhesus. qui dicitur a gentibus propheta veritatis. quem eius discipuli vocant filiu(m) dei. suscitans mortuos. et sanans languores. homo quidem statura procerus. et spectabilis. vultum habens venerabilem. quem intuentes possunt diligere et formidare. Capillos habens [coloris] nucis auellane (?) p(re)mature. et planos fere usq(ue) ad aures. Ab aurib(us) vero crispos aliqua(n)tulum. ceruliores. et fulgentiores ad humeris uentilantes. discrimen habens in medio capitis. iuxta morem nasarenoru(m). frontem planam. et serenissima(m). In facie sine ruga et macula aliqua. qua(m) rubor moderatus venuscat. Nasi et oris multa prors(us) (com)prehensio. Barbam ip(si)us copiosam et capill(is) concolorem. non longa(m). sed in m(e)dio (?) bifurcata(m). aspectu(m) simplice(m) et maturu(m). ocul(is) glaucis et claris existe(n)tib(us). In repatio(n)e terribilis. et ammonitione placid(us) et amabil(is). ylaris servata gravitate. qui nu(m)q(uam) vis(us) e(st) ride(re). flere aute(m) sit. in statura corporis p(ro)pagat(us) et rect(us). man(us) h(abe)ns et brachia visui delectabilia. In colloquio quibus (?) rarus. et modestus. Speciosus forma p(re) filiis homi(num). Hec ep(isto)la in annalibus romanorum comperta est.

2 On the Lentulus Letter, see Dobschütz 1899, pp. 308–330.

THE LEFT-HAND PANEL OF this Netherlandish diptych contains the text of the letter said to have been sent by Publius Lentulus, Governor of Judea, to Octavius Caesar. It apparently relates an eye-witness description of the appearance of Jesus Christ:

> In the time of Octavius Caesar, when those men who governed the provinces on behalf of the senate and people of Rome, wrote from every part of the world to the senators in Rome with news of events happening throughout the world, Publius Lentulus, the governor in Judea for the Roman senate and people, sent this letter, the words of which now follow:

> There appeared in these times and there still is a man of great virtue, called Jesus Christ, who by the people is called a prophet; but his disciples call him the Son of God. He raises the dead and cures all manner of diseases; he is somewhat tall in stature and has a comely and reverend countenance, such as the beholders both fear and love. His hair is the colour of an unripe hazelnut, and is smooth almost down to his ears, but from thence downward, is somewhat curled, darker and shinier, waving about his shoulders; with a parting in the middle of his head in the manner of the Nazarenes. His forehead is very plain and smooth. His face without either wrinkle or spot, beautiful with a comely red; his nose and mouth so formed that nothing can be reprehended. His beard is full, of the same colour of his hair, not long, and forked in form; simple and mature in aspect; his eyes, blue-grey, clear and quick. In reproving he is severe; in counselling calm and gentle. Light-heartedness is restrained by gravity; he is never seen by anyone to laugh, but often seen by many to weep; in proportion to his body, he is well shaped and straight, and both arms and hands are very delectable. In speaking he is very temperate, modest and wise. A man, for singular beauty, far exceeding all the sons of men. This letter was found in the records of the Romans.[1]

The so-called Lentulus Letter is the most famous of the literary descriptions of Christ's appearance.[2] It claims to have been written by an eye-witness, Publius Lentulus, the governor or pro-consul of Judea, supposedly (although not in fact) Pilate's predecessor. The description first appears, but not under the name of Lentulus, in fourteenth-century manuscripts and the account probably dates from that or the previous century. The description therefore follows the traditional way of depicting Christ and was presumably written while looking at such an image. This makes assessing its impact on artists' representations difficult to judge. Indeed with the exception of the details relating to the colour and style of Christ's hair and eyes, the letter gives few specifics that would be of any use to someone actually constructing a portrait.

The popularity of the letter in the fifteenth century and beyond reflects a growing interest in the historical Jesus. In 1500 Pope Alexander VI sent a lavishly illuminated text of the letter to Frederick the Wise, Elector of Saxony, and there was a proliferation of

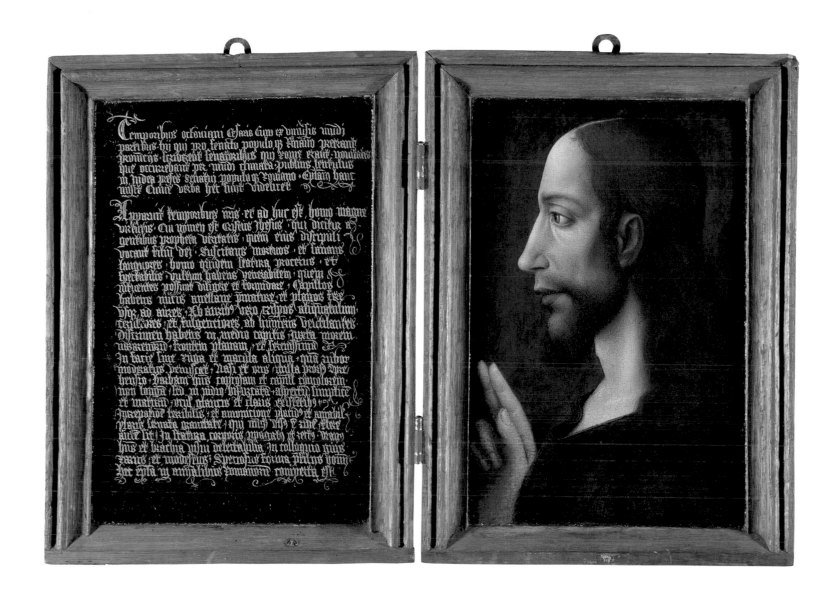

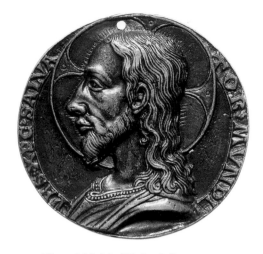

FIG 26 Portrait Medal of Christ, *Italian,
c.1490s. Bronze, diameter 86 mm. Private
collection.*

FIG 27 *Hans Burgkmair,* Head of Christ
and the Lentulus Letter, *c.1515. Engraving,
diameter of the medallion 111 mm. Munich,
Staatliche Graphische Sammlung.*

3 On the Emerald Vernicle, see King 1870, pp.
 181–90; Hill 1920; Shearman 1972, pp. 50–51;
 Tudor-Craig 1998, pp. 8–10.
4 Royal Collection, on loan to the Victoria and
 Albert Museum.

manuscript and printed versions of the letter in northern Europe around this time, when this diptych was also painted. The popularity of the letter coincided with scholars' attempts to renew the faith by returning to other original sources, such as the Hebrew and Greek Bibles and the writings of the early Church Fathers.

In this diptych the text of the letter is paired with a portrait of Christ that also had claims to historical authenticity. It derives from a then celebrated 'true likeness' that had only recently become known in the West. This was the profile of Christ carved onto an emerald which had come from the Treasury of Constantinople.[3] It had been among the gifts, which also included the head of the lance that had pierced Christ's side, given to Pope Innocent VIII in or around 1492 by the Sultan Bajazet II, in return for the Pope keeping the Sultan's brother, Djem, imprisoned in the Vatican. The gem, which also bore a portrait of Saint Paul, no longer survives, but its impact when it arrived in Rome was immediate. It was reproduced in a number of bronze medals dating from the end of the fifteenth-century (fig. 26). These in turn influenced artists' representations of Christ, most famously Raphael's in the tapestry cartoon of the *Miraculous Draught of Fishes*,[4] but also possibly Ghirlandaio's in his *Procession to Calvary* (cat. no. 33). The image of Christ in profile remained popular throughout the sixteenth century and beyond, and is found for example on the reverse of portrait medallions of Pope Pius IV (1555–59) and Sixtus V (1585–90), as well as on a medal celebrating the canonisation of Ignatius Loyola in 1622.

The combination of letter and image is not unique to the diptych. It is found in two prints by the German engraver Hans Burgkmair, one of about 1511 and another of about 1515 (fig. 27), although in both the text differs slightly from the present example – indeed in the earlier of the two prints, the letter, which is given in both Latin and German, is attributed to Pilate rather than Lentulus. The popularity of both image and letter at the beginning of the sixteenth century make their combination unsurprising, but did create problems for the artist. The Lentulus description, with its forked beard and centre parting is clearly better suited to a full-face representation. Here the insistent parting (absent from the medallion images) shows the artist responding to the description in the letter. This makes it even more surprising that Christ's eyes, described as blue-grey in the letter, are clearly brown in the painting. *AS*

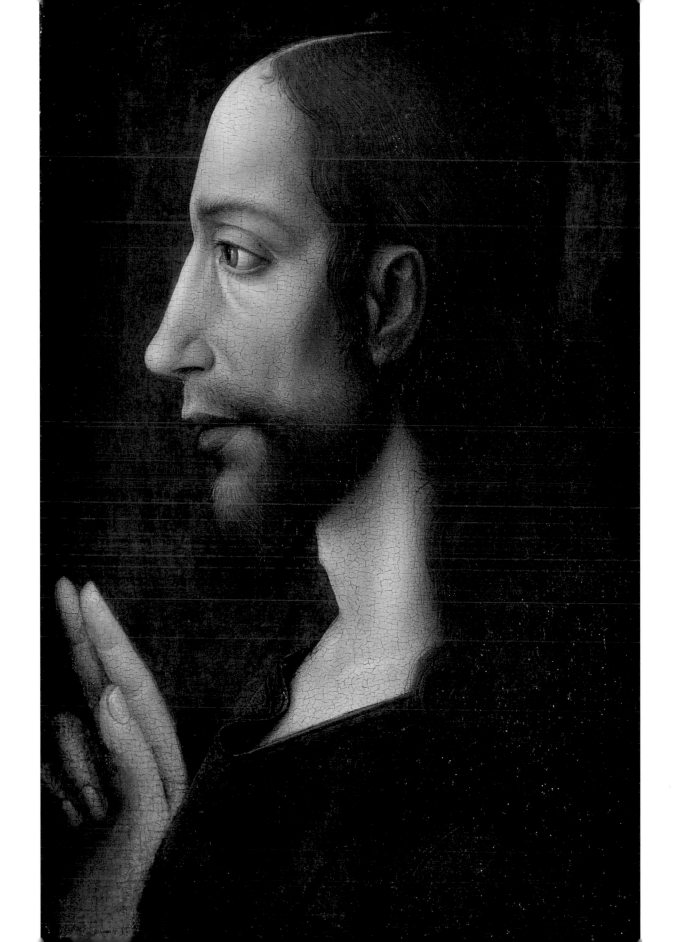

41 Icon of the Mandylion of Edessa, eighteenth century

Perhaps made in Italy

Egg tempera with resin glazes on wood, 40 x 32 cm.

In the cross of Christ's Halo: O ω N *(I am)*

Beneath Christ's Face: ΤΟΝ ΑΓΙΟΝ ΜΑΝΔΗΛΙΟ *(sic) (The Holy Mandylion)*

For translations of the inscriptions beside each scene, see illustration captions.

Hampton Court, The Royal Collection Trust, INV. HC 1567 403934

1 In its earliest version, found in Eusebius's *Church History* (c.325), Abgar receives a letter but no image from Christ. An image – a portrait from the life rather than a miraculous one – is first mentioned in the document known as the *Doctrine of Addai*, which probably dates from about AD 400. But it is in the sixth century, in the aftermath of the image's miraculous intervention in the war against the Persians, that the portrait of Christ is first described as 'divinely wrought … which the hands of men did not form'. Evagrius (c.536–600) *Church History*, 4. 27.

2 Wilson 1978, p. 238.

3 Ibid., p. 239.

4 Ibid., p. 242.

5 Ibid., p. 244.

FROM THE SIXTH TO THE EARLY thirteenth century the most famous miraculous image of Christ 'not made by human hands' was not Veronica's *sudarium* but the Mandylion of Edessa, which from AD 944 until 1203 was housed in the Imperial Treasury of Constantinople. This eighteenth-century icon from the Royal Collection not only reproduces the Mandylion image itself, but it illustrates episodes from the Mandylion legend.

All ten scenes around its border are accompanied by a Greek inscription, and have as their source the *Story of the Image of Edessa* written shortly after the image was transferred to Constantinople from Edessa (modern Urfa in Turkey, near the Syrian border) in 944, although elements of the legend can be traced back as far as the fourth century.[1] The legend, as recounted in the tenth century, tells of Abgar, King of Edessa during the time of Christ, who was afflicted with arthritis and leprosy. On hearing of Christ's reputation as a healer, he sent him a letter inviting him to come to Edessa. Abgar sent the letter with his servant Ananias and told him 'that if he was not able to persuade Jesus to return to him by means of the letter, he was to bring back to him a portrait accurately drawn of Jesus's appearance'.[2] On arrival in Judea, Ananias tried to draw Jesus, but Jesus called him over and gave him a letter declining Abgar's invitation but promising that the King would be cured. 'The saviour then washed his face in water, wiped off the moisture that was left on the towel that was given to him, and in some divine and inexpressible manner had his own likeness impressed on it'.[3] Ananias returned with both image and letter to Abgar who was cured and converted. To demonstrate his devotion to the portrait, Abgar then destroyed 'a statue of one of the notable Greek Gods' that had stood at the main gate of the city replacing it with the miraculous image'.[4] This part of the legend is depicted in the first six scenes around the icon.

The following three scenes relate to the re-discovery of the image in the sixth century. According to the legend, Abgar's descendants returned to paganism, and the sacred image on the city gate was hidden behind a tile and bricked in. It remained hidden and forgotten until the city was besieged by the Persians who tunnelled under the city walls. In a vision Eulalius, Bishop of Edessa, was told where the image was concealed. He found it intact with a lamp still burning in front of it and 'on the piece of tile which had been placed in front of the lamp to protect it he found that there had been engraved another likeness of the image'.[5] The Bishop then took the still-burning lamp and dripped oil from it in to the Persians' tunnel, killing them all and saving the city.

The final scene on the icon – at the bottom right hand corner – relates to a miracle during the journey of the miraculous image from Edessa to Constantinople in 944. By this time Edessa was under the control of the Muslim Empire and the Christian Emperor in Constantinople secured the Mandylion in return for the release of 200 Muslim prisoners and 12,000 pieces of silver.

Although the subject of this painting is easily recounted, it is far less certain when, where, or why it was produced. It has been attributed to the seventeenth-century Cretan

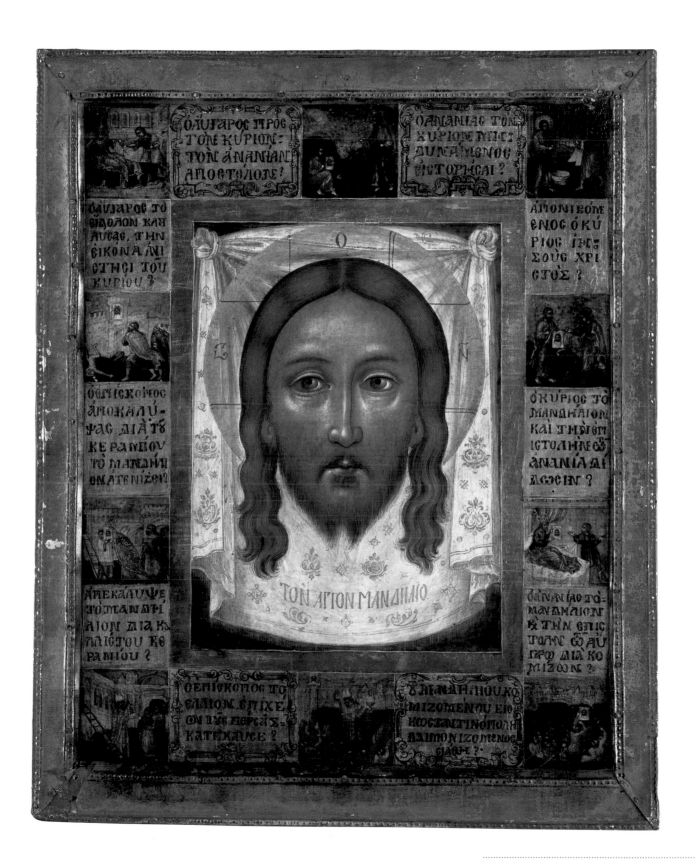

FIG 28 *In Eastern Orthodox countries the Mandylion image was used as a military banner as late as the twentieth century, as documented in this photograph of Bulgarian soldiers in the First World War. (London, The Imperial War Museum)*

FIG 29 *The Holy Face (The Mandylion), canvas fixed to panel with silver casing. c. 40 x 29 cm. S. Bartolomeo degli Armeni, Genoa.*

painter, Emmanuel Tzanes, who worked in Venice,[6] but this is no longer accepted and the icon probably dates from the following century.[7] It seems to be a free copy of the Mandylion image that is preserved at the Barnabite Monastery attached to the Church of S. Bartolomeo degli Armeni in Genoa (fig. 29). The Byzantine Emperor John V presented this strikingly archaic image to Leonardo Montaldo, the Captain of the Genoese colony on the Bosphorus, who in turn left it to the Monastery in 1384.[8] The Genoese picture is one of three Mandylion images that were claimed as original during the Middle Ages. Another, in the Sainte-Chapelle in Paris, was lost during the French Revolution, while the third, identical in size and very similar in appearance to the Genoa image, is now preserved at the Vatican, having belonged to the nuns of the order of Saint Clare in the Convent of S. Silvestro in Capite until 1870. Unlike the Vatican version, and indeed unlike other versions and copies of the Mandylion icon, the Genoese example has ten small scenes running around the silver gilt frame of the panel. These are identical in subject and arrangement to those on the Royal Collection icon and the inscriptions differ only very slightly.[9] This makes it highly likely that this icon was copied from the one in Genoa, or from a copy of that one. The icon was therefore probably painted in Italy, although the use of egg tempera as a medium, which was still employed by Byzantine icon-painters at this date, suggests a Greek artist. There is, however, a curious error in the Greek inscription beneath the face of Christ, which reads: ΤΟΝ ΑΓΙΟΝ ΜΑΝΔΗΛΙΟ rather than the correct ΤΟ ΑΓΙΟΝ ΜΑΝΔΗΛΙΟΝ (The Holy Mandylion). *AS*

SCENE 1 *Abgar sends Ananias to Jesus.*

SCENE 2 *Ananias is unable to draw Jesus.*

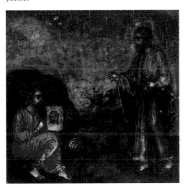

SCENE 3 *Jesus wipes his face.*

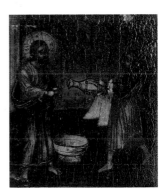

SCENE 4 *Jesus gives the Mandylion and the letter to Ananias.*

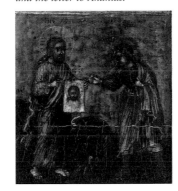

SCENE 5 *Ananias takes the Mandylion and letter to Abgar.*

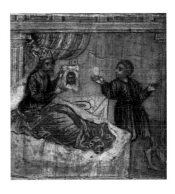

SCENE 6 *After Abgar has put down the idol he sets up the icon of Jesus.*

SCENE 7 *Having revealed the Mandylion behind the tile the Bishop looks upon it.*

SCENE 8 *He reveals the Mandylion on the most beautiful tile.*

SCENE 9 *The bishop burns the Persians by pouring the oil.*

SCENE 10 *As the Mandylion is carried to Constantinople a possessed man is healed.*

Scenes depicting the legend of the Mandylion. The captions are translations of the Greek inscriptions.

6 Cust/Dobschütz 1904.
7 Drandakis 1974.
8 Dufour Bozzo 1974 and in Kessler 1998.
9 Other narrative cycles relating to the Mandylion image found in manuscripts make a different selection of scenes. For example, Paris, B.N., Cod. gr. 1528, folios 181v and 182r; Moscow Historical Museum, Cod. 382, folio 192v; New York, Pierpont Morgan Library, Cod. 499. All these are discussed in Weitzmann 1971, pp. 231–46.

42 The Ostentation of the Holy Shroud of Turin, 1689-90

Pietro Antonio Boglietto, active late seventeenth century
Engraving on silk, 28 x 20 cm.
Sherborne Castle, Dorset, Mr John Wingfield Digby

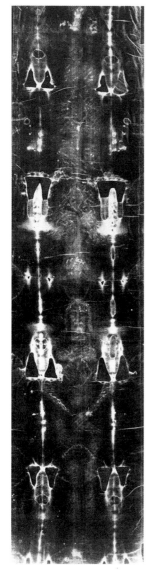

FIG 30 *Photographic negative of the Turin Shroud, photographed by Giuseppe Enrie in 1931.*

T HE PRINT RECORDS ONE OF THE periodic Ostentations, or public displays, of the Turin Shroud. Five bishops hold up the fourteen-foot cloth for veneration. The inscription below states that it is 'The True Portrait of the Most Holy Sudarium', the name sometimes used to describe the cloth in which Christ was laid in the tomb.

The Shroud was the most treasured relic of the House of Savoy, rulers of Piedmont in northern Italy and subsequently of a united Italy, who gained possession of it in the 1450s. The print is dedicated to three daughters of Duke Victor Amadeus II of Savoy (ruled 1675–1730) and Anne of Orléans, whose arms are shown to the left and right, respectively. The Duke and Duchess flank the bishop in the centre of the composition. The print is datable to the brief period between the birth of Maria Ludovica, the Duke's youngest daughter, in September 1688, and the death of his second daughter, Maria Anna, in August 1690. It is replete with Savoy emblems: the canopy is decorated with the cross of Saints Maurice and Lazarus and with the Savoy knot, while the flying flags are the Savoy standard of white cross on a red ground. The Shroud itself is presented as the most distinguished of the emblems associated with the Savoy family.

The image on the Turin Shroud (figs. 23 and 30) shows a man who has suffered all the torments described in the Gospels: the scourging; the crowning with thorns; the nailing to the cross and the lancing of the side.[1] Many believe that this is the cloth in which Christ himself was buried and that the image it bears is a miraculous imprint of his dead body. Some marks are visible to the naked eye, but the first photographs of the Shroud taken at the end of the nineteenth century proved revelatory: they showed a vast amount of additional detail and provided the haunting image of the suffering face which has today become the most reproduced likeness of Christ. In addition to being an object of veneration, the Shroud is now a scientific phenomenon. All manner of specialists, from professors of anatomy to experts on pigment and pollen, from nuclear scientists to computer specialists using the latest digital imaging technology, have sought to understand how the impressions were made. Various theories have been proposed, including the transference of a particular combination of chemicals from the body to the cloth; some kind of scorching process; and the effects of a thermo-nuclear flash at the moment of Resurrection. Although recent Carbon-14 tests have apparently indicated that the Shroud is medieval and not from the first century – results which have themselves been challenged – the Shroud refuses to yield many of its secrets.

The early history of the Shroud is unknown, although some considered it identical to the Mandylion of Edessa (cat. no. 41) which disappeared from Constantinople in 1204. The Shroud first appears in Lirey in France in the 1350s, when the first Ostentations are recorded. Pilgrims flocked to see it, but local bishops expressed misgivings from the start and tried to ban the displays. After various vicissitudes, including several changes of ownership, removal to different places in France and northern Italy, and damage by fire (the repair patches are apparent both in the photographs and in the print), the Shroud was brought to Turin in 1578. In 1694 it was placed in a special shrine in the spectacular

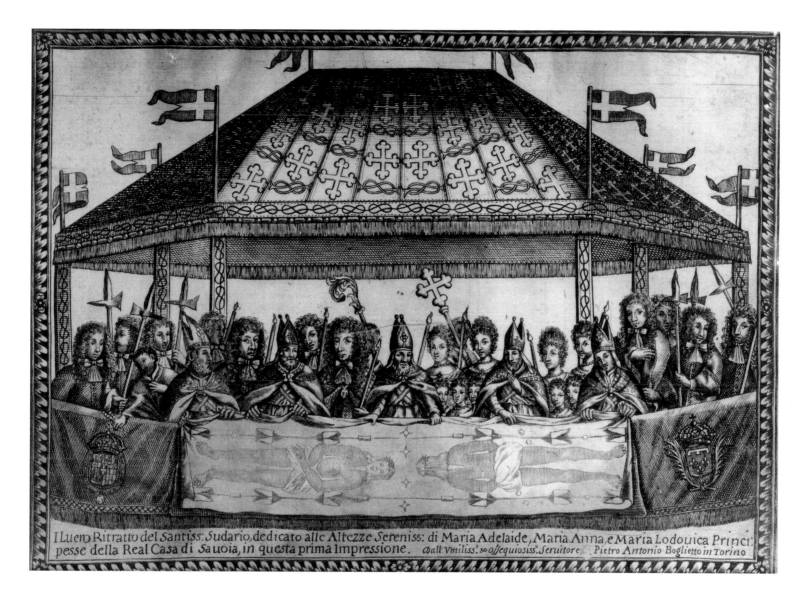

ILuero Ritratto del Santiss: Sudario, dedicato alle Altezze Sereniss: di Maria Adelaide, Maria Anna, e Maria Lodouica Princi: pesse della Real Casa di Sauoia, in questa prima Impressione. Dall'vmiliss.° & offequiosiss: Seruitore. Pietro Antonio Boglietto in Torino

Royal Chapel of the Cathedral of Turin designed by the architect Guarino Guarini.[2] In 1670, the Congregation of Indulgences granted an Indulgence 'not for venerating the cloth as the true Shroud of Christ, but rather for meditating on the Passion, especially his death and burial'.[3] Ecclesiastical authorities up to the present day have remained non-committal about the authenticity of the Shroud. *GF*

1 On the history and interpretation of the Turin Shroud, see Wilson 1978, and Moretto 1999.
2 The Chapel was severely damaged by fire in 1998, although the Shroud itself was rescued unharmed from the flames.
3 Quoted in Wilson 1978, p. 227.

4 PASSION AND COMPASSION

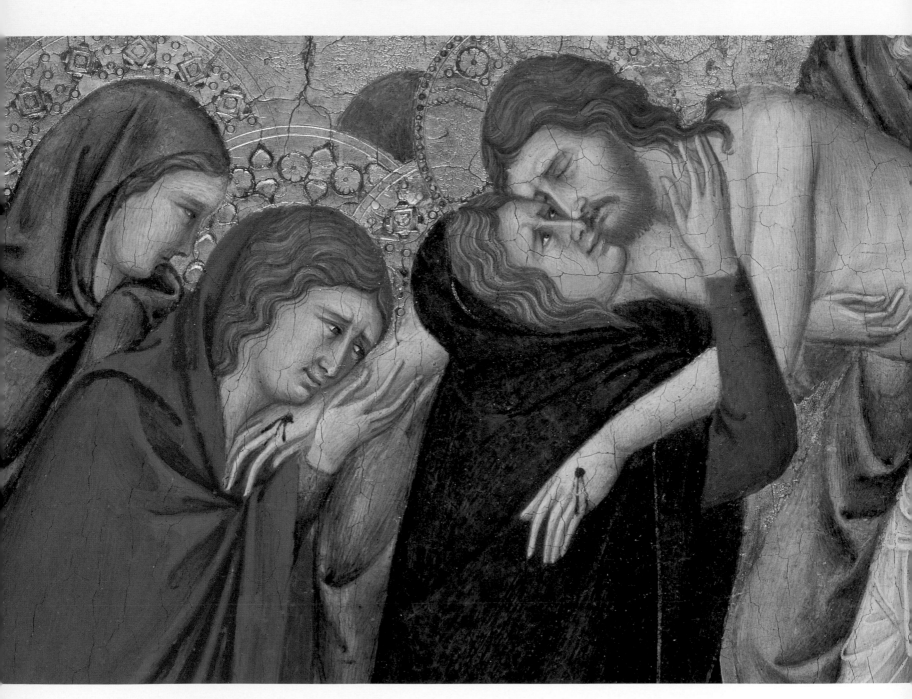

IMAGERY BASED ON THE Passion of Christ became increasingly common from the thirteenth century. The ground was prepared by the immensely influential writings of the Cistercian monk Saint Bernard of Clairvaux (1090–1153) and by the religious renewal brought about by the Franciscans. Both Saint Bernard and Saint Francis of Assisi (1182–1226) placed a special emphasis on the humanity of Christ and encouraged an 'affective' spirituality which concentrated on the Passion. Human compassion, the natural sense of sympathy and pity for the suffering of others, could be harnessed to inspire and deepen faith in Christ and to strengthen devotion to him. The image of Christ on the cross was no longer solely the sign of God's love and his sacrifice for humanity; it became the focus for humanity's own compassion for the suffering Saviour.

This change in religious sensibility can be clearly seen by comparing the imagery of the fifth-century ivory reliefs in the British Museum, and the thirteenth-century Umbrian diptych in National Gallery (cat. nos. 43 and 44). In the former, the Passion is conceived principally as the prelude to the Resurrection. The events shown are interpreted in the light of the final triumph and confirm Christ's divine status. No sign of vulnerability or human weakness is apparent in any of the scenes and even on the cross Christ is victorious. This is in marked contrast to the imagery of the diptych which shows Christ both as the tender infant of the Virgin and the 'Man of Sorrows', the signs of whose mental and physical anguish are clearly imprinted on his face and on his dead body. Confronted with such desolation even the angels have shielded their eyes. On the one hand the image denounces the viewer as the perpetrator of crimes against divinity, on the other, Christ's pathetic state appeals directly to our sense of pity and compassion. The mix of emotions which well up in the devout upon looking at such an image, a blend of guilt and gratitude, sorrow and sympathy, is a very powerful combination. The two works – the early ivory casket panels and the medieval diptych for private devotion – encompass the two extremes of the human manifestation of Christ's *kenosis,* his descent from victorious God-Man to abandoned wretch.

In his widely known *Life of Christ*, dating from the mid-fourteenth century, the Carthusian monk, Ludolph of Saxony (died 1378), expressed the attraction – without seeking to explain it – that the more human Christ held:

> I know not for sure … how it is that you are sweeter in the heart of one who loves you in the form of flesh than as the word … It is sweeter to view you as dying before the Jews on the tree, than as holding sway over the angels in Heaven, to see you as a man bearing every aspect of human nature to the end, than as God manifesting divine nature, to see you as the dying Redeemer than as the invisible Creator.[1]

1 Quoted from Duffy 1992, p. 237.

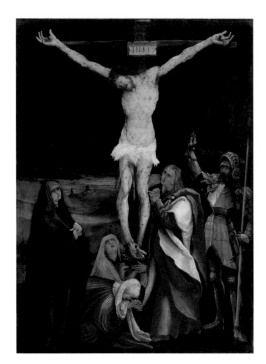

FIG 31 *Mathias Grünewald* The Crucifixion, *1500–8. Tempera on limewood, 73 x 52.2 cm. Basel, Kunstmuseum.*

At the same time, the image-makers were seeking new ways of giving a visual form to Isaiah's prophecy of the Man of Sorrows, the passage of Scripture that most clearly foreshadowed the Passion of Christ:

> He is despised and rejected of men; a man of sorrows, and acquainted with grief: and we hid as it were our faces from him; he was despised, and we esteemed him not. Surely he hath borne our griefs and carried our sorrows: yet we did esteem him stricken, smitten of God, and afflicted. But he was wounded for our transgressions, he was bruised for our iniquities: the chastisement of our peace was upon him; and with his stripes we are healed (ISAIAH 53: 3–5).

Images of the suffering Saviour were often inscribed with the verse from the Lamentations of Jeremiah: 'O all ye that pass by the way, attend, and see if there be any sorrow like to my sorrow' (LAMENTATIONS 1: 12),[2] which was understood as being spoken by Christ during the Passion.

One way of making the Passion images more engaging to the devout viewer was to represent the punishment and humiliation visited on Christ as extremely brutal. Thus, for example, in Grünewald's famous *Crucifixion*, Christ's body is contorted with agony and completely disfigured by the numerous wounds he bears (fig. 31); in certain fifteenth-century representations of the 'Way to Calvary', Christ is shown with spike blocks attached to a belt around his waist to make every stumbling fall unspeakably painful. Artists also devised new subjects, interpolations in the Gospel narrative, which could act as a focus for what might be termed 'meditational compassion', among them the Lamentation over the Dead Christ (cat. no. 52) and the *Pietà* (cat. no. 27). The subject of 'Christ on the Cold Stone', popular in northern Europe, was specifically invented to be, as it were, the Christ of the Lamentation of Jeremiah (cat. no. 48). In the narrative of the Passion it comes notionally between the episodes of the stripping of Christ's garments and the nailing to the cross, when he is awaiting crucifixion.

In the imagery of compassion, the gaze of Christ plays an important role. In one episode in the Gospels, on seeing the multitudes, 'he was moved with compassion on them, because they fainted and were scattered abroad, as sheep having no shepherd' (MATTHEW 9: 36). In his dialogue with the rich young man who questioned him about what he must do to inherit eternal life, Jesus 'beholding him, loved him' (MARK 10: 21). Most poignantly though, right in the middle of the Passion when he is in the High Priest's house, Christ gazes out at Peter who had betrayed him three times, 'And Peter went out, and wept bitterly' (LUKE 22: 61–2). It is this gaze, pitiful and reproving, which is portrayed by Bosch and by Correggio in their paintings of the *Crowning with Thorns* and the *Christ Presented to the People (Ecce Homo)* (cat. nos. 45 and 46).

Images were intended to be looked at, but it was equally clear that the images themselves had 'eyes to see'. A history of the first Dominicans written before 1269 by Gérard de Frachet reveals that 'in their cells they had before their eyes images of the Virgin and

2 English translation quoted from Marrow 1979, p. 65.
3 Quoted in Belting 1990, p. 57.

of her crucified Son so that while reading, praying, and sleeping, they could look upon them and be looked upon by them with the eyes of compassion'.[3] The representations of Veronica's sudarium are particularly interesting in this regard, since they actually 'record' the anguished appearance of Christ as he looked at the holy women on his way to Calvary, so – as we look at these images – he gazes at us in the very same way (cat. no. 36).

The Virgin lamenting over the dead Christ was the ideal model of compassion (cat. no. 52). She felt the pain of Christ's Passion more deeply than anyone else, like a 'sword piercing her soul' (LUKE 2: 35). She appears – unexpectedly prominent – in Correggio's *Ecce Homo* (cat. no. 46), and in Ugolino di Nerio's *The Deposition* she embraces his lifeless body (cat. no. 51). The *Stabat Mater*, the great Latin hymn attributed to Jacopone da Todi, a disciple of Saint Francis, articulated her anguish most pointedly for the whole western Church:

> At the cross her station keeping
> Stood the mournful mother weeping
> Close to Jesus to the last.
>
> [...]
>
> O how sad and sore distressed
> Was that mother highly blessed
> Of the sole-begotten one![4]

The most intense form of compassion for Christ though, is 'actual' participation in his sufferings and there is a rich iconography of the saints which has this self-identification with Christ's Passion as its subject. Saint Francis prayed to God that he might feel the pain and grief that Christ felt in his Passion and he was rewarded with the stigmata, the wounds that Christ bore on his body at the Crucifixion (fig. 32). This episode is the most frequently represented in the cycles of the life of Saint Francis, since it is the one that most completely demonstrated his conformity to Christ. Like Francis, the Dominican Saint Catherine of Siena (1347–80), also expressed her desire to be united with Christ in his Passion and appealed to him in prayer that 'during the time you want me to remain in the body you will allow me to share in all the sufferings you endured, including your final Passion, so that as I am not able for the moment to be united with you in heaven, I may be united with you through your Passion on earth'.[5] According to her biographer, Raymond of Capua, her request was granted. The painting by the seventeenth-century Sienese artist, Rutilio Manetti (cat. no. 50), shows Saint Catherine receiving the stigmata; remarkably though, she receives them not from a vision of Christ but from a painted medieval crucifix. During her meditation on the image she has been overtaken by ecstasy, causing her to faint. Manetti's painting is an eloquent testimony to the power of the religious image in the context of Passion meditation. *GF*

4 *Stabat Mater Dolorosa*
Iuxta crucem lachrymosa
Dum pendebat filius.

[...]

O quam tristis et afflicta
Fuit illa benedicta
Mater unigeniti!

5 Raymond of Capua 1960, p. 186.

43 Reliefs of the Passion and Resurrection, Roman, about AD 420–430
1 Christ Taking up his Cross
2 The Crucifixion
3 The Empty Tomb
4 Christ's Commission to the Apostles

Ivory, four sides of a casket, each one 7.5 x 9.8 cm.

London, British Museum, M & LA 56, 6–23, 4–7

THESE FOUR IVORY RELIEFS (shown here slightly larger than life-size), date from the early fifth century and formed the sides of a small casket possibly used to hold a relic or the consecrated host. The relief showing the Crucifixion appears to be the earliest surviving representation of it in a narrative context. The emphasis throughout the scenes is on Christ's divinity expressed through his physical strength and purposeful endurance, rather than on his humanity and suffering. Each scene shows Christ as the pivot around which the action turns, with secondary figures and props emphasizing his authority and triumph.

In the first scene we see Christ powerfully carrying his own cross and stepping forward without reluctance on the Road to Calvary. He is flanked by the seated figures of Pilate on the left and Peter on the right, both of whom recognised something of his true nature during the Passion. Pilate washed his hands of any involvement in Christ's death

1

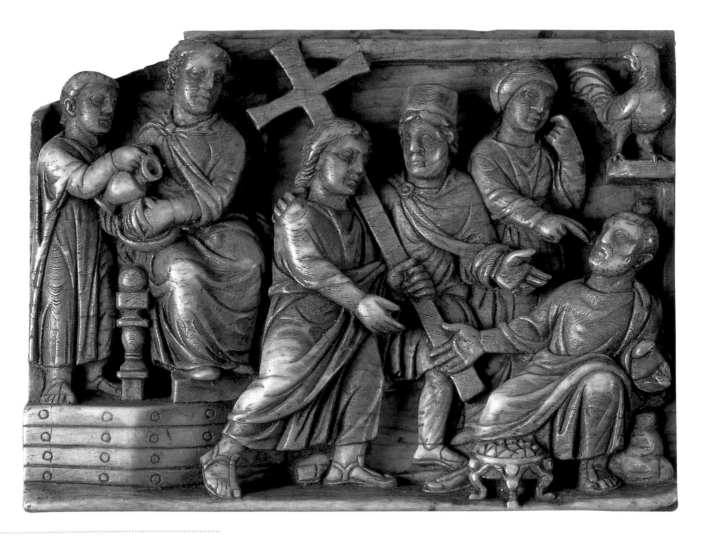

because he saw no fault in him, while Peter, having denied he knew Christ, recognised his error and wept bitterly at his betrayal. In the scene of the Crucifixion, his moment of greatest physical weakness, Christ is shown as superhuman: his muscular body stands out against the cross, he holds his head erect and has his eyes wide open. His glorious death is contrasted with Judas's ignominious suicide on the tree to the left, the pieces of silver spilling out of his pouch onto the ground. Here too, Christ's true status is recognised: the inscription above his head – REX IVD [EORUM] – declares him to be the 'King of the Jews' (the wording was Pilate's), and he alone has a halo. The man who looks up at him is probably the soldier, later known as Longinus, who, on spearing Christ's side, recognized him to be the Son of God.

Christ does not appear in the third panel which shows the empty tomb, its doors ajar (now partly damaged), containing the sarcophagus in which his body had been laid. His

2

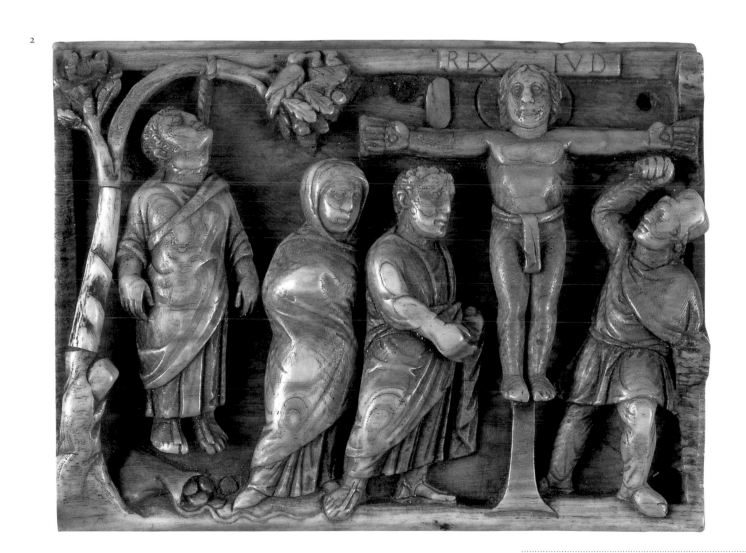

Resurrection, which took place while the soldiers slept, is signalled by his absence from the scene. The two women have come to anoint his body. The fourth panel probably represents the last scene from the Gospel of Saint Matthew which describes the Risen Christ taking his disciples to a mountain where 'they worshipped him but some doubted' (notably Thomas), and where he commissioned them to 'teach all nations' (MATTHEW 28: 16–20). On surveying the panels as a group, it becomes clear that the focus is less on Christ's Passion than on his Resurrection from the dead, less on the events of Good Friday than on those of Easter Sunday. The choice of scenes thus asserts a confident faith in Christ's godly nature, his mission of redemption, and the role of the Church, represented by the apostles, in the completion of the divine plan.

This notion of a triumphant Christ was certainly the one that was promoted up to the Middle Ages. It was rooted in texts such as that in the Letter to the Hebrews: 'God

3

hath in these last days spoken unto us by his Son, whom he hath appointed heir of all things, by whom also he made the worlds; Who being the brightness of his glory, and the express image of his person, and upholding all things by the word of his power, when he had by himself purged our sins, sat down on the right hand of the Majesty on high' (HEBREWS 1: 2–3). The New Testament and the early theologians (for instance Saint John Chrysostom, archbishop of Constantinople, AD 347–407) made use of language traditionally associated with imperial victories and with athletic contests to draw attention to Christ's power. Although the figure of the triumphant Christ was somewhat eclipsed during the Middle Ages, it reappeared during the Renaissance. Michelangelo's *Risen Christ* in the church of Santa Maria sopra Minerva in Rome, for instance, is a beautiful athletic victor who carries his cross easily while his body bears no traces of suffering. *SA-Q*

4

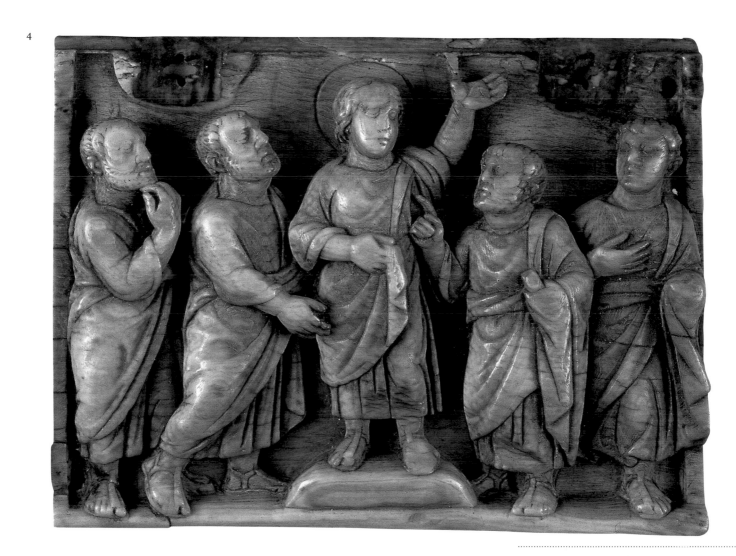

44 The Virgin and Child and The Man of Sorrows, about 1260

Anonymous Umbrian(?) Master

Egg tempera on panel, each panel 32.4 x 22.8 cm. Inscribed on NG 6573 IE[SUS] NAZARENUS./ REX IUDEORUM *(Jesus the Nazarene. King of the Jews)*

London, National Gallery, NG 6572 and NG 6573

THESE TWO PANELS, RECENTLY reunited after a lengthy separation, are very different in feeling from the triumphal fifth-century Passion and Resurrection reliefs in the British Museum (cat. no. 43). They derive from types of Byzantine icon which show Christ as a suffering human victim and the Virgin sharing in this pain.

In the right-hand panel the viewer is confronted with an image of the dead Christ, with the cross behind. His eyes are closed, his brow furrowed and his head droops. By contrast, in the image of the Virgin and Child, Christ is shown holding a scroll which symbolises his being the Living Word (JOHN 1: 1, 14). The representation of the dead Christ is based on the 'Man of Sorrows' icon, also known as the '*Imago Pietatis*' (Image of Pity), while the image of the Virgin and Child recalls two other icon-types: the '*Panagia Hodegetria*' in which the Virgin acts as intermediary between the believer (to whom she looks) and her son (to whom she points), and the '*Panagia Eleousa*' in which a lamenting Virgin presses her cheek tenderly against that of her son and thinks forward to his future suffering. These sources reflect the Eastern Church's early recognition of Christ's Passion as an event with sorrowful human implications.

This focus on Christ's suffering, which implies his ability to partake fully in our humanity, increasingly informed the thinking of believers in the West. Saint Bernard of Clairvaux developed a theology centred on Christ's sacrifice on the cross which was elaborated by Saint Francis of Assisi, and then found expression in much devotional literature in which the accounts in the Gospels of Christ's Passion were supplemented by new descriptive details and episodes. This literature appeared first in the form of Latin treatises for the clergy or those attached to monasteries or convents, but works like the *Meditations on the Life of Christ*, for a long time attributed to the Franciscan Saint Bonaventure, and the *Life of Christ* by the Carthusian Ludolph of Saxony, were translated into the vernacular and spread rapidly among the laity. These texts often dwell on the intensity of Christ's sufferings and on the savagery of his tormentors, and all of them stress the value to the readers of vividly imagining each event of the Passion story in turn, so that they might feel deeply involved in the sufferings and merits of Christ and of his mother the Virgin Mary. Indeed, the Virgin was usually cited as a role-model to guide the reader's response, and thousands of treatises, hymns and poems appeared on the theme of her compassion, one of the most popular being the 'Little Office of the Blessed Virgin' which was later printed in most Books of Hours, the sequence of prayers and religious texts that punctuated the day.

Such prayers or offices may have been said in front of this diptych, which was probably intended for private devotion. The intention of these dual images of Christ's Passion (*Christi Passio*), and Mary's compassion (*Mariae Compassio*), was to engender deep feelings of love, compassion and gratitude towards Christ for the love he demonstrated in his Passion and Crucifixion, and to his mother for her part in the story of salvation. Such diptychs were to become very popular in Italy and northern Europe in the fourteenth and fifteenth centuries. *SA-Q*

45 The Crowning with Thorns, about 1490–1500

Hieronymus Bosch (living 1474; died 1516)

Oil on oak, 73.5 x 59.1 cm.

London, National Gallery, NG 4744

ACCORDING TO THE GOSPEL of Saint Mark, after Pilate had handed Jesus over to be crucified, the Roman soldiers took him, and 'clothed him with purple, and plaited a crown of thorns, and put it about his head, and began to salute him, Hail, King of the Jews! And they smote him on the head with a reed, and did spit upon him, and bowing their knees worshipped him' (MARK 15.17–19).

Bosch has shown the moment just before the crown of thorns is forced onto Christ's head and pushed into his pale and delicate skin. His humble and serene expression contrasts with the ugliness of the tormentors cramped tightly around him. He gazes calmly at us, lost in his own thoughts amid the vile abuse of his aggressors, whose stares of hatred convert them into caricature-personifications of mockery and malice. The contrast of good and evil is emphasised by Bosch's choice of a white robe for Christ, rather than the purple one prescribed in the Gospel.

The mockers are dressed in contemporary sixteenth-century costume. By modernising the event, Bosch was perhaps making a satirical comment on the corruption of the society of his time. Only two of the figures are actually soldiers: the one on the right wears a spiked dog collar, recalling Psalm 22 (verse 16), which was read in the Good Friday liturgy, about dogs surrounding God's chosen one, and on his hat he has a cluster of oak leaves and an acorn.[1] The soldier on the left is more menacing: he wears a crossbow bolt in his turban (similar to that worn by one of the soldiers in Bruegel's *Adoration of the Kings*, cat. no. 32) and brings the crown of thorns down on Christ's head with his armoured fist. The other two figures offer Christ false homage and are probably kneeling before him. The headgear of the man at the left is embroidered with a crescent moon and star, identifying him as an unbeliever, while the other man is dressed like a contemporary merchant.

Recent infra-red reflectograms of the painting – which show the preparatory underdrawing beneath the paint surface – have revealed that Bosch changed his mind about several of the details in the composition. The tormentors originally looked more violent and aggressive than they appear in the finished painting. The man in the top right-hand corner was originally grabbing Christ with both hands from behind, and his staff had sharp spikes. These spikes do not appear in the finished painting and his stick has become a 'sceptre' which he is about to hand over to Christ. The hands of the man at lower right were originally placed lower down, grasping the edge of Christ's mantle, as if he was about to tear it off. The bearded man on the lower left had a longer stick and his left hand was pointing at his own mouth, perhaps to indicate that he had been spitting or shouting at Christ. In the finished work Bosch toned down the vulgarity of the oppressors in favour of a more subtle interpretation of the event. By suspending the action of the crowning with thorns for a split second, almost as though the painting were a 'still' from a Passion play, he enables us to ponder on the injustice of Christ's fate and on the cruelty of which humanity is capable. *XB*

1 It has been suggested that the oak leaves were intended as a reference to Pope Julius II (1503–13), whose family emblem was made up of oak leaves and acorns (his family name 'Della Rovere' means 'of the oak tree'), but it is more likely that the artist intended a more general allusion to the secular authorities of his day. For full discussion see Tudor-Craig/Foster 1986, pp. 12–13.

46 Christ presented to the People (Ecce Homo), about 1525–30

Antonio Allegri known as Correggio (about 1494; died 1534)

Oil on poplar, 99.7 x 80 cm.

London, National Gallery, NG 15

THIS PAINTING SHOWS THE SCENE in Christ's Passion when, having been scourged and mocked by the soldiers, he is presented by Pontius Pilate, the Roman governor of Judaea, to the Jews gathered outside the judgement hall: 'Pilate went out again, and saith unto them, Behold, I bring him out to you, that ye may know that I find no crime in him. Jesus therefore came out, wearing the crown of thorns and the purple garment. And Pilate saith unto them, Behold the Man (*Ecce Homo*). When therefore the chief priests and the officers saw him, they cried out, saying Crucify him, crucify him' (JOHN 19: 4–6). In accordance with the Gospel of Saint John, Christ is shown wearing the 'garment' (although Correggio makes it red, which conforms with Saint Matthew's account) and a crown of thorns, the mocking emblems of kingship with which the soldiers had earlier invested him (cat. no. 45). Looking out directly at the viewer with a piteous gaze, Christ dominates the composition. On the right a soldier (possibly Saint Longinus, the centurion who was converted at Calvary) stares at Christ with a look that seems to combine both guilt and compassion. On the left, from a window, the turbaned figure of Pilate points towards Christ, in accordance with the words 'Behold the man'. The prominence of the Virgin Mary, who faints at the realisation of her Son's predicament and is helped by a companion, is unusual in *Ecce Homo* scenes.

The view is close up and the composition cropped at the edges, giving the picture an immediacy which, for a modern audience, is familiar from the cinema. The figures are cramped in the picture space and the image is packed with emotional tension. Correggio has arranged the scene so that Christ is being presented not to the crowds outside the judgement hall, but to the viewer who looks at the painting. Like a film on a repeating loop, the *Ecce Homo* situation is recreated every time the painting is looked at, and on every occasion Pilate repeats the phrase, 'Behold the Man'. But Christ is offered up to our gaze for contemplation and not for judgement, and our response, like that of the Virgin, should be one of love and compassion.

An engraving of the painting (showing it in reverse), made by Agostino Carracci in 1587 (about sixty years after the painting), is inscribed with the following Latin verse: 'The offspring of God, Saviour of the World and our Creator, suffered as a Criminal'. This suggests that one form of meditation on the image in the sixteenth century may have focused on the profound humiliation that Christ, who was God, was made to suffer in his Passion when he was treated as a criminal. The painting was almost certainly commissioned for private devotional purposes, possibly by a member of the Prati family of Parma, who owned it when Agostino Carracci made his engraving. *XB*

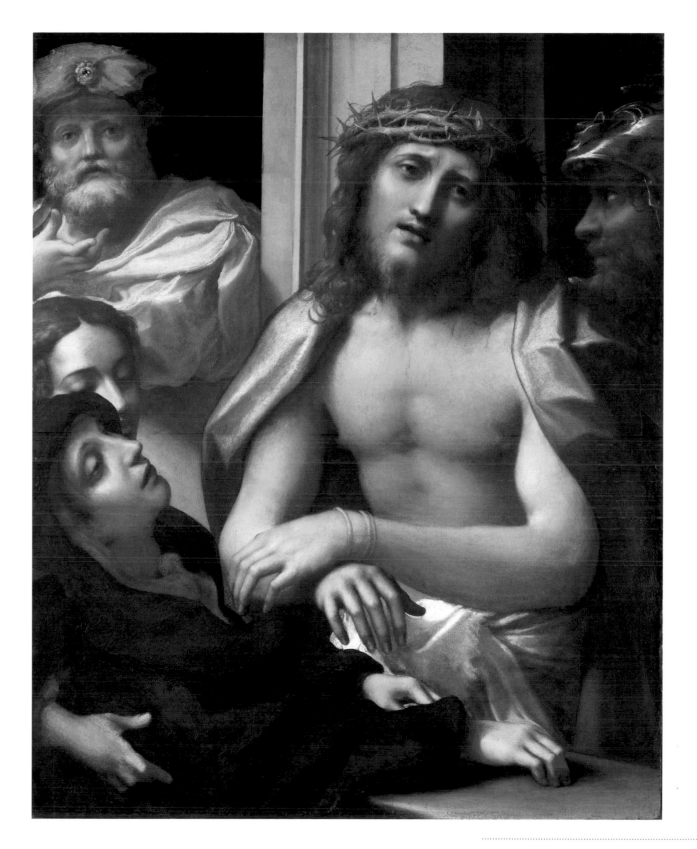

47 Christ as the Man of Sorrows, 1520s

Style of Jan Mostaert (about 1472/3–1555/6)

Oil on oak, 30.5 x 21 cm.

London, National Gallery, NG3900

CHRIST BEARS THE CROWN OF THORNS on his head and his hands are bound. In his right hand he holds the reed thrust on him by the Roman soldiers who mocked him as 'King of the Jews' (MATTHEW 27: 28-29); in his left is the birch with which he was flogged. To a modern viewer his crossed hands perhaps recall the imagery of the Egyptian pharaohs, who hold their regalia in a similar manner. But Christ, whom the Magi had worshipped as King, was only made to dress like a king so that he might be more thoroughly despised. In this picture he is, in fact, the 'Man of Sorrows' of Isaiah: 'He is despised and rejected of men; a man of sorrows, and acquainted with grief: and we hid as it were our faces from him; he was despised, and we esteemed him not' (ISAIAH 53: 3). Tears stream from his eyes in large crystal beads and he looks directly at us, lips slightly parted, as though he were about to speak words of reproach and disappointment.

The painter has employed all the artistic means at his disposal to induce feelings of compassion and contrition in the viewer, from the small scale of the image, which already assumes intimacy, to the catchlights in the tear-filled eyes, which make our response more immediate. Even the drooping lines of Christ's shoulders reflect the plaintive character of the painting. This was undoubtedly an image for private contemplation, and in the privacy of prayer it was intended to elicit tears.

The work was probably produced in the workshop of Jan Mostaert, an artist who came from Haarlem. From 1519 he was employed at the court of Margaret of Austria, Governess of the Netherlands, in Brussels and Malines, where he appears to have painted portraits and religious works. Several paintings of the 'Man of Sorrows' are thought to be by him or his studio.[1] This picture, which may date from the 1520s,[2] is closely related to the representation of Christ in *Christ crowned with Thorns*, one of the wings of the Oultremont Triptych in the Musées des Beaux-Arts, Brussels, which is attributed to Jan Mostaert.

In his rendition of the 'Man of Sorrows' theme, the artist may have been influenced by the spiritual movement in the Netherlands known as the 'Devotio moderna' (Modern devotion), which sought to make the faith more accessible to lay people, and encouraged a greater spiritual and emotional engagement with the person of Christ. *GF*

1 They are listed in Friedländer 1972a, nos. 15-18, p. 70, pl. 14.
2 Dendrochronology, the analysis of the growth rings of the oak panel on which the picture is painted, suggests that the panel was painted after 1516.

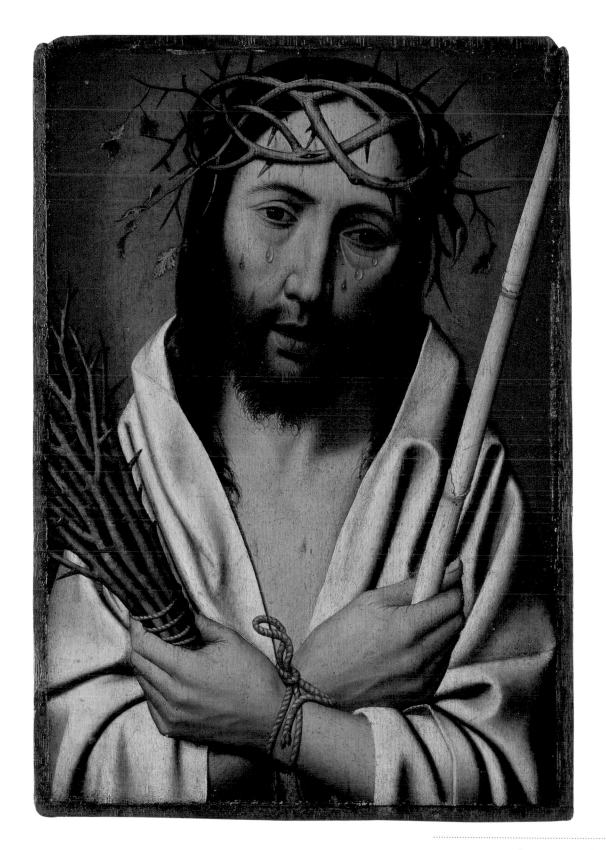

48 Christ on the Cold Stone, about 1500

Eastern Netherlandish
Carved limestone with traces of polychromy,
98 x 49.5 x 48.5 cm.
Utrecht, Museum Catharijneconvent, INV. ABM
bs 692

1 See Mâle 1986, III, figs. 45 and 49.

2 In the nineteenth century it was placed in the courtyard of a modern church in Azwjn, at the foot of a cross, an arrangement that almost certainly bore no relationship to the original one.

3 See Mâle 1986, III, p. 91.

4 English translation quoted from Marrow 1979, p. 65.

5 They were inscribed on a variety of Passion images, especially the 'Imago Pietatis', or 'Image of Pity', and they were sometimes employed to articulate the emotions of the Virgin in scenes of the *Pietà*. See Belting 1990, pp. 197–200.

6 Marrow 1979, p. 66.

THE IMAGE OF CHRIST seated on a stone awaiting Crucifixion is a particular invention of northern European late-medieval piety. The type of image is known as the 'Christ on the Cold Stone' or the 'Christ at Rest on Calvary'. This life-size figure is especially remarkable on account of its nudity. Most other examples show the figure draped in a loin cloth, his hands bound with rope, but here Christ wears nothing but the crown of thorns, which originally had metal spikes inserted into the now empty holes. He is completely exposed and vulnerable. The ghostly whiteness of the sculpture does not reflect its original appearance; it was probably all coloured, and traces of pigment are still visible on the surface. In eastern France similar sculptures are found inside churches and positioned above eye level so that the viewer looks up at Christ.[1] The original setting and location of this sculpture are not known.[2]

The Gospels make no mention of a hiatus in the sequence of events leading up to the Crucifixion, but the tendency in medieval devotion was to break up the Passion narrative into as many sections as possible to extend the number of individual focuses for meditation. In this image Christ seems to have momentarily withdrawn from the narrative that leads inexorably to his martyrdom so that the devout might contemplate the depth of his psychological and physical anguish. Emile Mâle, the French art historian who in the 1920s drew attention to the importance and innovatory character of the subject of 'Christ on the Cold Stone', wrote that 'the seated Christ summarises the entire Passion; he has exhausted the violence, the ignominy, the bestiality of man … Here is the abyss of suffering, and the extreme limit of art … The seated Christ thinks and suffers. Thus, art had to express the profoundest moral suffering imaginable and link it with the extreme of physical suffering'.[3]

Christ's pose with his cheek resting on his hand recalls the traditional representations of Melancholy. This is not accidental since this sculpture aimed to convey the inconsolable sorrow of the Saviour. It is a visualisation of the well-known verses from the Prophet Isaiah's 'Song of the Suffering Servant' and the verse from the Lamentations of Jeremiah: 'O all ye that pass by the way, attend, and see if there be any sorrow like to my sorrow' (LAMENTATIONS 1: 12).[4] The passage from which the latter comes was commonly interpreted as a prophecy of the Passion, and these very words were imagined on the lips of Christ himself.[5] The 'Christ on the Cold Stone' was designed to elicit the compassion of the viewer for the suffering God but at the same time to make the viewer feel both guilt on account of Christ's plight and gratitude for the love he had shown by undergoing the Passion on behalf of mankind.

It was the numerous resonances of the image that made it possible for so many complex and even contradictory responses to be drawn out from the devout. The seated mournful figure of Christ recalled the disconsolate Job on the ash heap lamenting his cruel fate and scratching his sores with a potsherd (BOOK OF JOB), and the more educated would have known that Jeremiah, according to the prefatory verses of medieval editions of the Latin Vulgate Bible, was 'the prophet who sits weeping and laments'.[6] *GF*

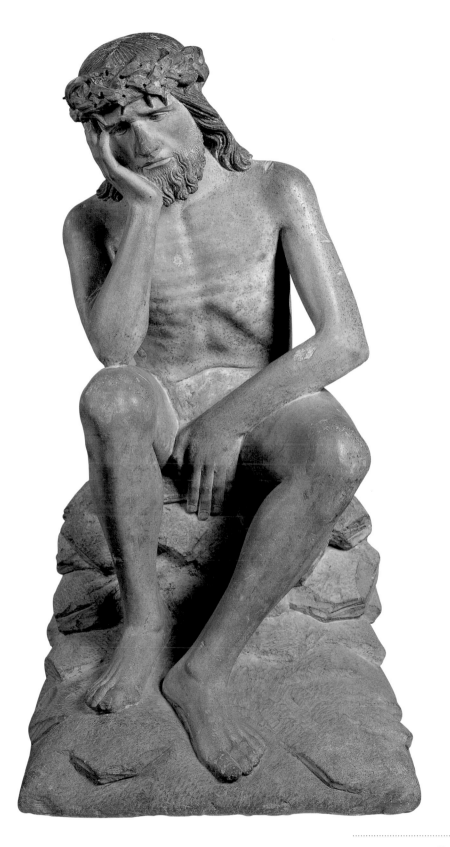

49 Saint Francis embracing the Crucified Christ, about 1620

Francisco Ribalta (1565–1628)

Oil on canvas, 208 x 167 cm.

Valencia, Museo de Bellas Artes, INV. 478

FIG 32 *Sassetta,* The Stigmatisation of Saint Francis, *1437–44. Tempera on poplar, 87.5 x 52.5 cm. London, National Gallery, NG 4760.*

1 *Little Flowers,* p. 189.
2 The *Song to the Crucified Christ* dates from the early seventeenth century.
3 Quoted in Spanish in Fitz Darby 1938, p. 119.

SAINT FRANCIS OF ASSISI frequently expressed the desire to be perfectly united with Christ, and this extraordinary painting by the Spanish artist Francisco Ribalta illustrates in symbolic form the mystical communion he experienced. Saint Francis embraces the crucified Christ with tenderness, bringing his lips to the wound in Christ's side in order to drink the blood which issues from it. This vivid detail, almost repellent to modern eyes, signifies the sacramental union he sought as well as recalling the dedication of the Franciscan Capuchin convent for which the painting was made, the Sangre de Cristo (Blood of Christ) in Valencia. Christ's response to the love shown him by Saint Francis is to pull away his right hand from the cross, to remove the crown of thorns from his own head and place it on that of the Saint, thus conferring upon him the honour of sharing in his Passion. An angel brings a garland of flowers to Christ while musician angels make divine music to the right. Saint Francis's contempt for worldly glory and his rejection of the seven capital sins is symbolised by the seven beasts with golden crowns which he tramples underfoot, most notable among them the leopard in the foreground.

The most obvious sign of Saint Francis's mystical communion with Christ was his reception towards the end of his life of the stigmata, the five wounds of the crucified Christ, on his own body. These are clearly apparent in Ribalta's painting and although the imagery does not correspond exactly with any of the visionary or mystical episodes recounted in the various *Lives* of Saint Francis, it clearly draws on the story of his stigmatisation. While on Mount Alverna near Arezzo, Saint Francis had fervently prayed to Christ that before dying he should be permitted to feel 'in my soul and in my body, so far as is possible all the pain and grief which Thou, O sweet Jesus, didst feel in Thy most bitter Passion'.[1] His stigmatisation was the answer to this prayer (fig. 32). Saint Francis's intimate and personal engagement with the Passion of Christ goes some way to explain the torrent of Franciscan devotional writing focusing on the Passion in the thirteenth and fourteenth centuries. Ribalta too, in his explicit and richly symbolic treatment of this Passion picture was clearly conditioned by the thinking of his Capuchin patrons. His rendering of this mystical subject in strongly sensual and physical terms, is also comparable to literary examples such as the hymn composed by the religious poet Miguel Sánchez[2] which was almost certainly known by the painter:

> Innocent Lamb
> Bathed in your blood
> Which frees the world of sin,
> From the strong wood
> Upon which you hang, with open arms
> You implore me to embrace you …
> Before your pure and royal soul
> Departs to save me,
> Turn your tender eyes to look upon me.[3]

GF

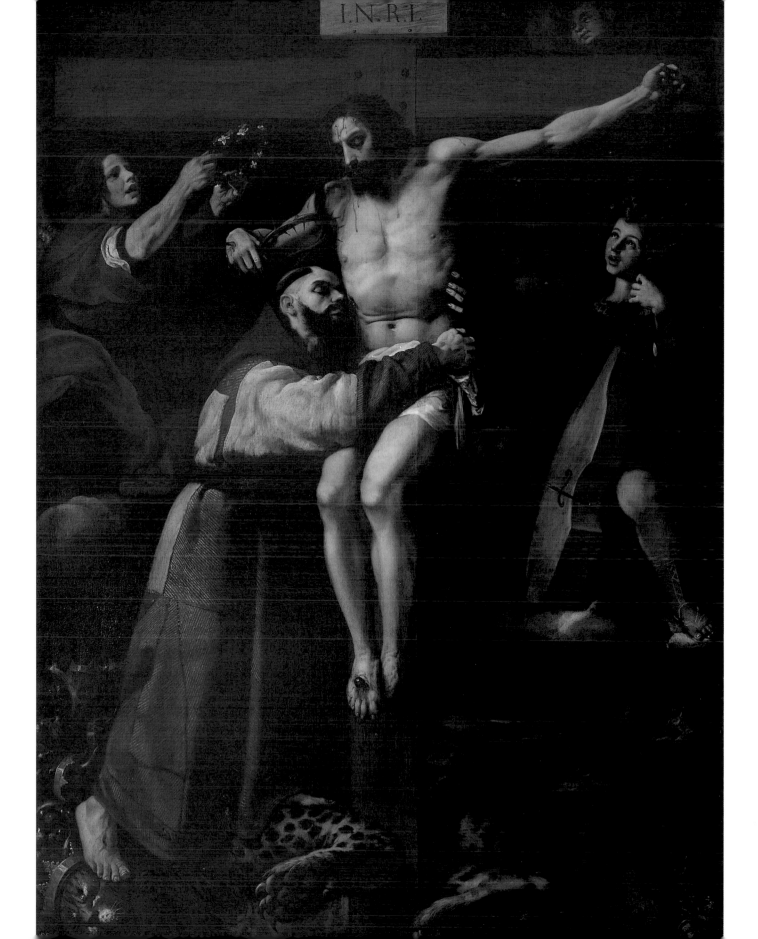

50 The Stigmatisation of Saint Catherine of Siena, about 1630

Rutilio Manetti (1571–1639)

Oil on canvas, 150 x 119.5 cm.

Private collection

LIKE SAINT FRANCIS OF ASSISI, Saint Catherine of Siena (1347–1380) also experienced the stigmata of Christ in her body. Manetti's painting shows Saint Catherine, identified by her Dominican habit and the lily signifying her purity, in an ecstatic state supported by a sister nun. She is struck in the hands, feet and side by shafts of light which come not from an apparition of the crucified Christ, nor from a seraphic vision like that of Saint Francis (fig. 32), but from a medieval painted crucifix above the altar where she had attended Mass. The shafts bind hand to hand, foot to foot, and side to side.

According to Saint Catherine's biographer, the Blessed Raymond of Capua (1330–1399), the stigmatisation took place on 1 April 1375, in the Chapel of Santa Cristina in Pisa. She described her experience to him in the following terms: 'I saw the Lord fixed to the cross coming towards me in a great light, and such was the impulse of my soul to go and meet its creator that it forced the body to rise up. Then from the scars of His most sacred wounds I saw five rays of blood coming down towards me, to my hands, my feet and my heart. Realizing what was to happen, I exclaimed, "O Lord God, I beg you – do not let these scars show on the outside of my body!" As I said this, before the rays reached me their colour changed from blood red to the colour of light, and in the form of pure light they arrived at the five points of my body, hands, feet and heart'.[1] The crucifix which, in some sense, brought about the mystical experience is traditionally identified with a thirteenth-century painted and gilded crucifix now in the church of St Catherine in Fontebranda near Siena. Manetti, himself a Sienese painter, was commissioned in 1625 by the Company of Saint Catherine in Siena, to make a copy of this crucifix to send to the Company of Saint Catherine in Rome; and the accuracy of the copy was attested to in a legal document.[2] The chronicler of the Sienese Company, Aurelio Tolomei, declared that the intention in making the gift was to 'diffuse the memory of the sacred stigmata' of the Saint.

The stigmata of Saint Catherine proved a highly controversial topic in the fourteenth and fifteenth centuries. It ranged the Dominicans against the Franciscans, the latter claiming that the privileged position of their founder, who had been the first person to receive the stigmata, was being usurped for political and propagandistic purposes. The Papacy took a prudent long-term view of this matter and made no official declaration until 1630, when Pope Urban VIII gave official recognition to the veracity and validity of the stigmatisation of Saint Catherine.[3] In that year Manetti painted a large standard for the Company of Saint Catherine showing the stigmatisation of the saint, and he also made another version of the painting shown here, possibly for the Pope himself.[4] *GF*

1 Raymond of Capua 1960, pp. 175–76.
2 This crucifix is still in Rome, see Siena 1978, nos. 41a & b.
3 Frugoni 1992.
4 Florence, private collection, 99.5 x 77 cm.

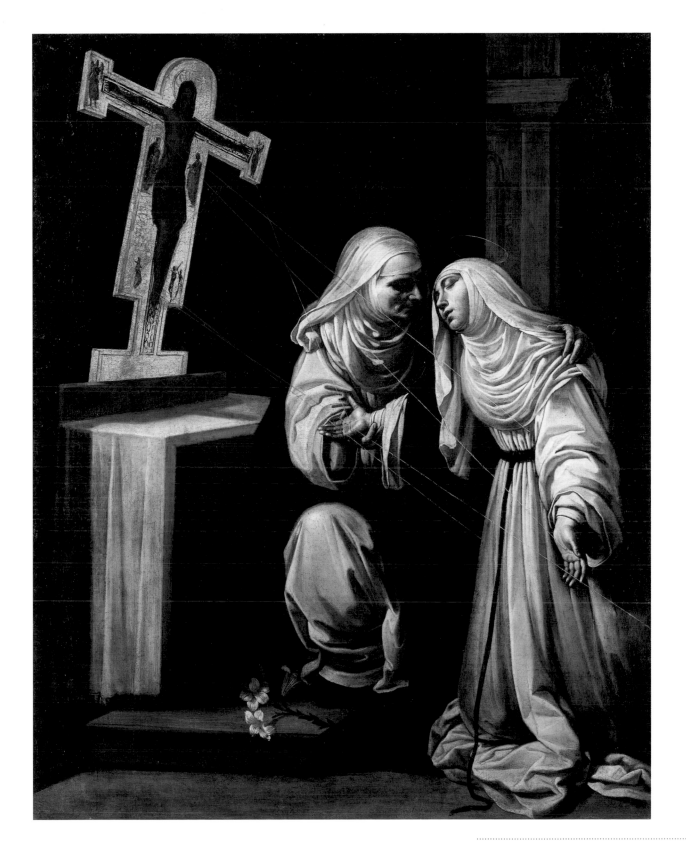

51 The Deposition, about 1325

Ugolino di Nerio (active 1317; died 1339/49?)

Tempera on panel, 34.5 x 53 cm.

London, National Gallery, NG 3375

THE FRANCISCAN FRIARS OF Santa Croce in Florence who got a close-up view of this panel of the main altarpiece of their church as they celebrated Mass, would have been able to inspect minutely the faces and gestures of each figure in turn and would perhaps have tried to empathise with the diverse emotions depicted, so as to feel closer to Christ and to the anguished Virgin. Events from the Passion narrative, like the Deposition, which are described only cursorily in the Gospels, were rounded out with imaginative details by medieval writers and artists for the benefit of the devout. Thus, Ugolino di Nerio in this work makes much of the tenderness with which Joseph of Arimathea lowers Christ's body from the cross and Nicodemus removes the nail from Christ's feet, and even more of the deep grief experienced by the other mourners. Mary Magdalene pours tears over Christ's hand, John weeps profusely as he holds Christ's body, and the grief-stricken Virgin embraces Christ and presses her face tight against his, emphasising the intimate bond between mother and son, between the Virgin's 'compassion' and Christ's 'Passion'.

Indeed, one of the most striking features of the composition is the way Christ's dead body seems to actually embrace his mother as he comes down from the cross, a motif that reflects the metaphor that the crucified Christ embraces the believer. Saint Bernard of Clairvaux described a vision in which the crucified Christ had lifted his arms from the cross beam and drawn him into his embrace.[1] In the *Meditations on the Life of Christ*, particularly relevant in the Franciscan context of Santa Croce, there is a detailed passage on the Deposition of Christ, in which the gesture of embracing is emphasised. The Virgin is described as embracing Christ's hand against her face. And having described how Joseph of Arimathea removed the metal nails from Christ's body, the author tells of how he gently helped to support Christ's body, and comments: 'Happy indeed is this Joseph, who deserves thus to embrace the body of the Lord!'[2]

This panel formed part of the lower horizontal section, or predella, of the altarpiece, which depicted the Easter story in seven scenes, from the Last Supper to the Resurrection. The Crucifixion itself does not appear in the predella but was placed in a prominent position above the main central image of the Virgin and Child. Ugolino probably derived ideas for his Passion sequence from his teacher, Duccio, who had painted scenes from Christ's Passion on the back of the double-sided *Maestà* altarpiece of Siena Cathedral (1308–11). While Ugolino's work shows the same interest in Byzantine painting and in combining a linear approach with ornamental and decorative elements, it is nonetheless distinguishable from Duccio's on account of the heightened, even harrowing emotion that his figures show. *SA-Q*

1 *Vita prima*; the passage is quoted in Belting 1990, p. 241, note 21. The famous twelfth-century hymn of lamentation, the *Planctus ante nescia*, which was often sung in Passion plays, has the line: 'Rush to the embrace! While he hangs on the tree of the cross, he offers himself with outstretched arms to the loving for a mutual embrace' (ibid. p. 75); for a full discussion of the subject of the Deposition in the context of liturgy and theatre ibid. pp. 143–66.

2 *Meditations*, pp. 341–2.

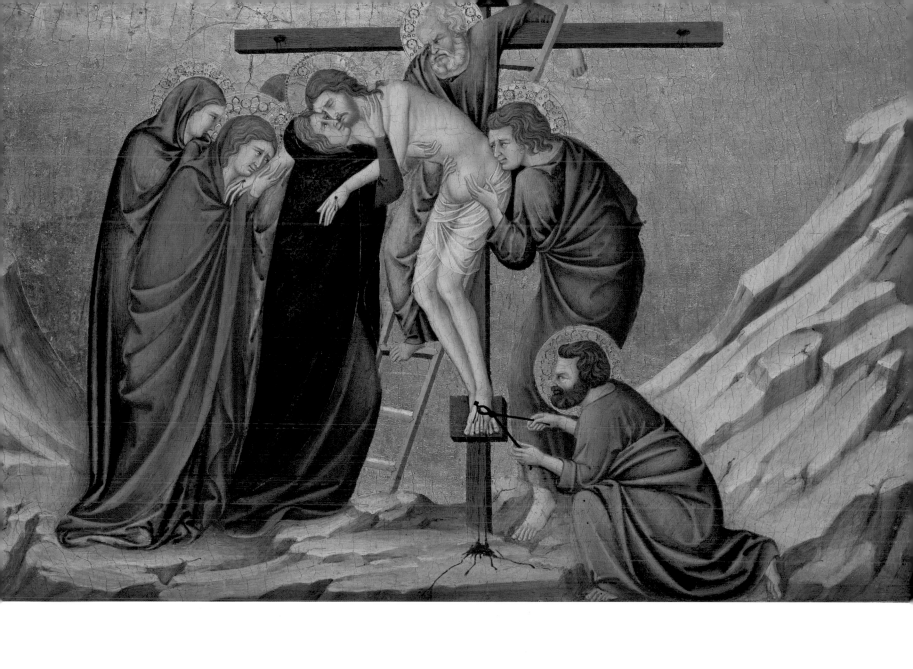

52 Lamentation over the Dead Christ, 1455–1460

Donatello (1386/87–1466)

Bronze relief, 33.5 x 41.5 cm.

London, Victoria and Albert Museum, INV.

8552–1863

DONATELLO EMPLOYS ALL HIS POWERS as a sculptor to convey the varied and deeply felt emotions experienced by Christ's mother and followers at his death. The scene is not described in the Gospels, which record simply that Christ's body was removed from the cross, prepared for burial, and laid in a new tomb. Yet by the mid-fifteenth century, the Virgin's lament over the dead Christ had become an established subject both for artists and writers of devotional literature. It gave the Virgin greater prominence in the Passion story and provided in her the ideal model of compassion for Christ. In this scene the Virgin also became the '*Addolorata*', the epitome of every grieving mother.

The lamentation of the Virgin became an important part of church liturgy and private devotion. The Virgin's grief was articulated in the form of hymns by Byzantine writers such as Ephraim of Syria (*c.*306–373). By the early thirteenth century these had been incorporated into both the Eastern and Western Church's liturgy for Good Friday. Commonly, the Virgin invokes the hearer to take pity on her by evoking Christ's childhood, accentuating the contrast between the past and present, birth and death, and happiness and sorrow. In the early fifteenth century Saint Bernardino of Siena (1380–1444) imagined that the Virgin, while holding the dead Christ 'believed that the days of Bethlehem had returned; … that he was sleeping, and she cradled him to her breast. She imagined the winding sheet in which he was wrapped to be his swaddling clothes'.[1]

Western artists were quick to convert such texts into images. Using the popular icon-type of Christ being laid in a tomb (the '*Threnos*') as their basis, they raised the emotional pitch by showing the Virgin actually cradling her son, and including mourners whose reaction to the corpse was histrionic. Donatello took up the challenge of exploring the emotions of the lament in all its possible ramifications, and gathered inspiration from a wide variety of sources to do so. His figures of the women who cry, gesticulate, cover their faces or tear wildly at their dishevelled hair, for instance, recall those from Roman and Etruscan tombs, in particular the sarcophagi which show women lamenting the death of the ancient hunter Meleager. By contrast, the figure of Saint John, who turns his back to Christ as though suffering from intense exhaustion, is based on early Florentine paintings such as Giotto's *Lamentation* in the Arena Chapel, Padua. In the midst of general hysteria, Donatello shows the Virgin, who is slumped on the ground to nurse her dead son, as though she has retreated into a private world of extreme grief.

By modelling with great vigour and spontaneity the wax from which this relief was cast – and by leaving it unfinished so that original tool-gouges are still visible in the bronze – Donatello is able to effectively suggest movement and drama and, more importantly, something of his personal empathy with the suffering depicted. To his contemporaries, used to a sweeter style of religious art, his raw and uncompromising depictions of religious subjects may have been an affront to their sensibilities, if not their beliefs. Yet it is precisely because Donatello's art has such emotional power that it can speak so directly to the modern viewer. *SA-Q*

1 Quoted in Mâle 1986, III, pp. 119–20.

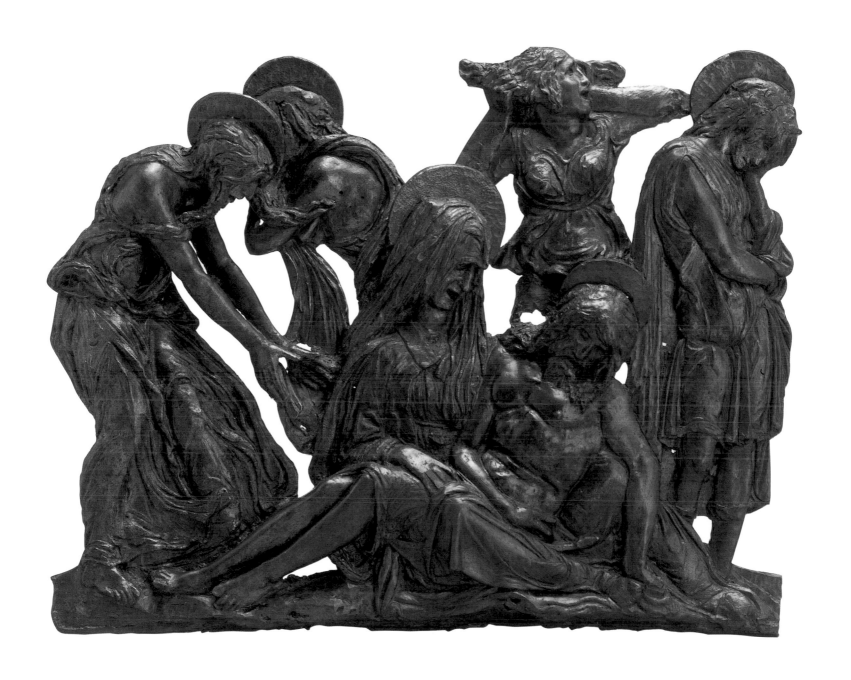

53 The Entombment, probably 1450s

Dirk Bouts (1400?–1474)
Glue tempera on linen, painted surface
approximately 87.5 x 73.6 cm.
London, National Gallery, NG 664

IN CONTRAST TO DONATELLO's treatment of the *Lamentation over the Dead Christ* (cat. no. 52), where extreme emotions are expressed through violent gestures, the Haarlem painter Dirk Bouts has chosen a more restrained type of pathos. The solemn figures surrounding the dead body of Christ mostly keep their emotions in check. The interpretation of the subject is contemplative, inviting compassionate reflection rather than seeking to inspire strong empathetic feelings in the viewer.

After Christ's death, Joseph of Arimathea went secretly to Pontius Pilate to request Jesus's body for burial. Once he had obtained Pilate's authorisation, he and Nicodemus, a Pharisee who was a secret disciple of Jesus, took the body and 'wrapped it in a clean linen cloth, and laid it in his own [Joseph's] new tomb, which he had hewn out in the rock' (MATTHEW 27: 59-60). Saint John, in his Gospel, adds that Nicodemus had brought a 'mixture of myrrh and aloes, about an hundred pound weight' (JOHN 19: 39) to anoint Christ's body, as was customary in the Jewish burial rites.

Christ's body, wrapped in a white shroud, is being gently lowered into a stone tomb which extends across almost the entire width of the painting. It is handled with extraordinary care and respect: only the Virgin touches Christ directly, all the other figures hold him through the shroud. Various medieval mystical texts describe the Virgin's physical attachment to her son as he was being buried. In the *Meditations* she is made to say: 'Willingly would I be buried with you, to be with you wherever you are. But if I cannot bury my body, I would be buried in mind. I shall bury my soul in the tomb with your body'.[1] Details such as the blood trickling from Christ's wounds and his crossed legs, shown in the position they were in when he was nailed to the cross, emphasise the fact of Christ's physical death. The Virgin is supported by Saint John and flanked by Mary Cleophas and Mary Salome. The bearded man at the left is presumably Nicodemus; Joseph of Arimathea supports Christ's feet. In the foreground is Mary Magdalene.

To intensify the atmosphere, Bouts has positioned the figures tightly around the tomb. Each of them seems to meditate on the event. Their expressions are subtly different, as though the artist's intention were to convey a variety of griefs and senses of loss. Of the women on the far side of the tomb, one wipes tears from her eyes and the other covers her mouth; the eyes of all three are downcast. The men, on the other hand, and the Magdalen, look directly at Christ's body. The beautiful landscape, the 'garden' Saint John describes as the site of Christ's burial, offers a serene setting for the sad event.

Bout's *Entombment* is painted using the delicate medium of glue tempera on fine linen. Very few pictures of this kind survive from the fifteenth century. In the nineteenth century it was in an Italian collection, together with three companion pieces, also on linen, showing the *Annunciation*, the *Adoration of the Kings* and the *Resurrection* (now respectively in the J. Paul Getty Museum, Los Angeles, a private collection, and the Norton Simon Museum, Pasadena). They may have formed part of an altarpiece with a Crucifixion at the centre, possibly the painting now in the Musées des Beaux-Arts, Brussels, also by Bouts, which is identical in style and technique. *XB*

1 *Meditations* 1961, p. 344.

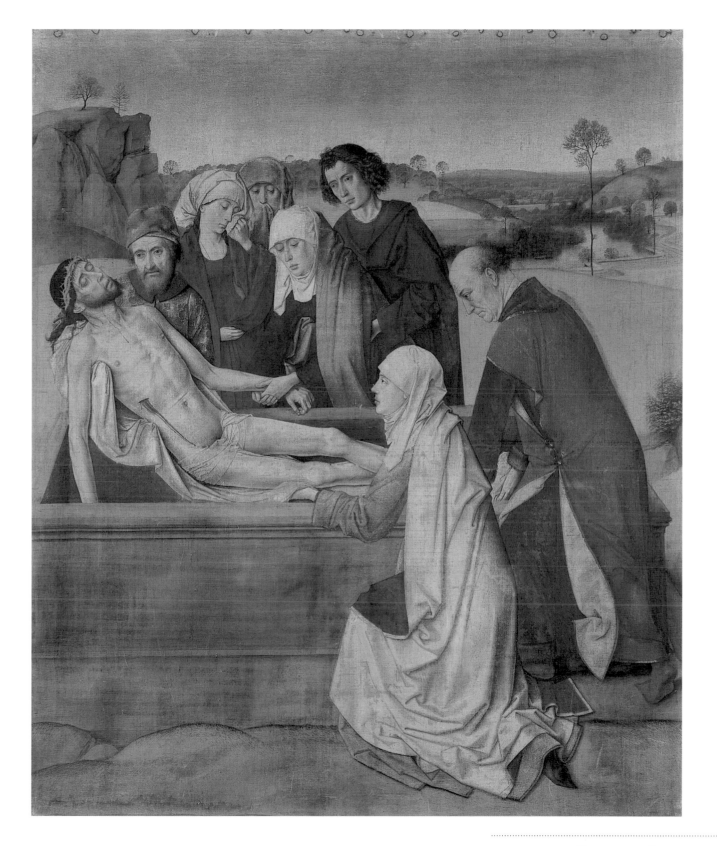

5 Praying the Passion

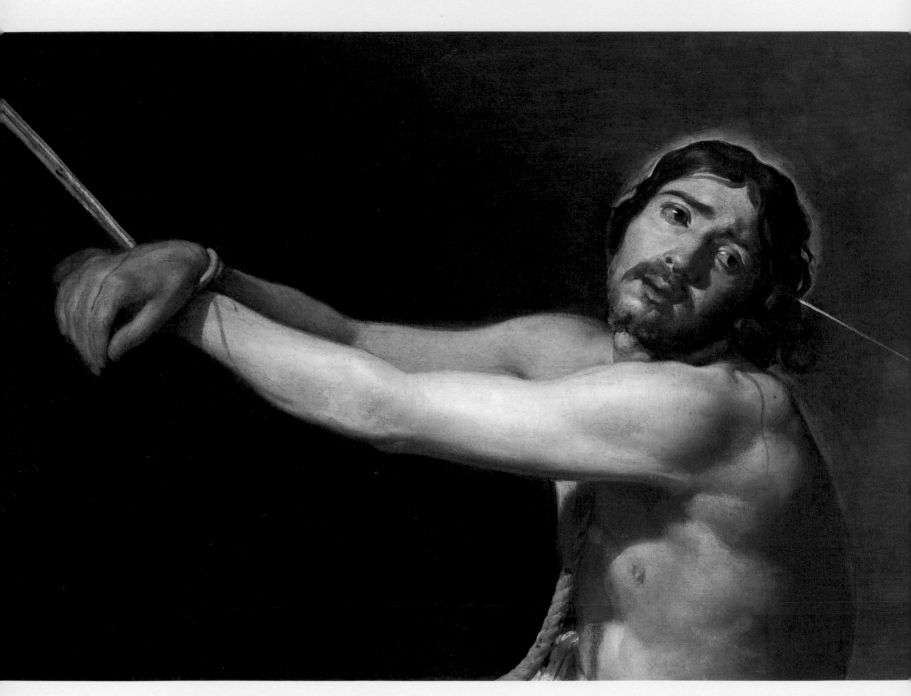

A PASSION IMAGE, whether an altarpiece in a church or a picture or print in the home, could serve as the focus for prayer. A depiction of the suffering Christ served as a reminder of the sacrifice he had made for the sake of humanity, and the feelings of gratitude, pity or pious remorse it inspired in the devout were intended to deepen their love of God. Most Christian traditions have placed great importance on the role that the image – narrative, icon or symbol – plays in the process of meditation and contemplation, since looking upon a representation of Christ is meant ultimately to lead to the imitation of Christ.

In the late nineteenth century Velázquez's painting of *Christ after the Flagellation contemplated by the Christian Soul* (cat. no. 54) was known as 'The Institution of Prayer', a title with a peculiarly Victorian ring to it, but one that nevertheless effectively explains the action of the picture. A child, the personification of a soul, is being instructed by an angel to focus its prayerful attention on the suffering Christ. The child-soul joins its hands together and looks towards Christ with both pity and longing and is rewarded with Christ's gaze, directly at his heart. The painting might be said to offer a clear exposition of the dynamic of prayer: the soul contemplates the suffering Christ with devotional fervour, and Christ in turn invests it with his sanctifying grace. But the painting is also designed to assist us, the viewer, to contemplate the Saviour in his Passion, and the angel's gestures, are obviously directed at us too.

Perhaps the Passion image in front of which most prayers were said in the Middle Ages was the '*Imago Pietatis*', or 'Image of Pity' (see cat. nos. 44, 59–60). It shows Christ taken down from the cross, sitting or standing in the tomb, his arms crossed in front of him and his head inclined to one side. He is placed frontally for our contemplation and the wounds in his hands and side are prominently displayed. Sometimes his eyes are open but more often they are shut, implying that he is dead. The image was apparently based on a vision which the sixth-century Pope Gregory the Great experienced while celebrating Mass, so its status was almost that of a 'true likeness'. It also eloquently identified the body of Christ with the Eucharist, but the most significant reason for its popularity was that it was an Indulgenced image (see p. 76). The inscription beneath an English print dating from about 1500 (cat. no. 60), states that those who 'before this Image of Pity devoutly say five Pater Nosters, five Ave Marias and a Credo … are granted 32,755 years of pardon'.

But there were other ways that images of the Passion could be used in prayer. It is interesting to note that the narrative pace of the Gospels slows down markedly at the Passion, and they give a careful and detailed account of the events leading up to Christ's Crucifixion and burial. There is an assorted cast of characters – Judas, Pilate, the High Priest, Peter, the Soldiers, Simon of Cyrene, the Virgin Mary and Holy Women, the two thieves and Joseph of Arimathea – and the settings are varied; we move from the Garden

ROSARIO DOLOROSO.

Anton. Wierx fecit et excudit.

FIG 33 *Anton Wierix, Rosario Doloroso, 1590s. Engraving, 143 x 92mm. London, British Museum. The print is the second in a series of three engravings showing the Joyful, Sorrowful and Glorious Mysteries of the rosary. Here the five Sorrowful Mysteries are shown on rose blooms joined by rosary beads and attached to a thorn bush. They are the Agony in the Garden, the Scourging, the Crowning with Thorns, the Carrying of the Cross and the Crucifixion. At the centre is the* Pietà.

of Gethsemane at night, to the High Priest's House, then to the *Praetorium* in the morning and through the streets of Jerusalem to Calvary, outside the city walls. The subject matter is ideally suited to serial representation and consequently to the sequential mode of meditation. The practice of meditating on the events of the Passion one after the other was rooted both in the liturgical calendar – with its succession of related feasts – and also in the tradition of pilgrimage to the Holy Places.

When Christians visited the Holy Land they would follow Christ's itinerary from Maundy Thursday to Holy Saturday, visiting the Holy sites, walking the *Via Crucis* (Way of the Cross) and praying at the Church of the Holy Sepulchre, built on the place where Christ was buried. Those who could not make the journey could nonetheless share the pilgrimage experience and live through Christ's final hours empathetically in the Stations of the Cross, a medieval devotion which comprises fourteen images representing the different events of the Passion, from the sentencing of Christ to his burial, before which prayers and petitions are made. Likewise, the rosary (cat. no. 55) offered the opportunity to live through Christ's Passion in the Five Sorrowful Mysteries often represented in prayer books and prints, during which sequences of prayers were recited while meditating upon the episodes from the Agony in the Garden to the Crucifixion (fig. 33). The eye could thus be led by the pictorial representation of the Mysteries while the mind focused on the prayers of the rosary.

Artists also devised their own series of Passion images for sequential meditation. Albrecht Dürer (1471–1528) made three different printed Passion series, one of which, the 'Small Passion', comprises as many as thirty-seven scenes (cat. no. 56). It was issued in book form with devotional poems in Latin attached so that user could both look upon the images and pray the words. The small Passion polyptych illustrated here, dating from the mid-sixteenth century (cat. no. 57), has four doors which open in sequence so that the whole Passion story is told in ten exquisitely painted scenes. The very act of opening and closing these doors becomes part of the process of prayer, enabling the devout viewer to delve ever deeper and with increasing sympathy into the suffering and humiliation of Christ. The two central scenes, both of which are reached at the end of the revelatory sequence of door-opening, are ostentation images in which Christ is presented to the viewer, first as the Man of Sorrows in the *Ecce Homo* scene, and then in the *Pietà* as the dead Saviour borne in the arms of his weeping mother.

For the purposes of private devotion, Passion imagery did not need to form explicit narrative. It often took on a very abstract character. Artists created a range of hieroglyphs or symbols which brought to mind the different parts of the Passion. These function in a different way from the visualised metaphors of the Good Shepherd and the lamb, or the chi-rho monogram and the Sacred trigram (pp. 9–11); they are mnemonics, visual clues that serve to remind the viewer of the torments that Christ underwent. When the Instruments of the Passion – the spear, the cross, the reed and sponge, and the crown of thorns – are abstracted from the narrative context they become *aides-memoires* acting as cues for mediation. No longer the tools of ignominy or dishonour, the Instruments of the Passion become the *Arma Christi* (Arms of Christ), the emblems of Salvation. Medieval artists outdid each other in expanding the repertory of hieroglyphs: Veronica's *sudarium* is one, the thirty pieces of silver another, and so too is the cock that made Peter realise that he had betrayed the Lord.

These abstracted emblems were readily comprehensible to the non-literate and the very lack of explicit narrative context could foster the practice of affective forms of devotion. Some of the objects of the *Arma Christi* had survived as relics – the *sudarium* and Longinus' spear for example – and these inspired their own prayers, like the *Salve sancta facies* (Hail, Holy Face, see cat. no. 37). The emblematic character of the Instruments meant that they could be arranged to make up the coat of arms of Christ and became a sort of heraldic blazon of Redemption (fig. 34).

The five wounds of Christ also formed part of this divine heraldry (cat. no. 62). The devotion to the wounds in the hands, feet and side was very widespread in late medieval Europe and gave rise to some fascinating imagery. The wounds became neat lozenges, floating away from Christ's body to rearrange themselves into abstract patterns in paintings, church furniture and jewellery (cat. no. 63). The cult of the wounds, like the devotion to the Image of Pity, was connected with universal concerns about judgement and eternal life. When a special Mass of the Wounds was instituted in the fourteenth century, it was often said for the dead. The wound in the side was always accorded special prominence because it was considered the door to Christ's heart (cat. nos. 64 and 65). After the Reformation the cults of the *Arma Christi* and the Wounds of Christ largely receded, together with the imagery associated with them. The devotion to the wound in the side, however, was transformed into the devotion to the Sacred Heart of Jesus, which also gave rise to a new, if less visually interesting, iconography. *GF*

FIG 34 *Circle of Bernard van Orley,* Christ the Redeemer and the Virgin with the Arma Christi, *c.1520s. Oil on canvas, 53 x 38 cm. Madrid, private collection.*

54 Christ after the Flagellation contemplated by the Christian Soul, late 1620s or early 1630s

Diego Velázquez 1599–1660

Oil on canvas, 165 x 206 cm.

London, National Gallery, NG 1148

THE ROPE THAT BINDS Christ to the column on the left of the composition is pulled taut by the weight of his body. The grim instruments of torture, the bloodstained whip and the birch, are neatly arranged on the floor in front of him, close to the viewer. Bits of birch have broken off and lie scattered around, indicating the ferocity of the Flagellation. But this is not a straightforward narrative picture. Christ's tormentors are not present; instead, to the right, is an angel who looks down tenderly at a kneeling child, the personification of a soul. The angel gestures with his right hand, directing the meditations of both the child-soul in the picture and the viewer of the picture towards contemplation of the suffering Christ.

Although the Gospels do not dwell on Christ's scourging, the episode proved a fertile one for the writers of commentaries and meditative texts, as well as for artists. Velázquez's particular treatment was not unprecedented and it appears to be modelled on a painting which the Sevillian priest-painter Juan de Roelas (1558–1625) made in 1616 for King Philip III of Spain.[1] That work originally bore an inscription: 'O Soul, have pity on me, for you have reduced me to this state',[2] a phrase which provides the key for interpreting Velázquez's painting.

Velázquez's rendering of the anatomy of Christ, with its fine modelling and elegant contours, suggests that he was seeking to show the contrast between the beauty of Christ and the ugliness of the punishment to which he was subjected. The sight of his broken body is meant to induce our compassion, but also sorrow for the sins which have visited this humiliation upon him. Christ's plaintive look seems to echo the Good Friday 'Reproaches', a hymn used in the Roman Good Friday liturgy, which articulates Christ's disbelief at the ingratitude of his people: 'My people, how have I offended you? Answer me. I bore you up with manna in the desert, but you struck me down and scourged me'.

When the picture was first exhibited at the National Gallery in 1883, various titles were proposed for a British audience quite unfamiliar with such imagery. The most pertinent of these was 'The Institution of Prayer' (see p. 133). At one stage the child was thought to be the medieval mystic, Saint Bridget of Sweden, and so the picture was called 'A Vision of Saint Bridget'. It was no doubt the combination of realism and pathos in the work that led at least one visitor to the National Gallery in 1884 to be profoundly moved before it, though for entirely the wrong reasons: Lord Napier remarked in a letter to the donor of the picture, John Savile Lumley, that 'an old woman of the better lower class' had felt deep emotion at the thought that it showed a child being taken to visit his suffering father in prison.[3]

Nothing is known of the circumstances in which Velázquez produced this picture. It is likely to have been painted for the private contemplation of a powerful and devout individual at the Spanish court where Velázquez worked, someone like the King's Dominican Confessor, Fray Antonio de Sotomayor, who appears in the early 1630s to have commissioned another of Velázquez's rare religious paintings, *The Temptation of Saint Thomas Aquinas*.[4] GF and XB.

1 Madrid, Convento de la Encarnación.

2 '*Alma duelete de mi, que tu me pusiste así*', Valdivieso/Serrera 1985, p. 158.

3 Glendinning 1989, p. 126.

4 Orihuela, Museo Diocesano.

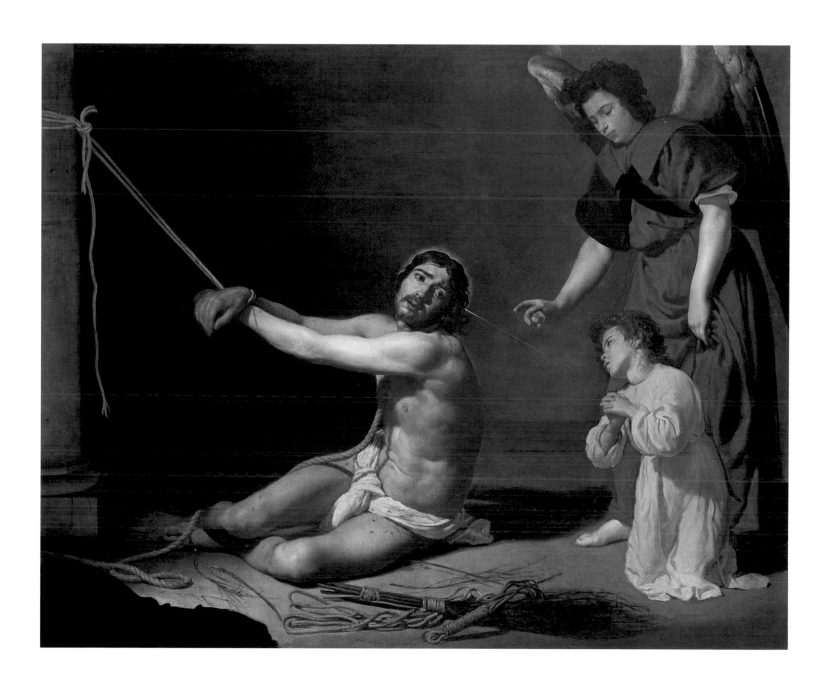

55 Prayer-nut with the Man of Sorrows, about 1500

Southern Netherlandish

Boxwood, diameter: 44 mm.

London, Victoria and Albert Museum, INV.

265–1874

FIG 35 *Sculptor from the Lower Rhine,* Saint Mary Magdalene, *c.1530. Oak, height 82 cm. Utrecht, Catharijneconvent. The Saint is dressed in contemporary early sixteenth-century costume with a rosary hanging from her belt to which is attached a prayer-nut.*

PRAYER-NUTS, or large single rosary beads, were commonly used for private devotion by members of the wealthy classes in the Netherlands prior to the Reformation. They were normally attached to a string of rosary beads, as may be seen in the sculpture from the Lower Rhine showing Saint Mary Magdalene (fig. 35). As well as being beautiful and precious objects, they could function as a focus for prayer and meditation, and in some cases they would have been scented with fragrant pastes or oils in order to heighten the sensory aspects of the religious experience.

Prayer-nuts were invariably made of boxwood, which is particularly suitable for intricate small-scale carving.[1] They were usually decorated on the outside with complex Gothic patterns and the two halves of the orb, joined by a hinge, opened like a prayer book to reveal scenes from the New Testament or from the lives of the saints. Through contemplation of the object the worshipper was drawn into a sort of religious micro-cosm, in which the minute scale and precision of the carving helped to concentrate the mind. The upper half of this prayer-nut (reproduced here larger than life-size) shows Saint John the Evangelist holding the Gospel; he might conceivably have been the patron saint of the original owner. The lower part shows Christ as the Man of Sorrows seated and tied to the column, before being led to his Crucifixion. The user would thus have had an image of the suffering Christ before his or her eyes while reciting the rosary.

The rosary, one of the most popular forms of sequential prayer, offered a definite structure for meditation and prayer.[2] In Europe the use of the rosary became wide-spread from the twelfth century and coincided with the rise of the mendicant orders, the Franciscans and the Domincans, who had a special devotion to the Virgin Mary. The Dominicans became the principal promoters of the rosary, claiming that the Virgin had appeared in a vision to their founder, Saint Dominic (1170–1221), and presented him with a chaplet of beads that he was to call 'Our Lady's Crown of Roses', hence 'rosary'.

Until the sixteenth century, the number and arrangement of rosary beads, forming either a string or a circle, varied according to local practice. Groups of beads for the Hail Mary prayers were interspersed with beads for the Our Father. During the course of the previous century the sequences of 'Ave Marias' and 'Paternosters' had become firmly associated with particular events in the life of Christ and the Virgin, enabling the devout to meditate upon the history of the redemption effected by Christ, from the Annuncia-tion to the Ascension of Christ and the Crowning of the Virgin as Queen of Heaven. The fifteen subjects of meditation, corresponding to the fifteen 'decades' of the Rosary (sets of ten Hail Marys, an Our Father, and a Gloria), were divided into three groups of five 'Mysteries': the Joyful Mysteries, which comprise the Annunciation, the Visitation, the Nativity, the Presentation in the Temple and the Finding of Jesus in the Temple; the Sorrowful Mysteries, based on the Passion, which comprise the Agony in the Garden, the Scourging, the Crowning with Thorns, the Carrying of the Cross and the Crucifixion (see fig. 33); and the Glorious Mysteries, comprising the Resurrection, the Ascension, the Descent of the Holy Spirit, the Assumption and the Coronation of the Virgin. Each of

these groups of Mysteries corresponds with one chaplet, or round, of the rosary, and each chaplet came to be associated with a different day of the week. *XB*

1 For prayer-nuts and carved pomanders, see Leeds 1999.

2 On rosary beads in general see: Wilkins 1969; Marks 1977; Baker 1992; Winston-Allen 1997; Roberta 1998.

56 Eight scenes from the 'Small Passion', 1509–11

Albrecht Dürer (1471–1528)

Woodcuts, each c.126 x 97 mm, comprising:
The Flagellation, Christ Crowned with Thorns, 'Ecce Homo', Pilate Washing his Hands, The Bearing of the Cross, Saint Veronica with the Sudarium and Saints Peter and Paul, The Nailing to the Cross, The Crucifixion.

Each print is signed with Dürer's monogram, the Bearing of the Cross *is dated 1509;* Saint Veronica with the Sudarium and Saints Peter and Paul *is dated 1510.*

London, British Museum, respectively, E.2 238, 239, 240, 241 and 1895-1-22-526, 527, 528, 529

THE DIVISION OF THE PASSION into a sequence of narrative scenes, each inviting individual contemplation, was not an innovation brought about by printing, but when series of prints started to be made from the 1440s onwards the Passion was certainly their most common subject. Early printed Passions survive throughout Europe and were produced by most early masters of the medium including Dürer's German predecessors, the so-called Master E.S. (active *c.*1450–1467) and Martin Schongauer (*c.*1450–1491). Dürer himself produced three series of Passion prints of which the so-called 'Small Passion' with its thirty-seven prints was by far the most extensive – indeed it was the longest series of woodcuts ever issued by Dürer. The 'Large Passion', published in 1511 and named from the size of each print rather than their number, consisted of twelve full-page woodcuts; the 'Engraved Passion', started in 1507 and completed in 1512, had fifteen separate scenes. The variety in the number of scenes reflects the fact that there was no standard way of dividing the Passion narrative and although the 'Small Passion' was unusually extensive it was not uniquely so.[1]

Not all the scenes of Dürer's 'Small Passion' were dedicated to the Passion itself and the work as a whole encompasses the Fall and Redemption of humanity. A frontispiece is followed by scenes of the Fall (Adam and Eve eating the apple), The Expulsion from Paradise, the Annunciation and the Nativity. Twenty-four Passion scenes are then followed by the Resurrection, four scenes of Christ's post-Resurrection appearances, and then the Ascension, Pentecost and the Last Judgement.

The 'Small Passion' was issued by Dürer as a book rather than as separate prints. It was published in 1511, the prints having been made over the previous two years (two

1 An early Netherlandish printed Passion of 1457 (British Museum, M, A.7; S.127 ff.) has all but one of the scenes that Dürer depicted, from the *Last Supper* onwards and includes two additional ones. The closest precedent to the 'Small Passion' in both number, choice and treatment of scenes was a Passion series made by Dürer's pupil Hans Schäufelein, published in 1507 to accompany Ulrich Pinder's *Speculum Passionis* (The Mirror of the Passion). Some scholars have been so disturbed to find the characteristically imitative Schäufelein apparently inspiring his master, that they have suggested Dürer must have acted as adviser on the series. See Winkler 1941 pp. 197–208; Washington 1971, p.184.

THE FLAGELLATION

CHRIST CROWNED WITH THORNS

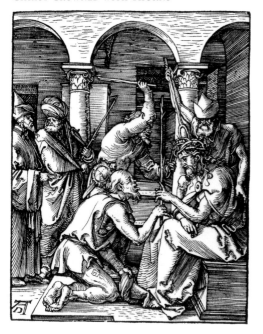

prints are dated 1509 and two 1510). In the same year Dürer published both the 'Large Passion' and his large-scale series of the Life of the Virgin (although he started work on these in the late 1490s and had issued some scenes as single sheets). All three works were accompanied by Latin verses written by the Augustinian monk 'Benedictus Chelidonius' a Latinised version of the German name *Schwalbe*, meaning swallow. The poems accompanying the 'Small Passion' were apparently written in about two months, after the prints themselves had been completed, but they would always have been an integral part of the work as conceived by Dürer, even if many later editions and copies of the series did not include them. The original woodblocks continued to be used after Dürer's death and all but two of them survive, preserved in the British Museum.[2]

The title page makes clear the importance of the relationship between images and verses and the title gives Chelidonius almost as great a prominence as Dürer.[3] Beneath it is an image of Christ as the Man of Sorrows on the Cold Stone (cat. no. 47) accompanied by a short verse addressed to the reader, exploiting the idea of the perpetual Passion, which is that Christ's suffering is perpetuated by humanity's ongoing sins:

O cause of much great sorrow to me who is just,
O bloody cause of the cross and of my death,
O man, is it not enough that I have suffered these things for you once?
O cease crucifying me for new sins.

The twenty-line verses that accompany each subsequent print do not describe Dürer's scenes, but they do frequently call on us to behold or look upon Christ's misery. They

'ECCE HOMO'

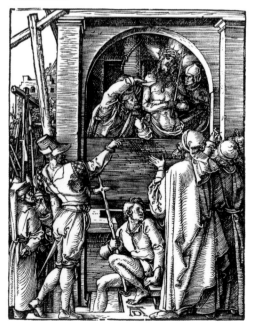

PILATE WASHING HIS HANDS

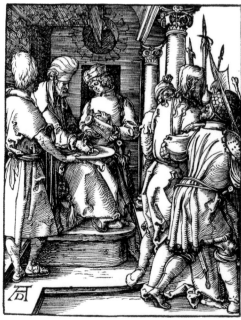

2 For later issues and versions see *The Illustrated Bartsch*, 10 (Commentary), pp. 256–319. There are also some rare impressions, including those exhibited here, made before the addition of the text.
3 'The Passion of Christ illustrated by Albrecht Dürer of Augsberg with verses of various kinds of brother Benedictus Chelidonius Musophili' (Musophili may be translated as 'Lover of the Muses').

share Dürer's concentration on Christ's human suffering, and emphasise, as do the prints, his patient endurance. They also continue to implicate the reader as a cause of Christ's agony, as for example in the verses that accompany the *Christ crowned with Thorns*:

> It is not enough to have flayed Christ with whips
> And vilely persecuted him with all manner of insults
> Behold him more dreadfully tormented …
> He takes in his right hand a broken reed
> With briars and brambles the divine head, true object of veneration,
> Is choked and gouged. Stabbed. Battered.
> Then he is hailed as the King of the Jews on bended knee,
> With mocking laughter he is invested as the ruler of all things.
> Spat upon. Kicked. Pummelled with blows. Torn
> From his high throne and dragged by the hair.
> Look you wretched man, you cause of so much pain.
> The holy body is opened all over with wounds.
> Christ, you have been made man so as to make us gods, and
> You have been chained so as to release us from our chains. God
> Tortured with floggings and thorns under an unjust judge,
> You teach us to bear our sorrows with calm resignation …

THE BEARING OF THE CROSS

SAINT VERONICA WITH THE SUDARIUM AND
SAINTS PETER AND PAUL

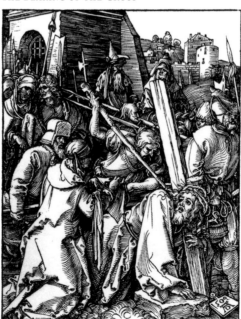

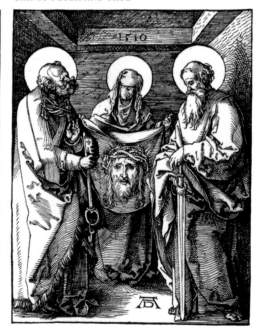

The scale of the 'Small Passion' would have made it an eminently portable devotional aid, but it is less easy to say who might have had it in their pocket. In contrast to the intricate and iconographically subtle 'Engraved Passion', the 'Small Passion' is characteristically described as Dürer's 'most popular Passion',[4] in which the scenes were rendered 'in a direct, easily understandable manner for a wide audience'.[5] But the Latin verses were clearly aimed at an educated elite. They are constructed in a variety of meters and forms, in emulation of Horace's 'Odes', and aim at classical erudition, using terms such as 'Elysium' and 'Styx' for Heaven and Hell, and 'Ceres' and 'Bacchus' for bread and wine. The cost of the work would also have limited its audience. Our knowledge of the price and dissemination of Dürer's prints is almost entirely based on his own diary covering his trip to the Netherlands in 1520–21. This records him either selling or giving away thirty copies of the 'Small Passion' including sixteen copies to a dealer Sebald Fischer in Amsterdam for six *stuiver* each – the same price he asked for the shorter but larger format 'Apocalypse', 'Large Passion' and 'Life of the Virgin', but half as much as he charged for the 'Engraved Passion'. Although the diary shows that Dürer charged more when he could get it, including at one point ten times as much, six *stuiver* a copy is probably the best guide to the value Dürer set on the work. According to the diary, it was equivalent to the price of a pair of shoes, three times the cost of an evening meal or a visit to the barber and twice as much as he paid for an elk's foot. *AS*

THE NAILING TO THE CROSS

THE CRUCIFIXION

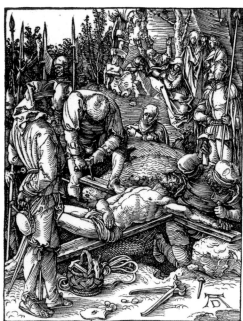

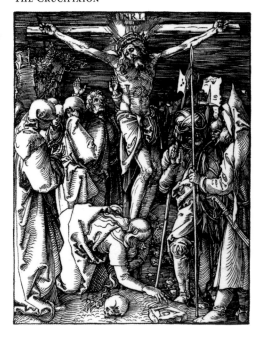

4 Wölfflin 1971, p.175.
5 Strauss 1980, p. 445.

57 Portable Passion Polyptych, mid-sixteenth century

Netherlandish

Oil on oak panels. The brass casing, hinges and nails are modern.

Overall dimensions (including brass casing), 27.8 x 20.9 x 5 cm; individual panels 24.6 x 19.2 cm. (outer doors); 24.2 x 20.2 cm. (inner doors).

The arms of the Spanish families of Ribera (left) and Enríquez (right) appear on both the front and back.

London, The Wernher Collection

THIS REMARKABLE POLYPTYCH shows ten scenes from the Passion, beginning with the arrest of Christ and ending with the Virgin's Lamentation over his dead body (the *Pietà*). The object survives in a complete state, which makes it possible to understand how it was intended to function. It bears the arms of the Enríquez de Ribera family of Seville, who held the title of the Marquisate of Tarifa.[1] Designed to be portable, it closes very neatly and could have been placed in a box or wrapped in a cloth when taken on a journey.[2] In Spain it would have been called an *oratorio portatil*, or portable oratory, a description which implies that it was intended to be used for prayer.[3]

The very act of opening and shutting the various panels of the polyptych enabled the viewer to follow the narrative of Christ's Passion. The individual scenes would have provided a focus for prayer and meditation on the Passion, perhaps in conjunction with set texts, rather like the *Via Crucis*, or Stations of the Cross, a devotion which comprises fourteen images from the Passion before which prayers and passages of the Gospels are recited, usually in Holy Week.

The devotional journey begins with all the panels shut and only the first scene of the *Arrest of Christ* (1) visible on the front. As this panel is opened (there was probably a thread of some sort attached to the door to help it open; the brass fittings currently attached to the outer edges of the panels appear to be modern), it reveals the reverse, which has the next scene in the sequence, *Christ before the High Priest* (2). The opening of this panel exposes the third scene, now in the central area, showing the *Flagellation* (3). As that panel is opened, its reverse shows the *Crowning with Thorns* (4). At this point the central iconic image of the *Ecce Homo* becomes visible (5). The panels are then closed and the altarpiece turned around. A similar process of opening the panels on the other

1 If the picture dates from the middle decades of the sixteenth century, the most likely candidates for the patron who commissioned it are Fadrique Enríquez de Ribera, first Marqués de Tarifa, who died in 1539, or his nephew and successor Per Afán Enríquez de Ribera, who died in 1571.

2 For a discussion of folding polyptychs designed to be portable, see *Art of Devotion*, pp. 137–56.

3 A late example of the use of the term is found in a Spanish inventory of 1662, which describes an object that sounds as though it was similar in type to this one: 'A painting of Our Lady on panel with four doors with various paintings which is called a portable oratory which is about three quarters [of a *vara*] high [about 61.5 cm.]', Inventory of the goods of Pedro Pacheco, Doctor, who died in Madrid, see Getty Provenance Index, E-428, item 0083.

FIG 36 *Diagram showing the sequence for viewing the scenes.*

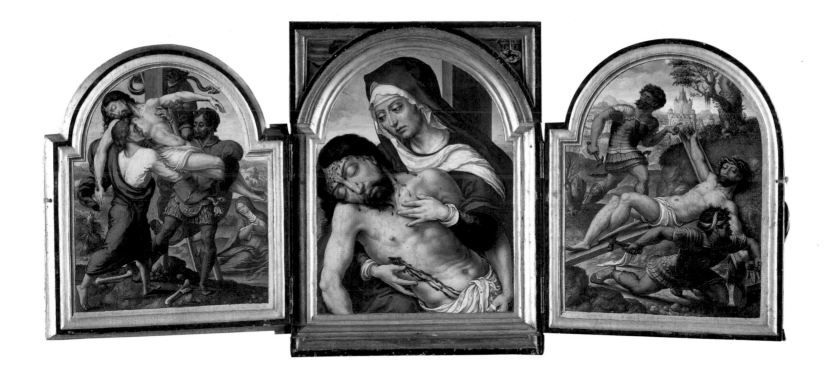

side leads the viewer from the *Way to Calvary with Simon of Cyrene* (6) through the *Nailing to the Cross* (7), the *Crucifixion* (8), and the *Descent from the Cross* (9), to the last scene, the *Pietà* (10), in which the Virgin holds the body of the dead Christ. Both the front and back sequences end with Ostentation images, in which the suffering or dead Christ is put before the viewer for silent contemplation.

Figure 37 shows the panels on the back of the polyptych open, and it may be seen that only two out of the three scenes which are visible appear in narrative order. Because of the way in which the sequence of scenes has been arranged on the panels, we may be sure that the polyptych was intended to be viewed as a succession of consecutive stages rather than as an open and static object, and this makes it more akin to an illustrated book than to an altarpiece. It is unlikely that the polyptych was ever meant to be shown fully open on both sides.

Each panel is painted with great attention to the details of costume, armour, gesture, expression and landscape. The artist has not yet been identified but would appear to be a Netherlandish painter, or one who trained in the Netherlands, who was very familiar with Italian art.[4] The *Flagellation* (3), for example, recalls Michelangelo's famous composition of the subject.[5] The first scene introduces us to some of the artist's peculiar mannerisms: the arm holding a sword on the left of the composition is that of the Apostle Peter, who struck at the High Priest's servant's ear. The painter's tendency to show disembodied limbs at the edges of a composition is designed to suggest that the action extends beyond its borders, and perhaps to draw the viewer on to the next episode in the

FIG 37 *Back view showing the Descent from the Cross (9), the* Pietà *(10), and the Nailing to the Cross (7).*

4 Several other paintings which appear to come from the same workshop are known: a *Crucifixion* and a *Descent from the Cross* are reproduced in Friedländer, 1972, nos. 16 and 17, and attributed to Gossaert; three others appeared at Christie's, London, attributed to the circle of Gossaert: *The Betrayal of Christ*, 16 April 1999, lot 93, and *Christ before the High Priest* and *The Nailing to the Cross*, on 17 December 1999, lot 122. They are less refined in execution than the Wernher Polyptych shown here. It is possible that those five panels went together, with others that are lost, to form a similar polyptych.

5 This composition is best known from Sebastiano del Piombo's painting in S. Pietro in Montorio, Rome.

1 FRONT RIGHT WING (OUTER):
THE ARREST OF CHRIST

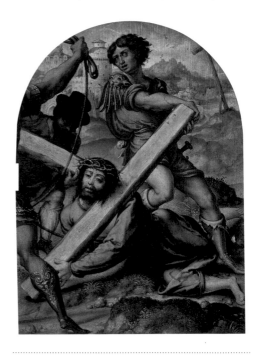

2 FRONT RIGHT WING (INNER):
CHRIST BEFORE THE HIGH PRIEST

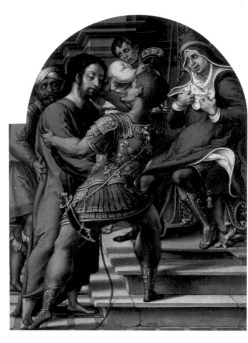

3 FRONT LEFT WING (OUTER):
FLAGELLATION AT THE COLUMN

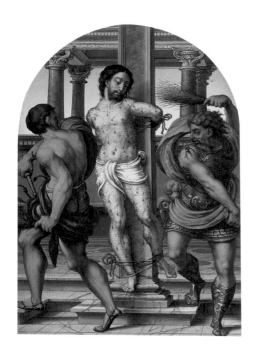

6 BACK RIGHT WING (OUTER):
THE WAY TO CALVARY WITH SIMON OF CYRENE

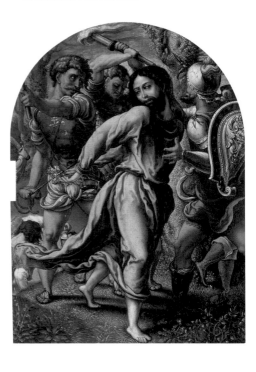

7 BACK RIGHT WING (INNER):
NAILING TO THE CROSS

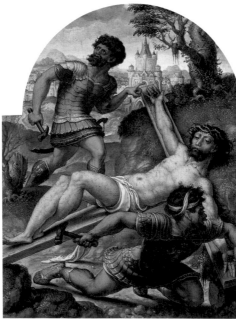

8 BACK LEFT WING (OUTER):
THE CRUCIFIXION

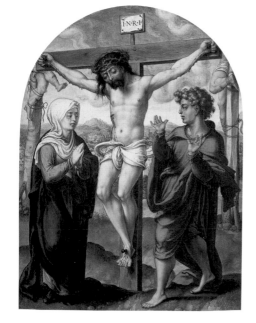

4 FRONT LEFT WING (INNER):
CROWNING WITH THORNS

5 FRONT CENTRE PANEL:
ECCE HOMO

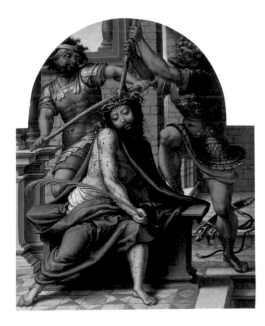
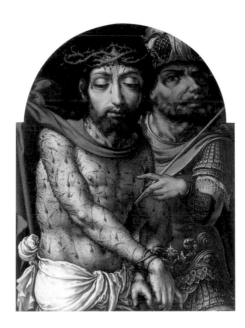

9 BACK LEFT WING (INNER):
DESCENT FROM THE CROSS

10 BACK CENTRE PANEL:
PIETÀ

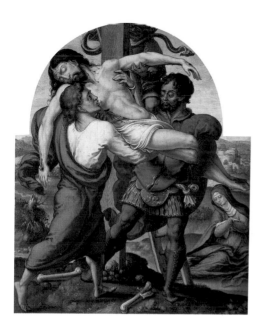
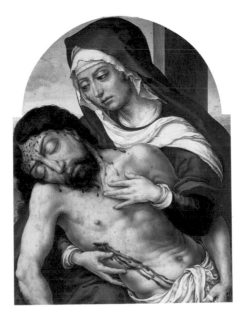

The scenes are shown here in narrative order.

narrative. Several panels, such as the *Flagellation* and the *Crowning with Thorns* (3 and 4), have an elaborate architectural setting, but what is particularly striking is the emphasis on the blood of Christ, which runs down his pale skin in large scarlet beads. The blood is very apparent, too, in the *Ecce Homo* scene (5), where it seems as if Pontius Pilate is actually raising Jesus's cloak in order to draw attention to his numerous flagellation wounds. This is clearly intentional and may have been designed to satisfy the (to modern eyes) morbid spirituality of the Spanish patron of the polyptych, but it is in tune with the contemporary obsession with the minutiae of the Passion.

In earlier times various authors had attempted to work out the number of Christ's wounds, and even the number of drops of blood he shed. The fourteenth-century English mystic and poet, Richard Rolle, devised some very ingenious conceits in his *Meditations on the Passion* which compared Christ's scourged body to a starry heaven, a net with many holes, a dovecot and a honeycomb: 'More yet, Sweet Jesu, thy body is like a book written all with red ink; so is thy body all written with red wounds.'[6]

The artist has not always been attentive to continuity between the scenes: the cross that Christ carries in the *Way to Calvary* (6) is not the same as the one on which he is shown crucified (8), and Saint John wears different garments and has a different hair style in scenes 8 and 9. *GF*

6 Gray 1963, pp. 84-5.

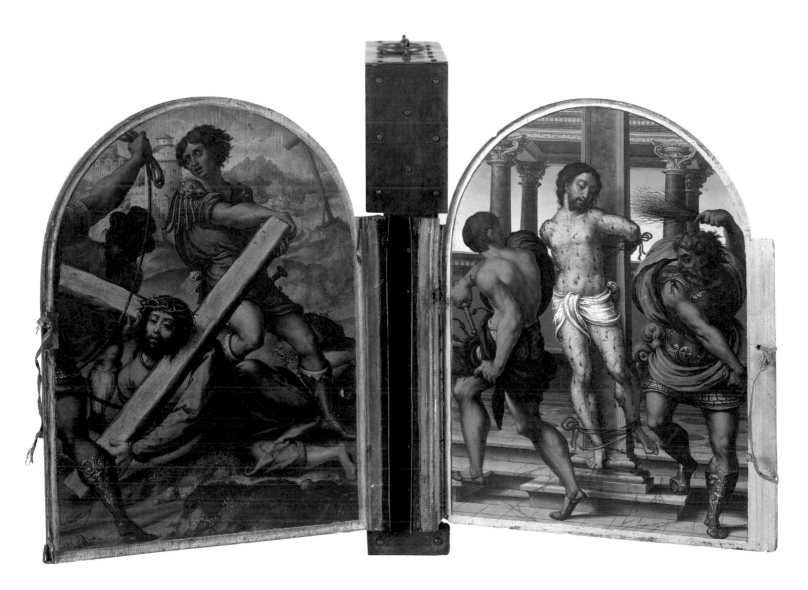

FIG 38 *Side view showing the* Way to Calvary with Simon of Cyrene *(back right wing, outer, 6) and the* Flagellation at the Column *(front left wing, outer, 3).*

58 Mass of Saint Gregory, 1490s(?)

Israhel van Meckenem (about 1440–1503)
*Engraving, made from two plates, 419 x 293
mm. Signed:* IV.M.; *inscribed on the altar
frontal:* I jhesus maria M

London, British Museum, 1845-8-9-348

FIG 39 The Imago Pietatis Icon *from Santa
Croce in Gerusalemme, Rome. Twelfth or
thirteenth century. Mosaic, 19 x 13 cm.*

THIS ENGRAVING COMMEMORATES a vision which Pope Gregory the Great (*c.*540–604) is said to have experienced as he celebrated Mass one day in Rome, in the church of Santa Croce in Gerusalemme. He is shown kneeling in front of the altar between two acolytes; on the left a cardinal holds his papal tiara and on the right another cardinal holds his cross. Above the altar and in front of the open triptych altarpiece showing scenes of the Passion and Resurrection, Christ appears as the Man of Sorrows, standing or seated in his tomb. The cross above him is surrounded by the Instruments of the Passion (cat. no. 59).

In addition to this engraving, Israhel van Meckenem made two others showing only the Man of Sorrows image, which bear a Latin inscription declaring that they were copies of 'the first Image of Pity (*ymaginis pietatis*), which is preserved in the Church of Santa Croce' and which Pope Gregory 'ordered to be painted according to a vision that he had had'. In fact the image which is preserved in the church, a Carthusian foundation, is not a painting but a Byzantine mosaic (fig. 39), which was either transferred from Constantinople to Rome in the twelfth or thirteenth century, or was made by Western craftsman in this period after an Eastern model. An Indulgence of 20,000 years was available to those who said certain prayers after confession in front of the mosaic icon. The Indulgence was extended by Pope Urban IV (1328–59) to apply equally to copies, and over time the number of years of pardon from Purgatory was greatly increased, so that by the second half of the fifteenth century, 45,000 years were pledged. As a result, the Image of Pity became one of the most popular of all devotional images throughout medieval and early Renaissance Europe.

The story of Saint Gregory's vision also invested the Image of Pity with the status of an 'authentic' portrait of Christ, and it was skilfully disseminated as such by the Carthusians through the Charterhouses of Europe. In the narrative context of the vision, the Image of Pity also pointed to the underlying relationship between the Body of Christ and the Eucharist. The chalice stands on the altar but the bread of the Eucharist, which represents Christ's broken body, is not shown and has been substituted by the figure of Christ himself. In the clearest possible way the image demonstrates that, so far as the Roman Catholic Church was concerned, the sacrificial elements of the Mass become, at the moment of consecration, the Body and Blood of Christ, and that those who partake of the elements receive Christ directly. Naturally ecclesiastical authorities were keen to promote an image which spoke so eloquently on the doctrine of the 'Real Presence' in the Eucharist.

Israhel van Meckenem was a goldsmith and a prolific printmaker; about 620 engravings by him are known. He probably came from Meckenheim near Bonn, and may have been the pupil of the anonymous artist known as Master E.S.. After 1475 he was based mainly in Bocholt, a town in Westphalia on the border between Germany and the eastern Netherlands. *SA-Q*

59 The Man of Sorrows as the Image of Pity, second half of the fourteenth century

Venetian(?)

Tempera and gold on poplar panel, arched top, 53.1 x 30.2 cm.

London, National Gallery, NG 3893

60 The Image of Pity, about 1500

English

Woodcut pasted into a manuscript prayer book, 225 x 140 mm. Inscribed To them that before this ymage of pyte deuoutly say fyue Pater noster fyue Aueys & a Credo pytously beholdyng these armes of xps *[Christ's]* passyon ar graunted XXXII M. VII. C. & LV. yeres of pardon (*The inscription has been crossed out but is in the most part readable*).

Oxford, The Bodleian Library, University of Oxford, MS Rawl.D 403, fol. 2v

FIG 40 *Giovanni Bellini*, Dead Christ supported by Angels, *c.1465–70. Tempera and oil on wood, 94.6 x 71.8 cm. London, National Gallery, NG 3912.*

THE *IMAGO PIETATIS*, or Image of Pity, had a variety of manifestations. Christ is usually shown alone, as in these examples, but he is sometimes upheld by two angels (fig. 40) or by the Virgin Mary and Saint John the Evangelist. He is occasionally shown full-length and sometimes reveals his side wound (cat. no. 68), or raises one hand in the act of Judgment (cat. no. 75). The two images discussed here differ from one another in that the painting shows him with his eyes closed, and therefore dead in the tomb, whereas the print shows him alive. While the former would have been found in a wealthy household, the rather crude woodcut of the Image of Pity would have been affordable to all. Prints like this one were hawked at pilgrimage shrines and fairs, or sold by itinerant pedlars travelling around the countryside, and so were very widely disseminated. Once purchased they could be attached to the chimney-mantel for all the members of a family to see, or pasted into Books of Hours or private prayer books, as is the case here.[1]

Both objects served the purposes of private devotion. Typical of the sort of prayer that was said before them is this one from a Franciscan prayer book compiled in Genoa in about 1300: 'O how intensely Thou embraced me, good Jesu, when the blood went forth from Thy heart, the water from Thy side, and the soul from Thy body. Most sweet youth, what hast Thou done that Thou shouldst suffer so? Surely, I, too, am the cause of Thy sorrow'.[2] The prayer most frequently associated with the Image of Pity in fifteenth-century England was the *Adoro te, Domine Jesu Christus in cruce pendentem* (I adore you, Lord Jesus Christ, hanging upon the cross), which comprises seven appeals to Christ in his Passion to be merciful and to defend the soul against sin and hell. Although the prayer was not written specifically to accompany the image, it had been adapted from an earlier prayer to concentrate on Christ's meritorious suffering, rather than on his triumph, and so accorded better with the iconography of the Image of Pity.[3]

The print bears an inscription which states that an Indulgence of 32,755 years was offered to those who said five Our Fathers, five Hail Marys and recited the Creed while looking at the image. Although the words have been roughly cancelled out with a pen they remain readable. This probably happened at the hands of a Protestant for whom the Roman Catholic notions of Purgatory and Indulgences were repellent. Indeed, it was the abuse and sale of Indulgences in Germany at the beginning of the sixteenth century that led Martin Luther to post his ninety-five propositions on the door of the castle church at Wittenberg, which launched the Reformation.

This emphasis on the number five (five Our Fathers, five Hail Marys, etc.) was quite common in the rubrics accompanying Indulgenced images of the Man of Sorrows, and was clearly associated with the five wounds of Christ. The Image of Pity was frequently shown with the Instruments of the Passion, the objects used to humiliate and to kill Christ. The purpose of these displays was to enable the viewer to visualise and then meditate more comprehensively and in greater detail on Christ's sufferings. The items vary in number but usually include objects symbolic not only of the Crucifixion (ladder and nails) but the whole Passion, from the Betrayal (Judas's face and the thirty pieces

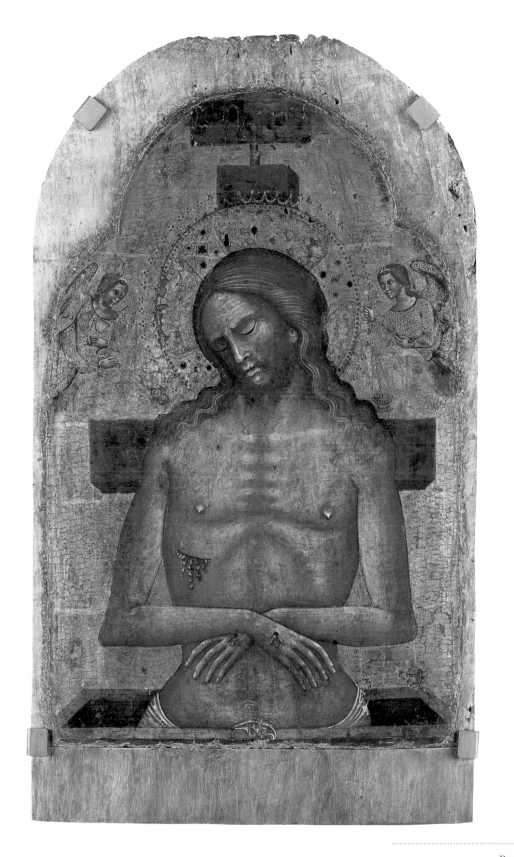

of silver) and Peter's Denial (the cockerel), through to the Trial and the Way to Calvary (Pilate's jug and basin, the column, the heads of mocking soldiers and the hand that struck Christ, and Saint Veronica's veil) and finally the Deposition and Entombment (the jars of spices and ointments brought to the grave by the three Marys). In this particular print, the Sacrifice of Christ is alluded to both by the pelican, a bird that was traditionally believed to wound her own breast in order to feed her young with her blood, and by the Eucharistic elements. *SA-Q*

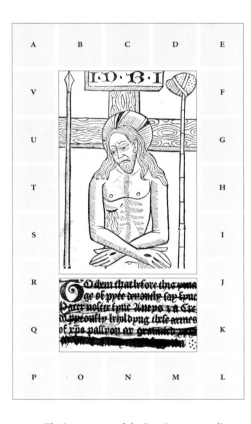

FIG 41 *The Instruments of the Passsion surrounding the Image of Pity, beginning upper left:*

A *The mocking soldier*
B *Peter's cockerel*
C *Veronica's cloth*
D *The High Priest*
E *Pontius Pilate*
F *The Pelican in its piety*
G *Christ's seamless garment*
H *The hammer and pincers*
I *The clubs and swords used in the arrest of Christ*
J *The thirty pieces of silver paid to Judas*
K *The three dice with which the soldiers played for Christ's cloak*
L *The nails*
M *The chalice and host*
N *The jar of vinegar*
O *The jars of spices and ointments*
P *The hand pulling Christ's hair*
Q *The ladder of the Crucifixion*
R *The birches used for the flogging*
S *The column, rope and scourges*
T *Pilate's basin*
U *The lantern used in the arrest of Christ*
V *The hand that slapped Christ in the face in front of the High Priest*
To the left of Christ: The spear that pierced his side
To the right: The stick with a sponge dipped in vinegar

1 This print (cat. no. 59) was inserted with two other woodcuts showing a *Pietà* and the Last Judgement, into a manuscript which was written in about 1500 in the Briggittine Convent of Syon, near Isleworth, Middlesex, a religious house founded by Henry v in 1415.
2 Quoted in *Art of Devotion*, p. 110.
3 Duffy 1992, pp. 239–41.

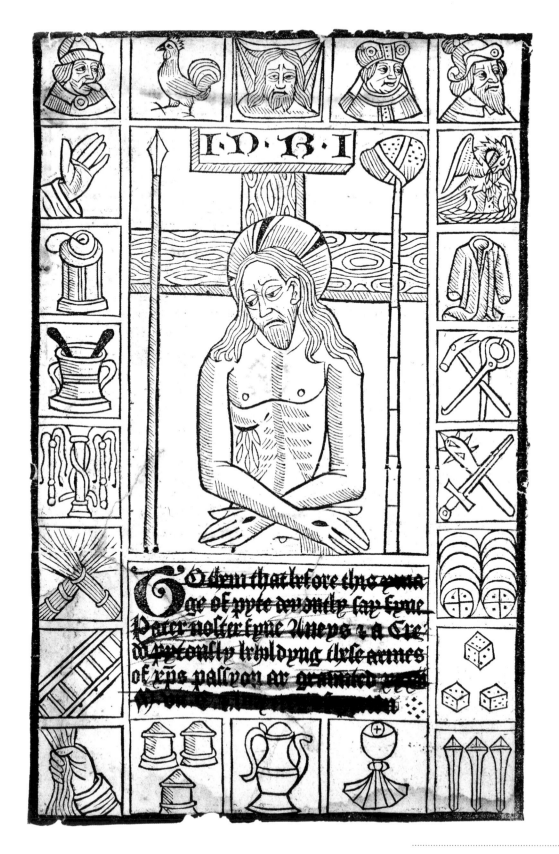

61 Devotional Booklet, about 1330–40

German, Lower Rhine or Westphalia
Elephant ivory with painted and gilded leaves. Height: 10.5 cm; Width: 5.9 cm. (each leaf)

London, Victoria and Albert Museum, INV. 11–1872

THIS LUXURY BOOKLET, with its carved and painted ivory covers and painted ivory leaves, would have acted as a private devotional aid to meditation on the Passion. The book was almost certainly custom-made, in or around Cologne, for the monk (perhaps an abbot) who appears kneeling on both the front and back covers. The front shows him with Saint Lawrence and a bishop saint who presumably had particular significance for the kneeling monk or his religious house. On the back he appears with the scene of the Coronation of the Virgin.

Neither cover relates directly to the Passion, but this is the subject of the scenes inside. The division of the Passion so that each of Christ's sufferings stands alone as a focus of devotion was encouraged by the early fourteenth-century Franciscan *Meditations*, written shortly before this booklet was made and of particular influence in Germany at this time, where they were adapted by Ludolf of Saxony (died 1378) in his own *Life of Christ*. In both the *Meditations* and the ivory booklet the reader is encouraged to enter into each individual episode of the Passion: 'now we shall see each event individually, with great industry'. The emphasis of both is on the sufferings inflicted 'not just by one but by many' on a passive and accepting Christ. This idea is given clear visual expression in the first four scenes of the booklet in which Christ's pose remains almost identical as his tormentors change around him.

BACK COVER FRONT COVER THE LAST SUPPER THE BETRAYAL

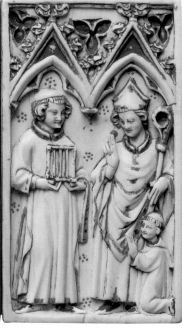

CHRIST BEFORE PILATE CHRIST BEFORE HEROD THE FLAGELLATION PILATE WASHING HIS HANDS

CHRIST CARRYING THE CROSS THE CRUCIFIXION THE RESURRECTION THE 'VERONICA'

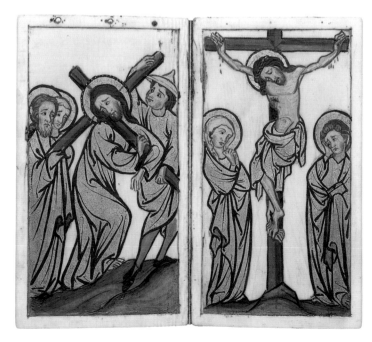

There are six ivory leaves painted on both sides. The first eight panels show scenes from Christ's Passion: the Last Supper, the Betrayal, Christ before Pilate, Christ before Herod, the Flagellation, Pilate Washing his Hands, Christ Carrying the Cross, and the Crucifixion. These are followed by the Resurrection and an image of the Face of Christ or Veronica. Its position after the Resurrection scene, the absence of the crown of thorns and the presence of the letters Alpha and Omega above Christ's head, all accentuate the idea that the miraculous face is not a Passion image as such but rather stands for Christ's actual and continuing presence. In contrast, the Veronica in Dürer's 'Small Passion' (cat. no. 56) immediately follows the scene of the Bearing of the Cross.

The four panels that follow the Veronica image contain a striking collection of images of the so-called *Arma Christi* (see cat. no. 60) which comprise both the Instruments of the Passion and other objects which serve as hieroglyphic reminders of the episodes of the Passion narrative, for example, the hand that slapped Christ when he was before the High Priest and the extraordinary red lozenge shape, which is the wound in Christ's side. The three nails and hammer with which Christ was fastened to the cross are shown with the pincers for removing the nails, the cloth with which Christ was blindfolded and the thirty pieces of silver for which Judas betrayed him (one of these has been erased in error possibly because the third row was thought to contain nine coins like the two rows above it). Below them are three bloody footsteps standing for the walk to Calvary. On the adjacent leaf are Christ's cloak and the three dice with which soldiers gambled for it, the stick or reed which Christ was given to hold as a sceptre, a bloodied whip, the ladder used to take Christ down from the cross, the spear that pierced his side and Christ's tomb seen from above.

The fourteenth century saw the appearance of hymns addressing individual instruments, particularly the crown of thorns and lance: 'Hail triumphal iron, by piercing the breast of the Saviour, you opened the gates of heaven to us'.[1] Devotions to these objects were certainly encouraged by the fact that many of the miraculous relics were believed still to survive in the churches of Europe. But these disembodied reminders of Christ's suffering were also perfectly suited to meditational ends. The aim of meditation is to progress from a contemplation of the physical to the spiritual in order to achieve eventual union with God. Where a narrative depiction of Christ's suffering might tie one to the physical aspects of his Passion through its very detail, these disembodied hieroglyphs are self-evidently a starting point for meditation rather than its end. *AS*

1 Quoted in Mâle 1986, III, pp. 100–101.

62 Angel holding a Shield with the Wounds of Christ, 1475–85

Netherlandish

Oak, 42 x 22.5 x 10 cm.

Utrecht, Museum Catharijneconvent, INV. BMH

bh 562

FIG 42 *David Teniers,* Antonius Triest, Bishop of Ghent, at his Devotions, *1652. Detail. Oil on canvas, 44 x 36 cm. St Petersburg, State Hermitage Museum*

1 See Gray 1963 and Duffy 1992, pp. 234–48.
2 A medieval English example of a bench-end decorated with the Blazon of the Wounds is in the parish church of North Cadbury, Somerset. See Anderson 1955, pl. 12.

DEVOTION TO THE WOUNDS of Christ was very widespread in the Middle Ages, and gave rise to some very interesting, although to modern eyes perhaps rather morbid, imagery. The cult of the Wounds arose from the paradox of Christ's death as a life-giving event – his Passion was terrible but glorious – and his wounds, like the Instruments of the Passion, were frequently described as 'sweet' or 'lovely' in the hymns and religious poems of the time. The Five Wounds of Christ, in his hands, feet, and side, were perceived as the 'doors' or 'wells' of salvation, the signs by which mankind had been redeemed from sin and death, and they were consequently invoked at times of distress and on the deathbed. When a special Mass of the Five Wounds was established in the fourteenth century, it was commonly specified for funerals.[1]

The representation of the Wounds of Christ, disembodied and abstracted from any narrative context, as in this wooden carving, could serve as the focus of devotion and prayer. Henry VI of England (1422–61) was said to have ordered his chaplain to place before him at table a picture representing the Wounds so that he could gaze upon it as he ate, and a painting by Teniers shows an image of the wounds being held up by a Franciscan friar for the devotions of Antonius Triest, the Bishop of Ghent (fig. 42). The wounds on this relief are arranged on a shield held by an angel, and they acquire a heraldic character, like certain representations of the Instruments of the Passion (fig. 34). The type of image is consequently known as the 'Blazon of the Wounds', or sometimes the 'Passion Shield'. The Blazon of the Wounds was adopted as a badge of the Catholics in the Pilgrimage of Grace, the name of the rising against Henry VIII in 1536–37.

Numerous examples of this imagery survive in fifteenth-century woodcuts, in stained-glass windows, engraved tombstones, roof-bosses and bench-ends.[2] This oak relief, which seems originally to have been coloured (traces of black and blue-green paint have been found), may well have been intended as a fitting in a church interior. *GF*

63 Ring with the Five Wounds of Christ and the Image of Pity ('The Coventry Ring'), fifteenth century

English

Gold, diameter: 27 mm. Inscribed on the **outside** *the well of pitty, the well of merci, the well of confort, the well of gracy, and* **by the wound in the side** *the well of ever-lastingh lyffe*

London, British Museum, M & LA AF 897

THIS LARGE FINGER RING, of fifteenth-century English manufacture, demonstrates the variety of objects on which the wounds could be found. In 1533 the German writer Johann Justus Landsberger recommended in his *Pharetra Divini Amoris* (The Quiver of Divine Love) that the faithful should place an image of the Five Wounds where it might encourage devotion, and clearly a ring – since it was worn – was particularly appropriate. This ring was found in Coventry in 1802 and was said to have originally had black enamel in the inscriptions and red enamel in the wounds and drops of blood. These have since disappeared. Other examples of 'Wound rings' are known and they must have been popular in England in the fifteenth century. In his will drawn up in 1487, Sir Edmund Shaw, who was both a goldsmith and Mayor of London, directed that the following be made for his friends: 'XVI. Ringes of fyne gold to be graven with the well of pitie, the well of mercy, and the well of everlasting life'.[1] The combination of the hieroglyphs of the wounds with the Image of Pity, as here, confirms that the devotion to the Wounds was intimately bound up with the devotion to Christ as the Man of Sorrows.

In prayers and religious poems, the association of the individual Wounds of Christ with separate graces or benefits is common. An English devotional poem on the Five Wounds of Christ, composed in the middle of the fifteenth century, begins as follows:

> Gracious lorde for thy bitter passion
> Accepte my prayers that I do repete,
> And on my soule take compassyon
> At my deth for all thy woundes grete.
>
> Of the ryght hande
> Wel of mercy passyng all mysdede,
> Of mercy I pray the I may spede
> The ryght hand, lorde, of trought and unyte,
> Thorough perced with a rugged nayle,
> Be my socoure in the extremitie
> Of deth when he shal me assayle.[2]

FIG 43 *Diagram of the 'Coventry Ring', adapted from Dalton/Tonnochy 1924, p. 151.*

The poem continues in a similar vein with all the other wounds. Because they were perceived as having protective qualities, invocations to the Wounds are often found in charms. In fact on the inside of the Coventry Ring is the following inscription which combines the common devotional formula of the '*vulnera quinque*' (five wounds) with an appeal to the presumed protective properties of the names of God and the Three Kings: *Vulnera quinq dei sunt medicina mei pia/ crux et passio xpi sunt medicina michi jaspar melchior baltasar ananyzapta tetragrammaton* (The five wounds of God are for me a medicine; the holy cross and passion of Christ are for me a balm; Caspar, Melchior, Balthazar, ananizapta, tetragrammaton). The names of the Magi were believed to give protection against various forms of sickness, and the word 'ananizapta', frequently met with in medieval charms, was a talisman against sudden or violent death. The meaning of the letters was explained by the early sixteenth-century Spanish cleric, Martin de Arles, as: *Antidotum Nazareni Auferat Necem Intoxicationis Sanctificet Alimenta Pocula Trinitas Alma* (May the antidote of Jesus avert death by poisoning and the Holy Trinity sanctify my food and drink).[3] The 'tetragrammaton' is the name given to the four Hebrew letters that form the name of God (see p. 9). *GF*

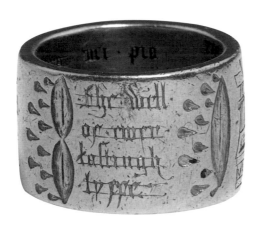

1 Gray 1963, p. 165.
2 MS Douce 1, Oxford, Bodleian Library, transcribed in Gray 1963, pp. 50–51.
3 Lightbown 1992, p. 99.

64 Prayer Roll, late fifteenth century

English

Parchment, c.341 x 10.2/11.8 cm. (made up of four attached membranes, 90 x 11.8 cm., 70 x 11.8 cm., 87.5 x 10.3 cm., 93.8 x 10.2 cm.). The initials are in gold or blue. Inscribed at the top of the second membrane: W[ill]yam thomas I pray yow pray for me your lovyng master Prynce Henry.

Private collection

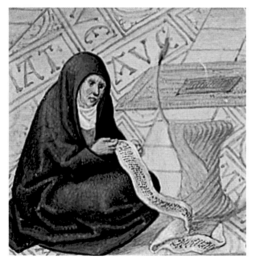

FIG 44 *A woman at her devotions using a prayer roll. Detail from a miniature of the* Coronation of the Virgin *in the 'Rothschild Prayerbook' of about 1510 (fol. 134v).*

1 The prayer roll was probably made for the bishop who is shown kneeling before the Trinity in the first miniature on the first membrane. His arms are present but have not yet been identitified. At some point before 1509 Prince Henry Tudor, later Henry VIII, added the inscription at the top of the second membrane. The William Thomas mentioned in the inscription has not been certainly identified.

2 Uzielli 1899, Bühler 1964.

THIS IS ONE OF THE FINEST surviving English prayer rolls and has never before been exhibited.[1] It contains thirteen miniatures which are juxtaposed with devotional texts, prayers in Latin and English, and cues for individual Psalms. The exhibited section of the roll, which consists of the second section of parchment, shows the Image of Pity (cat. nos. 58–60), the Crucifixion with Angels, the Wound in the Side, and the Nails with the Wounds of Christ and the Crown of Thorns. The images which precede these show the Trinity and the Crucifixion and among those that follow are the Virgin and Child, and a variety of individual saints including Michael, George, and the lesser-known Pantaleon and Armagil.

The user would have scrolled down the roll reciting the texts and prayers while focusing his or her attention on the images. The principal advantage of the prayer roll over a traditionally bound prayer book was that it was more portable; it could be rolled quite tightly and tucked neatly into a pocket. The texts indicate that the roll was intended to be carried around, as it offered protection against accidents and dying without the sacraments. Some prayer rolls were used as 'birth girdles', worn round the belly by mothers during labour as a sort of medical charm. This may account for why so few survive.

The rubric to the right of the image of the Crucified Christ in this roll explains that the miniature is based on the measurement of the length of the Body of Christ: 'This cros. xv. tymes moten [measured] is the length of our Lord IHU [Jesus] Criste and that day that ye bere it upon you ther shal no evyl spirite have power of you on lande ne on watter ne with thonder ne litenyng be hurt … and if a woman be in travell off childe lay this on her body and she shall be delyverd with oute pane the childe Cristendyn.' The 'Measure of the Cross' was a charm with a long history and a Europe-wide diffusion.[2] It functioned in a manner similar to a Relic of the True Cross since it brought the bearer into a privileged contact with the Crucified Christ, if only through a relationship of scale. According to the measurement Christ would have been about 195 centimetres tall.

Related to the 'Measure of the Cross' was the 'Measure of the Nails', which also appears in this prayer roll. The three nails are supposedly life-size representations of those which held Christ on the cross and in the miniature they pass through his disembodied hands and feet. The crown of thorns is woven through the nails and in the middle is Christ's heart, pierced through the wound in the side, which itself appears in the vignette above, borne aloft by angels in a cloud of glory. The text adjacent to the nails shows why devotion to the wounds and the nails was so popular: 'Pope Innocent hath granted to every man and woman that berith upon them ye length of these nailes seying daily v Pater nosters v Ave Marias and i Credo shall have vij giftes. The first is that he shal not dye no soden deth. The second is he shal not be slayne with no sword ne smyte. The iija is he shal not be poysoned. The iiij his enemys shal not overcome hym. The v is he shall have sufficient goodes to his lyves ende. The vj is he shal not dye withowte all the sacramentes of holy church. The vij is he shall be defended from evell'. *GF*

65 Prayer sheet with the Wounds and the Nail, late seventeenth century

Issued by J. P. Steudner in Augsburg, Germany. Engraving, 40 x 31 cm.

Nuremberg, Germanischer Nationalmuseum,

INV. 24492/1199

THIS BIZARRE PRINT is an illustrated prayer sheet showing, at the top, an abstracted rendition of the wound on Christ's shoulder which resulted from his carrying the cross; in the centre, one of the nails of the Crucifixion, and underneath, the wound in the side. The print was published in Augsburg in southern Germany at the end of the seventeenth century and testifies to the enduring nature, in Roman Catholic regions, of the medieval devotions to the Wounds of Christ.

It should be said, however, that depictions of the wound on Christ's shoulder are rare and seem not to have inspired a very significant devotional tradition. The prayer directly beneath it opens as follows: 'O dearest Lord Jesus, you gentle Lamb of God, I, a poor and sinful person, greet and honour the most sacred wound which you received on your shoulder as you carried the heavy cross'. It ends with an appeal to Christ that he should forgive the devotee's sins and that he should let him follow in the 'way of the cross and in your bloodstained footprints to eternal happiness'. This recalls the imagery of the fourteenth-century German devotional booklet (cat. no. 61).

The prayer to the wound in the side addresses Christ as 'Gracious Pelican' (see cat. no. 60) and then turns to the wound: 'O most healing wound of the heart of Jesus Christ, in your divine goodness I adore you and greet you. Blessed is the love which split you open and blessed is the blood and water flowing from your side to wash our sins away'. The prayer entreats Christ to show his 'honeysweet wound' to God the Father on Judgement Day so that he may forgive 'all the sins which I, with my sinful heart, have often committed'. This is precisely the subject of the painting by Petrus Christus of *Christ as Saviour and Judge* (cat. no. 75).

To the modern viewer the similarity of the cartouche images to male and female genitalia suggests disturbing pornographic comparisons, but the seventeenth-century viewer may not have found the similarities so unsettling. The highly sensual, at times almost obsessively erotic, concern with the Wounds of Christ demonstrated in the poetry, devotions and visual imagery of the Middle Ages, indicates that the sensual mode was felt to be a legitimate and effective means of entering into a relationship with the Christ of the Passion narratives. Even the libido could be redirected from its base concerns towards a proper and virtuous devotion to holy things. *GF*

Eigentliche Abbildung der Wunden/ so Christo dem HErrn in

seiner Heil. Seyten gestochen worden/ sambt schönen Gebettlein.

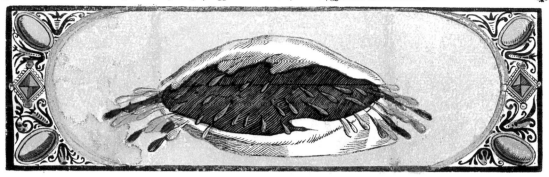

Abbildung der Näglen/ so Christo durch seine Heilige Händ vnd Füß geschlagen worden.

Allerliebster HErr JEsu Christe/ du sanfftmütiges Lämblein GOttes/ Ich armer sündiger Mensch/ grüsse vnd ehre die allerheiligste Wunden/ die du auff deiner Achsel empfangen/ als du dein schweres Creutz trugest: Welcher wegen du/ zugleich wegen der drey außstehender Gebeine/ sonderlich grossen Schmertzen vnd Pein über alle andere an deinem gebenedeyten Leib gelitten. Ich bette dich an/ O schmertzhaffter JEsu/ dir sage ich Lob/ Ehr vnd Preiß/ auß

aus innigem Hertzen/ vnd dancke dir für die allerheiligste/ tieffeste vnd peinlichste Wunden deiner H. Achsel/ vnd bitte demütiglich/ du wöllest dich wegen der grossen Schmertzen/ vnd Pein/ so du in diser tieffsten Wunden erlitten/ vnd wegen deß schweren Last deß Creutzes/ den du auff deiner Wunden geduldet/ über mich armen Sünder erbarmen/ mir alle meine läßliche vnd tödliche Sünden zuverzeyhen/ vnd mich in deinem Creutzweg vnd blutigen Fußstapffen/ zur ewigen Seeligkeit begleitten/ Amen.

Gebett zu der Seyten-Wunden.

Gütiger Pelican HErr JEsu Christe/ der du vns mit deinem H. Blut von vnsern Sünden gereiniget hast/ Ich sage dir hertzlichen danck/ für die allersüsseste vnd heylsambste Wunden der Liebe/ welche du vmb vnsert willen am Creutz empfangest/ als die vnüberwündliche mit ihrem Liebes Pfeil dein hönigflüssende Seyten eröffnete/ vnd dein überflüssestes Hertz durchstochen hat. O allerheylsambste Wunden deß Hertzen JEsu Christi/ in Göttlicher Gütigkeit anbette vnd grüsse ich dich. Gebenedeyet sey die Lieb/ die dich zerspalten hat/ vnd gebenedeyet sey das Blut vnd Wasser/ so auß dir zur Abwaschung vnser Sünden geflossen ist. Mit disem heiligen Wasser/ wasche ab mein Sündige Seel/ vnd mit disem heiligen Blut/ stärcke vnd ziere mein elendiges Hertz vnd laß mir nur ein einiges Tröpflein/ dises allerheiligsten Bluts zum besten kommen/ O süssister JEsu/ ich bitte dich durch die Liebe/ mit welchen du dise hönigflüssende Wunden hast wöllen empfangen/ daß du am Tag deß strengen Gerichts/ dieselbige theure Wunden deinem Himlischen Vatter zeigen wöllest/ für alle Sünden/ welche ich mit meinem sündigen Hertzen offtmal begangen hab/ Amen.

Augspurg/ bey Johann Philipp Steudner/ Brieffmahler/ Hauß vnd Laden bey der Metz.

6 THE SAVING BODY

WESTERN ART IS UNIQUE in its preoccupation with the naked body, in particular the naked male body. In the language of art, of course, the naked body is not usually a naked body, but a nude – 'an art form invented by the Greeks in the fifth century BC'.[1] Despite Christianity's ambivalent view of the body, this pagan invention profoundly affected Christian imagery.

Although the Gospels refer to Jesus's nakedness only once, when he is stripped of his garments to be crucified, fifth- and sixth-century Christian artists represented him as a classical nude in scenes of his Baptism in the River Jordan. They did so partly because he was then immersed in water, where he would have been expected to take off his clothes, but mainly because it was at the Baptism that his dual nature as man and God was revealed. The nudity once associated with Graeco-Roman statues of pagan gods, expressing ideal harmony and beauty, was still, at that date, the clearest visual sign of divinity.

Ancient Greek philosophers introduced the distinction between body and soul, but pagan Greeks and Romans generally believed that body and soul developed in tandem: 'a healthy mind in a healthy body'. Christians, on the other hand, came to perceive body and soul as virtual opposites; Christian ascetics mortified their bodies for the welfare of their souls. The nude was reduced to the naked: a body humiliated, shorn of dignity, vulnerable to mockery, injury and pain. By the seventh century, it no longer seemed decorous to show the Son of God naked even on the cross, where he often appears clothed in a tunic or knee-length skirt; in Baptism scenes his body is concealed under a solid, bell-shaped mass of water.

Yet Christianity teaches that Christ was, as we ourselves shall be, resurrected in the body, and the notion of Christ's body is central to Christian belief and practice. From the thirteenth century, as greater stress was put on an affective relationship with Christ (see cat. no. 23), artists once again divested him of his garments – in order, now, to evoke pity for his abject, human nakedness (cat. no. 44). By the fifteenth century, as Italian artists rediscovered the expressive formulae of Graeco-Roman art, the naked and the nude were fused. Complex doctrines could be now communicated simply by picturing the saving body of the risen Christ – a beautiful body beyond the reach of Mary Magdalene's earthly love (cat. no. 66), but also the body proffered to doubting Thomas as tangible proof of Christ's victory over death (cat. no. 67).

The significance of Christ's body in the life of the Church was first enunciated in the Gospels, most clearly by Saint John, and in the Letters of Saint Paul. Christ speaks of himself as:

> … the living bread, which came down from heaven: if any man eat of this bread, he shall live for ever: and the bread that I will give is my flesh, which I will give for the life of the world. (JOHN 6: 51)

1 K. Clark, *The Nude: A Study of Ideal Art*, London, 1956, p. 3.

Christ's body is the Eucharist administered at the altar table. But it is also more. Through Holy Communion, Christians are made one with Christ and with each other; Christ's body becomes the Church of Christ:

> He that eateth my flesh, and drinketh my blood, dwelleth in me, and I in him. (John 6: 56)
> For we being many are one bread, and one body: for we are all partakers of that one bread. (1 Corinthians 10: 17)

If to the faithful the Eucharistic body is essentially the means of fellowship and salvation, to the historian the sacrament of the Eucharist, as administered by the Church, can also appear as a political instrument: it was above all through this sacrament that the Roman Church claimed authority over Christendom. The doctrine of transubstantiation, defined by the Lateran Council in 1215, holds that Christ is truly present in the bread and wine consecrated by an ordained priest. The belief in transubstantiation is thus by definition also an assertion of the clergy's exalted role. When threatened by schism or the loss of privilege, the Roman Church has usually responded by celebrating the Eucharistic mystery with renewed fervour and pomp.

This first became apparent in 1264, when, to combat heretical doubt, Pope Urban iv declared that the Feast of Corpus Christi – the Body of Christ – until then a local festival in honour of the Real Presence, should be celebrated throughout the whole

FIG 45 *Ercole de'Roberti,* The Institution of the Eucharist, *probably 1490s. Egg on wood, 29.8 x 21 cm. London, National Gallery,* NG 1127.

Church. Corpus Christi became one of the Church's principal feasts, marked by splendid pageants and processions during which time the consecrated Host was displayed and in which secular institutions and even princes and sovereigns were encouraged to take part. The rejection of the doctrine of transubstantiation by Protestant reformers naturally led to the suppression of the festival in reformed churches, in mainly Protestant or anti-clerical countries, and to its ever greater prominence in Roman Catholic ones, where to this day it continues to involve entire communities.

Since seeing and adoring the Host, whether in procession or in church, is itself thought of as a form of communion, elaborate containers were created for its display. Not surprisingly, their decoration, like that of Roman Catholic altars and liturgical vessels in general, is designed to reinforce belief in Christ's Real Presence in the Eucharist (cat. no. 72).

Some episodes in the Gospels are especially suited to the purpose. The Last Supper, at which the Eucharist was instituted (fig. 45), and the Crucifixion. In Raphael's altarpiece (fig. 46), angels collect Christ's blood in chalices and Christ's body is elevated on the

cross, just as the Eucharist is lifted by the priest above the altar. In scenes of the Deposition from the Cross, Christ's body can appear to be being lowered onto the altar (cat. no. 69). However, a purely symbolic Eucharistic imagery was also invented. Bellini's *Blood of the Redeemer,* which may once have decorated the door of a tabernacle where the consecrated Host was kept, does not illustrate a particular moment either in Christ's life or after his death (cat. no. 71). Timeless, like the nude sculptures of classical Greece whose relaxed pose he adopts, Christ appears as the sacrifice that supersedes the idolatrous pagan sacrifices of the bas-reliefs in the background. His blood flows perpetually from the wound nearest his heart into the chalice, and he compassionately bares his body to our gaze as the living bread which came down from heaven. Palma Giovane (cat. no. 70) makes a similar point in his drawing. If this design was, as seems probable, embroidered on the back of a priestly vestment worn while celebrating Mass, it would have been most clearly visible when the priest – according to sixteenth-century liturgical practice – raised the chalice above the altar with his back to the congregation.

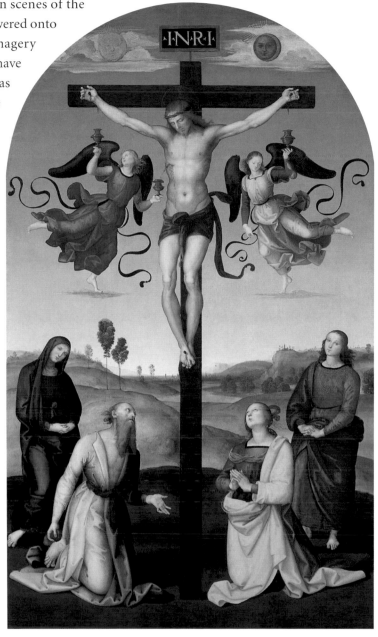

While these images are demonstrably related to liturgical use, the intended function of other works shown here is less obvious; their symbolism perhaps even more complex. The anonymous Florentine artist's grasp of the classical idiom of the nude enables him to contrast the beauty of Christ's body with the pathos and horror of its injury (cat. no. 68). No more is needed either to arouse compassion or to evoke meditation.

Northern European artists, perhaps less confident in their ability to communicate feelings and ideas through Christ's body alone, tended to rely more on the context in which it appeared. The wine press, because it is a recurrent biblical metaphor as well as a Eucharistic symbol, represents Christ as the fulfilment of Old Testament prophecies (cat. nos. 73 and 74). By using the conventions of both royal portraiture and scenes of the Last Judgment, Petrus Christus's exceptionally rich image shows Christ as at once the object of Sacrifice, and as our Saviour, Advocate, Judge and King (cat. no. 75).

All these works, however, whatever their origins and intended functions, depend on the extraordinary conjunction of Christian theology and the Western artistic tradition – for the body is central to both. Christ's saving body, the visible symbol of his abiding presence in the world, could never have spoken so eloquently to believers had the pagan Greeks not invented the nude, the human body sublimated into art. *EL*

FIG 46 *Raphael,* The Crucified Christ with the Virgin Mary, Saints and Angels *(Mond Crucifixion), c.1503. Oil on poplar, 280.7 x 165.1 cm. London, National Gallery,* NG 3943.

66 Noli me Tangere, about 1515

Titian (active about 1506–1576)

Oil on canvas, 109 x 91 cm.

London, National Gallery, NG 270

T HE LATIN TITLE OF Titian's painting, *Noli me Tangere* (Touch me Not), are the words spoken by Christ to Mary Magdalene at his first apparition the morning after his resurrection. According to the Gospel of Saint John, the Magdalen had come to Christ's tomb, but finding it empty and thinking that his body had been taken away, she began to weep in distress (JOHN 20: 11-18). At that moment a man appeared before her and, mistaking him for a gardener, she implored him to tell her where she might find Christ's body. When the man spoke her name, she recognised Jesus and attempted in vain to touch him. It is this very moment that Titian has depicted.

The artist shows Christ holding a gardener's hoe, enabling us to understand the Magdalen's initial reaction. X-rays of the picture demonstrate that Titian had originally painted Christ wearing a gardener's hat, perhaps to disguise him further, but he subsequently painted it out. We, however, quickly recognise him as the Christ who died on the cross, for his feet bear the marks from the nails. We recognise him, too, as the risen Christ, because the white garment that covers his nakedness symbolically alludes to his resurrection. Mary enthusiastically leans forward on the jar of ointment she has brought to anoint him in order that she might touch him. But Christ draws back saying, 'Touch me not; for I am not yet ascended to my Father'. Instead, he tells her to 'go to my brethren, and say unto them, I ascend unto my Father, and your Father; and to my God, and your God' (JOHN 20: 17).

This passage from the Gospel of Saint John has both fascinated and puzzled people through the ages. Christ reserves his first appearance after his resurrection for Mary Magdalene, the woman who had been a sinner (LUKE 7: 47), yet the boldness of the Latin phrase *Noli me Tangere* hints at reproach. Other translations render Christ's words as 'Do not desire to touch me', or 'Do not cling to me', suggesting that the love Mary Magdalene had for Christ, which had transformed her, must now itself be transformed. The time of Christ's bodily presence on earth is passing and she will learn to love him spiritually, as God rather than as a man. Titian captures the subtlety and profoundness of the exchange between them in the poses and gestures, in Christ's graceful pulling away and in the reaching out and yearning of the Magdalen.

Nothing is known of the circumstances in which Titian painted this picture. Nevertheless, his sensitive interpretation of the Gospel story and his evocative treatment of the north Italian landscape in which the figures are set, suggest that the original patron would have enjoyed the picture for its aesthetic merits as well as its religious sentiment. *XB*

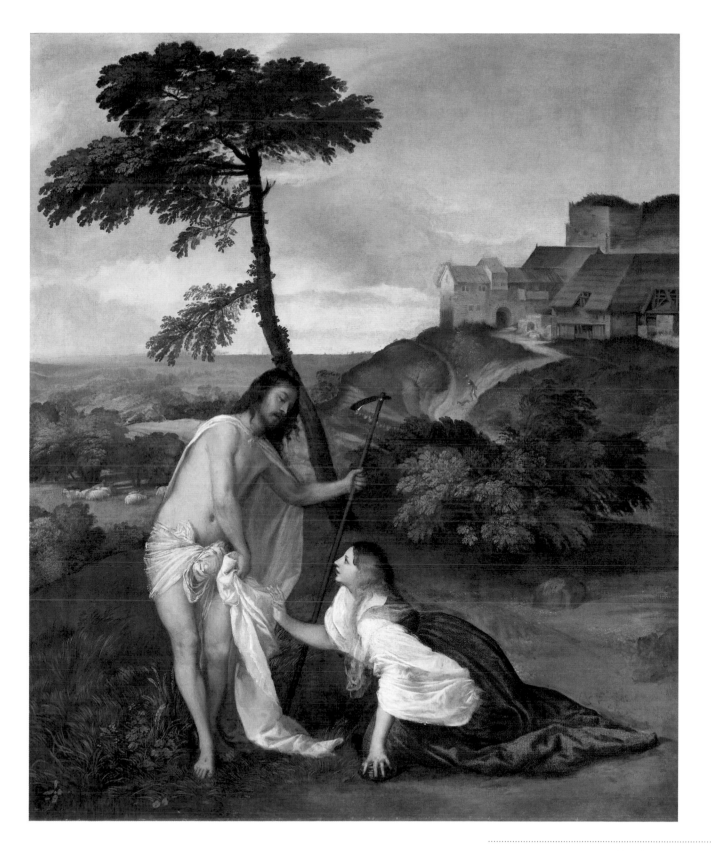

67 The Incredulity of Saint Thomas, about 1620

Bernardo Strozzi (1581–1644)

Oil on canvas, 89 x 98.2 cm.

Compton Verney House Trust (Peter Moores Foundation)

THERE WERE NO WITNESSES to the actual moment of Christ's Resurrection, and it was through his subsequent appearances to his disciples that Christians found confirmation that the event had occurred. On the first occasion that Christ appeared to the Apostles as a group, Thomas was not present. Christ invited them to assure themselves, by touching him, that he was not a phantom but the Risen Jesus, 'for a spirit hath not flesh and bones, as ye see me have' (LUKE 24: 39). However, it was not until he 'did eat before them' that they were fully convinced that his resurrected body was real (LUKE 24: 43). When they told Thomas of Christ's appearance to them, he declared that he would not believe until he too had satisfied himself by sight and touch: 'Except I shall see in his hands the print of the nails, and put my finger into the print of the nails, and thrust my hand into his side, I will not believe' (JOHN 20: 25). Eight days later, when he appeared again, Thomas was present. Christ told him to touch his wounds: 'Reach hither thy finger, and behold my hands; and reach hither thy hand, and thrust it into my side: and be not faithless, but believing' (JOHN 20: 27).

This is the moment that the Genoese priest-painter, Bernardo Strozzi – also known as 'Il Cappuccino', because he was a Franciscan Capuchin – has represented in this picture. The scene is shown close-up and the figures are cropped so that the viewer feels implicated in the drama of recognition. The lighting of the composition draws our eyes towards Thomas's finger as he gingerly pushes it into the wound in the side. Christ actually assists him by holding and guiding his hand. The difference in tone between Thomas's tanned bald patch and Christ's radiant whiteness reflects the contrast between the risen and transformed state of Christ and the earthbound cynical nature of doubting Thomas. The artist shows the figure of Christ exposed and in full view, whereas that of Thomas is seen from behind and in shadow.

In his post-Resurrection appearances, Christ insisted on the physical nature of his body. His wounds proved that it was the same body as before, even though his disciples found it difficult to recognise him. Yet Christ's body was transformed, not bound by physical laws and limitations. He could appear and disappear, he could pass through closed doors, and he was later to ascend physically into heaven. Unlike Lazarus, or Jairus's daughter, who were restored to life by Jesus but remained subject to mortality (JOHN 11 and LUKE 8: 41–42, 49–56), Christ's Resurrection was to immortality. Saint Paul was unequivocal on this point: 'We know that Christ has been raised from the dead and will never die again. Death has no power over him any more' (ROMANS 6: 9).

The Gospel of Saint John states that Thomas's reaction to the Risen Christ was immediate and adoring: 'My Lord and my God' (JOHN 20: 28). This profession of faith is one of the most powerful in the New Testament. In response, Christ said, 'Because thou hast seen me, thou hast believed: blessed are they that have not seen, and yet have believed' (JOHN 21: 29). For the Apostles, the Resurrection was the ultimate proof of Christ's divinity, and the confirmation of the truth of his teaching. *XB*

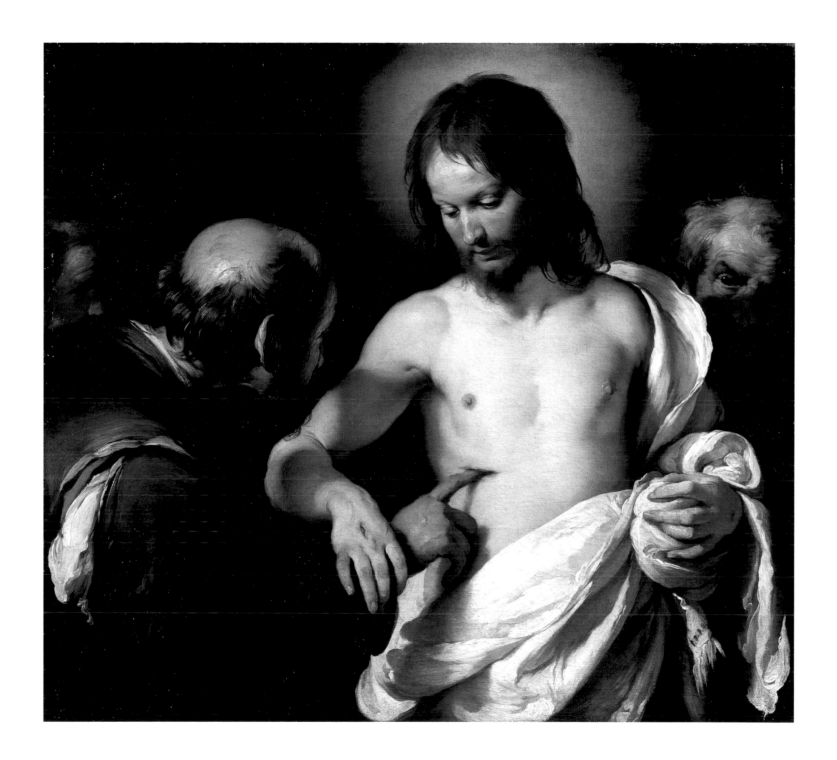

68 Christ showing the Wound in his Side, about 1420–25

Italian (Florentine)

Terracotta, with traces of polychromy, height 105 cm.

London, Victoria and Albert Museum, INV.

A.43-1937

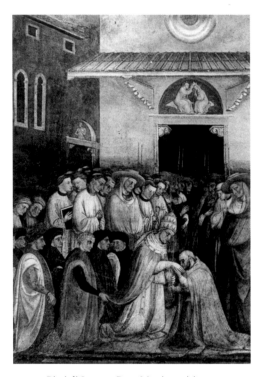

FIG 47 *Bicci di Lorenzo* Pope Martin v visits the Church of S. Egidio (detail), c.1420–25. *Fresco. Florence, S. Maria Nuova. A sculpture of Christ displaying the wound in his side, similar to the one shown here, can be seen in the lunette above the door on the left.*

IN THIS IMPRESSIVE, almost life-size sculpture, Christ draws the viewer's attention to the wound in his side, which he holds open with his hands. Although he does not look out at us, he invites us to look and perhaps to touch. The gesture recalls Christ's invitation to Thomas to touch and to believe (cat. no. 67), but the sculpture should not really be thought of primarily in narrative terms. Rather, it is a richly allusive image which speaks of the ongoing relationship between Christ and humanity: the wound is a symbol of Christ's continual and gracious action in the world and of his promise to act as humanity's advocate before the Throne of Judgment on the Last Day (cat. no. 75).

Elaborate devotions grew up based on the Wounds of Christ. The veneration of the side wound seems to have its origin in the fact that it was the wound nearest Christ's heart and could therefore be taken as a pledge of his perpetual heartfelt love for humanity. The side wound was often evoked as a refuge for sinners, for instance in prayers such as the *Salve plaga lateris nostri Redemptoris* (Hail the wound in the side of our Redeemer). Traces of this devotion may be detected in the words of *Rock of Ages*, a hymn still popular today, which includes the lines: 'Rock of Ages cleft for me/ Let me hide myself in Thee'. Apart from sheltering sinners, the side wound was seen to cleanse and feed them. A whole genre of images emerged which presented the blood from the side wound flowing into a pool in which people bathe, while other images portrayed Christ's blood flowing into a chalice; occasionally Eucharist wafers are seen falling from the wound.

The wound in the side was also referred to as a door, recalling Christ's description of himself: 'I am the door: by me if any man enter in, he shall be saved, and shall go in and out, and pasture' (JOHN 10: 9). The metaphor of Christ as the door to the Father or the way to Eternal Life is especially appropriate in the case of the present sculpture since it is very likely that it was placed above a doorway. The design of the figure seems to demand viewing from below, and a very similar sculpture can be seen in a fresco by the fifteenth-century painter, Bicci di Lorenzo, over a doorway leading to the *Chiostro delle Ossa*, or 'Cloister of Bones', next to the entrance to the church of S. Egidio in the hospital of Santa Maria Nuova, Florence. In a hospital, such an image of Christ would have been intended to offer comfort and consolation to the sick and dying, and to their visitors.

The present work has been tentatively identified as the sculpture which is visible in the fresco by Bicci di Lorenzo (fig. 47) and it has been attributed to the sculptor Dello Delli, who is known to have produced some sculptures for S. Egidio. However, the identification, and consequently the attribution, seem very unlikely.

It is just possible that this sculpture may have served as a Passion reliquary; at any rate, when it was acquired by the Victoria and Albert Museum a circular cavity in the chest area was discovered, containing sand and a thorn, presumably a relic from Christ's crown of thorns. *SA-Q*

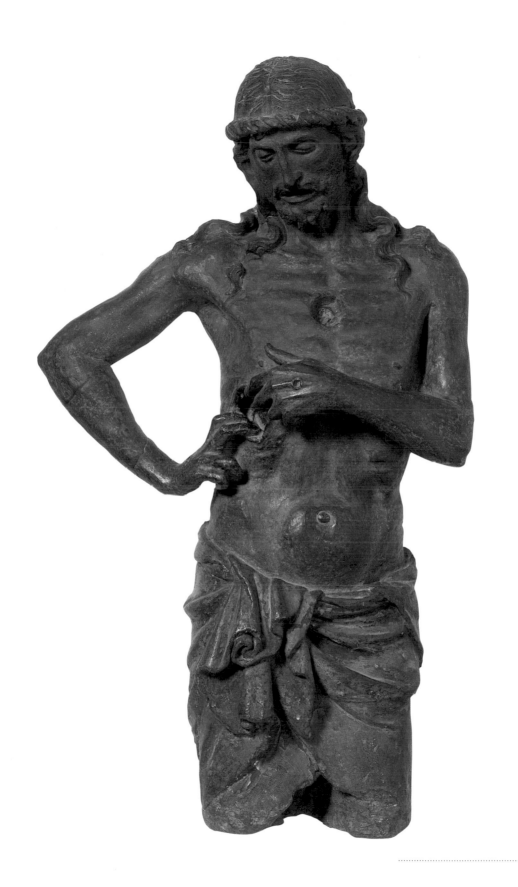

69 The Deposition, about 1500–1505

Master of the Saint Bartholomew Altarpiece
(active about 1470 to about 1510)
Oil on oak, 74.9 x 47.3 cm.
Inscribed at the top of the cross in Hebrew and Greek: Jesus of Nazareth King of the Jews.

London, National Gallery, NG 6470

THE STIFFENED BODY OF the dead Christ dominates the composition of this picture, his outstretched arms mirroring the form of the cross on which he has just died. With reverence and tenderness, Nicodemus and an assistant lower the body into the arms of Joseph of Arimathea (MATTHEW 27: 37). In the left foreground, Saint John the Evangelist supports the swooning Virgin and behind them one of the holy women joins her hands in prayer. Mary Magdalene, whose vase of ointment is on the ground, mourns the death of Christ, while another woman holds the crown of thorns. The skull identifies the site of the Crucifixion as Golgotha, the 'place of the skull' (JOHN 19: 17).

The anonymous painter, whose name derives from the Saint Bartholomew Altarpiece, made for a church in the German city of Cologne, has broadly followed the description of the episode given in the Gospels, seeking only to make it more immediate by showing the figures in modern dress. With skill and inventiveness, however, he draws attention simultaneously to the veracity of the story and to its significance in worship. The lower part of the picture shows the figures set in a real landscape, with plants and rocks naturalistically rendered; further up the picture, however, the natural setting gives way to a gilded box-like arrangement with tracery which actually comes in front of the horizontal beam of the cross, as though the scene were set in a shrine, in the manner of a fifteenth-century painted wooden altarpiece. It is not clear whether this painting was an independent work or part of a larger ensemble, but it would seem likely that it was intended to stand above an altar, for it is there that its meaning would be most clear.

At his death Christ becomes, as it were, the 'Body of Christ', a phrase obviously replete with Eucharistic resonance. The theological parallels between the Crucifixion and the Eucharist are mirrored in the vocabulary that is employed to describe them: Christ speaks of his body in the Eucharist as 'given for you' (LUKE 22: 20); both the Crucifixion and the Sacrament are therefore a sacrifice, and both are redeeming and propitiatory (able to satisfy the just demands of God). The painting subtly alludes to the parallels between the Deposition from the Cross and the Sacrament, in line with certain mystical interpretations of the Middle Ages. In his mid fourteenth-century *Life of Christ*, the Carthusian monk, Ludolph of Saxony, compared the honour of taking Christ down from the cross with that of receiving communion: 'It is far greater', he wrote, 'to receive the Body of Christ from the sacrificial place of the altar than it is to take him down from the sacrificial place of the cross. For those who did the latter received him in their arms and hands, while the former receive him in their mouths and hearts'.[1]

If the panel was indeed above an altar, the visual conjunction of the Sacrament and Christ's represented body would have become especially apparent to the congregation when the priest raised the Host in front of the painting during the Rite of Consecration. It was just such a conjunction that was described by the Italian visionary, Angela of Foligno (*c*.1248–1309), a member of the Franciscan order, who related that on one occasion, 'At the display of the Host during Mass,' she saw a vision of the crucified Christ, looking as if 'he had just been removed from the cross'.[2] *XB and GF*

1 Quoted in Belting 1981, p. 70.
2 Ibid., p. 71.

70 Christ in a Chalice sustained by Angels, about 1620

Jacopo Negretti, called Palma Giovane
(1544–1628)

Pen and brown ink over traces of pounced black chalk, 269 x 193 mm. The sheet is laid down and is cropped on all four sides; the corners are also cut.

Inscribed Palma

Edinburgh, National Galleries of Scotland, INV.

D3099

THE DRAWING SHOWS THE dead Christ in a chalice supported by angels. Blood pours from the wound in his side into the chalice, establishing a complete identification between the blood shed by Christ during his Passion and death; and that of the blood of the Eucharistic Sacrament. In some representations of the Mass of Saint Gregory, for example, the figure of Christ is shown with blood spurting from all his wounds directly into the chalice, thus emphasising this same identification. Likewise, Giovanni Bellini's *Blood of the Redeemer* shows an angel collecting the blood from his side wound in a chalice (cat. no. 71). These images conform to the Roman Catholic belief that the bread and wine consecrated by the priest on the altar become the Body and Blood of Christ. While they retain the appearance and character of bread and wine their nature has been transformed into the living presence of Christ.

The drawing was made by the Venetian painter Jacopo Negretti, known as Palma Giovane, and is a design either for a tabernacle door or, more likely, for embroidery on a church vestment. There is a similar representation of Christ standing in the chalice with attendant angels on the embroidered orphrey cross on the back of a chasuble (the liturgical over-garment worn by a Catholic priest at Mass) in the collection of the Duomo of Motta, near Venice, dating from about 1500.[1] Palma Giovane may have made the design for one of the many Venetian lay confraternities, or *scuole*, devoted to the Sacrament. In his sixteenth-century guide to Venice, Francesco Sansovino states that in most churches in the city there were Sacrament confraternities and that their principal concern was the maintenance of the altar of the tabernacle (the place where the consecrated Host was reserved), and the provision of the vestments, vessels and candles that were required.[2] The frontispiece of the written constitution of the *Scuola del Santissimo Corpo di Cristo* (Confraternity of the Most Holy Body of Christ) in the parish church of S. Agnese in Venice, has a miniature showing a similar subject as the Palma drawing, with the difference that the angels carry the instruments of the Passion.

The black dots seen on this drawing indicate that the basic design was transferred from another sheet of paper by means of dusting black chalk powder through perforated contours. The pen lines diverge from the dusted chalk, indicating that the artist was modifying his earlier design. Another drawing by Palma Giovane showing Christ standing in a chalice supported by Angels, which is very similar in design, is in the Museo Correr in Venice.[3] *GF*

1 See *Ornamenta Ecclesiae* 1988, p. 82. The orphrey cross is the decorative cross-shaped band on the back of a chasuble.

2 Sansovino 1603, p. 198v; see also Black 1989, pp. 95–98.

3 INV. 1242, pen and ink, 268 x 191 mm. See Tietze/Tietze-Conrat 1944, no. 1179, p. 222. Another drawing, a variant of this composition, probably the work of one of his collaborators, was with the Paris dealer, Paul Prouté, in 1971.

71 The Blood of the Redeemer, 1460–65

Giovanni Bellini (active about 1459; died 1516)

Egg on poplar, 47 x 34.3 cm.

London, National Gallery, NG 1233

CHRIST, A GRACIOUS AND ELEGANT FIGURE, holds the cross which bears the crown of thorns and the superscription – now partly worn – with the letters I.N.R.I., which stand for 'Jesus of Nazareth, King of the Jews'. The cross, crown and superscription are the 'Arma Christi', emblems of Christ's triumph over suffering and death, and attributes of the Redeemer. His wounds are prominent and from his side blood pours into a chalice held by a kneeling angel. With his left hand Christ assists the flow and direction of the blood. The puffy clouds which cluster around his knees were originally formed of the heads of cherubim and seraphim in blue, red and gold. The features of one of them, together with its halo, are just visible between the chalice and the angel's head, but at some stage in the painting's history these clouds and cherubim were scraped away.

To the left and right are classical reliefs, painted in gold on a porphyry background, inset in a white marble parapet which divides the foreground area from the landscape beyond. The relief on the left shows a sacrifice scene, with a satyr playing the pipes and two other figures, one of them a pagan priest, holding a ewer in his left hand and possibly with his other hand pouring a libation of wine into the flames which rise from the altar.[1] That this action is obscured by Christ's wounded hand is almost certainly significant, since Christ's sacrifice, effected with his blood, was understood to have superseded all earlier forms of sacrifice, whether the idolatrous offerings of pagans or the Old Testament animal sacrifices.[2] The relief on the right shows two standing figures in front of a candelabrum, or perhaps an incense burner, before a seated figure who may be the god Hermes. The juxtaposition of Christ with these classical reliefs conveys the meaning that with his Passion and Resurrection he had eclipsed the pagan cults of antiquity and instituted a new order.

This sense of passage from the old to the new is echoed in the landscape. The barren and desolate countryside to the right, with ruined arch and column base, gives way on the left to an ordered cityscape surmounted by a church tower. A priest and an acolyte tread the winding path that leads from the former to the latter, while the dawn light radiates from the left, illuminating the underside of the long thin clouds that stretch across the sky.

The blood of Christ was the currency with which the ransom of fallen humanity had been paid and it was also the pledge of his ongoing relationship with the Church in the Eucharist. Bellini's painting is clearly a Eucharistic image and it has been suggested that the painting may have been designed as the door to a tabernacle, the place in which the consecrated host was reserved.[3] Several fifteenth- and sixteenth-century Italian tabernacles are decorated with very similar images of the standing Christ shedding his blood into a chalice and holding the cross.[4] However, it should be stated that the painting shows no physical signs of having been a tabernacle door and its dimensions are larger than one would expect had it been made for this purpose. The alternative is that it was painted as a work of private devotion for a patron of considerable aesthetic sophistication. *GF*

1 The lettering on the altar is just visible: 'DI[VI]S MANIB[VS] / AVRELIVS [...]T(?)I'. The inscription is incomplete and possibly inaccurate, but it presumably indicates that the altar is dedicated to the 'Gods of the departed Aurelius', perhaps the Emperor Marcus Aurelius (121–180 AD).

2 See HEBREWS chapters 9 and 10.

3 Robertson 1968, p. 33, and Braham 1978, p. 12.

4 Several Florentine and Roman examples are listed in Middeldorf 1962. On the iconography of the 'Christ of the Passion', the name given to this type of image in Italy, see Horster 1962 and Eisler 1969.

72 Monstrance with The Last Supper, 1705

Johannes Zeckel (apprenticed in 1658; died 1728)

Silver and parcel-gilt, set with stones, height 85 cm, width at widest point 47 cm.
Bears Zeckel's mark and the town mark of Augsburg (1705). The lunula and the orb and cross are later replacements.

London, Victoria and Albert Museum, INV. M.3-1952

1 The former opens with this verse:
 'Down in adoration falling / Lo, the sacred Host we hail / Lo, o'er ancient forms depart-ing / Newer rites of grace prevail'; the latter runs: 'He gave himself in either kind, / His precious Flesh, His precious Blood; / Of flesh and blood is man combined / And he of man would be the Food'.

2 Seling 1980, pp. 271–72.

THE WORD 'MONSTRANCE' DERIVES from the Latin *monstrare*, to show or display, and the purpose of such vessels was to expose the consecrated Host of the Eucharist for adoration. The Host would be placed in the *lunula* (the crescent-shaped holder) in the specially designed receptacle in the centre, and the monstrance either borne aloft in procession or placed on the altar for the service of Benediction. During this service the Host is incensed and hymns such as the *Tantum Ergo* and the *O Salutaris Hostia*,[1] both attributed to Saint Thomas Aquinas (1227–1274), are sung. The Host is venerated in this way because, according to Roman Catholic belief, in the consecration during the Mass it becomes the Body of Christ, just as the wine becomes his Blood. Thus if the Sacrament is fully identified with the person of Christ, the same honour that is due to him is due to it. That said, the tradition of venerating the Host in a monstrance is not an ancient one but originated with the institution by Pope Urban IV of the Feast of Corpus Christi (The Body of Christ) in 1264.

In the present monstrance, the identification between the Sacrament and the person of Christ is rendered by visual means. The scene on the main body of the vessel is the Last Supper, during which Christ instituted the Eucharist by taking bread in his hands, breaking it and giving it to his disciples saying: 'This is my body which is given for you: this do in remembrance of me' (LUKE 22: 19). The apostles, with Judas recognisable on the right, are seated around the table with the wine chalice on it, but Christ himself is not represented. Instead, in his place at the centre of the group, is the window for the placing of the Host. The dove of the Holy Spirit hovers above, while the entire piece is surmounted by an imperial crown with orb and cross, which stands for God the Father. Thus only when the monstrance contains the Host does the imagery assume its full significance. The Host is both Christ in the Last Supper and Christ in the Holy Trinity (cat. no. 21). Rays issue from the Host, signifying the divine presence and recalling the description of Christ as the 'Dayspring from on high [who] hath visited us, To give light to them that sit in darkness' (MATTHEW 1: 78–79).

The monstrance is rich in subsidiary imagery, too. On either side the decorative cornucopias hold a vine tendril with grapes and ears of corn, both Eucharistic symbols. The vessel's stem has allegorical figures of Faith, Hope and Charity, the three theological virtues, and above them is the Lamb with the Seven Seals of the Book of Revelation. On the foot there are silver reliefs of the Crucifixion at the centre and the Adoration of the Kings to the right; these are paired with two Old Testament scenes which were typically understood as foreshadowing the Eucharist: the priest Melchizedek offers bread and wine to God (GENESIS 14: 18), and Moses commands the people of Israel in the desert to gather the manna (EXODUS 17: 15–17).

Johannes Zeckel was one of the leading goldsmiths of the imperial city of Augsburg at the turn of the eighteenth century. He became a Master in 1691 and specialised in making church plate. Several other monstrances also bearing his mark are known.[2] *GF*

73 Christ as the Man of Sorrows in the Wine Press, about 1425

German

Clay mould, approximately 10.2 x 10.2 cm. Inscribed der get schone *(beautiful God [?]);* der komet von eben *(come now from above);* myn liebe ist glancz und rot *(my love is splendid and red [?]);* allein han ich die kelter getrede un waz neman der *(I have trodden the winepress alone; and of the people there was none with me).*

London, Victoria and Albert Museum, INV. C-329-1926

1 Mâle 1986, pp. 110–16; Réau 1955 II, pp. 421–24; Defoer 1980; Alexandre-Bidon 1990.

2 Mâle 1986, pp. 111–12.

3 Réau 1955, II p. 422.

4 INV. 86, 185, 101 x 102 mm. Von Bode/Volbach 1918, p. 129, no. 36, pl. IV, no. 8.

5 Ibid., pp. 103–4, fig. II.

6 Ibid., pl. IV, nos. 9–10.

ALTHOUGH LARGELY UNFAMILIAR TODAY, the imagery of the 'mystic winepress', was relatively popular in northern Europe in the late Medieval period, and was employed sporadically after that.[1] The imagery, which shows Christ treading the winepress and being crushed like grapes to produce Eucharistic wine, is based on two passages from the Old Testament which were understood by the early Church Fathers as prefigurations of both Christ's Passion sacrifice and the Eucharistic sacrament. When Saint Augustine (AD 354–430) declared that 'Jesus is the cluster of grapes of the Promised Land and the grapes placed under the press,'[2] he was identifying Christ with the bunch of grapes brought back on a staff by the Hebrew spies whom Moses had sent to scout the land of Canaan (NUMBERS 13: 17–29), and with the prophecy of Isaiah who described the avenging God of Israel treading the oppressor nations in the winepress of his wrath: 'I have trodden the winepress alone; and of the people there was none with me: for I will tread them in mine anger, and trample them in my fury; and their blood shall be sprinkled upon my garments, and I will stain all my raiment' (ISAIAH 63: 3). The grapes on a staff recommended themselves as an image of the crucified Christ on the cross.[3] Isaiah's text was understood to refer to the Passion: Christ trod the winepress where the enemy nations were humanity's sins; but the blood sprinkled on his garments was his own, because, in the words of Saint Paul, God 'made him to be sin for us' (2 CORINTHIANS 5: 21), and he took on himself the punishment due to humanity. Saint John, in the Book of Revelation, draws a direct parallel with the text from Isaiah, when he describes Christ as the victor, 'clothed with a vesture dipped in blood' (REVELATION 19: 13).

Isaiah's text gave rise to hymns and prayers using the same imagery and from there it was a short step to the visual representation of the winepress. The early fifteenth-century clay mould – which of course shows the design and lettering in reverse – shows Christ standing in a winepress filled with grapes, directly beneath the press itself. The juice of the grapes, which is his blood, trickles into a vat below. An angel on the right pushes down the bar, while Christ himself turns the screw with his hand. The scroll bearing Isaiah's verse in German is shown coming out of Christ's mouth, making the words his own. A kneeling figure on the left, possibly the Virgin, prays before the scene, and the head at upper right, surrounded by stars, may represent God the Father. The inscriptions are not especially easy to make out and have been transcribed from a cast taken from another clay mould in the Decorative Arts Museum in Berlin,[4] which is practically identical to the one shown here. These moulds were used to produce decorative reliefs, and one such relief, in metal, is found on a bell dated 1540 in Bisperode, Germany.[5] There are other reliefs very similar to this one in style and size which were probably made in the same workshop.[6] They show subjects such as the Circumcision and the Crowning of Thorns, suggesting that a variety of different reliefs was made available to prospective buyers. *XB*

74 Christ in the Wine Press, about 1600

Hieronymus Wierix (1553–1619)

Engraving, 140 x 92 mm.

London, British Museum, 1863-5-9-624

THIS SMALL ENGRAVING, which circulated widely in seventeenth-century Catholic Europe, contains a visual exposition of the entire theology of Redemption and the Eucharist. It is a particularly clear and eloquent example of mystical winepress imagery, and employs narrative techniques to make the Eucharistic allusions even clearer. In the background on the left are the Patriarchs and Judges of the Old Testament planting the vines. After centuries of waiting for the harvest (i.e. the coming of Christ), the Apostles pick the grapes and place them in the vat. Instead of the grapes, it is Christ who will be crushed. His cross has been transformed into the press and God the Father and the dove of the Holy Spirit bear down on the cross to effect the sacrifice. The inscription on the print quotes the verse from Isaiah which is the basis of the imagery: 'I have trodden the winepress alone; and of the people there was none with me' (ISAIAH 63: 3). Christ's blood fills a chalice held by two angels, and on the right in the background, the Virgin contemplates her son's fate, her heart pierced by a sword. On the left, sinners are seen praying in preparation for receiving the Eucharist. *XB*

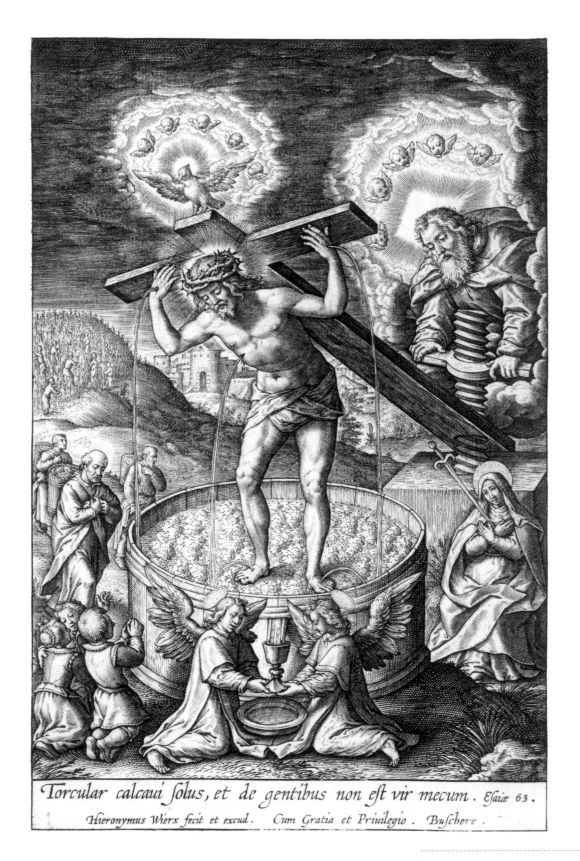

Torcular calcaui solus, et de gentibus non est vir mecum. Esaie 63.

Hieronymus Wierx fecit et excud. Cum Gratia et Priuilegio. Buschere.

75 Christ as Saviour and Judge, about 1450

Petrus Christus (active 1444; died 1475/6)
Oil on fruitwood (?), 11.2 x 8.5 cm.
Birmingham Museums and Art Gallery, INV.
P.306.35.C.1979.

FIG 48 *Jean Fouquet,* Portrait of Charles VII
of France, *c.1450. Oil on wood, 86 x 72 cm.*
Paris, Musée du Louvre.

PETRUS CHRISTUS'S TINY PAINTING is a rich and multi-layered image of the post-Resurrection Christ, who appears as Saviour and Sacrifice, King, Judge and Advocate. He draws attention to his wounds, displaying them as a sign of the sufferings that he willingly underwent on our behalf. In accordance with traditional eschatological iconography (imagery of the end of time), he also displays them to God the Father in an appeal to him to show mercy to humanity. The sword and the stem of lilies held by the two angels indicate that at the Last Judgement, when all will be judged according to how they have lived their life, Christ will administer justice tempered with mercy. The green brocade curtains of the pavilion that open to reveal the figure of Christ are a convention of fifteenth-century royal portraiture which the artist has adopted in order to identify Christ as a powerful king (fig. 48). The blue band at the bottom of the picture, painted with wispy strokes, has been interpreted as water, and may refer to the waters of Baptism or, more generally to Christ's beneficent role as the Redeemer, able to wash away humanity's sin once and for all. However, it may represent the sky, which would fit in better with the imagery of the painting.

This type of image became very popular in northern Europe in the late fourteenth century. Sometimes Christ is shown wearing a kingly cloak which angels open to reveal his wounds, and occasionally he is shown addressing the viewer with words. Another variant of this theme shows God the Father, rather than Christ, as Judge. In a celebrated painting attributed to the fifteenth-century Netherlandish painter, Robert Campin, God the Father is shown seated in a pavilion with Christ's body arranged on his lap (Saint Petersburg, The Hermitage), and in one of the miniatures in the *Turin-Milan Book of Hours* (about 1440–45) by an unknown Netherlandish illuminator he appears alone but with two angels outside the pavilion holding lilies and a sword. Such images were meant to encourage believers to consider how they could help heal the metaphorical wounded members of Christ's body – the poor and needy referred to in the Gospel of Saint Matthew (MATTHEW 25: 34–40) – so that on the Last Day they might be found worthy of God's mercy. These considerations led to the undertaking of charity work, often organised by confraternities.

In this painting the manner in which the curtains are carefully drawn back by the two angels brings to mind the unveiling of some precious object, such as a relic or the reserved sacrament. The original function of the picture is not known, but its subject matter, small size, and excellent state of preservation, suggest that it may have adorned a reliquary of some description. *SA-Q*

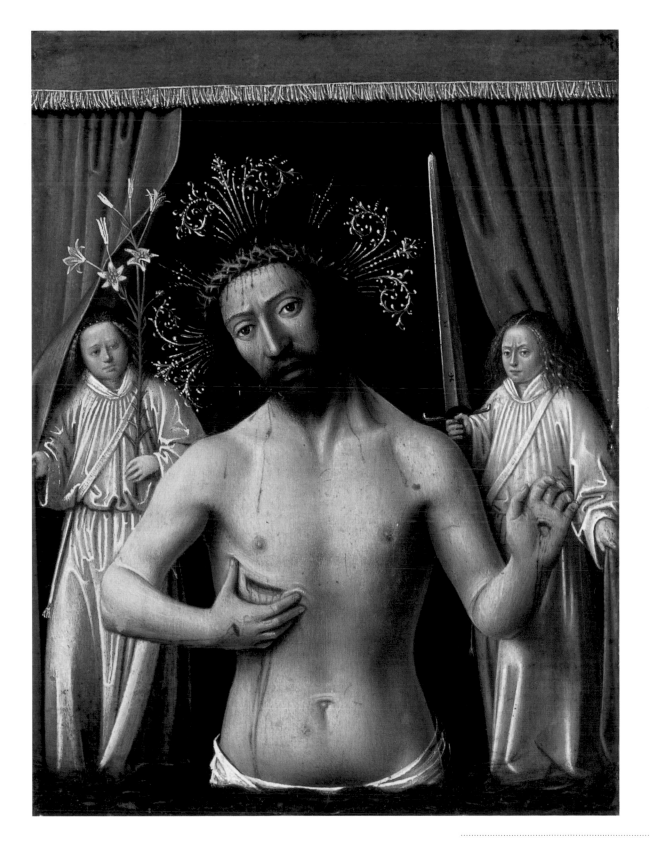

7 THE ABIDING PRESENCE

CHRIST'S APPEARANCES to his followers after the Resurrection were, in pictorial terms at least, never particularly problematic. Artists could, by definition, show what had been seen – the physical body, crucified, dead and risen. But those apparitions, to Mary Magdalene, Thomas and the disciples at Emmaus, were only the first part of the larger promise, given at the end of St Matthew's Gospel: 'Lo, I am with you alway, even unto the end of the world.' (MATTHEW 28: 20) – the quickening reassurance that we will not be abandoned, that the events of this world are somehow under divine guidance. It is perhaps the need for such reassurance in the face of the atrocities of war and genocide that made images of Christ's abiding presence among the most popular and the most controversial in twentieth-century Britain. Yet how is this bewildering mixture of physical absence and spiritual presence to be made visible?

The latest of three versions, Holman Hunt's *Light of the World* (cat. no. 16), already markedly old-fashioned when it was finished around 1904, belongs in every sense to another, earlier age. No picture, it is probably safe to say, has ever enjoyed such rhapsodic praise in the English-speaking world and it is not hard to see why it appealed so strongly to the public of the day. This is a very British Christ, a very Victorian Christ. Three centuries before, John Donne, whose tomb in St Paul's Cathedral is only a few dozen yards from the picture, longed for the violent assaults of a Christ who would come to claim him by force: 'Batter my heart, three-person'd God; for you As yet but knock.' Holman Hunt's Christ, on the other hand, merely knocks courteously, asking to be admitted, with no hint of any desire to intrude, unlikely and perhaps unwilling, to trespass into private territory. This is no terrifying judge coming to pursue us, no shepherd rescuing us in spite of ourselves, but a gentle Jesus in every sense – well-bred, restrained and mild.

Holman Hunt's Christ walks in an overgrown landscape symbolising selfish greed, worldliness and sloth. These are not social injustices, but the private jungle of each particular soul. Fourteen years later, around 1918, Jacob Epstein's larger than life bronze Christ (fig. 49) addressed a world where private concerns had been overwhelmed by one great concern – war.

Epstein chose not to show Christ in the traditional 'true likeness' (see chapter three) long familiar to European eyes, which Hunt had adopted for his picture. Instead, he made a cast of the suffering face of a sick friend which for him possessed and revealed the inherent qualities of Jesus – 'Its pitying accusing eyes and the lofty and broad brow denoting great intellectual strength'[1]. Churchmen were horrified by this unfamiliar, unidealised face 'with his Bolshevik appearance': 'Since Cimabue's day till our own Holman Hunt's, sculptors and artists have followed the traditional idea about the

1 Epstein 1942, pp. 104.

2 Ibid., p. 106–7.
3 Ibid., p. 105.

features and expression of our Divine Lord … Who is the man who, standing in the presence of this shapeless specimen, could imagine coming from its brutally thick throat the words "I am the Light of the World?"'[2]

This attitude still flourishes. In 1999, Mark Wallinger also used a cast of a real person to make his sculpture of Christ – *Ecce Homo* (fig. 50), conceived for a plinth in Trafalgar Square. Once again, many commentators, shaken by the fact that this did not 'look like Christ', argued that a real man could not stand for Jesus. The tradition of the 'true likeness' is resilient.

Epstein's Christ makes his appearance not to prove the Resurrection to his followers, but to challenge us now. He shows his wound not in triumph over death, but in reproach and compassion. Epstein, in his autobiography written in 1940, makes clear the purpose of this strange mixture of images: 'My statue of Christ still stands for what I intended it to be. It stands and accuses the world of its grossness, inhumanity, cruelty and beastliness, for the World War and for the new wars in Abyssinia, China, Spain and now our new Great War'.[3]

Later, Spencer, Sutherland and Dalí also made their Christs in response to the wars of the twentieth century. All are in different ways about a Christ who transcends and transforms suffering, and each suggests a quite different relationship between God and Man.

As Campin's infant Christ is bathed in a house in the Low Countries (cat. no. 25) and Titian's adult Christ rises in the landscape of northern Italy (cat. no. 66), Spencer's *Christ Carrying the Cross* (cat. no. 76) is placed in the artist's village of Cookham on the Thames. Christ goes about his daily task among us, or so it seems; for in spite of its subject, this is only in a very limited sense – perhaps not even at all – a Passion image. This Christ with his cross is like a window-cleaner or carpenter with his ladder, showing that sacrificial loving is daily work, and joyful work at that. In Blake's words we all 'must learn to bear the beams of love'. Spencer's picture is a denial of tragedy, a refusal to dwell on suffering, all the more startling for being the work of an artist who, as a medical orderly, had seen at close quarters the squalid agonies of First World Warfare. Here those memories have been distilled into love – for his neighbours at Cookham, and for the continuing Christ among and in those neighbours.

Designed in 1953, after another war, Graham Sutherland's *Christ in Glory*, a cartoon for the tapestry which would dominate the newly rebuilt Coventry Cathedral, is equally remote from any idea of suffering or violence (cat. no. 78). This Christ, presiding over a building dedicated to forgiveness and reconciliation, insists that suffering, like all human phenomena, is finite and transient. Sutherland's Christ is above us, not among us, ultimate protector of the humanity that takes refuge at his feet, under his throne. There is little sense here of judgement. Indeed the cathedral was rebuilt in a deliberate rejection of all human judgement, not least about the circumstances of the bombing which had destroyed the old cathedral and a large part of the city.

The difference from Spencer is striking. The figure and face of Christ are stylised and simplified. This is a king, not just a man. He bears the wounds of the Crucifixion, but all that is now in the past. Suffering here, far from being transmuted into daily duties, is serenely considered as the price paid for error overcome and confusion resolved on a cosmic scale. Spencer and Sutherland, it might be said, show the theology of two different political responses to war in the twentieth century – one focused on transforming the routines of working life, the other on creating supranational harmony.

FIG 50 *Mark Wallinger,* Ecce Homo, *1999. Life-size figure of Christ in marble resin wearing a gold crown of barbed wire. The sculpture was placed on the empty plinth on the north-west corner of Trafalgar Square between July 1999 and January 2000.*

And what of Dalí (cat. no. 77)? Painted, he said, as a reflection on Hiroshima, his picture shows a world over which the crucified Christ keeps constant watch. Its popular appeal has always been enormous. As an image of Christ it astonishes. Although we, the spectators, clearly belong to the tranquil world below, where the fishermen go about their business, we are given a view of the universe from above – the world and Christ, as God the Father might see them. The earth is remote and disconcertingly fragile. And between the earth and God is Christ. Dalí specifically stated that he wanted to emphasise not his suffering but his beauty. The details of his Passion are concealed. Arms outstretched over the world, he intercedes not by pleading the cause of humanity, but faithful to a long tradition of Spanish religious painting (see cat. no. 49), by embracing us from the cross. However disturbing the composition, this is a view of Christ always present, which is both profoundly reassuring (which surely explains part of its popularity) and entirely traditional.

As spiritual perceptions and preoccupations shift, the figure of Christ among us can be endlessly remade, shaped by artists to carry new, sometimes startling meanings. In Spencer's *Resurrection, Cookham* (cat. no. 79) he takes on a female, maternal role, holding his babies while the village wakes to the cosy warmth of new and abundant life – this in the 1920s, long before God the Mother had become a commonplace of religious debate. The body of Christ, the figure of one human being who can stand for all, is an inexhaustible language. *NM*

76 Christ carrying the Cross, 1920

Stanley Spencer (1891–1959)

Oil on canvas, 153 x 143 cm.

London, Tate Gallery, N 04117

SPENCER REPRESENTS CHRIST on the way to Calvary, but does not make it the deeply mournful event imagined by most artists since the Middle Ages (cat. no. 56). Rather he evokes a sense of cheerfulness by filling his painting with sunlight (the people have to shield their eyes from it), and a sense of burgeoning life is suggested, one house covered with lush ivy, while from another house a group of people lean joyfully out of the windows. Spencer's interpretation stems directly from his personal understanding of Christ's life and death as something to be celebrated.

Spencer thought that Christ's decision to enter our humanity gave human life great dignity; by undertaking a mission of teaching and healing, Christ had made all human tasks worthy, even holy. This way of thinking induced Spencer to find value and beauty in the people, places, and activities which he encountered, especially in his native village of Cookham in Berkshire, where he spent much of his adult life. He explained: ' … quite suddenly I became aware that everything was full of special meaning and this made everything holy. The instinct of Moses to take his shoes off, when he saw the burning bush was similar to my feelings. I saw many burning bushes in Cookham. I observed this sacred quality in the most unexpected quarters.'[1]

In this painting Spencer draws attention to the sacredness of human life and endeavour by transferring the Gospel scene from first-century Jerusalem to Cookham. The house is 'Fernlea', where Spencer was born, and the adjacent ivy-covered cottage, 'The Nest', belonged to his grandmother. Christ, just visible in the background, is surrounded by figures that appear very much like him, several of them based on Cookham villagers, including the builders from the local building firm, Fairchild's. These workmen are engaged in an activity very similar to Christ's: Spencer deliberately chose to use the word 'carrying' not 'bearing' in the title of the picture because he 'particularly wished to convey the relationship between the carpenters behind him carrying the ladders & Christ in front carrying the cross, each doing their job of work.'[2]

Of this picture Spencer declared that, 'a sense of suffering … was not my intention'.[3] He believed that Christ's self-sacrifice had led to a reconciliation between humanity and God, and he was able to view Christ's cross without sadness. This belief may also have helped him to cope with the prospect of his own death which loomed large after he enlisted in the First World War, an event which may be recalled in this picture. The railings in the foreground resemble spears and shields, while the five bystanders who hold the rails may recall the men of the Spencer family going off to war, and the figure of the Virgin could be their mother, sorrowing at their departure.

After the work was acquired by the Tate Gallery, Spencer asked that the title be corrected from the inaccurate *Christ bearing his cross*. He explained that 'there may be many burdens to bear but there was never more than one cross & that was the one Christ carried & is properly therefore referred to as *the* cross … This is in accordance with the Gospel. He was not doing *a* job or *his* job, but *the* job.'[4] SA-Q

1 Quoted in MacCarthy 1997, cat. no. 28.

2 Quoted in Rothenstein 1979, p. 80.

3 Ibid., p. 80.

4 Ibid., p. 80.

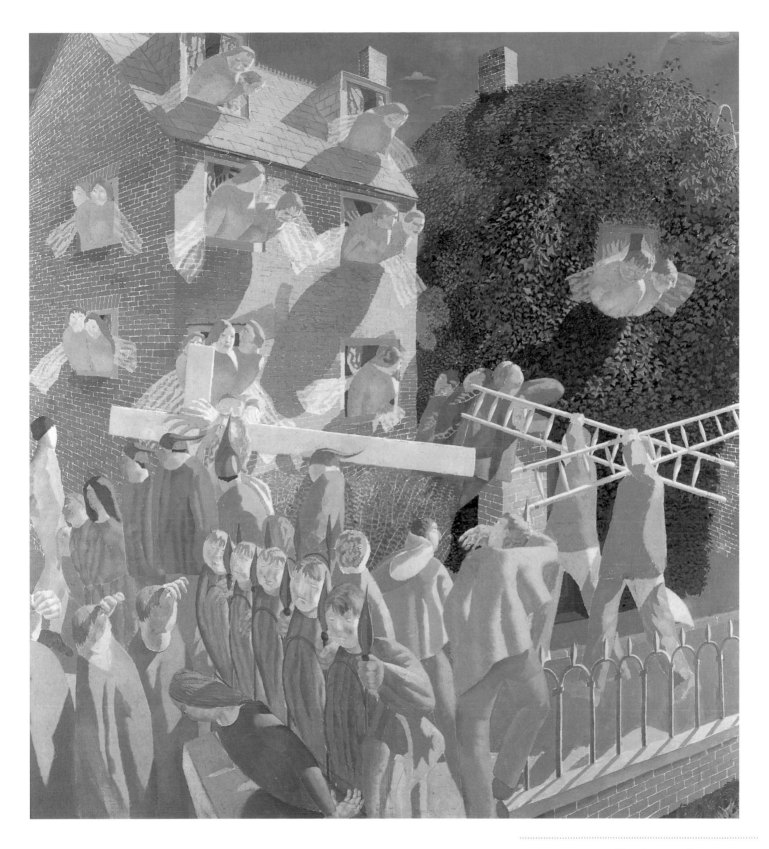

77 Christ of Saint John of the Cross, 1951

Salvador Dalí (1904–1989)

Oil on canvas, 204.8 x 115.9 cm.

Signed: GALA. S. DALÍ

Glasgow Museums, The St Mungo Museum of Religious Life and Art

FIG 51 *Saint John of the Cross ,* Christ on the Cross, *1572–77. Pen and ink on paper, 57 x 47 mm. Avila, Carmelite Convent of the Encarnación.*

1 *Daily Express*, 5 December 1951. Quoted in Etherington-Smith 1992, p. 385.

2 Quoted in the *Scottish Art Review*, vol. VI, no. 4, 1958, p. 15.

3 From a letter printed in the *Scottish Art Review*, vol IV, no. 1, 1952, p. 5.

4 Ibid.

5 Louis le Nain, *Farmers in front of their House*, 1642. Oil on canvas, San Francisco, Palace of the Legion of Honor.

6 Velázquez, study for *The Surrender of Breda*, c.1635. Charcoal on paper, Madrid, Biblioteca Nacional.

ALÍ'S *CHRIST OF SAINT JOHN OF THE CROSS* is perhaps the most celebrated and reproduced religious painting made in the twentieth century and it has always provoked strong reactions. Its purchase by the Glasgow Art Gallery in 1952 met with considerable criticism from the art press for its price (£8,200 was considered exorbitant), and its quality. It was described variously as 'skilled sensationalist trickery' and 'calculated melodrama', while in the *Express*, Osbert Lancaster credited it with 'about as much religious feeling as "Through the night of doubt and sorrow" played on a Wurlitzer in the interval of a leg show'.[1] But despite this chorus of condemnation, the people of Glasgow flocked to see the picture. Fifty thousand people saw it in the first two months, and reports spoke admiringly, if condescendingly, both of the social mix of the crowds, 'shop girls and students', and their reactions: 'Men entering the room where the picture is hung instinctively take off their hats. Crowds of chattering, high-spirited school children are hushed into awed silence when they see it.'[2]

The work is a startling re-interpretation of one of the most familiar icons of Christian art and its power rests, in part, on the paradoxes it presents to the viewer. The monumental figure of the crucified Christ hovers above the world yet we look down on him. In the detail of Christ's body and his closeness to the picture surface (he appears to project beyond it), Christ is immediately and physically present and yet he is distant, above the clouds, his face hidden.

The painting's title comes from Dalí's principal source of inspiration – a drawing preserved in Avila, Spain, attributed to the Spanish Carmelite friar and mystic, Saint John of the Cross (1542–1591, fig. 51). According to Dalí: 'The drawing so impressed me the first time I saw it that later in California, in a dream, I saw the Christ in the same position, but in the landscape of Port Lligat, and I heard voices which told me, "Dalí you must paint this Christ"'.[3] Like the drawing, Dalí's painting shows the cross suspended in mid air and Christ's head tilted so that his face is hidden from the viewer; Dalí apparently used a specially posed photograph of the acrobatic Hollywood stand-in Russ Saunders tied to a panel, as his model. But if Saint John's vision was Dalí's starting point, he developed his image in a dramatically different way. For Saint John, the crucified Christ was primarily a focus for compassion, a tortured and murdered man, but Dalí aimed instead at an image of perfection and transcendence: 'My aesthetic ambition … was completely the opposite of all the Christs painted by most of the modern painters, who have all interpreted him in the expressionistic and contortionistic sense, thus obtaining emotion through ugliness. My principal preoccupation was that my Christ would be beautiful as the God that he is.'[4]

Dalí showed his Crucifixion hovering above Port Lligat in eastern Spain where he lived and worked and which often appears in his paintings, including the slightly earlier *Madonna of Port Lligat* (1949). The figure by the boat comes from a work by the French seventeenth-century painter Louis Le Nain,[5] his face altered to resemble a local fisherman, while the silhouette on the extreme left is borrowed from a drawing by Velázquez.[6]

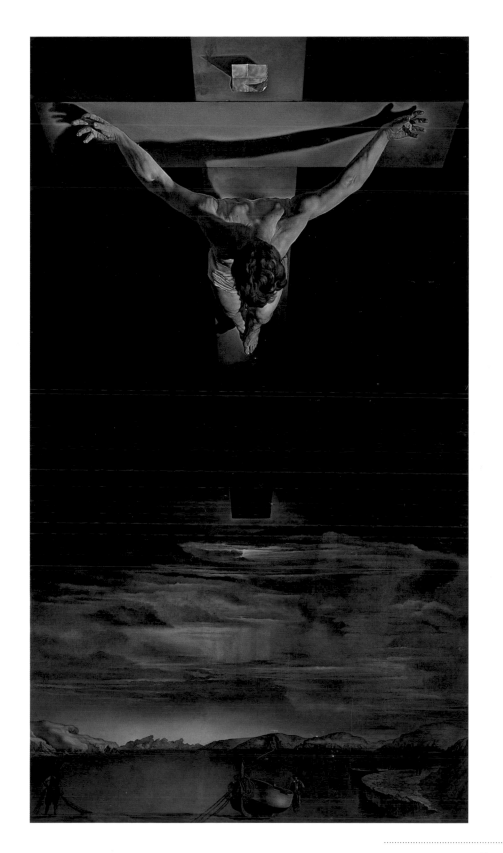

The painting was one of a number with religious and mystical themes Dalí painted from 1949 onwards, during his period of 'religious, nuclear and hallucinogenic mysticism' in which he published his *Manifesto Mystique* (April 1951). He later described himself, with typical opacity, as being in a 'rigorous, architectonic, Pythagorean and exhausting mystical reverie', triggered in part by the explosion of the atomic bomb at Hiroshima on 6 August 1945. One of Dalí's various accounts of the painting's gestation describes its design – in which the figure of Christ can be inscribed in an inverted triangle with his round head near the bottom corner – as being linked to a 'cosmic dream' in which a triangle containing a circle stood for the nucleus of the atom.[7]

A parallel preoccupation was what Dalí described as the 'mechanistic materialism' of modern painting, in contrast to the transcendent ideals of perfection established during the Renaissance which he hoped to reclaim. Or, as he put it in his colourful and mischievous retrospective account in *The Unspeakable Confessions of Salvador Dalí*: '"No more denying," I shouted at the height of my ecstasy "no more Surrealist malaise of existential angst. I want to paint a Christ that is a painting with more beauty and joy than have ever been painted before. I want to paint a Christ that is the absolute opposite of Grünewald's materialistic savagely anti-mystical one"'.[8] (fig. 31). *AS*

7 Dalí, 1976, p. 217. The account of Dalí's cosmic
 dream is on a small gouache study for *Christ of the
 Cross* of 1950–51, Glasgow Art Gallery and Museums.
8 Dalí 1976, p. 217.

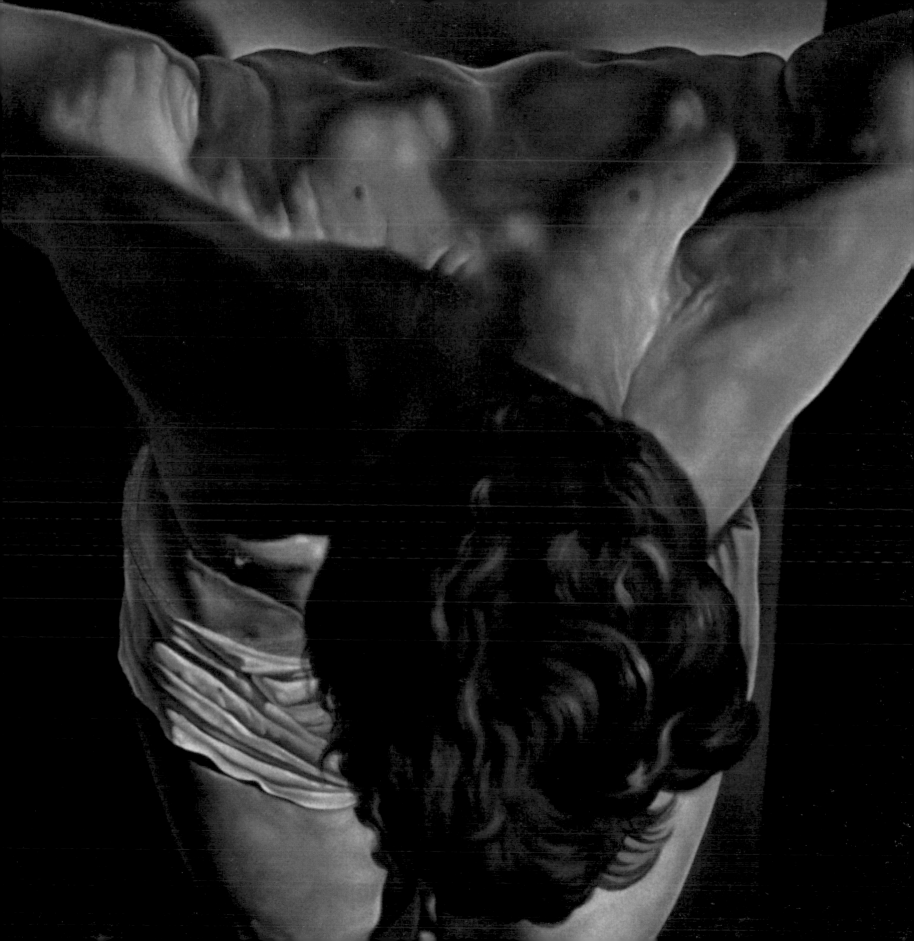

78 Christ in Glory in the Tetramorph (First Cartoon), 1953

Graham Sutherland (1903–1980)

Oil on gouache on board, 201.9 x 110.5 cm.

Herbert Art Gallery, Coventry, 1974.50.46

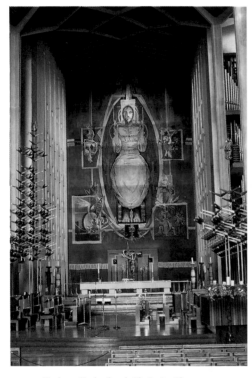

FIG 52 *Graham Sutherland,* Christ in Glory, *1962. Tapestry, 22.76 x 11.58 m. Coventry Cathedral.*

1 Révai 1964, p. 24.

2 Berthoud 1982, 204 and 205.

3 Cooper 1961, p. 30.

AS A COMMITTED CHRISTIAN, it must have seemed an act of religious affirmation to Sutherland when he accepted the invitation to design a gigantic tapestry to hang behind the altar of the new Coventry Cathedral (fig. 52). The old Gothic building had been almost completely destroyed by German bombing in November 1940. Sutherland had painted religious images in the past, including a *Crucifixion*, a *Deposition*, and a *Christ Carrying the Cross*, but had never had the subject-matter or style dictated to him. On this occasion the Cathedral's reconstruction committee required quite specifically a Christ in Glory as described in the Book of Revelation (REVELATION 4: 2-7), which would combine 'victory, serenity, and compassion'.[1]

The challenge was to find a means of expression which both drew upon the established convention of portraying such an image, and yet in places might break entirely free from it so that it could speak directly to the contemporary viewer. Sutherland was determined that his image would 'have in its lineaments something of the power of lightning and thunder, of rocks, of the mystery of creation generally – a being who could have caused these things' and would 'look vital, non-sentimental, non-ecclesiastical, of the moment, yet for all time'.[2] He was attracted by the 'pent-up' force that he found in Egyptian royal figures of the Fourth and Fifth Dynasties, as well as the stillness inherent in the Pantocrator half-figures of Christ found in Byzantine Greek and Sicilian churches. To arrive at his final design, Sutherland produced no fewer than three trial cartoons, of which this is the first. The most significant difference between this cartoon and the finished tapestry is the position of Christ's arms: whereas here they are down by his sides, in the tapestry he holds them up in a gesture which Sutherland considered less submissive.

Much of the surrounding imagery also alludes to Christ's glory and power, such as the burst of light entering from above symbolising the Holy Ghost; the image of Saint Michael overcoming the Devil; the four creatures representing the Evangelists (the tetramorph), kneeling in reverence towards him; and the tiny figure of Man standing, as if for protection, between Christ's feet. Only a mournful representation of the *Pietà* at the foot of the cross recalls Christ's suffering. This scene was later replaced with a Crucifixion which the Cathedral authorities preferred, as it was a biblical subject. Interestingly, Sutherland had already alluded to the duality of Christ as suffering human and omnipotent God in his Northampton *Crucifixion* (1946), where Christ's anguished body is contrasted with the 'superbly blue' and beautiful heavens which encircle him. Sutherland explained that while Christ's death was 'the most tragic' event, 'yet inherent in it is the promise of salvation'.[3]

When the tapestry was unveiled on 25 May 1962, reactions were mixed. Many people found its ambiguous passages difficult to accept, especially the lack of clarity about whether or not Christ was seated. Sutherland himself commented only that it could have been worse. By contrast, Kenneth Clark described it as 'a great work of religious art', and the Cathedral architect, Basil Spence, declared that it was 'a triumph'. *SA-Q*

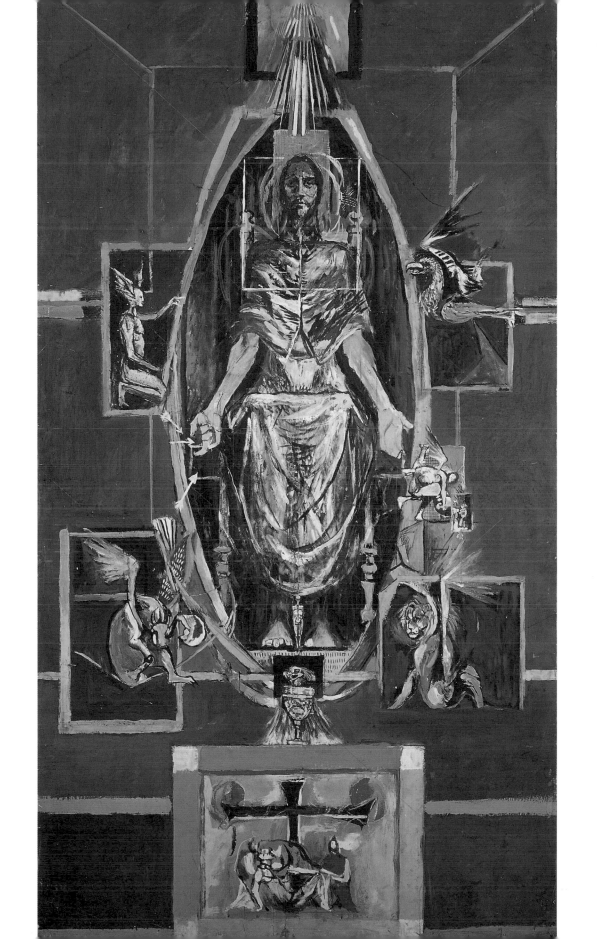

79 The Resurrection, Cookham, 1924–26

Stanley Spencer (1891–1959)

Oil on canvas, 274 x 549 cm.

London, Tate Gallery, N 04239

I N CONTRAST TO THE CRITICAL reception that greeted the acquisition of Dalí's *Christ of Saint John of the Cross* (cat. no. 77), Spencer's *Resurrection, Cookham* was received enthusiastically and by some even rapturously. Charles Marriott of *The Times* felt sure enough about its merits to pronounce it, 'in all probability … the most important picture painted by an English artist in the present century'. Spencer, too, was very satisfied with it: 'I was on bedrock with this picture', he declared, 'I knew it was impossible for me to go wrong'.[1] On its completion, Spencer felt he had succeeded in both conveying outwardly, and achieving inwardly, a state of contentment and, indeed, of Resurrection as he understood it.

Although in the painting Spencer associates the Resurrection event with the Last Judgment and the meting out of just deserts, he does not portray Christ as a threatening judge but rather as a loving and merciful maternal figure, who nurses two babies cosily in his arms. Nor does he show much suffering; he reduces the punishment of the wicked to a mild rebuke which seems to be going on in one or two of the graves, and shows nearly all of the souls as righteous, experiencing feelings of the utmost happiness and peace as they clamber out of their tombs to make their way to the pleasure-boat which will take them to Heaven.

Spencer deliberately confuses the boundaries between heaven and earth – he shows Christ enthroned not in an obviously celestial sphere but in the grave-yard of Cookham Parish Church. People are both naked (as though newly resurrected) and fully clothed (as though still alive on earth) – not just so as to remain faithful to the biblical notion that on the Last Day the living will join the dead before the Judgment Throne, but also so that Spencer can explore the implications of his own understanding of 'Resurrection' as the attainment of a state of transcendence. To his mind, there were two kinds of Resurrection, a 'particular' kind which involved a person being raised after death to a state of fulfilment in heaven, and a 'general' kind which could come to anyone at any time and place on earth, and which consisted in being overwhelmed by a sense of perfect peace and love.

Here, both sorts of Resurrection appear to be experienced. The newly resurrected dead are enjoying again many of the pursuits which on earth had brought them to a state of transcendence. One woman (modelled on Spencer's mother), enjoys an intimate reconciliation with her husband as she brushes down his jacket, and another (who represents Spencer's first wife, Hilda Carline) delights in smelling a flower. She is repeated elsewhere reclining on the ivy-covered tomb and climbing over the stile leading to the River Thames. Spencer himself is visible lying in an 'open book' tomb in the foreground, enjoying a moment of utter tranquillity and delight. Spencer explained: 'No one is in any hurry … Here and there things slowly move off but in the main they resurrect to such a state of joy that they are content… In this life we experience a kind of Resurrection when we arrive at a state of awareness, a state of being in love, and at such times we like to do again what we have done many times in the past, because now we do it anew in Heaven.'[2]

1 Quoted in Bell 1992, p. 414.
2 Quoted in Carline 1978, p. 172.

Moments of Resurrection of one sort or another preoccupied Spencer in several of his paintings and writings. The theme of souls being raised to new life appears in numerous works, including his *Resurrection of Soldiers* at Burghclere Chapel, Buckinghamshire (1928–29), and *The Resurrection: The Hill of Zion* from his Port Glasgow series of shipbuilding murals (1946). He often made a sense of 'general' Resurrection the focus of his painting, commonly expressing this state of being as the result of the interaction of two people revelling in, and being amazed by, their love for one another. This is certainly the case in two of his most important cycles of paintings: the 'Beatitudes' series (in which pairs of sometimes very ugly lovers enjoy one another physically) and in the paintings for his unrealised 'Church House' scheme, which show people, places, or activities which had filled Spencer himself with such delight that he felt he was in Heaven.

Not that Spencer's own life was lived in a state of constant bliss; far from it. He experienced two failed marriages and much loneliness; he was often deeply frustrated as an artist because of the realisation that the majority of people, including his patrons, found his most imaginative work unintelligible, if not offensive; and he suffered from regular bouts of debilitating illness, eventually dying of cancer. It seems that the artist turned to painting in order to recapture moments of Resurrection, of joy which he had once felt, and also so that he might feel afresh a sense of transcendence as he actually applied the paint to canvas. Of the production of this painting he recalled: 'I experienced a spiritual exultation as I put this here and that there'.[3] Such experiences were to be treasured, Spencer believed, as transitory tokens of the ultimate love that he, with the rest of mankind, would experience constantly in the afterlife, when reunited with Christ, who is love. *SA-Q*

3 Bell 1992, p. 59.

Provenance and Bibliography

1 Sign and Symbol

1. The Good Shepherd, Roman, fourth century AD
PROVENANCE: Possibly from the Museo Kircheriano, the collection of antiquities, natural history and ethnological material formed by the seventeenth-century Jesuit priest, Atanasio Kircher (1602–1680).
BIBLIOGRAPHY: Unpublished.

2. Funerary slab of Aurelius Castus with the Good Shepherd, Roman, third or fourth century AD
PROVENANCE: Catacomb of St Callixtus on the Via Appia Antica, Rome.
BIBLIOGRAPHY: Marucchi 1910, p. 57, pl. LVII, no. 6; *Inscriptiones*, IV, 1964, p. 488, no. 12572.

3. Funerary slab of Florentius with the Good Shepherd, Roman, fourth century AD
PROVENANCE: Uncertain.
BIBLIOGRAPHY: Marucchi 1910, p. 57, pl. LVII, no. 4; *Inscriptiones*, I, 1922, p. 203, no. 1623.

4. Funerary Slab with a Fish, Roman, fourth or fifth century AD
PROVENANCE: Cemetery of Pretestato (Via Appia) or Cemetery of Ciriaca (Via Tiburtina), Rome.
BIBLIOGRAPHY: Marucchi 1910, p. 57, pl. LVII, no. 20; *Inscriptiones*, I, 1922, p. 245, no. 1921; entry by G. Spinola in Donati 1996, no. 74, p.224.

5. Coin of the Emperor Constantine looking Heavenwards, Roman, AD 327
BIBLIOGRAPHY: *Roman Imperial Coinage*, VII, p. 621, no. 132.

6. Coin of the Emperor Constantine with the Monogram of Christ crowning the Labarum, Roman, AD 327
BIBLIOGRAPHY: *Roman Imperial Coinage*, VII, p. 572, no. 19; Bruun 1962, pp. 21–22; Kent 1978, no. 649, pp. 52 and 331.

7. Coin of Decentius with the Monogram of Christ and the Alpha and Omega, Roman, AD 351
BIBLIOGRAPHY: *Roman Imperial Coinage*, VIII, p. 163, nos. 318 and 319.

8. Coin of the Emperor Jovian holding the Labarum with the Monogram of Christ, Roman, AD 363–4
BIBLIOGRAPHY: *Roman Imperial Coinage*, VIII, p. 393, no. 110; see also Carson 1981, p. 58, no. 1414.

9. Ring with the monogram of Christ, Roman, fourth or fifth century AD
PROVENANCE: Bequeathed to the British Museum by Sir Augustus Wollaston Franks, 1897.
BIBLIOGRAPHY: Dalton 1901, p. 12, no. 77; Dalton 1912, p. 6, no. 32.

10. Rings with the monogram of Christ, Roman, fourth or fifth century AD
PROVENANCE: From the Castellani collection, acquired by the British Museum in 1872.
BIBLIOGRAPHY: Fortnum 1871, p.281, no. 5; Dalton 1901, p. 12, no. 78; Dalton 1912, p. 6, no. 33.

11. Family Group with the monogram of Christ, Roman, fourth or fifth century(?)
PROVENANCE: Presumed to come from the Roman catacombs; in the Matarozzi collection; acquired by the British Museum in 1863.
BIBLIOGRAPHY: Dalton 1901, p. 120, no. 610; Morey 1959, p. 54, no. 315.

12. Lamp with the monogram of Christ, Roman, fifth or sixth century AD
PROVENANCE: Apparently 'From the catacombs of Rome' (Sotheby's sale catalogue, London, 2 July 1929, lot 106, where it was acquired for the British Museum).
BIBLIOGRAPHY: Bailey 1996, p. 76, Q3825.

13. Grave Slab with the monogram of Christ and the Alpha and Omega. Merovingian, fifth–sixth century AD
PROVENANCE: Found in a sandpit near the church of St Acheul, near Amiens, in 1858; in the collection of Masse, then Charles Dufour; given to the British Museum by Sir John Evans in 1889.
BIBLIOGRAPHY: Dusevel 1858, p. 495; Corblet 1859, p. 17; Le Blant 1865, pp. 568–69 and pl. 91, fig. 544.

14. *The Adoration of the Name of Jesus*, about 1578
El Greco (1541–1614)
PROVENANCE: Don Luis Méndez de Haro y Gúzman, second Conde-Duque de Olivares (died 1675); bought by the National Gallery in 1955 from Lt.-Col. W.J. Stirling of Keir.
BIBLIOGRAPHY: Blunt 1939–40, pp. 58–69; MacLaren/Braham 1970, pp. 27–34; Braham 1981, pp. 47–8; *Felipe II: un príncipe del renacimiento*, exh. cat., Madrid, Museo del Prado, 1998–99, cat. 156 (entry by David Davies).

15. *The Nativity at Night*, late 15th century
Geertgen tot Sint Jans (about 1455/65; died about 1485/95)
PROVENANCE: Bought in Paris for the Richard von Kauffmann collection, Berlin, before 1901; it passed into the collection of Michiel Onnes at the castle of Nijenrode at Breukelen, north west of Utretcht; later owned by the iron founder Hans Tietje in Amsterdam; purchased by the National Gallery in 1925.
BIBLIOGRAPHY: Panofsky 1953, I, pp. 325; Snyder 1960, pp. 121–23; Boon 1967, pp. 8–9; Friedländer 1969, vol. 5 pp. 21–22, no. I; Campbell 1998, pp. 232–39.

16. *The Light of the World*, about 1900–1904
William Holman Hunt (1827–1910)
PROVENANCE: Bought from the artist by Charles Booth; presented to St Paul's Cathedral, 5 June 1908.
BIBLIOGRAPHY: Hunt 1905, I, pp. 299–300, 307–8, 346–7, 350–1, 355–9, 404–6, 416–7; Bennett 1969, nos. 24 and 25, pp. 31–35; Landow 1983, pp. 473–76; Maas 1984, *passim*.

17. *The Bound Lamb* ('Agnus Dei'), about 1635–1640
Francisco de Zurbarán (1598–1664)
PROVENANCE: Marquesa del Socorro, Madrid; Madrid, Durán (auction house), February 1986, no. 200, lot. 47, where acquired by the Museo Nacional del Prado.
BIBLIOGRAPHY: Angulo Iñíguez 1950, pp. 77–78; Soria 1953, no. 77; Guinard 1960, no. 592; Gaya Nuño/Frati 1976, no. 9; Gállego/Gudiol 1976, no. 282; Moreno 1998, pp. 92–93; Díaz Padrón 1999, pp. 153–154.

18. Coin of the Emperor Valens holding the Labarum inscribed with a Cross, Roman, AD 364–7
BIBLIOGRAPHY: *Roman Imperial Coinage*, IX, p. 272, no. 2d; Carson 1981, p. 66, no. 1452.

19. Cross, 1897
Designed by Phillip Webb (1831–1915) and executed by Robert Catterson-Smith
PROVENANCE: Made for the chapel, designed by Webb, of the Rochester and Southwark Diocesan Deaconess's House, Clapham Common; given by the Trustees of the House to the Victoria and Albert Museum in 1970.
BIBLIOGRAPHY: Lethaby 1935, p.189; London (Victoria and Albert Museum) 1971, cat. K7.

20. *Christ Crucified on the Vine*, Germany, Middle Rhineland, about 1435
PROVENANCE: Bought in Paris by the Victoria and Albert Museum in 1856.
BIBLIOGRAPHY: Von Bode/Volbach 1918, pl. IV, p. 6; Weckwerth 1968; Arens 1971, p.123; Beranek 1986.

2 The Dual Nature

21. *The Heavenly and Earthly Trinities*, 1681–82
Bartolomé Esteban Murillo (1617–1682)
PROVENANCE: Don Carlos Francisco Colarte, second Marqués del Pedroso, Cadiz, in 1708; in the Pedroso collection at Seville by 1800; bought in Seville by James Campbell for the dealer Buchanan and brought to London in 1810; by 1824 it was in the collection of Thomas Bulkeley Owen; purchased by the National Gallery in 1837.
BIBLIOGRAPHY: Curtis 1883, no. 135; MacLaren/Braham 1970, pp. 60–61; Angulo Iñiguez 1981, II, no. 192; London (Royal Academy) 1981, no. 54; Helston 1983, p. 42; Young 1986, pp. 10–13.

22. *The Holy Family with Saint John*, about 1500
Andrea Mantegna (1430/31–1506)
PROVENANCE: By 1856 in the collection of Cavaliere Andrea Monga in Verona; acquired in 1885 by J.P. Richter and in 1891 by Ludwig Mond; bequeathed to the National Gallery as part of the Mond Bequest in 1924, entered the Collection in 1946.
BIBLIOGRAPHY: Richter 1910, I, pp. 255–67; Davies 1961, pp. 338–9; Lightbown 1986, no. 49.

23. *Saint Francis receiving the Christ Child from the Virgin*, about 1583–85
Ludovico Carracci (1555–1619)
PROVENANCE: Apparently in the collection of the Pepoli family, Bologna; acquired in Florence in 1787 by Lord Hume; by descent to the Earl of Brownlow and sold at Christie's, London, 4 May 1923; Captain Langton Douglas; Prof. Dr. Otto Lanz, Amsterdam; acquired by the Rijksmuseum, Amsterdam in 1960.
BIBLIOGRAPHY: Bodmer 1939, pp. 43–44, no. 79; Askew 1969, p. 295; Graas 1975; Bologna/Fort Worth 1993–4, no. 14 (English edn.); Van Os 1992.

24. Cradle, about 1480–1500
Southern Netherlandish
PROVENANCE: Apparently in the collection of Baron Gustave de Rothschild; bought by Sir William Burrell from M.R. Stora in 1937.
BIBLIOGRAPHY: Wentzel 1962, pp. 1–7.

25. *The Virgin and Child in an Interior*, about 1430
Workshop of Robert Campin, late 1370s–1444 (Jacques Daret?)
PROVENANCE: Melanie von Risenfels (1898–1984); acquired by the National Gallery in 1987.
BIBLIOGRAPHY: Urbach 1995, pp. 557–68; Reynolds in Foister/Nash 1996, pp. 183–196; Steinberg 1996, pp. 257–8; Campbell 1998, pp. 83–91.

26. *The Circumcision*, about 1500
Workshop of Giovanni Bellini (active from around 1459, died 1516)
PROVENANCE: Probably Muselli collection, Verona, by 1648; Duc de Gramont; Orléans collection by 1727; brought to England 1798; Lord Carlisle, Castle Howard; presented to the National Gallery by the 9th Earl of Carlisle, 1895.
BIBLIOGRAPHY: Pallucchini 1959, pp. 148–9; Davies 1961, pp. 68–70; Heinemann 1962, cat. 145, pp. 42–44.

27. *The Virgin with the Dead Christ* (*Pietà*), about 1430
'The Rimini Master' (Southern Netherlandish)
PROVENANCE: Given by Sir Thomas Barlow to the Victoria and Albert Museum in 1960.
BIBLIOGRAPHY: Manchester 1947, cat. 11a; Nuis Cahill 1971, p. 13; Williamson/Evelyn 1988, pp. 187–91; *Art of Devotion*, p. 104.

28. *The Madonna of the Meadow*, about 1500
Giovanni Bellini, active from around 1459, died 1516
PROVENANCE: Purchased from Achille Farina, Faenza, 1858.
BIBLIOGRAPHY: Davies 1961, pp. 57–58; Robertson 1968, pp. 119 120; Cast 1969, pp. 247–257; Dunkerton et al. 1991, p. 356; Tempestini 1992, pp. 230–1, no. 82.

29. *The Christ Child Resting on the Cross*, 1670s
Bartolome Esteban Murillo (1617–1682)
PROVENANCE: Sale of Mr and Lady Arthur Bagnal, London, 1757, lot 89 (listed as 'Our Saviour Sleeping … Morrillios'); bought by Charles Jennings and recorded in 1766 in his London collection; inherited by the 1st Earl Howe in 1824 through his father, a cousin of Charles Jennings; Howe Sale of 7 December 1933, Christie's, London, lot 45, where it was bought by J.G. Graves.
BIBLIOGRAPHY: *The English Connoisseur* 1766, I, pp. 36 and 81; Stirling-Maxwell 1873, p. 80; Curtis 1883, no. 157; Mâle 1932, p. 331; Angulo Iñiguez 1981, I, p. 422, and II, no. 215; London 1982–3, cat. 60.

30. *The Adoration of the Kings and Christ on the Cross*, about 1465–75
Attributed to Benedetto Bonfigli (active 1445; died 1496)
PROVENANCE: Conte Fabiani Sale, Gubbio, April–May, 1882; purchased from Elia Volpi, Florence, 1901.
BIBLIOGRAPHY: Bombe 1912, p. 102; Davies 1961, pp. 92–3; Davisson 1971, p. 133; Mancini 1992, no. 15, p. 143.

31. *The Adoration of the Kings*, 1500–15
Jan Gossaert (active 1502; died 1532)
PROVENANCE: Possibly commissioned by Jan de Broeder, abbot of the Benedictine Abbey of St Adrian at Geraardsbergen in East Flanders; in 1601 Albert and Isabella, the Governors of the Spanish Netherlands, bought it; later in the posession of Charles of Lorraine, Governor of the Austrian Netherlands from 1744; included in sale of his effects in Brussels in June 1781; by 1795 in the possession of the dealer and writer Michael Bryan (1787–1821) from whom acquired by Frederick Howard 5th Earl of Carlisle (1748–1825); passed by descent through the family to the widow of the 9th Earl of Carlisle, Rosalind Frances Stanley (1845–1921), from whom acquired by the National Gallery in 1911.
BIBLIOGRAPHY: Friedländer 1948, p. 7; Panofsky 1953, I, p. 277; Steppe 1965, pp. 39–46; Davies 1968, pp. 63–66; Friedländer 1976, vol. 14, p. 27; Campbell, Foister, Roy 1997, pp. 87–97.

32. *The Adoration of the Kings*, 1564
Pieter Bruegel the Elder (active: 1550/1; died: 1569)
PROVENANCE: Probably in the Imperial collection at Vienna in the 1610s; Georg Roth, Vienna, by 1898; bought from the Roth Collection by Guido Arnot, from whom purchased by the National Gallery with contributions from the NACF in 1920.
BIBLIOGRAPHY: Friedländer 1976, vol. 14, pp. 27–35; Pevsner 1948, pp. 215–17; Davies 1968, pp. 21–22; Grossman 1973, pp. 195–96; Pinson 1994, pp. 109–27.

3 The True Likeness

33. *The Procession to Calvary*, probably about 1505
Ridolfo Ghirlandaio (1483–1561)
PROVENANCE: Church of San Gallo, Florence, until 1529; said to have been removed to Santo Spirito in Florence and then to the Palazzo Antinori da San Gaetano also in Florence; bought by the National Gallery from the heirs of the Antinori family in 1883.
BIBLIOGRAPHY: Gould 1975, p. 100; Chiarini 1986, p. 44.

34. *Saint Veronica with the Sudarium* about 1420
Master of Saint Veronica (active early fifteenth century)
PROVENANCE: Said to have been in the church of St Lawrence, Cologne (demolished in 1817); later in the hands of a priest whence it passed to the Cologne dealer, Spanner; apparently acquired from him by Johann Peter Weyer by 1851; bought by the National Gallery at the Weyer sale, 25 August 1862, lot 116.
BIBLIOGRAPHY: Levey 1959, pp. 95–6, London 1977, cat. no. 6, p. 32; Dunkerton et al. 1991, p. 242; Cologne 1995, cat. no. 147, pp. 560–61.

35. *Two Angels Holding the Veronica*, 1513
Albrecht Dürer (1471–1528)
PROVENANCE: Bequeathed to the British Museum in 1799 as part of the Cracherode collection.

BIBLIOGRAPHY: Panofsky 1953, no. 132; Hollstein 1962, no. 26; Boston 1971, no. 183; Strauss 1981, no. 69; Koerner 1993, pp. 91–92.

36. *The Veil of Saint Veronica*, about 1635
Francisco de Zurbarán (1598–1664)
PROVENANCE: Bequeathed to King Louis Philippe from the collection of Frank Hall Standish, Paris, in 1842; bought by William Stirling-Maxwell of Keir at the Louis-Philippe and Standish sale, Christie's, London, 27 May 1853, lot 230; bought by the Nationalmuseum, Stockholm, in 1957.
BIBLIOGRAPHY: New York 1987, no.54 with full bibliography.

37. *Portrait of a Young Man*, 1450–60
Petrus Christus (active 1444; died 1475/6)
PROVENANCE: In an Italian collection in the late eighteenth or early nineteenth century; bought in 1863 by Thomas Baring from the dealer Henry Farrar; Thomas George Baring, Lord Northbrook; in the collection of George Salting by 1895; entered the National Gallery as part of the Salting Bequest, 1910.
BIBLIOGRAPHY: Davies 1968, pp. 33–34; Belting 1994, pp. 542–4; Campbell 1998, pp. 104–9 with bibliography.

38. *The Face of Christ*, late fifteenth century
German/Netherlandish
PROVENANCE: Bought in Munich in about 1922 by Dr J.H. Maasland and given by his widow, Mrs M.A.J. Maasland-van Troostenburg de Bruyn, to the Aartsbisschoppelijk Museum, Utrecht, 1972.
BIBLIOGRAPHY: Unpublished.

39. *The Veil of Saint Veronica*, 1649
Claude Mellan (1598–1688)
PROVENANCE: Bequest of George Grote, 1872
BIBLIOGRAPHY: Paris 1988, nos. 106–8; Préaud 1988, no. 21.

40. *Diptych with the Head of Christ and the Lentulus Letter*, late fifteenth- or early sixteenth-century
Southern Netherlandish(?)
PROVENANCE: Said to be from the St Lambertuskerk, Swolgen.
BIBLIOGRAPHY: Bouvy 1965, pp. 45–6.

41. *Icon of the Mandylion of Edessa*, eighteenth century
Perhaps made in Italy
PROVENANCE: Bought by Albert, Prince Consort, as part of the Oettingen-Wallerstein Collection, 1851.
BIBLIOGRAPHY: Waagen 1854, no. 4, pp. 3–4; Cust/Dobschütz 1904; Drandakis 1974, pp. 38–39.

42. *The Ostentation of the Holy Shroud of Turin*, 1689–90
Pietro Antonio Boglietto, active late seventeeth century
BIBLIOGRAPHY: *L'Ostensione della S. Sindone*, exh. cat., Turin, 1931, cat. no. 13, pl. XXVIIIb; Wilson 1978, reproduced between pp. 146 and 147; E. Bertana and others, *La Sindone di qua dai monti: Documenti e testimonianze*, Turin, 1978, p. 51, and entry by A. Bo Signoretto, pl. XV; B. Cilento and M. Macera, *La collezione sindonica della Cappella Reale*, Turin, 1998, cat. no. R.880–6

4 Passion and Compassion

..

43. *Reliefs of the Passion and Resurrection*, Roman, AD 420–430
1 Christ Taking up his Cross
2 The Crucifxion
3 The Empty Tomb
4 Christ's Commission to the Apostles
PROVENANCE: Purchased by the British Museum from the collection of William Maskell in 1856
BIBLIOGRAPHY: Maskell 1905, pp. 89–93; Dalton 1909, no. 7, pp. 5–6; Weitzman 1979, cat. no. 452; Buckton 1994, cat. no. 5; Kötzsche 1994, pp. 80–90.

44. *The Virgin and Child and The Man of Sorrows*, about 1260
Anonymous Umbrian(?) Master
PROVENANCE: NG 6572: Ruef, Munich, 14–15 December 1989, lot 113 (as north Italian, 19th century); acquired by the National Gallery from a private collector, 1999. NG 6573: Brussels, Adolphe Stoclet Collection (bought from Gnecco, Genoa, 26 October 1926); subsequently collection of Madame Feron-Stoclet; acquired by the National Gallery from the heirs to the Feron-Stoclet Collection, 1999.
BIBLIOGRAPHY: Belting 1990, pp. 166, 174–85; Cannon 1999, pp. 107–12; Gordon 1999, p. 16.

45. *The Crowning with Thorns*, about 1490–1500
Hieronymus Bosch (living 1474; died 1516)
PROVENANCE: Possibly owned by the Portuguese humanist, Damião de Góis in 1572; bought in Spain before 1867 by Hollingworth Magniac; inherited by his eldest son Charles Magniac in 1867; sold at the Magniac sale, Christie's, London in 1892 and bought by Robert Thompson Crawshay; purchased by the National Gallery from the Sangiorgi Gallery, Rome, 1934.
BIBLIOGRAPHY: Davies 1953, pp. 18–21; Marrow 1977, p. 178; Tudor-Craig/Foster 1986; Campbell 1999.

46. *Christ presented to the People (Ecce Homo)*, about 1525–30
Antonio Allegri known as Correggio (about 1494; died 1534)
PROVENANCE: Probably the picture engraved by Agostino Carracci as in the Prati collection, Parma, in 1587; recorded in the Colonna Gallery, Rome, in 1783; bought from there by Alexander Day before 1802 when he sold the picture to Ferdinand IV of Naples; bought by the National Gallery from the 3rd Marquess of Londonderry, 1834.
BIBLIOGRAPHY: Gould 1975, pp. 61–3; Gould 1976, pp. 216–219; Ekserdjian 1997, pp. 163–66.

47. *Christ as the Man of Sorrows*, 1520s
Style of Jan Mostaert
PROVENANCE: Henry Willett, Brighton, until his death in 1905; acquired by Henry Wagner and presented to the National Gallery in 1924.
BIBLIOGRAPHY: Friedländer 1972a, vol. 10, p. 70; Davies 1968, pp. 133–34.

48. *Christ on the Cold Stone*, about 1500
Eastern Netherlandish
PROVENANCE: Possibly formerly in the church of Zeddam or Terborg (Eastern Netherlands); transferred to the Roman Catholic Parish Church of St Matthew in Azewijn in the nineteenth century; donated to the Utrecht Museum in 1926.
BIBLIOGRAPHY: Bouvy 1962, no. 186, pp. 110–11

49. *Saint Francis embracing the Crucified Christ*, about 1620
Francisco Ribalta (1565–1628)
PROVENANCE: Painted for the Franciscan Capuchin Convent of the Sangre de Cristo in Valencia; following the secularisation of the convent in 1835, it passed to the Museo de Valencia, where it was first catalogued in 1847.
BIBLIOGRAPHY: Fitz Darby 1938, pp. 118–19; Kowal 1985, no. F. 40, pp. 254–55; Benito Domenech 1987, no. 39.

50. *The Stigmatisation of Saint Catherine of Siena*, about 1630
Rutilio Manetti (1571–1639)
BIBLIOGRAPHY: Avignon 1992, cat. no. 65.

51. *The Deposition*, about 1325
Ugolino di Nerio (active 1317; died 1339/49?)
PROVENANCE: The altarpiece was probably commissioned by the Almanni family; this panel was brought to England at beginning of the nineteenth century, with several other fragments from the altarpiece, by William Young Ottley; his son, Warner Ottley; Warner Ottley sale, June 1850 where acquired by the Reverend John Fuller Russell; Fuller Russell sale, April 1885, where bought by Henry Wagner;

presented by him to the National Gallery in 1918.
BIBLIOGRAPHY: Coor-Achenbach 1955, pp. 155, 160–1;
Cannon 1982, pp. 87–91; Gordon/Reeve 1984, pp. 36, 44;
Davies/Gordon 1988, pp. 533–39; Bomford/Gordon 1989,
pp. 98–123.

52. *Lamentation over the Dead Christ*, 1455–1460
Donatello (1386/87–1466)
PROVENANCE: Possibly a trial piece for the western portal
of Siena Cathedral (1457–59), a project that was aborted
after only a couple of relief panels in wax had been pro-
duced. Palazzo Mocenigo di S. Luca, Venice; later owned by
Armand Baschet, Paris; acquied by the South Kensington
Museum in 1863.
BIBLIOGRAPHY: Janson 1957, pp. 206–8; Pope-Hennessy
1964, I, pp. 75–6; Bennett/Wilkins 1984, pp. 14–15, 98–100;
Bellosi 1993, cat. no. 21; Pope-Hennessy 1993, p. 192;
Rosenauer 1993, pp. 258, 260, cat. no. 60, p. 289; Penny
1994, pp. 11–15.

53. *The Entombment*, (probably 1450s)
Dirk Bouts (1400?–1474)
PROVENANCE: Foscari collection, Venice; acquired in the
early nineteenth century by Diego Guicciardi (1756–1837)
and kept in Milan; purchased by the National Gallery from
the Guicciardi family in 1860.
BIBLIOGRAPHY: Davies 1953, pp. 24–27; Davies 1968,
pp. 15–16; Bomford 1986, pp. 39–57; Dunkerton 1991,
pp. 296–297; Campbell 1988, pp. 38–45.

5 Praying the Passion

54. *Christ after the Flagellation contemplated by the Christian Soul*, late 1620s or early 1630s
Diego Velázquez (1599–1660)
PROVENANCE: Bought in Madrid by John Savile Lumley
(later Lord Savile, 1818–1896) from the painter dealer José
Bueno; presented by him to the National Gallery in 1883.
BIBLIOGRAPHY: Jameson 1881, pp. 81–83; 'The latest addi-
tion to the National Gallery' in the *The Times*, 16 August
1883, p. 7; López-Rey 1963, no. 12; MacLaren/Braham 1970,
pp. 119–21; Glendinning 1989, p. 123; Harris 1982, p. 117;
Moffitt 1992, pp. 139–154; Brigstocke 1999, pp. 17–19
and 25.

55. Prayer-nut with the Man of Sorrows, *c*.1500
South Netherlandish
PROVENANCE: Aquired by the Victoria and Albert Museum
from the Webb collection in 1874.
BIBLIOGRAPHY: *List of the Objects in the Art Division South
Kensington Museum aquired during the year 1874*, London,
1875, p. 20.

56. Eight scenes from the 'Small Passion', 1509–11
Albrecht Dürer (1471–1528)
*Woodcuts, each c.126 x 97 mm., comprising The
Flagellation, Christ Crowned with Thorns, 'Ecce Homo',
Pilate Washing his Hands, The Bearing of the Cross, Saint
Veronica with the Sudarium and Saints Peter and Paul,
The Nailing to the Cross, The Crucifixion.*
PROVENANCE: First four prints bequeathed by Joseph
Nollekens via Francis Douce, 834; second four presented
by William Mitchell, 1895.
BIBLIOGRAPHY: Berliner 1928; Meder 1932, nos. 125–61,
pp. 129–50; Winkler 1941; Panofsky 1948, I, pp. 139–45;
Kisser 1964; Munich 1971, cat. no. 374; Wölfflin 1971,
pp. 175–00; Washington 1971, cat. nos. 156–93; Strauss
1980, nos. 106–42, pp. 342–415, no. 155, pp. 445–46;
Fehl 1992; London 1995 pp. cat. nos. 27–29.

57. Portable Passion Polyptych, mid-sixteenth century
Netherlandish
PROVENANCE: Enríquez de Ribera collection, Spain, in the
sixteenth century; Julius Wernher, Luton Hoo.
BIBLIOGRAPHY: Unpublished.

58. *Mass of Saint Gregory*, 1490s(?)
Israhel van Meckenem (about 1440–1503)
PROVENANCE: Bought by the British Musuem from
William Smith in 1845.
BIBLIOGRAPHY: Lehrs 1934, no. 354; Breitenbach 1974,
pp. 21–26, Koreny/Hutchinson 1981, no. 102, p. 101; Mâle
1986, pp. 95–96; *Art of Devotion*, pp. 110–12.

59. The Man of Sorrows as the Image of Pity, second half of the fourteenth century
Venetian(?)
PROVENANCE: Charles Butler Sale, London, 25 May 1911;
bought by Henry Wagner, by whom presented to the
National Gallery in 1924.
BIBLIOGRAPHY: Davies/Gordon 1988, p. 118

60. *The Image of Pity*, about 1500
English
PROVENANCE: The prayer book comes from the Briggitine
convent of Syon, near Isleworth; acquired by the Bodleian
Library from the collection of Richard Rawlinson (died
1755).
BIBLIOGRAPHY: Dodgson 1928–29, pp. 96, 99–101,
pl. XXXV ©; Jackson, Ferguson and Pantzer 1976, p. 3;
Duffy 1992, p. 214, fig. 85.

61. Devotional Booklet, about 1330–40
German (Lower Rhine or Westphalia)
PROVENANCE: Purchased from John Webb, London, 1872
BIBLIOGRAPHY: Koechlin 1924, I, pp. 194, 198, 207, 210; II,
no. 526; III, pl. XCIV; Longhurst 1927–29, II, pp. 24–25;

Berliner 1955, p. 51; Martin 1961, p. 17; Wentzel 1962,
pp. 193–212; Wixom 1972, pp. 96–99; Hamburger 1989,
p. 30; *Art of Devotion*, pp. 114–15, p.182; Williamson 1996,
pp. 212–13; Detroit 1997, pp. 193–97.

62. Angel holding a Shield with the Wounds of Christ, 1475–85
Netherlandish
PROVENANCE: Said to come from the Monastery of Saint
Cecilia in Utrecht; donated to the Bisschoppelijk Museum,
Haarlem, by G.B. Brom, 1876.
BIBLIOGRAPHY: *Gids in het Bisschoppelijk Museum
Haarlem*, Haarlem, 1913, p. 24, no. 383.

63. Ring with the Five Wounds of Christ and the Image of Pity ('The Coventry Ring'), fifteenth century
English
PROVENANCE: Found at Coventry in 1802; Thomas Sharp;
entered the British Museum in 1897 with the Franks
Bequest.
BIBLIOGRAPHY: Sharp 1817; Dalton 1912, no. 718; Evans
1922, p. 126; Dalton/Tonnochy 1924, p. 151; Gray 1963,
p. 165.

64. Prayer Roll, late fifteenth century
English
PROVENANCE: Before 1509, possibly the William Thomas
mentioned in the inscription on the second membrane;
the subsequent history is unknown until it was supposedly
found in Liverpool shortly before 1858.
BIBLIOGRAPHY: Charlton 1858; Ker/Piper 1992, IV, no. 29,
pp. 538–40.

65. Prayer sheet with the Wounds and the Nail, late seventeenth century
Issued by J.P. Steudner in Augsburg, Germany.
BIBLIOGRAPHY: Coupe 1966, no. 160; Hamburg 1983, no.
138.

6 The Saving Body

66. *Noli me Tangere*, about 1515
Titian (active about 1506; died 1576)
PROVENANCE: Muselli collection, Verona, by 1648; brought
to Britain after purchase from the Orléans collection, 1792;
bequeathed to the National Gallery by Samuel Rogers,
1856.
BIBLIOGRAPHY: Gould 1975, pp. 275–78; Hope 1980, pp.
20–22; MacGregor 1995.

67. *The Incredulity of Saint Thomas*, about 1620
Bernardo Strozzi (1581-1644)
PROVENANCE: Probably Canadelli, by whom sold in Milan, Genoline, 15-18 February 1897, lot 86; Favre Repetto, Genoa; Aquiles Ponzini, Montevideo, Uruguay; sold by an anonymous private collector at Sotheby's London, 9 July 1988, lot 73, where acquired by the Compton Verney House Trust (Peter Moores Foundation).
BIBLIOGRAPHY: Mortari 1995, p. 130, no. 221.

68. Christ showing the Wound in his Side, about 1420-25
Italian (Florentine)
PROVENANCE: Purchased in Florence, 1937, from Signorina Testi.
BIBLIOGRAPHY: Middeldorf 1941, pp. 71-78; *Europäische Kunst*, 1962, no. 352, p. 322; Pope-Hennessy, 1964, no. 55, pp. 64-65; Borngässer 1987, p. 276; Gentilini 1992, p. 31, p. 153 note 39.

69. *The Deposition*, about 1500-1505
Master of the Saint Bartholomew Altarpiece
PROVENANCE: Ingram family collection, Temple Newsam, 1714; bought by the National Gallery from the Earl of Halifax, 1981.
BIBLIOGRAPHY: National Gallery Report 1980-81, pp. 50-51; Smith 1985, p. 82; Dunkerton et al. 1991, p. 368; MacGregor 1993, pp. 29, 41.

70. *Christ in a Chalice sustained by Angels*, about 1620
Jacopo Negretti, called Palma Giovane (1544-1628)
PROVENANCE: Bequeathed by W.F. Watson to the National Gallery of Scotland in 1881.
BIBLIOGRAPHY: Tietze/Tietze-Conrat 1944, p. 202, no. 896; Edinburgh 1961, no. 12; Andrews 1968, I, p. 84; Pignatti/Romanelli 1985, under no. 6, p. 52.

71. *The Blood of the Redeemer*, 1460-65
Giovanni Bellini (active about 1459; died 1516)
PROVENANCE: Robert Prioleau Roupell collection by 1887; bought by the National Gallery in 1887 from Charles Fairfax Murray.
BIBLIOGRAPHY: Davies 1961, pp. 60-1; Braham 1978, pp. 11-24; Goffen 1989, pp. 82, 224-5; Dunkerton et al. 1991, pp. 22, 120.

72. Monstrance with The Last Supper, 1705
Johannes Zeckel (apprenticed in 1658; died 1728)
PROVENANCE: Acquired in Cologne by Dr W.L. Hildburgh FSA, in 1922; given by him to the Victoria and Albert Museum in 1952.
BIBLIOGRAPHY: Unpublished.

73. *Christ as the Man of Sorrows in the Wine Press*, about 1425
German
PROVENANCE: Bequest to the Victoria and Albert Museum of Lt.-Col. G.B Croft-Lyons, 1926.
BIBLIOGRAPHY: The object is upublished, but for an identical mould, see Von Bode/Volbach 1918, p. 129, no. 36, pl. IV, no. 8.

74. *Christ in the Wine Press*, about 1600
Hieronymus Wierix (1553-1619)
PROVENANCE: Acquired by the British Museum in 1863.
BIBLIOGRAPHY: Mauquoy-Hendrikx 1978, I, no. 583, p. 102.

75. *Christ as Saviour and Judge*, about 1450
Petrus Christus (active 1444 – died 1475/6)
PROVENANCE: Possibly the Empress Maria Theresa of Austria (her seal, embossed in paper, is affixed with red sealing wax on reverse); later in the collection of the Reverend Henry Parry Liddon, Canon of St Paul's Cathedral, who bequeathed it to his niece, Mary Ambrose, in 1890; Major M.R. Liddon; Trustees of the Feeney Charitable Trust, and given by them to the Birmingham Museum and Art Gallery, in 1935.
BIBLIOGRAPHY: Birmingham, 1960, p. 51; Rowlands 1962, pp. 419-23; Friedländer 1967, vol. 1, p. 107; Sterling 1971, p. 24; Schabacker 1974, cat. no. 13, pp. 105-6; Upton 1990, pp. 44-45. 55-56; Ainsworth 1994, cat. no. 9, pp 112-116.

7 The Abiding Presence

76. *Christ carrying the Cross*, 1920
Stanley Spencer (1891-1959)
PROVENANCE: Purchased by the Contemporary Art Society through the Grosvenor Galleries for the Tate Gallery, 1921.
BIBLIOGRAPHY: Spencer 1961, pp. 158, 167; Carline 1978, pp. 124-125; Robinson 1979, pp. 23-5; Rothenstein 1979, pp. 73, 80; Robinson, 1990, pp. 25, 28; Pople 1991, pp. 86-92, 114; Bell 1992, pp. 42, 396-7, cat. no. 38; MacCarthy 1997, cat. no. 9, see also cat. no. 28.

77. *Christ of Saint John of the Cross*, 1951
Salvador Dalí (1904-1989)
PROVENANCE: Bought by the Glasgow Art Gallery from the Grafton Galleries, London, in 1952.
BIBLIOGRAPHY: *Scottish Art Review*, IV, no. 2, 1952; VI, no. 4, 1958, pp. 14-16; Dalí 1976; Descharnes 1994 pp.436-42 and 450-51.

78. *Christ in Glory in the Tetramorph* (First Cartoon), 1953
Graham Sutherland (1903-1980)
PROVENANCE: Redfern Gallery; acquired by Lord Iliffe and presented to the Herbert Art Gallery in 1964.
BIBLIOGRAPHY: Alley 1982, pp. 130-33; Berthoud 1982, pp. 201-22; Cooper 1961, pp. 35-6; Hayes 1980, pp. 35-37, 144; Révai 1964, *passim*; Thuillier 1982, pp. 62-69.

79. *The Resurrection, Cookham*, 1924-26
Stanley Spencer (1891-1959)
PROVENANCE: Purchased by the Duveen Paintings Fund Committee through the Goupil Gallery, for the Tate Gallery, 1927.
BIBLIOGRAPHY: Spencer 1961, pp. 172-173, 175; Carline 1978, pp. 163-6, 168-75, 206; Robinson 1979, pp. 8, 29-30; Robinson 1990, pp. 36-37; Pople 1991, pp. 225-32, 235-49; Bell 1992, pp. 52, 52-59, 66-67, 413-414, cat. no. 116; MacCarthy 1997, cat. no. 13; Avery-Quash 1999, pp. 5-6.

General Bibliography

AINSWORTH 1994 M.W. Ainsworth, ed. *Petrus Christus: Renaissance Master of Bruges*, exh. cat., Metropolitan Museum of Art, New York, 1994.

ALEXANDER 1997 J. Alexander, ed. *Money: A History*, London, 1997.

ALEXANDRE-BIDON 1990 D. Alexandre-Bidon, ed. *Le Pressoir Mystique*, Actes du Colloques de Recloses, (1989), Paris, 1990.

ALLEY 1982 R. Alley, *Graham Sutherland*, exh. cat., The Tate Gallery, London, 1982.

ALOIS 1936 T. Alois, *Die Darstellung Christi in der Kelter*, Düsseldorf, 1936.

ANDERSON 1955 M.D. Anderson, *The Imagery of British Churches*, London, 1955.

ANDREWS 1968 K. Andrews, *National Gallery of Scotland, Catalogue of Italian Drawings*, 2 vols., Cambridge, 1968.

ANGULO IÑÍGUEZ 1950 D. Angulo Iñíguez, 'Una variante del Agnus Dei del Museo de San Diego (Estados Unidos)', *Archivo Español de Arte*, 23 (1950), pp. 77–78.

ANGULO IÑÍGUEZ 1981 D. Angulo Iñíguez, *Murillo. Su vida, su arte, su obra*, 3 vols., Madrid, 1981.

ARENS 1971 F. Arens, 'Die ursprüngliche Verwendung gotischer Stein-u. Tonmodel', *Mainzer Zeitschrift*, 66 (1971), pp. 106–31.

Art of Devotion; The Art of Devotion in the Late Middle Ages in Europe, 1300–1500, exh. cat., H. Van Os, ed. Rijksmuseum, Amsterdam, 1994–5, London, 1994.

ASKEW 1969 P. Askew, 'The Angelic Consolation of Saint Francis of Assisi in Post-Tridentine Italian Painting', *Journal of the Warburg and Courtauld Institutes*, 32 (1969), pp. 280–306.

AVERY-QUASH 1999 S. Avery-Quash, '"Valuable Assistance": Stanley Spencer's friendship with Gwen and Jacques Raverat', *Apollo*, 150 (1999), pp. 3–11.

AVIGNON 1992 *Catherine de Sienne*, exh. cat., E. Moench and J-P Blanc, eds. Avignon, Palais des Papes, 1992.

BAILEY 1996 D.M. Bailey, *A Catalogue of the Lamps in the British Museum*, vol. IV, *Lamps of Metal and Stone, and Lampstands*, London, 1996.

BAKER 1992 M. Baker in 'Renaissance and later Sculpture with works of art in bronze: Thyssen-Bornemisza Collection'. A. Radcliffe, ed. London, 1992.

BELL 1992 K. Bell, *Stanley Spencer: A Complete Catalogue of the Paintings*, London, 1992.

BELLOSI 1993 L. Bellosi, ed. *Francesco di Giorgio e il Rinascimento a Siena 1450–1500*, exh. cat., Milan 1993.

BELTING 1990 H. Belting, *The Image and its Public in the Middle Ages: Form and Function of Early Paintings of the Passion*, New York, 1990.

BELTING 1994 H. Belting, *Likeness and Presence: A History of the Image before the Era of Art*, Chicago, 1994.

BENITO DOMENECH 1987 F. Benito Domenech, *Los Ribalta y la Pintura Valenciana de su Tiempo*, exh. cat., Valencia and Madrid, Museo Nacional del Prado, 1987.

BENNETT 1969 M. Bennett, ed. *William Holman Hunt*, exh. cat., Walker Art Gallery, Liverpool, 1969.

BENNETT/WILKINS 1984 B.A. Bennett and D.G. Wilkins, *Donatello*, Oxford, 1984.

BERANEK 1986 R. Beranek, 'Der Model-Fund von Marienwohlde', *Lauenburgische Heimat, Zeitschrift des Heimat und Geschichtsvereins Herzogtum Lauenburg*, Neue Folge, 116 (1986), pp. 60–64.

BERLINER 1928 R. Berliner, 'Zu Dürer's Kleiner Passion', *Die christliche Kunst*, 25 (1928–29), pp. 314–18.

BERLINER 1955 R. Berliner, 'Arma Christi', *Münchner Jahrbuch der bildenden Kunst*, 3rd ser., 6 (1955), pp. 35–152.

BERTELLI 1967 C. Bertelli, 'The *Image of Pity* in Santa Croce in Gerusalemme', in *Essays in the History of Art presented to Rudolf Wittkower*, London, 1967, pp. 40–55.

BERTHOUD 1982 R. Berthoud, *Graham Sutherland: A Biography*, London, 1982.

BIRMINGHAM 1960 *Catalogue of Paintings: City Museum and Art Gallery, Birmingham*, Birmingham, 1960.

BLACK 1989 C. Black, *Italian Confraternities in the Sixteenth Century*, Cambridge, 1989.

BLUNT 1939–1940 A. Blunt, 'El Greco's "Dream of Philip II": An allegory of the Holy League', *Journal of the Warburg and Courtauld Institutes*, 3 (1939–1940), pp. 58–69.

BODMER 1939 H. Bodmer, *Ludovico Carracci*, Burg, 1939.

BOLOGNA/FORT WORTH 1993–94 *Ludovico Carracci*, exh. cat., Andrea Emiliani ed. Museo Civico Archeologico, Bologna, 1993; Kimbell Art Museum, Fort Worth, 1994.

BOMBE 1912 W. Bombe, *Geschichte der Peruginer Malerei*, Berlin, 1912.

BOMFORD 1986 D. Bomford, A. Roy, A. Smith, 'The Techniques of Dieric Bouts: Two Paintings Contrasted', *National Gallery Technical Bulletin*, 10 (1986), pp. 39–58.

BOMFORD/GORDON 1989 D. Bomford and D. Gordon, *Art in the Making: Italian Painting before 1400*, exh. cat., National Gallery, London, 1989.

BOON 1967 K.G. Boon, *Geertgen Tot Sint Jans. Art and Architecture in the Netherlands*, Amsterdam, 1967.

BOSTON 1971 *Albrecht Dürer: master printmaker*, exh. cat., Museum of Fine Arts, Boston, 1971.

BORNGÄSSER 1987 B. Borngässer, 'Die Apsisdekoration der alten Kathedrale zu Salamanca und die Gebr. der Delli aus Florenz', *Mitteilungen des Kunsthistorischen Institutes in Florenz*, 31 (1987), pp. 237–290.

BOUVY 1962 D.P.R.A. Bouvy, *Beeldhouwkunst van de Middeleeuwen tot heden uit het Aartsbiss-choppelijk Museum te Utrecht*, Amsterdam/Brussels, 1962.

BOUVY 1965 D.P.R.A. Bouvy, *Kerkelijke Kunst I, Schilderkunst*, Bussum, 1965.

BRAHAM 1978 A. Braham, M. Wyld and J. Plesters, 'Bellini's "Blood of the Redeemer"', *National Gallery Technical Bulletin*, 2 (1978), pp. 11–24.

BREITENBACH 1974 E. Breitenbach, 'Israhel von Meckenem's Man of Sorrows', *Quarterly Journal of the Library of Congress*, 31, (January 1974), pp. 21–26.

BRIGSTOCKE 1999 H. Brigstocke, 'El descubrimiento del arte español en Gran Bretaña', essay in *En torno a Velázquez: Pintura española del siglo de oro*, exh. cat., Z. Veliz, ed. Museo de Bellas Artes de Asturias, Oviedo, 1999, pp. 5–25.

BRUUN 1962 P. Bruun, 'The Christian Signs on the Coins of Constantine', *Arctos*, New Series, 3 (1962), pp. 5–35.

BRUUN 1997 P. Bruun, 'The Victorious Signs of Constantine: A Reappraisal', *The Numismatic Chronicle*, 157 (1997), pp.41–59.

BUCKTON 1994 D. Buckton, ed. *Byzantium: Treasures of Byzantine Art and Culture from British Collections*, exh. cat., British Museum, London, 1994.

BÜHLER 1964 C.F. Bühler, 'Prayers and charms in certain Middle English scrolls', *Speculum*, 39 (1964), pp. 270–78.

CABROL/LECLERQ 1907–53 F. Cabrol O.S.B. and H. Leclerq O.S.B., *Dictionnaire d'Archéologie Chrétienne et de Liturgie*, 15 vols, Paris, 1907–53.

CABROL/THURSTON 1907–14 F. Cabrol, O.S.B. and H. Thurston S.J., *Catholic Encyclopedia*, 15 vols and index, New York, 1907–14.

CAMPBELL, FOISTER, ROY 1997 L. Campbell, S. Foister and A. Roy, 'Gossaert's *Adoration of the Kings*', *National Gallery Technical Bulletin*, 18 (1997), pp. 87–97.

CAMPBELL 1998 L. Campbell, *National Gallery Catalogues: The Fifteenth-Century Netherlandish Schools*, London, 1998.

CAMPBELL 1999 L. Campbell, 'Bosch, "Christ Mocked (The Crowning with Thorns)", NG 4744', in *La Peinture dans les*

Pays-Bas au 16ème Siècle, Practiques d'Atelier Infrarouges et autres Methodes d'Investigation, Le Dessin Sous-jacent et la Technologie dans la Peinture, Colloque XII, 11–13 septembre, Hélene Verougstraete and Rogier Van Schoute, Leuven, eds. 1997, 1999, pp.29–36.

CANNON 1982 J. Cannon, 'Simone Martini, the Dominicans, and the Early Sienese Polyptych', *Journal of the Warburg and Courtauld Institutes*, 45 (1982), pp. 69–93.

CANNON 1999 J. Cannon, 'The Stoclet *Man of Sorrows*: a thirteenth-century Italian diptych reunited', *The Burlington Magazine*, 141 (1999), pp. 107–12.

CARLINE 1978 R. Carline, *Stanley Spencer at War*, London, 1978.

CARSON 1981 R.A.G. Carson, *Principal Coins of the Romans*, vol. III, *The Dominate*, AD 294–498, British Museum Publications, London, 1981.

CAST 1969 D. Cast, 'The stork and the serpent, a new interpretation of the Madonna of the Meadow by Bellini', *Art Quarterly*, 32 (1969), pp. 247–57.

CHARLTON 1858 E. Charlton, 'Roll of Prayers formerly belonging to Henry VIII when Prince', *Archaeologia Aeliana*, New Series 2 (1858), pp. 41–5.

CHIARINI 1986 M. Chiarini, ed. *Andrea del Sarto*, exh. cat., Palazzo Pitti, Florence, 1986.

COLOGNE 1974 *Vor Stefan Lochner, Die Kölner Maler von 1300 bis 1430*, exh. cat., R. Wallrath, ed. Wallraf-Richartz-Museum, Cologne, 1974.

COLOGNE 1995 *Lust und Verlust. Kölner Sammler zwischen Trikolore und Preußenadler*, exh. cat., H. Kier and F.G. Zehnder, eds. Museen der Stadt, Cologne, 1995.

COOK 1889 E. Cook, *A popular Handbook to the National Gallery*, London, 1889.

COOPER 1961 D. Cooper, *The Works of Graham Sutherland*, London, 1961.

COOR-ACHENBACH 1955 G. Coor-Achenbach, 'Contributions to the Study of Ugolino di Nerio's Art', *The Art Bulletin*, 37 (1955), pp. 153–165.

CORBLET 1859 Corblet, *Bulletins de la Société des antiquaires de Picardie*, 7 (1859), p. 17.

COUPE 1966 W. A Coupe, *The German illustrated broadsheet in the seventeenth century*, 2 vols., Baden-Baden, 1966/1967.

CURTIS 1883 C.B. Curtis, *Velázquez and Murillo. A descriptive and Historical catalogue of the Works*, London and New York, 1883.

CUST/DOBSCHÜTZ 1904 L. Cust and E. von Dobschütz, 'Notes on Pictures in the Royal Collections: Article III – The Likeness of Christ', *The Burlington Magazine*, 5 (1904), pp. 517–28.

DALÍ 1976 S. Dalí, *The Unspeakable Confessions of Salvador Dalí: as told to André Parinaud*, London, 1976.

DALTON 1901 O.M. Dalton, *Catalogue of Early Christian Antiquities in the British Museum*, London, 1901.

DALTON 1909 O.M. Dalton, *Catalogue of the Ivory Carvings of the Christian Era in the Department of British and Medieval Antiquities of the British Museum*, London, 1909.

DALTON 1912 O.M. Dalton, *Catalogue of the Finger Rings bequeathed [to the British Museum] by Sir Augustus Wollaston Franks*, London, 1912.

DALTON/TONNOCHY 1924 O.M. Dalton and A.B. Tonnochy, *A Guide to Medieval Antiquities and Objects of Later Date in the Department of British and Medieval Antiquities*, Oxford, 1924.

DAVIES 1953 M. Davies, *Les Primitifs Flamands, Corpus de la Peinture des Ancien Pay-Bas Méridionaux au Quinzième Siècle*, Antwerp, 1953.

DAVIES 1961 M. Davies, *National Gallery Catalogues: The Earlier Italian Schools*, London, 1961.

DAVIES 1968 M. Davies, *National Gallery Catalogues: The Early Netherlandish School*, London, 1968.

DAVIES/GORDON 1988 M. Davies, revised by D. Gordon, *The National Gallery Catalogues: The Early Italian Schools Before 1400*, London, 1988.

DAVISSON 1971 D.D. Davisson, *The Advent of the Magi: A study of the Transformations in Religious Images in Italian Art, 1260–1425*, Ph.D thesis, The John Hopkins University, 1971.

DEFOER 1980 H.L.M. Defoer, 'Pieter Aertsen: The Mass of St Gregory with the Mystic Winepress', *Master Drawings*, 18 (1980), pp. 134–42.

DESCHARNES 1994 R. Descharnes, *Dalí: the Paintings*, 2 vols., Cologne, 1994.

DETROIT 1997 *Images in Ivory: Precious objects of the Gothic Age*, exh. cat., P. Barnet, ed. Detroit Institute of Arts, 1997.

DÍAZ PADRÓN 1999 M. Díaz Padrón, 'Una sexta repetición del *Agnus Dei* de Zurbarán', *Goya*, 270 (May–June 1999), pp. 153–55.

DIDRON 1851 M. Didron, *Christian Iconography*, 2 vols., London, 1851.

DOBSCHÜTZ 1899 E. von Dobschütz, *Christusbilder: Untersuchungen zur Christlichen Legende*, Leipzig, 1899.

DODGSON 1928–29 C. Dodgson, 'English Devotional Woodcuts of the late Fifteenth Century with special reference to those in the Bodleian Library', *The Walpole Society*, 17 (1928–29), pp. 95–108.

DONATI 1996 A. Donati, ed. *Dalla Terra alle Genti: La diffusione del Cristianesimo nei primi secoli*, Milan, 1996.

DRANDAKIS 1974 N.B. Drandakis, 'Sympliromatika eis ton Emmanouil Tzane. Dyo agnostoi eikones tou', *Thesaurismata*, 11 (1974), pp. 36–72.

DUFFY 1992 E. Duffy, *The Stripping of the Altars: Traditional Religion in England 1400–1580*, New Haven and London, 1992.

DUFOUR BOZZO 1974 C. Dufour Bozzo, *Il "Sacro Volto" di Genova*, Rome, 1974.

DUNKERTON ET AL. 1991 J. Dunkerton et al., *Giotto to Durer, Early Renaissance Painting in the National Gallery*, London, 1991.

DUSEVEL 1858 Dusevel, *Bulletins de la Société des antiquaires de Picardie*, 6 (1858), p. 495.

EDINBURGH 1961 *Fifty Master Drawings in the National Gallery of Scotland*, exh. cat., introduction by D. Baxandall, 1961.

EISLER 1969 C. Eisler, 'The Golden Christ of Cortona and the Man of Sorrows in Italy', *The Art Bulletin*, 51 (1969), pp. 107–18, 233–46.

EKSERDJIAN 1997 D. Ekserdjian, *Correggio*, London, 1997.

EPSTEIN 1942 J. Epstein, *Let there be Sculpture*, London, 1942.

ETHERINGTON SMITH 1992 M. Etherington-Smith, *Dalí: a Biography*, London, 1992.

EUROPÄISCHE KUNST 1962 *Europäische Kunst um 1400*, exh. cat., V. Oberhammer, ed. Kunsthistorisches Museum, Vienna, 1962.

EVANS 1922 J. Evans, *Magical Jewels of the Middle Ages and the Renaissance particularly in England*, Oxford, 1922.

FAGIOLO DELL'ARCO 1984 *L'iconografia della Veronica a Roma*, exh. cat., M. Fagiolo dell'Arco, ed. Rome, 1984.

FEHL 1992 P.P. Fehl, 'Dürer's literal presence in his pictures: reflections on his signatures in the Small woodcut Passion' in *Der Kunstler uber sich in seinemWerk: internationales Symposium der Bibliotheca Hertziana Rom 1989*, Weinheim, 1992 pp. 191–244.

FERGUSON 1954 G. Ferguson, *Signs and Symbols in Christian Art*, Oxford, 1954.

FIRESTONE 1942 G. Firestone, 'The Sleeping Christ-Child in Italian Representations of the Madonna', *Marsyas*, 2 (1942), pp. 43–62.

FITZ DARBY 1938 D. Fitz Darby, *Francisco Ribalta and his School*, Cambridge (Mass), 1938.

FOISTER/NASH 1996 S. Foister and S. Nash, eds. *Robert Campin, New Directions in Scholarship*, Turnhout, 1996.

FORTNUM 1871 C.D. Fortnum, 'On finger-rings in the Early Christian period', *The Archeological Journal*, 28 (1871), pp. 266–92.

FRIEDLÄNDER 1948 M.J. Friedländer, *Jan Gossaert (Mabuse) The Adoration of the Kings*, (National Gallery Books, no. 19), London, 1948.

FRIEDLÄNDER 1967 M.J. Friedländer, *Early Netherlandish Painting*, 14 vols, Leyden and Brussels, 1967–1976, vol. 1, *The van Eycks and Petrus Christus*, 1967.

FRIEDLÄNDER 1969 M.J. Friedländer, *Early Netherlandish Painting*, 14 vols, Leyden and Brussels, 1967–1976, vol. 5., *Geertgen tot Sint Jans and Jerome Bosch*, 1969.

FRIEDLÄNDER 1972 M.J. Friedländer, *Early Netherlandish Painting*, 14 vols, Leyden and Brussels, 1967–1976, vol. 8., *Jan Gossart and Bernart van Orley*, 1972.

FRIEDLÄNDER 1972a M.J. Friedländer, *Early Netherlandish Painting*, 14 vols., Leyden and Brussels, 1967–1976, vol. 10, *Lucas van Leyden and other Dutch Masters of his Times*, 1972.

FRIEDLÄNDER 1976 M.J. Friedländer, *Early Netherlandish Painting*, 14 vols, Leyden and Brussels, 1967–1976, vol. 14, *Pieter Bruegel*, 1976.

FRUGONI 1992 C. Frugoni, 'Des Stigmates', in *Avignon* 1992, pp. 55–78.

GÁLLEGO/GUDIOL 1976 J. Gállego and J. Gudiol, *Zurbarán 1598–1664*, Barcelona, 1976.

GAYA NUÑO/FRATI 1976 J.A. Gaya Nuño and T. Frati, *Zurbarán*, Barcelona, 1948, 2nd edn., Barcelona, 1976.

GENTILINI 1992 G. Gentilini, *I della Robbia, La Scultura invetriata nel Rinascimento*, Florence, 1992.

GIBSON 1997 I. Gibson, *The Shameful Life of Salvador Dalí*, London, 1997.

Glass of the Caesars; Glass of the Caesars, exh. cat., D.B. Horden, ed. British Museum, London, 1987.

GLENDINNING 1989 N. Glendinning, 'Nineteenth-century British envoys in Spain and the taste for Spanish art in England', *The Burlington Magazine*, 103 (1989) pp. 117–26.

GOFFEN 1989 R. Goffen, *Giovanni Bellini*, New Haven and London, 1989.

GORDON 1999 D. Gordon, 'Acquisitions: The Virgin and Child and The Man of Sorrows', *National Gallery Review* April 1998–March 1999, London, 1999.

GORDON/REEVE 1984 D. Gordon and A. Reeve, 'Three Newly-Acquired Panels from the Altarpiece for Santa Croce by Ugolino di Nerio', *National Gallery Technical Bulletin*, 8 (1984), pp. 36–52.

GOULD 1975 C. Gould, *National Gallery Catalogues: The Sixteenth Century Italian Schools*, London, 1975.

GOULD 1976 C. Gould, *The Paintings of Correggio*, London, 1976.

GRAAS 1975 T. Graas, 'Een nieuwe interpretatie van Lodovico Carracci's Visioen van Anthonius van Padua', *Bulletin van het Rijksmuseum*, 23 (1975), pp. 173–75.

GRAF 1928 E. Graf o.s.b., *The Revelations and Prayers of Saint Bridget of Sweden*, London, 1928.

GRAY 1963 D. Gray, 'The Five Wounds of Our Lord', *Notes and Queries*, 208 (1963), pp. 50–51, 82–89, 127–34, 163–68.

GROSSMAN 1973 F. Grossman, *Pieter Bruegel: Complete Edition of the Paintings*, London, 3rd edn., 1973.

GUINARD 1960 P. Guinard, *Zurbarán et les peintres espagnols de la vie monastique*, Paris, 1960.

HAMBURG 1983 *Luther und die Folgen für die Kunst*, exh. cat., W. Hofmann, ed. Hamburger Kunsthalle, 1983–84.

HAMBURGER 1989 J.F. Hamburger, 'The Use of Images in the Pastoral Care of Nuns: The case of Heinrich of Suso and the Dominicans' *The Art Bulletin*, 71 (1989), pp. 20–46.

HAMBURGER 1998 J.F. Hamburger, *The visual and the visionary: art and female spirituality in late medieval Germany*, New York, 1998.

HARRIS 1982 E. Harris, *Velázquez*, Oxford, 1982.

HASKINS 1993 S. Haskins, *Mary Magdalen: Myth and Metaphor*, New York, 1993.

HAYES 1980 J. Hayes, *The Art of Graham Sutherland*, Oxford, 1980.

HEINEMANN 1962 F. Heinemann, *Giovanni Bellini e i belliniani*, Venice, 1962.

HELSTON 1983 M. Helston, *The National Gallery Schools of Painting – Spanish and Late Italian Paintings*, London, 1983.

HERTLING/KIRSCHBAUM 1960 L. Hertling and E. Kirschbaum, *The Roman Catacombs and their Martyrs*, London, 1960.

HILL 1920 G.F. Hill, *The Medallic Portraits of Christ*, Oxford, 1920.

HIMMELMANN 1980 N. Himmelmann, *Über Hirten-Genre in der antiken Kunst*, Opladen, 1980.

HOLLSTEIN 1962 F.W.H. Hollstein, *German Engravings, Etchings and Woodcuts, 8: Albrecht and Hans Dürer*, K.G. Boon and R.W. Scheller, eds. Amsterdam, 1962.

HOMMEL 1952 H. Hommel, 'Die Satorformel und ihr Ursprung', *Theologia Viatorum. Jahrbuch der Kirchl. Hochschule Berlin*, 4 (1952), pp. 133–80.

HONEYMAN 1971 T.J. Honeyman, *Art and Audacity*, London, 1971.

HOPE 1980 C. Hope, *Titian*, London, 1980.

HORSTER 1963 M. Horster, ' "Mantuae sanguis preciosus" ', *Wallraf-Richartz-Jahrbuch*, 25 (1963), pp. 151–80.

HUNT 1905 W.H. Hunt, *Pre-Raphaelitism and the Pre-Raphaelite Brotherhood*, 2 vols., London, 1905.

Inscriptiones; Inscriptiones Christianae Urbis Romae Septimo Saeculo Antiquiores, I.B. De Rossi et al., Nova Series, 10 vols., Rome, 1922–1992.

JACKSON, FERGUSON AND PANTZER 1976 W.A. Jackson, F.S. Ferguson and K.F. Pantzer, *A Short-title Catalogue of Books printed in England, Scotland, and Ireland and of English Books Printed Abroad 1475–1640*, 2nd edn., London, 1976.

JACOB 1985 K.A. Jacob, *Coins and Christianity*, 2nd edn., London, 1985.

JAMESON 1881 Mrs Jameson, *The History of Our Lord as exemplified in works of art*, 4th edn., London, 1881.

JANSON 1957 H.W. Janson, *The Sculpture of Donatello*, Princeton, 1957.

KELLER 1998 P. Keller, *Die Wiege des Christuskinders*, Worms, 1998.

KENT 1978 J.P.C. Kent, *Roman Coins*, London, 1978.

KER/PIPER 1992 N.R. Ker and A.J. Piper, *Medieval Manuscripts in British Libraries*, vol. IV (Paisley-York), Oxford, 1992.

KESSLER 1998 H.L. Kessler, ed. *The Holy Face and the Paradox of Representation*, Bologna, 1998.

KING 1870 C.W. King, 'The Emerald Vernicle of the Vatican', *Archaeological Journal*, 27 (1870), pp. 181–90.

KISSER 1964 M. Kisser, *Die Gedichte des Benedictus Chelidonius zu Dürers Kleiner Holzschnittpassion. Ein Beitrag zur Geschichte der spätmittelalterlichen Passionliteratur*, doctoral dissertation, Vienna, 1964.

KLAPISCH-ZUBER 1985 C. Klapisch-Zuber, 'Holy Dolls: Play and Piety in Florence in the Quattrocento', in *Women,*

Family and Ritual in Renaissance Italy, Chicago, 1985, pp. 310–29.

KNIPPING 1974 J.B. Knipping, *Iconography of the Counter Reformation in the Netherlands: Heaven on Earth*, 2 vols., Nieuwkoop, 1974.

KOECHLIN 1924 R. Koechlin, *Les ivoires gothiques français*, 3 vols., Paris, 1924.

KOERNER 1993 J.L. Koerner, *The Moment of Self-Portraiture in German Renaissance Art*, Chicago, 1993.

KORENY/HUTCHINSON 1981 F. Koreny and J.C. Hutchinson, *Early German Artists, The Illustrated Bartsch*, vol. 9, part 1, W. Strauss, ed. New York, 1981.

KÖTZSCHE 1994 L. Kötzsche, 'Die trauernden Frauen. Zum Londoner Passionskästchen', in *Studies in Medieval Art and Architecture presented to Peter Lasko*, D. Buckton and T.A. Heslop, eds. Stroud, London, Dover (New Hampshire), 1994, pp. 80–90.

KOWAL 1981 D.M. Kowal, *Ribalta y los Ribaltescos: La Evolución del Estilo Barroco en Valencia*, Valencia, 1985.

KURYLUK 1991 E. Kuryluk, *Veronica and Her Cloth, History, Symbolism, and Structure of a "True" Image*, Cambridge (MS), 1991.

LANDOW 1983 G.P. Landow, 'Shadows cast by the Light of the World: William Holman Hunt's Religious Paintings 1893–1905', *The Art Bulletin*, 65 (1983), pp. 471–84.

LE BLANT 1865 E. Le Blant, *Inscriptions Chrétiennes de la Gaule antérieures au viiie siècle*, 2 vols., Paris, 1865.

LEEDS 1999 *A Sense of Heaven*, exh. cat., with two essays by F. Scholten and R. Falkenburg, The Henry Moore Institute, Leeds, 1999.

LEHRS 1934 M. Lehrs, *Geschichte und kritischer Katalog des deutschen, niederländischen und französischen Kupferstichs im xv. Jahrhundert*, 9 vols., Vienna 1908–1934; vol. IX, Israhel van Meckenem, Vienna, 1934.

LETHABY 1935 W. Lethaby, *Philip Webb and his Work*, London, 1935.

LEVEY 1959 M. Levey, *National Gallery Catalogues: The German School*, London, 1959.

LEWIS 1986 S. Lewis, *The Art of Matthew Paris in the Chronica Majora*, Berkeley, 1986

LIGHTBOWN 1986 R.W. Lightbown, *Mantegna*, Oxford, 1986.

LIGHTBOWN 1992 R.W. Lightbown, *Mediaeval European Jewellery with a Catalogue of the Collection in the Victoria and Albert Museum*, London, 1992.

LINDET 1900 L. Lindet, 'Les Répresentations allégoriques du Moulin et du Pressoir dans l'Art Chrétien', *Revue Archeologique*, 36 (1900), pp. 403–13.

Little Flowers; The Little Flowers of Saint Francis of Assisi, London (Burns Oates and Washbourne Ltd.), no date.

LONDON 1971 *Victorian Church Art*, exh. cat., Victoria and Albert Museum, London, 1971–72.

LONDON 1977 *Late Gothic Art from Cologne*, exh. cat., A. Smith, ed. National Gallery, London, 1977.

LONDON 1981 *El Greco to Goya. The Taste for Spanish Paintings in Britain and Ireland*, exh. cat., A. Braham, ed. National Gallery, London, 1981.

LONDON 1982–83 *Bartolomé Esteban Murillo 1617–1682*, exh. cat., M. Mena Marqués, ed. Royal Academy of Arts, London, 1982–83.

LONDON 1995 *German Renaissance Prints*, exh. cat., Giulia Bartrum, ed. London, British Museum, 1995.

LONDON 1996 *William Morris 1834–1896*, exh. cat., L. Parry, Victoria and Albert Museum, London, 1996.

LONGHURST 1927–29 M.H. Longhurst, *Catalogue of Carvings in Ivory*, 2 vols., London, Victoria and Albert Museum, 1927–9.

LÓPEZ-REY 1963 J. López-Rey, Velázquez, *A Catalogue Raisonné of his Oeuvre*, London, 1963.

MAAS 1984 J. Maas, *Holman Hunt and The Light of the World*, London and Berkeley, 1984.

MacCARTHY 1997 F. MacCarthy, *Stanley Spencer: An English Vision*, exh. cat., Hirshhorn Museum and Sculpture Garden, Smithsonian Institution, Washington, D.C., 1997.

MacGREGOR 1993 N. MacGregor, 'A victim of Anonymity: the Master of the Saint Bartholmew Altarpiece', London, 1993.

MacGREGOR 1995 N. MacGregor, 'Titian: Noli me Tangere', *The National Gallery News*, December 1995.

MacLAREN/BRAHAM 1970 N. MacLaren and A. Braham, *National Gallery Catalogues*: The Spanish School, London, 1970.

MÂLE 1932 E. Mâle, *L'art religieux après le Concile de Trente*, Paris, 1932.

MÂLE 1986 E. Mâle, *Religious Art in France*, 3 vols., vol. III, Princeton, 1986 (vol. I, 1978; vol. II, 1984).

MANCHESTER 1947 *Artists and Craftsmen of the Middle Ages: exhibitions from private collections of incunabula, sculpture, paintings and drawings of the fifteenth and sixteenth centuries*, exh. cat., Whitworth Art Gallery, Manchester, 1947.

MANCINI 1992 F.F. Mancini, *Benedetto Bonfigli*, Perugia, 1992.

MARKS 1977 R. Marks, 'Two Early sixteenth-century Boxwood Carvings associated with the Glymes Family of Bergen op Zoom', *Oud Hollander*, 91 (1977), pp. 132–44.

MARROW 1977 J. Marrow, 'Circumdederunt me canes multi: Christ's Tormentors in Northern European Art of the Late Middle Ages and Early Renaissance', *The Art Bulletin*, 59 (1977), pp. 167–81.

MARROW 1979 J.H. Marrow, *Passion Iconography in Northern European Art of the Late Middle Ages and Early Renaissance*, Kortrijk, 1979.

MARTIN 1961 K. Martin, 'Zur oberrheinischen Malerei im beginnenden 14. Jahrhundert', in *Eberhard Hanfstaengl zum 75. Geburtstag*, E. Ruhmer, ed. Munich, 1961.

MARUCCHI 1910 O. Marucchi, *I monumenti del Museo Cristiano Pio Lateranense*, Milan, 1910.

MASKELL 1905 A. Maskell, *Ivories*, London, 1905.

MAUQUOY-HENDRICKX 1978 Mauquoy-Hendrickx, *Les Estampes des Wierix conservées au cabinet des estampes de la Biblioteque Royale Albert Ier*, 3 vols. (4 parts), Brussels, 1978.

MAYER 1936 A.L. Mayer, *Velázquez*, London, 1936.

MEDER 1932 J. Meder, *Dürer Katalog: Ein Handbuch uber Albrecht Dürers Stiche, Radierung, Holzschnitte, deren Züstande, Ausgaben und Wasserzeichen*, Vienna, 1932.

Meditations; Meditations on the Life of Christ. An Illustrated Manuscript of the Fourteenth Century, Paris, Bibliothéque Nationale, MS. Ital. 115, translated by I. Raguna and completed from the Latin and edited by I. Ragusa and R.B. Green, Princeton, 1961.

MIDDELDORF 1941 U. Middeldorf, 'Dello Delli and *Man of Sorrows* in the Victoria and Albert Museum', *The Burlington Magazine*, 78 (1941), pp. 71–78.

MIDDELDORF 1962 U. Middeldorf, 'Un rame inciso del Quattrocento', in *Scritti di Storia dell'arte in onore di Mario Salmi*, Rome, 1962, II, pp. 273–89.

MOFFITT 1992 J.F. Moffitt, 'The meaning of "Christ after the Flagellation" in Siglo de Oro Sevillian painting', *Wallraf-Richartz-Jahrbuch*, 53 (1992), pp. 139–54.

MORENO 1998 A. Moreno, *Zurbarán*, Madrid, 1998.

MORETTO 1999 G. Moretto, *The Shroud: A Guide*, Paulist Press, 1999.

Morey 1959 C.R. Morey, The Gold-glass collection of the Vatican Library with additional catalogues of other gold-glass collections, G. Ferrari, ed. Vatican City, 1959.

Mortari 1995 L. Mortari, *Bernardo Strozzi*, Rome, 1995.

Munich 1971 *Albrecht Dürer: 1471 1971*, exh. cat., P. Strieder, ed. Bayerische Staatsgemäldesammlungen, Munich, 1971.

New York 1987 *Zurbarán*, exh. cat., J. Baticle, ed. The Metropolitan Museum of Art, New York, 1987.

Niffle-Anciaux 1889 E. Niffle-Anciaux, 'Les Repos de Jésus et les berceaux reliquaires', *Annales de la Société Archéologique de Namur*, 18 (1889), pp. 420-84.

Niffle-Anciaux 1911 E. Niffle-Anciaux, '"Repos de Jésus" alias "Jésueau"', *Annales de la Société Archéologique de Namur*, 30 (1911), pp. 194-202.

Nuis Cahill 1971 J. van Nuis Cahill, 'Two Franco-Flemish Sculptures', Dayton Art Institute Bulletin, 39 (1971), pp. 2-16.

Ornamenta Ecclesiae; Ornamenta Ecclesiae, Dipinti, oreficeria liturgica e paramenti ecclesiali a Motta di Livenza, exh. cat., A. Argentieri Zanetti and S. Claut, Motta di Livenza, eds. 1988.

Pallucchini 1959 R. Pallucchini, *Giovanni Bellini*, Milan, 1959.

Palomino (1724) 1986 A. Palomino, *Vidas*, N. Ayala Mallory, ed. Madrid, 1986.

Panofsky 1927 E. Panofsky, '"Imago Pietatis"', in *Festscrift für M.J. Friedländer zum 60. Geburtstag*, Leipzig, 1927, pp. 261-308.

Panofsky 1948 E. Panofsky, *The Life and Art of Albrecht Dürer*, 3rd edn., 2 vols., Princeton, 1948.

Panofsky 1953 E. Panofsky, *Early Netherlandish Painting: Its Origin and Character*, Cambridge (Mass.), 2 vols., 1953.

Paris 1988 *L'œil d'or. Claude Mellan 1598-1688*, exh. cat., Bibliothèque Nationale, Galerie Mazarine, Paris, 1988.

Paris 1988 *Zurbarán*, exh. cat., J. Baticle, ed. Grand Palais, Paris, 1988.

Penny 1994 N. Penny, 'Non-finito in Italian Fifteenth-Century Bronze Sculpture', in *Antologia di belle arti: La Scultura. Studi in onore di Andrew S. Ciechanowiecki*, 1994, pp. 11-15.

Pevsner 1948 N. Pevsner, 'Bruegel's "The Adoration of the Kings"', *The Listener*, 5 Feb 1948, pp. 215-17.

Pignatti/Romanelli 1985 *Drawings from Venice: Masterworks from the Museo Correr*, Venice, exh. cat., T. Pignatti and G. Romanelli, eds. The Drawing Center, New York, 1985.

Pinson 1994 Y. Pinson, 'Bruegel's 1564 Adoration: Hidden Meanings of Evil in the Figure of the Old King', *Artibus et Historiae*, 30 (1994), pp. 109-27.

Pope-Hennessy 1964 J. Pope-Hennessy, *Catalogue of Italian Sculpture in the Victoria and Albert Museum in London*, 3 vols., London, 1964.

Pope-Hennessy 1993 J. Pope-Hennessy, *Donatello: Sculptor*, New York, London, Paris, 1993.

Pople 1991 K. Pople, *Stanley Spencer: A Biography*, London, 1991.

Préaud 1988 M. Préaud, 'Claude Mellan', *Inventaire du fonds français*: Graveurs du XVIIème siècle, vol. XVII, Paris, 1988.

Radcliffe Baker/Maek-Gérard 1992 M. Radcliffe Baker and M. Maek-Gérard, *The Thyssen-Bornemisza Collection. Renaissance and later sculpture with works of art in Bronze*, London, 1992.

Raymond of Capua 1960 The Blessed Raymond of Capua, *The Life of Saint Catherine of Siena*, London, 1960.

Réau 1955 L. Réau, *Iconographie de l'art chrétien*, 3 vols., Paris, 1955.

Révai 1964 A. Révai, *Sutherland. Christ in Glory in the Tetramorph: The Genesis of the Great Tapestry in Coventry Cathedral*, London, 1964.

Reynolds 1996 C. Reynolds 'Reality and Image: Interpreting Three Paintings of the *Virgin and Child in an Interior* associated with Campin', in Foister/Nash 1996, pp. 183-95.

Richter 1910 J.P. Richter, *The Mond Collection*, 2 vols., London, 1910.

Roberta 1998 J.M. Roberta, 'The Rosary and its Iconography, Part I: Background for Devotional Tondi', *Arte Cristiana*, Anno LXXXVI, 787 (1998), pp. 263-74.

Robertson 1968 G. Robertson, *Giovanni Bellini*, Oxford, 1968.

Robinson 1979 D. Robinson, *Stanley Spencer: Visions from a Berkshire Village*, Oxford and London, 1979.

Robinson 1990 D. Robinson, *Stanley Spencer*, Oxford, 1990.

Roman Imperial Coinage VII C.H.V. Sutherland and R.A.G. Carson, eds. *Roman Imperial Coinage*, vol. VII, *Constantine and Licinius, AD 313-337*, by P.M. Bruun, London, 1966.

Roman Imperial Coinage VIII C.H.V. Sutherland and R.A.G. Carson, eds. *Roman Imperial Coinage*, vol. VIII,

The Family of Constantine I, AD 337-364, by J.P.C. Kent, London, 1981.

Roman Imperial Coinage IX H. Mattingly, C.H.V. Sutherland and R.A.G. Carson, eds. *Roman Imperial Coinage*, vol. IX, *Valentinian I to Theodosius I*, by J.W.E. Pearce, London, 1951.

Rooses 1886-92 M. Rooses, *L'Oeuvre de P.P Rubens: histoire et description de ses tableaux et dessins*, 5 vols., Antwerp, 1886-92.

Rosenauer 1993 A. Rosenauer, *Donatello*, Milan, 1993.

Rothenstein 1979 J. Rothenstein, *Stanley Spencer: The Man: Correspondence and Reminiscences*, London, 1979.

Rowlands 1962 J. Rowlands, 'A Man of Sorrows by Petrus Christus', *The Burlington Magazine*, 104 (1962), pp. 419-23.

Sansovino 1603 F. Sansovino, *Venetia, citta nobilissima et singolare/descritta gia in XIIII libri da Francesco Sansovino*, Venice, 1603.

Schabacker 1974 P.H. Schabacker, *Petrus Christus*, Utrecht, 1974.

Schiller 1972 G. Schiller, *Iconography of Christian Art* translated by Janet Seligman, London, 1972.

Scott 1892 W.B. Scott, *Autobiographical Notes of William Bell Scott*, W. Minto, ed. London, 1892.

Seling 1980 H. Seling, *Der Kunst der Augsberger Goldschmeide 1529-1868*, 2 vols., Munich, 1980.

Seymour 1966 C. Seymour, Jr., *Sculpture in Italy 1400-1500*, Harmondsworth, 1966.

Sharp 1816 T. Sharp, 'On a gold ring found at Coventry Park', Letter addressed to the Society of Antiquarians. *Archaeologia*, 18 (1817), pp. 306-8.

Shearman 1972 J.K.G. Shearman, *Raphael's cartoons in the collection of Her Majesty the Queen, and the tapestries for the Sistine Chapel*, London, 1972.

Shearman 1992 J. Shearman, *Only Connect, Art and the Spectator in the Italian Renaissance*, Princeton, 1992.

Smith 1985 A. Smith, *National Gallery Schools of Paintings: Early Netherlandish and German Paintings*, London, 1985.

Snyder 1960 J.E. Snyder, 'The Early Haarlem School of Painting, II: Geertgen tot Sint Jans', *The Art Bulletin*, 42 (1960), pp. 113-32.

Soria 1953 M. Soria, *The Paintings of Zurbarán*, London, 1953.

Spencer 1961 G. Spencer, *Stanley Spencer by his Brother Gilbert*, London, 1961.

STEINBERG 1996 L. Steinberg, *The Sexuality of Christ in Renaissance Art and Modern Oblivion*, 2nd rev. edn., Chicago and London, 1996.

STEPPE 1965 J.K. Steppe, 'Tableaux de Jean Gossaert dans l'ancienne Abbaye de Saint-Adrien B Grammont', in *Jean Gossaert dit Mabuse*, exh. cat., Museum Boymans-van Beuningen, Rotterdam; and Groeningenmuseum, Bruges, 1965, pp. 39-46.

STERLING 1971 C. Sterling, 'Observations on Petrus Christus', *The Art Bulletin*, 53 (1971), pp. 1-26.

STIRLING MAXWELL 1873 W. Stirling Maxwell, *Essay Towards a Catalogue of Prints Engraved from Works of Velázquez and Murillo*, London, 1873.

STOICHITA 1991 V.I. Stoichita, 'Zurbarán's Veronica', *Zeitschrift für Kunstgeschichte*, 54 (1991), pp. 190-206.

STOICHITA 1995 V.I. Stoichita, *Visionary Experience in the Golden Age of Spanish Art*, London, 1995.

STRAUSS 1980 W.L. Strauss, *Albrecht Dürer, Woodcuts and Woodblocks*, New York, 1980.

STRAUSS 1981 W.L. Strauss, *The Intaglio Prints of Albrecht Dürer: Engravings, etchings and drypoints*, New York, 1981.

SULZBERGER 1925 M. Sulzberger, 'Le symbole de la croix et les monogrammes de Jésus chez les premiers Chrétiens', *Byzantion*, 2 (1925), pp. 337-448.

TEMPESTINI 1992 A. Tempestini, *Giovanni Bellini: catalogo completo*, Florence, 1992.

The English Connoisseur; The English Connoisseur. Containing an account of whatever is curious in painting, sculpture … in the palaces and seats … of England, 2 vols., London, 1766.

THUILLIER 1982 R. Thuillier, *Graham Sutherland Inspirations*, Guildford, 1982.

THURSTON 1900 H. Thurston, *The Holy Year of Jubilee*, St Louis, 1900 (reprint 1980).

TIETZE/TIETZE-CONRAT 1944 H. Tietze and E. Tietze-Conrat, *The Drawings of the Venetian Painters in the 15th and 16th Centuries*, New York, 1944.

TORR 1898 C. Torr, *On Portraits of Christ in the British Museum*, London, 1898.

TORRES MARTÍN 1963 R. Torres Martín, *Zurbarán el pintor gótico del siglo XVII*, Seville, 1963.

TUDOR-CRAIG 1998 P. Tudor-Craig, 'Times and Tides', *History Today*, 48 (4), (May 1998), pp. 8-10.

TUDOR-CRAIG/FOSTER 1986 P. Tudor-Craig and R. Foster, 'Christ crowned with thorns', *The Listener*, 9 October 1986, pp. 12-13.

UPTON 1990 J.M. Upton, *Petrus Christus: His Place in Fifteenth-Century Flemish Painting*, University Park and London, 1990.

URBACH 1995 S. Urbach, 'On the iconography of Campin's *Virgin and Child in an Interior*: the Child Jesus comforting his mother after the Circumcision' in *Flanders in a European Perspective, Manuscript Illumination around 1400 in Flanders and Abroad*, Proceedings of the International Colloquium, Leuven, 7-10 September 1993, M. Smeyers and B. Cardon, eds. Corpus of Illuminated Manuscripts, vol. 8, Low Countries series 5, Leuven 1995 pp. 557-68.

UZIELLI 1899 G. Uzielli, *Le misure lineari medioevali e l'effigie di Cristo*, Florence, 1899.

VALDIVIESO 1998 E. Valdivieso, *Zurbarán*, exh. cat., Museo de Bellas Artes, Seville, 1998.

VALDIVIESO/SERRERA 1985 E. Valdivieso and J.M. Serrera, *Pintura Sevillana del Primer Tercio del Siglo XVII*, Madrid, 1985.

VAN OS 1992 H.W. van Os, C.O. Jellema and A.W.A. Boschloo, *Meeting of Masterpieces: Titian – Ludovico Carracci*, dual-language (Dutch – English) exhibition booklet, Rijksmuseum, Amsterdam, 1992.

Vatican Collections; The Vatican Collections, The Papacy and Art, exh. cat., The Metropolitan Museum of Art, New York, 1983.

VIRGIL 1974 Virgil, *Georgics*, Book II, Loeb Classical Library, Virgil, vol. I, Cambridge (Mas.), 1974.

VON BODE/VOLBACH 1918 W. Von Bode and W.F. Volbach, 'Mittelrheinische Ton-Und Steinmodel aus der ersten halfte des XV. Jahrhunderts', *Jahrbuch der Koniglich Preuszischen Kunstsammlungen*, 39 (1918), pp. 89-136.

VOORHELM SCHNEEVOGT 1873 C.G. Voorhelm Schneevogt, *Catalogue des estampes … d'après Rubens*, 1873.

VORAGINE 1993 Voragine, Jacobus de, *The Golden Legend, Readings on the Saints*, trans. by W. Granger Ryan, Princeton, 1993.

WAAGEN 1854 G. Waagen, *Descriptive Catalogue of a collection [Oettingen-Wallerstein] of Byzantine, Early Italian, German, Flemish and Dutch Pictures now at Kensington Palace*, London, 1854.

WASHINGTON 1971 *Dürer in America: His Graphic Work*, exh. cat., C. W. Talbot, ed. National Gallery of Art, Washington, 1971.

WASHINGTON 1985 *The Treasure Houses of Britain: five hundred years private patronage and art collecting*, exh. cat., National Gallery of Art, Washington, 1985.

WECKWERTH 1968 A. Weckwerth, 'Einiges zur Darstellung des Reben-Christus', *Raggi* 8 (1968), pp. 18-24.

WEITZMANN 1971 K. Weitzmann, *Studies in Classical and Byzantine Manuscript Illumination*, H. L. Kessler, ed. Chicago, 1971.

WEITZMANN 1979 K. Weitzmann, ed., *Age of Spirituality. Late Antique and Early Christian Art, Third to Seventh Century*, exh. cat., Metropolitan Museum of Art, New York, 1979.

WENTZEL 1960 H. Wentzel, 'Eine Wiener Christuskindwiege in München und das Jesuskind der Margaretha Ebner', *Pantheon*, 19 (1960), pp. 276-83.

WENTZEL 1962 H. Wentzel, 'Ein Christkindbettchen in Glasgow: Addenda aus der Burrell Collection', *Pantheon* 20 (1962), pp. 1-7.

WENTZEL 1962 H. Wentzel, 'Ein Elfenbeinbüchlein zur Passionsandacht', *Wallraf-Richartz-Jahrbuch*, 24 (1962), pp. 193-212.

WILKINS 1969 E. Wilkins *The Rose-Garden Game*, London, 1969.

WILLIAMSON 1996 P. Williamson, *The Medieval Treasury: The Art of the Middle Ages in the Victoria and Albert Museum*, 2nd edn., London, 1996.

WILLIAMSON/EVELYN 1988 P. Williamson and P. Evelyn, *Northern Gothic Sculpture 1200-1450*, London, 1988.

WILPERT 1929-36 J. Wilpert, *I sarcofagi cristiani antichi*, 5 vols., Rome, 1929-36.

WILSON 1978 I. Wilson, *The Turin Shroud*, London, 1978.

WINKLER 1941 F. Winkler, 'Dürers Kleine Holzschnittpassion und Schäufeleins Speculum-Holzschnitte', *Zeitschrift des deutschen Vereins für Kunstwissenschaft*, 8 (1941) pp. 197-208.

WINSTON-ALLEN 1997 A. Winston-Allen, *Stories of the Rose: the making of the rosary in the Middle Ages*, University Park, Pennsylvania State University Press, 1997.

WINTER 1977 D. Winter, *After the Gospels*, London and Oxford, 1977.

WIXOM 1972 W.D. Wixom, 'Twelve Additions to the Medieval Treasury', *Bulletin of the Cleveland Museum of Art*, 59 (April 1972), pp. 87-111.

WÖLFFLIN 1971 H. Wölfflin, *The Art of Albrecht Dürer*, trans. by A. and H. Grieve, New York, 1971.

YOUNG 1986 E. Young, 'The Two Trinities in the School of Seville and an unknown version by Zurbarán', *Apollo*, 123 (1986), pp. 10-13.

Photographic Credits

Lenders

The Royal Collection © 2000, Her Majesty the Queen, cat. no. 41

The Dean and Chapter of St Paul's Cathedral, London, cat. no. 16

John Wingfield Digby, cat. no. 42

Amsterdam, Rijksmuseum, cat. no. 23

Birmingham Museums and Art Gallery, cat. no. 75

Compton Verney House Trust (Peter Moores Foundation), cat. no. 67

Coventry, Herbert Art Gallery and Museum, cat. no. 78

Edinburgh, National Gallery of Scotland, cat. no. 70

Glasgow Museums: The Burrell Collection, cat. no. 24

Glasgow Museums: The St Mungo Museum of Religious Life and Art, cat. no. 77

London, British Museum, Department of Coins and Medals, cat. nos. 5, 6, 7, 8 and 18

London, British Museum, Department of Medieval and Later Antiquities, cat. nos. 9, 10, 11, 12, 13, 43, 63

London, British Museum, Department of Prints and Drawings, cat. nos. 35, 56, 58 and 74

London, Trustees of the Tate Gallery, cat. nos. 76 and 79

London, Victoria and Albert Museum, cat. nos. 19, 20, 27, 52, 55, 61, 68, 72 and 73

Madrid, Museo Nacional del Prado, cat. no. 17

Nuremberg, Germanischer Nationalmuseum, cat. no. 65

Oxford, Bodleian Library, University of Oxford cat. no. 60

Sheffield Galleries and Museums Trust, cat. no. 29

Soprintendenza Archeologica di Roma, cat. no. 1

Stockholm, Nationalmuseum, cat. no. 36

University of London, College Art Collections, cat. no. 39

Utrecht, Museum Catharijneconvent, cat. nos. 38, 40, 48 and 62

Valencia, Museo de Bellas Artes, cat. no. 49

Vatican City, Vatican Museums, cat. nos. 2, 3 and 4

The Wernher Collection, cat. no. 57

Private collection, cat. nos. 50 and 64

Authors' Acknowledgements

We would like to express our gratitude for the generous assistance we have received from colleagues in museums and galleries who have lent works to this exhibition, in particular, to colleagues in the British Museum, the Victoria and Albert Museum, the Tate Gallery, the Glasgow Museums, the National Gallery of Scotland, the Vatican Museums, the Museo Nazionale di Roma, and the Catharijneconvent Museum in Utrecht. In addition we have received much help from all our colleagues at the National Gallery. The raw material of the catalogue has been turned into a beautiful book thanks to our colleagues at National Gallery Company Limited, the assistant editor, Mandi Gomez, and the designer, Sarah Davies. In writing this catalogue we have benefited greatly from the writings of numerous scholars, but especially Emile Mâle, Sixten Ringbom, Hans Belting, Henk van Os, Eamon Duffy and the anonymous Franciscan author of the *Meditations on the Life of Christ*; to them all we are grateful.

Special thanks are due to the following:

Richard Abdy, Brigadier R.W. Acworth, Barry Ager, Robert Anderson, Charles Avery, Silvia Ballantyne, Janet Barnes, Giulia Bartrum, Fernando Benito Domenech, Anna Benn, Diane Bilbey, Sieske Binnendijk, Alan Borg, Hugh Brigstocke, Judith Bronkhurst, Anthea Brook, David Buckton, Francesco Buranelli, Revd. Richard Burridge, Ignacio Cano Rivero, Emma Chambers, Hugo Chapman, Arabella Cifani, Mary Clapinson, Ron Clarke, Andrew Clary, Timothy Clifford, Judith Collins, Patricia Collins, Robin Cormack, David Davies, Henri L. M. Defoer, Stephen De Winter, Revd. Tom Devonshire Jones, Zena Dickinson, David Djaoui, Eamon Duffy, Harry Dunlop, Rosanna Eady, Patrick Elliott, Christopher Entwhistle, Jane Farrington, Stephen Feeke, Luca Finaldi, Piero Finaldi, Father Alan Fudge, Nigel Glendinning, Anne Goodchild, Olle Granath, Richard Gray, Antony Griffiths, G. Ulrich Großmann, María-Inés Guerrero Parra de Finaldi, Canon John Halliburton, Marianne Harari, Enriqueta Harris Frankfort, William Hobson, Louise Hofman, Jill Holmen, Barbara Holmes, Revd. Nicholas Holtam, Clive Hurst, Susan Jenkins, Norbert Jopek, Revd. Graham R. Kent, Lothar Lambacher, Christopher Lloyd, Rupert Maas, Eckard Marchand, Gregory Martin, Susan Mileham, Monasterio de la Encarnación, Avila, Franco Monetti, Peter Moores, The Dean of St Paul's, the Very Revd. Dr John Moses and the Chapter of St Paul's Cathedral, Laurence Morocco, Peta Motture, Sandy Nairne, Douglas Nurse, Sheila O'Connell, Mark O'Neill, Revd. Mark Oakley, John Orna-Ornstein, Leila Nista, St Vedast parish church, St Martin Ludgate parish church, Viola Pemberton-Pigott, Edgar Peters Bowron, Revd. Ben Quash, François Quiviger, Jan T. Rhodes, Sarah Robinson, Graham Rogers, William Schupach, Peter Seed, Nicholas Serota, Giandomenico Spinola, Luke Syson, Stéphane Tarica, Roger Tolson, Maria Vassilakis, Marieke Vlyerden, Lisa Voden-Decker, June Wallis, Jean Walsh, Geoffrey West, Aidan Weston-Lewis, Patricia Wheatley, Jonathan Williams, Paul Williamson, Ian Wilson, John Wingfield Digby, Jenny Wood and Miguel Zugaza.

Susanna Avery-Quash
Xavier Bray
Gabriele Finaldi
Erika Langmuir
Neil MacGregor
Alexander Sturgis

Index